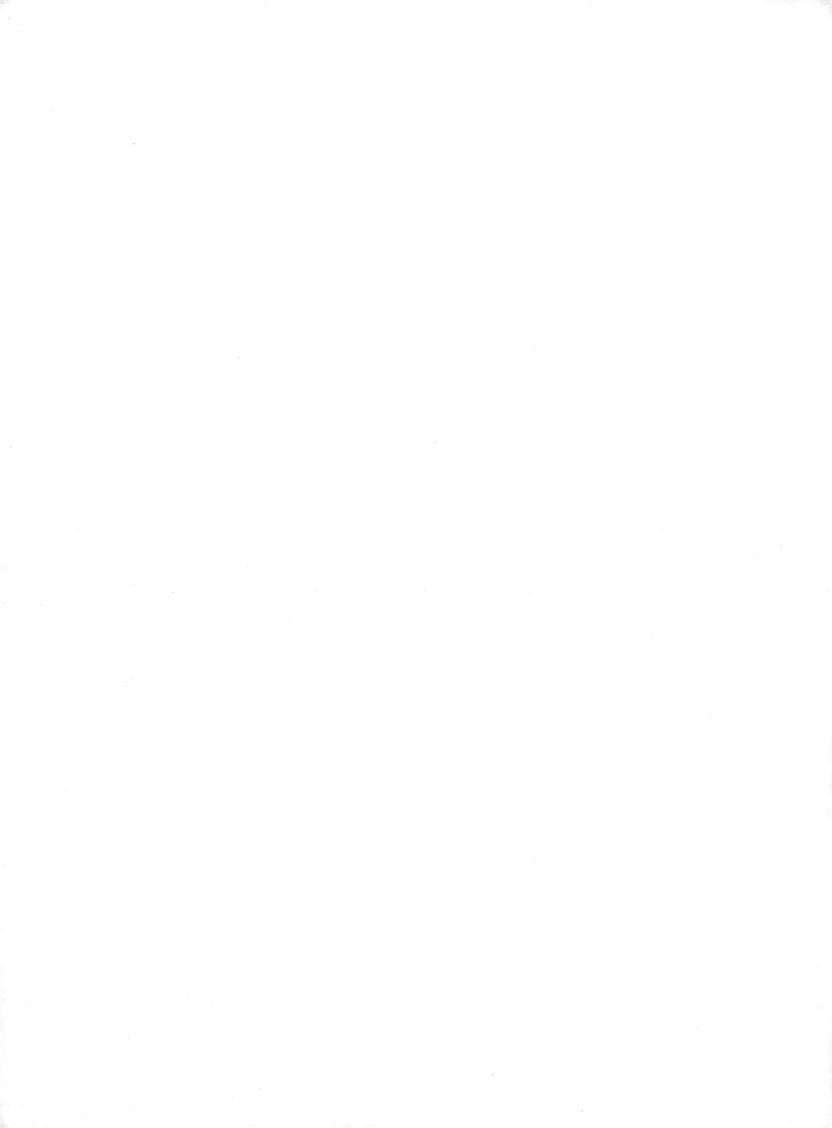

THE ARTS CLUB OF CHICAGO

The Collection 1916–1996

SOPHIA SHAW, EDITOR

THE ARTS CLUB OF CHICAGO

THE ARTS CLUB OF CHICAGO: *The Collection 1916–1996*
is published in conjunction with the inauguration of the
new Arts Club building, 201 East Ontario Street,
Chicago, Illinois 60611, April 4, 1997.

© 1997 by The Arts Club of
Chicago.

ISBN 0-96434-403-3

Artistic Director of
The Arts Club, Kathy Cottong;
book conceived and edited by
Sophia Shaw;
copy editing, Sue Taylor;
designed by Tamar Burchill;
photographs by Michael Tropea,
unless otherwise indicated.

This book was typeset in Gill
Sans regular and Fairfield light;
5,000 copies were printed by
Congress Printing Company,
Chicago, Illinois.

Cover: Natalia Goncharova,
Spring, 1927/28.

Table of Contents

Preface 7
STANLEY M. FREEHLING

Contributors 8

Acknowledgments 9
SOPHIA SHAW

A Welcome Mat for Modernism 10
NEIL HARRIS

Gracious Provocation 15
KATHY COTTONG AND SUE TAYLOR

A Collection to Remember 21
SOPHIA SHAW

Collection Highlights 31

Catalogue 110
ADAM JOLLES

Chronology of Exhibitions 122

Index 134

STANLEY M. FREEHLING
President

FROM ITS INCEPTION, The Arts Club of Chicago has attracted and benefited from the leadership of a number of dynamic individuals dedicated to enriching the cultural life of their community. Their impressive contributions live on in our memories and, tangibly, in the institution they built; an important aspect of their legacy can be seen in the works of art that have become part of the very fabric of the Club through the years. Honoring the early achievements of past officers such as Rue Winterbotham Carpenter and Alice Roullier, Elizabeth Goodspeed Chapman and Arthur Heun, we are pleased to present this catalogue of the collection they inaugurated. In many ways, the collection is a living document of their vision—of Rue Shaw's, for instance, whose tenure as president brought us our former Mies-designed incarnation on Ontario Street and the delightful mobile by Alexander Calder that became a signature piece for the Club. Her story is one of the many engagingly told in the following pages.

A sense of history is not new to The Arts Club, whose members have long understood the signal role the Club has played in Chicago in providing a forum for innovative art and ideas. The Club's archives, including not only minutes and resolutions but also personal correspondence with artists such as Calder, Jean Dubuffet, Marcel Duchamp, and Natalia Goncharova, have been preserved in the Newberry Library since 1972. Histories of the Club have accompanied significant anniversary exhibitions, thanks especially to the careful research of James M. Wells and the late Everett C. McNear. Their work has provided the foundation for the burst of creative investigation conducted by Sophia Shaw and her colleagues for *The Arts Club of Chicago: The Collection 1916–1996*. It was Sophia, granddaughter of Rue Shaw, who proposed the book, launched the inventory and documentation of the collection, and enlisted the distinguished writers whose insights about these works of art we can now share. To her we owe a debt of fond appreciation and gratitude.

The administration of the project has been the task of our exceptional artistic director, Kathy Cottong, amidst the countless other responsibilities she has shouldered at a most exciting time in the life of The Arts Club. Because of her efforts, we can offer this volume to coincide with the auspicious occasion of the Club's relocation to a permanent home. As we celebrate a future full of promise in our elegant new headquarters designed by John Vinci of Vinci/Hamp Architects, we can also look to the past, to the many benefactors to the collection, those who established a tradition we now find ourselves extending.

Contributors

Richard A. Born, *Curator,* The David and Alfred Smart Museum of Art, The University of Chicago

Douglas W. Druick, *Prince Trust Curator of Prints and Drawings and Searle Curator of European Painting,* The Art Institute of Chicago

Kathy S. Cottong, *Artistic Director,* The Arts Club of Chicago

Richard Francis, *James W. Alsdorf Chief Curator,* Museum of Contemporary Art, Chicago

Neil Harris, *Preston and Sterling Morton Professor of History,* The University of Chicago

Adam Jolles, *Editorial Associate,* The Art Institute of Chicago

Judith Russi Kirshner, *Director,* School of Art and Design, University of Illinois at Chicago

Chapurukha M. Kusimba, *Assistant Curator of African Archaeology and Ethnology,* The Field Museum, Chicago/*Adjunct Professor of Anthropology,* University of Illinois at Chicago

Stephen L. Little, *Pritzker Curator of Asian Art,* The Art Institute of Chicago

Jessica Morgan, *Curatorial Assistant,* Museum of Contemporary Art, Chicago

Mark Pascale, *Assistant Curator of Prints and Drawings,* The Art Institute of Chicago

Daniel Schulman, *Assistant Curator of Twentieth-Century Painting and Sculpture,* The Art Institute of Chicago

Franz Schulze, *Betty Jane Hollender Professor of Art,* Lake Forest College, Illinois

Sophia Shaw, *Curatorial Assistant,* Museum of Contemporary Art, Chicago

Elizabeth E. Siegel, *Research Assistant,* Department of Photography, The Art Institute of Chicago

Dean Sobel, *Chief Curator,* Milwaukee Art Museum

Robert Storr, *Curator of Painting and Sculpture,* The Museum of Modern Art, New York

Sue Taylor, *Independent Scholar,* Chicago

Christa C. Mayer Thurman, *Christa C. Mayer Thurman Curator of Textiles,* The Art Institute of Chicago

David B. Travis, *Curator of Photography,* The Art Institute of Chicago

Andrew Weislogel, *Graduate Assistant,* Department of Prints, Drawings, and Photographs, Herbert F. Johnson Museum of Art, Cornell University

Acknowledgments

Sophia Shaw

THIS BOOK originated with the "Backstage Tour" program developed principally by Victoria Drake, Kathleen Hess, Jean Ross, Cynthia Winter, and myself as members of the Junior Council of The Arts Club in 1992. While writing the script for tours of the 109 East Ontario Street building, we realized the need for a comprehensive list of the paintings, sculptures, decorative objects, and works on paper in the Club's collection. A checklist, created with the assistance of Helyn Goldenberg at Sotheby's and Leslie Hindman of Leslie Hindman Auctioneers, prompted questions about the relationship of these works to their artists' careers, their donors, the Club's exhibitions, and, subsequently, about how these three histories are interwoven. Helen Harvey Mills suggested I uncover these answers and share them in the form of a book, and from the outset, the officers of The Arts Club—Stanley M. Freehling, John D. Cartland, Marshall M. Holleb, Helen Harvey Mills, Patrick Shaw, and Robert A. Wislow—gave their generous support. Kathy Cottong has been closely involved with this project since she arrived at the Club as artistic director in 1993; her guidance and enthusiasm have been nurturing and unwaivering.

The Arts Club is honored by the scholars who have given their time and expertise to realize this book's primary purpose: to enrich the experience of the Club's collection of art. We deeply thank the authors of the catalogue entries for their efforts to contextualize and interpret these well-loved objects for audiences old and new. Neil Harris, Preston and Sterling Morton Professor of History at the University of Chicago, has added a national and historical perspective of the Club in his important introductory essay. In addition, the individuals who conducted the extensive archival research for the book have allowed us to fulfill our second purpose: to compile a thorough and reliable scholarly record for future use. Adam Jolles meticulously researched the provenance, exhibition history, and published references of each work in the collection and, with Patricia Bernath, compiled the exhaustive exhibition history of the Club. Melinda Murphy Thompson pored over The Arts Club archive at the Newberry Library, where all of us have been graciously assisted by Diane Haskell and the entire Special Collections circulation staff. Claire Lieberman provided careful bibliographical information. The previous research of James M. Wells and Everett C. McNear, published in the Club's seventieth and seventy-fifth anniversary catalogues, has been a rich resource, supplemented by the advice of Patricia Scheidt, the Club's former director. Conservators David Chandler, Ruth Jongsma, and Faye Wrubel made detailed physical examinations of many of the works and added to the book's accuracy as an historical document. The expertise of Richard Townsend, Curator of African, Oceanic, and Ancient-American Art at the Art Institute of Chicago was also helpful, as was the cooperation of the Institute's registrar, Mary Solt, and of Janice B. Klein, Registrar, in the Field Museum's Department of Anthropology. All their efforts have helped us produce a book worthy of our third goal—to honor the contributors to the Club's collection. The Arts Club presents this document as a tribute to the artists, collectors, and members who helped form this impressive group of works over the course of the Club's first, and historic, eighty years.

A Welcome Mat for Modernism

Neil Harris

MODERNISM was by both its nature and its history urban and cosmopolitan. In just a half-dozen years following 1910 (after decades of preparation) it exploded, along with the rest of the Western world. Nurtured by clusters of rebels in European cities—Paris, Berlin, Munich, Vienna, Zurich, Moscow—its message to the New World was passed on most easily to the American cosmopolis: New York. There a gaggle of practicing insurgents, organizations, and sympathetic patrons provided a welcome mat. Avant-garde artists steamed frequently back and forth across the Atlantic highway, stopping usually at this single port of entry to the United States, and often going no further. In New York specialist dealers, enterprising journalists, collectors, and enthusiastic connoisseurs spread a gospel of aesthetic revolution. Its institutional expression was crowned, for the visual arts at least, by the 1929 creation of the Museum of Modern Art.

In an era when distances still counted, long before airplanes and ultimately faxes revolutionized the ease of intercontinental contact, the domestic spread of the new art spirit was surprisingly rapid, if also bitterly contested and inevitably uneven. We are learning belatedly just how several American cities, in the decade of normalcy and George Babbitt, found themselves sheltering modernist enclaves, some of them, like Chicago, boasting their own traditions of revolt. Artists, writers, poets, musicians were drawn into the new movement by their own creative ambitions and elective affinities, but what attracted its patrons and supporters? Why did so many living in the "provinces" climb onto the modernist bandwagon? Skeptical journalists and outraged moralists may have angrily condemned radical trends, and supporters were certainly outnumbered by opponents, but Modernism, in the teens and twenties, during the flourishing early years of The Arts Club, was both a cause and a crusade to true believers. They identified its new rhythms, colors, shapes, and sounds with modernity itself—with progressive attitudes, sensory liberation, and even with civic obligation. Purchasing a work of art, attending a lecture or a concert, visiting sympathetic galleries, acquiring books of modern poetry and criticism, private acts though they were, bore the cachet of audacity and derring-do; at times they could even became statements of affiliation that were laden with political overtones. To be a Modernist, to champion these difficult, sometimes maddeningly obscure artistic modes, could be, as opponents often argued, no more than a choice of fashion, a trendy source of self-expression. But for others it was to line up in an ancient battle, a struggle, to adopt an Emersonian phrase, between the parties of Hope and of Memory. In city after city, ardent enthusiasts for the cause joined hands to promote broader appreciation for the new art. These kindred spirits established journals, clubs, galleries, and experimental theaters in the interest of widening audiences. The cause they adopted was, at once, progressive, cosmopolitan, and emancipating, complementing the Progressive era of political reform which it succeeded. The geography of Modernism and its lay leadership in this springtime of action are yet to be fully described, but America's provinces were surprisingly active and even innovative, within a larger climate of suspicion and rejection.

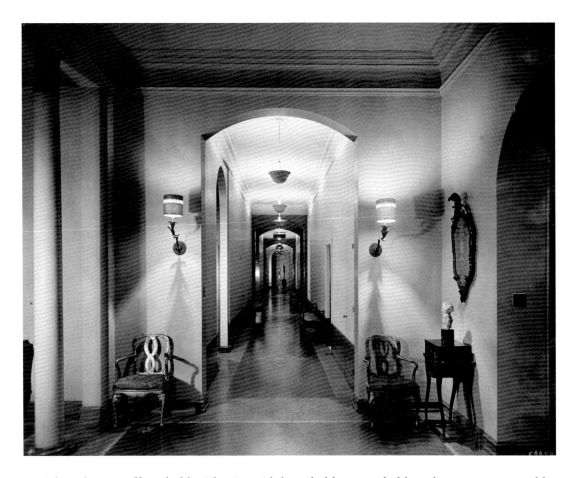

Fig. 1. Corridor of The Arts Club at 410 North Michigan Avenue in November 1929. Brancusi's polished bronze *Golden Bird* of 1919, now in the collection of the Art Institute of Chicago, is visible at the end of the corridor. A marble Roman sculpture, stolen from the Club in 1993, is at right.

The Chicago effort, led by The Arts Club and ably seconded by other organizations like the Renaissance Society, *Poetry*, *The Little Review*, and the Little Theatre, typified, in its leadership and strategies, movements in many other locations. It was no accident, for example, that enthusiasm for Modernism was fostered by liberal, well informed, and often (though not always) well-to-do women, finding here an outlet for energies that conventions in business and politics still checked. Rue Winterbotham Carpenter and Alice Roullier, the presiding spirits during the Club's most daring period, had counterparts elsewhere. Mabel Dodge of Greenwich Village and Taos, Katherine Dreier of Brooklyn, Claribel and Etta Cone of Baltimore, Anne Evans of Denver, Louise Arensberg of New York and Los Angeles, Lizzie Bliss, Mary Quinn Sullivan, Marie Harriman, and Abby Aldrich Rockefeller of New York were among the highly placed women who helped legitimate the modernist cause for America's visual arts. Given the important role of women as reform leaders, rarely so visible as they were in the Chicago of Jane Addams and Harriet Monroe, such active involvement is understandable, but the achievement remains, nonetheless, impressive.

The leadership of women also calls attention to the role socializing rituals played in the world of the avant garde. The artists, poets, composers, and theorists attracting so much attention during the teens and twenties were often colorful figures who rarely hesitated to deploy the dramatic legends of their private lives in the interests of their aesthetic philosophy. Lecture tours and exhibitions were indispensable aids to popularization; entertainments and social encounters with people of influence became a favored strategy. Opera houses, symphonic halls, and art museums, with their monumental facades and dramatic spaces, had

already demonstrated their utility to business and professional interests. Clubs and societies, more intimately scaled but just as carefully built around social rituals, supplied the cause with settings that might compete with the larger, generally conservative bastions. Again it was no accident that Carpenter combined her avant-garde interests with an impressive career as an interior decorator, including commissions to design quarters for the Casino, Fortnightly, and Racquet Clubs in Chicago, and a set of interiors in New York. Innovative and elegantly modern interiors have themselves long been a feature of Arts Club life. Modernism could be housebroken and shown off to best advantage when creature comforts and handsome decor were allowed to complement its charms.

In Chicago, institutional opposition was less savage than in some other places. The Club itself was hardly monolithic. The Arts Club deserved "much of the credit of breaking down the barrier of prejudice against progressive art, not only in Chicago but in all America—New York included," art critic C. J. Bulliet observed, in an October 1932 issue of the *Chicagoan*. But he also insisted that a majority of the Club's members were probably conservative in their taste. And the major local art forum, the Art Institute of Chicago, acted quite differently than some cultural institutions did elsewhere, notably New York's Metropolitan Museum of Art. The Art Institute had, after all (not without some grumbling) hosted the Armory Show in 1913, and had long been a conspicuous venue for the exhibition of contemporary American artists. Many Arts Club members were themselves among the Institute's most generous supporters, while museum trustees like Frederic Clay Bartlett, Walter Brewster, Arthur Aldis, Charles Hutchinson, and Charles Worcester helped found the Club, and, in many cases, contributed to its exhibitions. And, of course, before forming its own collection The Arts Club donated purchases to Art Institute collections.

Still, there were tensions between the two, and when, in 1927, The Arts Club ended five years of using an Art Institute gallery as its principal exhibition space, there must have been sighs of relief on both sides. The two institutions had very different commitments, reflected in their governing boards. This was, nonetheless, a family quarrel, for the social connections among art supporters, liberal and conservative, survived such upsets.

By 1929, the impact of the Club was clear. A loan exhibition of modern paintings owned by Chicagoans included almost seventy works owned by almost two dozen local collectors, most of them linked to the Club's activities. Further exhibitions of Chicago holdings during the 1930s demonstrated a firmly expanded constituency for contemporary art, European and American. Chicago Modernism faced ups and downs within the establishment, as traditionalists counterattacked in the 1930s with Josephine Logan's Sanity in Art Committee. Newspaper critics were often brutal in their ridicule. But The Arts Club persevered.

Perseverance, indeed, is one of the hallmarks of this Club, and distinguishes the Chicago story from some others. The energy and vision of Carpenter and Roullier, compelling as it was, took the club only through its first two decades. Depression, war, and several moves did not seem to divert the Club from its mission, nor did the increased numbers of commercial galleries and museum settings. Surviving the triumph of Modernism proved to be in some ways even more difficult than its pioneering. Riding new crests of enthusiasm was one thing, patiently husbanding energy and resources was another. What helped the Club, certainly, was its continuity of leadership, the lengthy tenures of Carpenter, Roullier, and Rue Shaw corresponding, in some measure, to the decades of service offered by their counter-

parts in the Art Institute, Hutchinson, Potter Palmer, Jr., and Chauncey McCormick. Creative adaptation, local pride, and curiosity about the cutting edge have helped sustain a continuing round of lectures, exhibitions, and concerts.

Today's contemporary art forms may well be more demanding than were yesterday's. Institutionalizing novelty is now pervasive throughout our culture, but the support of living artists remains as parlous as ever. In the eighty years since The Art Club's establishment, museums and galleries have multiplied dramatically, and along with orchestras, publishers, and opera companies, have regularized contemporary art's contact with broader audiences. And government support for the arts has, for three decades at least, enjoyed a stubbornly persistent existence. Yet bringing people together who take contemporary art seriously is still not widespread. Neutral ground on which collectors, dealers, artists, critics, and lookers-on can mingle constitutes a feature of mature urbanity, an ideal which cities have been struggling toward for centuries. At a time when stadia, athletic arenas, huge convention halls, and professional sports franchises are the hallmarks of successful city status, the continuing presence of The Arts Club suggests an older dream of urban accreditation: hospitality to creativity, collective concern with free expression, an alliance between the city's economic interests and its artistic activities. This is, as historians have long pointed out, a system of mutual accommodation. Benefits are variously economic, social, and psychological. And in the course of its socialization, Modernism has often been purged of its subversiveness, tamed, commercialized, and exploited in a variety of interests.

Again, this is no surprise. Cities have traditionally been creations and defenders of the marketplace, their cultural promotions, particularly in the United States, invariably working in tandem rather than against commercial institutions. Chicago department stores served, for a time, as exhibition salons for independent artists unhappy about the juried requirements of the Art Institute and eager for a no-jury system; retailers and artists alike seemed unfazed by the juxtaposition of lingerie and household furnishings with paintings and sculpture. In keeping with this pattern, The Arts Club has remained a facilitator, a broker, a link connecting different cultures. In doing so it has been faithful to its original charge, marrying to the cultural boosterism of its founders the civic boosterism of its host metropolis. The Arts Club, Bulliet concluded after its first decade had ended, has been at heart a teacher; through it Chicago has "been kept aware of what is going on in the world beyond its gates." Today's Chicago has many other instruments for learning about the arts, but few that combine, with such intimacy, the social, pedagogical, and commercial. Its relocation, again in the city's heart, demonstrates that the spirit which gave it birth more than eighty years ago remains alive and well.

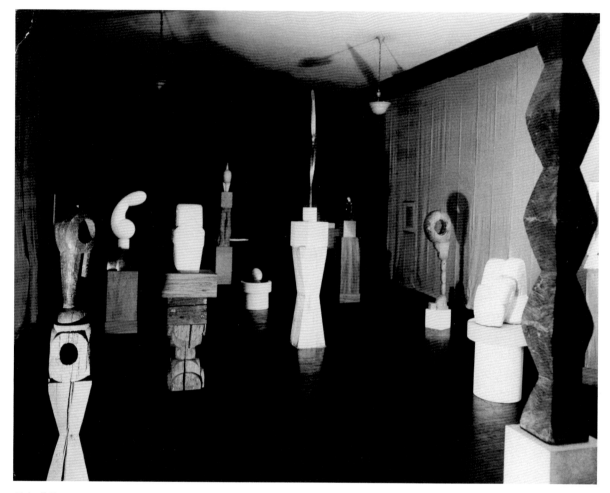

Fig. 2. The Arts Club of Chicago,
410 North Michigan Avenue,
Wrigley Building North Tower, *An
Exhibition of Sculpture by Brancusi*,
1927.

Gracious Provocation

KATHY COTTONG AND SUE TAYLOR

"THE ARTS CLUB conducted its tea with its usual enthusiasm," wrote a *Chicago Daily News* reporter on December 5, 1934,[1] announcing the opening of two new exhibitions—drawings by the French poet Jean Cocteau and modern paintings from the collection of ballet master Leonide Massine. Teas regularly provided the elegant backdrop for such events, with attention "tactfully shared between the startling visions on the walls and the long black table set with candles and tea services." Mrs. Henry Field of the *Herald and Examiner* noticed the composer Aaron Copland in attendance, in Chicago for performances of his ballet *Hear Ye, Hear Ye,* and following tea, she lingered among the aggressively contemporary paintings by Braque and Picasso, André Derain, Natalia Goncharova, Fernand Léger, and Henri Matisse. "I had a chance to listen to the remarks of [exhibition chairman] Alice Roullier," Mrs. Field recounted appreciatively, "who is a veritable walking encyclopedia on the subject of art."

Always a blend of the gracious and provocative, The Arts Club has attracted creative individuals of world renown since Roullier and then president Rue Winterbotham Carpenter launched its earliest exhibitions and programs. Among their notable collaborators in 1927, for instance, was none other than Marcel Duchamp, who, while he was redefining the very concept of art for modern audiences, was also earning a living buying and selling works by other artists. (His stated goal was "to break even, plus ten percent.")[2] Among the artists he represented was his friend Constantin Brancusi, so he worried when a number of the latter's sculptures came to auction after the death of the great collector John Quinn in 1924. Since many feared prices would be depressed by a glut of modern works on the market, Duchamp and two partners purchased twenty-nine Brancusis from the sale. Duchamp retained his share of these sculptures over the next fifteen years, releasing one from time to time whenever he needed money.

In 1926, the New York dealer Joseph Brummer presented an exhibition of Brancusi sculptures from the late Quinn's collection, augmented by pieces from the artist's studio. Duchamp packed the additional sculptures in Paris and traveled with them, meeting Brancusi in New York. Both were shocked when the transported work was refused the designation of art by the United States Customs agency, subjected to duty tax, and admitted on a temporary basis for the Brummer exhibition only.[3] Duchamp contacted a Philadelphia lawyer to plead Brancusi's case, and matters were settled in the sculptor's favor, but not until November 1928 and after much ridicule in the press. All this is to underscore the audacity of Carpenter, who had met Brancusi in Paris, and Roullier, who had a long friendship with Duchamp, in arranging for an abbreviated version of the Brummer exhibition—of such categorically questionable material—to come to The Arts Club. Duchamp accompanied the work to Chicago, installed the polished-bronze, stone, and wooden objects on their distinctive bases, and the historic *Exhibition of Sculpture by Brancusi* opened at The Arts Club on January 4, 1927.

Writing to Brancusi about the reception of his work in Chicago, Duchamp characterized the exhibition from which The Arts Club purchased the glorious *Golden Bird* (1919/20) as

1. All newspaper reviews cited in this essay can be found among the press clippings in The Arts Club's papers in the Newberry Library, Chicago (hereafter, "Newberry Papers").

2. Calvin Tomkins, *Duchamp, A Biography* (New York: Henry Holt and Co., 1996), 271.

3. For more detailed information on Quinn, Brancusi, Duchamp, and The Arts Club, see Margherita Andreotti, "Brancusi's *Golden Bird*: A New Species of Sculpture, *The Art Institute of Chicago Museum Studies* 19:2 (1993): 135-53, 198-203, and Tomkins, *Duchamp*, 270-73.

4. Quoted in Andreotti, "Brancusi's *Golden Bird,*" 150. The Art Institute acquired *Golden Bird* from The Arts Club in 1990, as discussed by Sophia Shaw in "A Collection to Remember" in this volume.

5. Quoted in Tomkins, *Duchamp,* 274.

6. The Duchamp-Roullier correspondence, left in a trunk at the latter's death in 1963, is preserved among the Newberry Papers. See Jane Allen and Derek Guthrie, "Duchamp Letters Found," *New Art Examiner* 1:6 (March 1974): 1,12. (The *Examiner* article, p. 1, erroneously dates the 1927 Brancusi Arts Club exhibition to 1928.)

7. The portrait, exhibited in the Brummer exhibition in 1926, is illustrated in Andreotti, "Brancusi's *Golden Bird,*" figs. 11 and 14.

8. Fernand Léger, "Chicago Seen Through the Eyes of a Visiting French Cubist," trans. Thornton Wilder, *Chicago Evening Post,* March 15, 1932. All Léger citations here are drawn from the *Post* article.

9. For Barr's letter and others, telegrams, and press notices regarding Stein's visit, see the Newberry Papers.

"a moral success."[4] He enjoyed the attentions shown him in Chicago, moreover, boasting to his friend Ettie Stettheimer (sister of Florine) about attending the opera every night; "I have at least a lunch a day," he wrote enthusiastically, "and tea as well—and it is a real delight to see myself swimming in these social perfumes."[5] Back in Europe, Duchamp kept in touch with Roullier, and in subsequent years she helped him place examples of his *Green Box* (1934) and *Box in a Valise* (1935-41) in Chicago collections.[6] In 1937, The Arts Club exhibited a group of his early paintings, including the *Nude Descending a Staircase No. 2* (1912, now Philadelphia Museum of Art) that had caused a such a stir during its American debut at the Armory Show in 1913.

Brancusi's affection for The Arts Club president who so believed in his art is recorded in a portrait drawing of Carpenter from about 1926, in the collection of the Art Institute.[7] When Carpenter died suddenly in December 1931, one of the many tributes to her came from Léger, who had just visited Chicago for an exhibition of his paintings and drawings at The Arts Club that November. The artist renowned for his grand celebrations of the modern urban industrial world had fallen in love with the city, which he praised as "the highest point of mechanical beauty"; returning to Paris, he shared his impressions of Chicago with European readers, publishing an appreciation in the French journal *Plans* in January 1932—dedicated to Carpenter. Thornton Wilder, who was teaching at the University of Chicago at the time, translated the piece for the *Chicago Evening Post.*[8] "Bridges, more bridges," Léger enthused, "Chicago is a city hung from above." One can imagine him gazing west from The Arts Club's Wrigley Building location on Michigan Avenue at the succession of great steel structures spanning the river along Wacker Drive. He was impressed, too, with the cultural vitality of the city, noted that the finest examples of French painting had been collected here, and concluded by acknowledging The Arts Club's progressive efforts: "America is deeply interested in the new schools of art and presents and exhibits them admirably."

Carpenter's successor as president of the Club, Elizabeth "Bobsy" Goodspeed, continued work with Roullier on avant-garde exhibitions and programs. They received exciting news on March 10, 1934 from the director of the Museum of Modern Art in New York: "Gertrude Stein is coming to America," wrote Alfred Barr, Jr. "She is willing to lecture once or twice a week to intelligent audiences during her stay. Do you think the Arts Club would be interested?"[9] The expatriate poet, novelist, and critic would arrive in November for the production of Virgil Thomson's opera *Four Saints in Three Acts*—for which she had written the libretto—at the Auditorium Theater (with Thomson himself conducting), and it seemed to Barr that The Arts Club "would provide the best auspices under which [Stein] could lecture in Chicago." The Club had first choice among six lectures, and selected "The History of English Literature as I Understand It," booking Stein for Sunday evening, November 25. Arrangements were also made for her to present "The Development of the Conception of Personality, Portrait, Poetry, Middle Period, Including Discussion of Repetition" at the Friday Club and "Pictures and What They Mean to Me" at the Renaissance Society at the University of Chicago.

Chicago society then eagerly awaited Stein's arrival. Mrs. Field, in her column "The Social Whirl," predicted that the upcoming visit would change the poet's sensational local image:

> Whereas she is now painted as a fantastic, mysterious cult, a granite mountain, a
> wordy lady, an American who is returning after thirty-four years abroad to cash in on

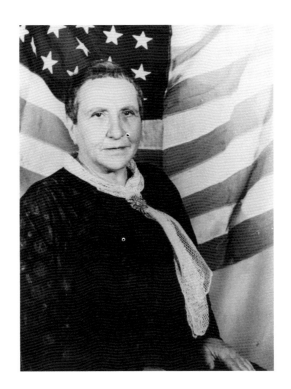

Fig. 3. Carl van Vechten, *Gertrude Stein*, January 24, 1935, gelatin silver print, 24 x 18.4 cm (9³/₁₆ x 7¹/₄ in.), detail, The Arts Club of Chicago. Stein inscribed this photograph for Alice Roullier.

her fame, a lady who refuses to travel without her poodles or Alice B. Toklas, one who wears corduroy trousers, corduroy skirts...she will leave having worn ordinary clothes, given very interesting lectures [...] she will not waste words where her silence would have a better chance of being understood.[10]

When Stein spoke to a crowd of more than two hundred Arts Club members about how she believed English literature had, in the twentieth century, ceded its power to American letters, she was repaid with sustained applause. The *Chicago Sunday Tribune* described her impressive physical presence at the Club: "The sole decor for her stage was two large black urns filled with big, white chrysanthemums. As she burst through flame taffeta curtains, with slate gray toga, slate gray hair, she took the breath of her smart audience, unprepared for such plainness."[11] So successful were Stein's appearances, and so agreeable her hosts, that her visit turned into two. "Chicago," in fact, "became Gertrude's favorite city during her American tour," according to one biographer, and she returned within a month, "royally entertained by the Goodspeeds," taken to concerts, teaching a seminar at the University of Chicago, even accompanying a police detail to the seamier parts of the city in a squad car.[12] Through Goodspeed, she met Wilder, who became a fast friend and important literary colleague for the rest of her life. Her involvement with The Arts Club continued as well after her departure from the city. She had written a catalogue text, in typical Steinian fashion, for an exhibition of paintings by her Scottish protégé Sir Francis Rose, which opened at the Club just before her arrival—"He is happy when he paints, he paints with both hands, he paints, he just paints"—and she provided a foreword, too, for a catalogue of paintings by the French artist Elie Lascaux in 1936 and an essay titled "The Life and Death of Juan Gris" for The Arts Club's Gris retrospective of 1939.

In May 1939, Goodspeed received a letter from Sidney Janis on behalf of the American Artists' Congress announcing a U.S. tour of Picasso's recent masterpiece, *Guernica* (now

10. Mrs. Henry Field, "The Social Whirl," *Chicago Herald and Examiner,* October 17, 1934.

11. "Gertrude Stein's Entrance Makes Audience Gasp," *Chicago Sunday Tribune,* December 2, 1934.

12. James R. Mellow, *Charmed Circle: Gertrude Stein and Company* (New York: Avon Books, 1974), 467–70.

Madrid, Prado Museum) together with fifty-nine related works, to benefit the Spanish Refugee Relief Campaign. The large painting had come to the Valentin[e] Gallery in New York to begin its American tour and would return for a Picasso exhibition at the Museum of Modern Art in November. Rental fees and proceeds from catalogue sales would be sent to the artist for donation to the relief fund. Goodspeed responded immediately, ultimately arranging for The Arts Club to open early that fall to accommodate the painting's itinerary. The great canvas and its attendant drawings and oil studies arrived from the San Francisco Museum of Art for the Club's preseasonal opening on October 2, remaining on public view for one week.

The Arts Club had long before introduced Picasso's work to Chicago audiences—in 1923, with the exhibition of fifty-three works on paper from which the Club's monumental *Head of a Woman* (1922) was acquired—but local critics still resisted the abstracting tendencies and expressive distortions of *Guernica*. Eleanor Jewett of the *Chicago Sunday Tribune* asked rhetorically (and, from our present perspective, obtusely): "Where is the anguish in this composition, where terror, horror, pain, shock, havoc, and ruin? Where the noise and weeping of war?"[13] She compared Picasso unfavorably with his predecessor Francisco Goya, claiming that six inches of a painting by the latter conveyed more about the atrocity of war than the entire mural exhibited at The Arts Club. Nonetheless, two hundred and forty-five catalogues sold in Chicago at twenty-five cents each, and Goodspeed cabled Picasso in Paris on October 10 to report "Guernica Exposition grand success." The exhibition was dismantled the next day and shipped to New York, where the painting remained for more than four decades on extended loan to the Museum of Modern Art—not to be returned to Spain, according to the artist's wishes, until after the death of the hated fascist general Francisco Franco.[14]

The exhibition season that saw *Guernica* installed was Goodspeed's last as president of The Arts Club; she resigned in May 1940, moving to New York. Her successor, Rue Winterbotham Shaw (Carpenter's niece), was elected in November, and one of the memorable events of her early tenure was an astonishing musical program: the young composer John Cage, who had already received national notice in *Time* for his raucous sound experiments at Mills College in California,[15] performed "Music for Percussion Orchestra" at The Arts Club on March 1, 1942. Cage and his group of nine percussionists presented six pieces, two each by composers Lou Harrison, William Russell, and Cage himself. Their instruments were cymbals, drums, piano, tambourine, triangle, and woodblocks, but also entirely unconventional and "un-musical" sound-making objects such as the brake drum of a car, cow bells, flower pots, a slide whistle, and thunder sheets. Cage's "Imaginary Landscape No. 3" must have produced the strangest effect, incorporating an audio-frequency oscillator, recorded sounds, tin cans, buzzers, gongs, a marimba, and coil of wire. For Russell's "3 Dance Movements," consisting, according to the program, of a waltz, march, and foxtrot, the musicians rang a dinner bell, banged an iron pipe, and broke a bottle while performing on more traditional percussion instruments. "They Break Beer Bottles Now to Make Music in Chicago," read the headline above the next day's review in the *New York World-Telegram*. Chicago papers described Cage as "resourceful" and the packed house as "slightly confused" but positive, offering up "hysterical applause."[16]

Cage went on to a brilliant career, returning to The Arts Club years later, in 1980, to

13. Eleanor Jewett, "Art for Every Taste Hangs in City Galleries," *Chicago Sunday Tribune*, October 15, 1939.

14. Franco outlived Picasso, who died in 1973, by two years. The artist's heirs decided in 1981 that the painting could finally be restored to Spain, where it now hangs in the Prado.

15. "Fingersnaps & Footstomps," *Time*, July 29, 1940.

16. *Chicago Daily News* and *Chicago Daily Tribune*, March 2 and 3, 1942, respectively, Newberry Papers.

honor his by then late friend with the second Rue Winterbotham Shaw Memorial lecture, "James Joyce, Marcel Duchamp, Erik Satie: An Alphabet—A Fantasy about Modernism." Shaw had died in 1979, and was remembered for extraordinary accomplishments during her thirty-nine-year presidency, not the least of which was the Mies van der Rohe commission to design the interior of the headquarters at 109 East Ontario Street. The Arts Club opened its 1951 exhibition season in the handsome new space with *Paris Masters, 1941-1951,* and later that winter presented a selection of paintings by Jean Dubuffet. Famed for his vehement rejection of the traditional ideals of timeless beauty and refinement in art, Dubuffet advocated the qualities of what he called art brut, produced by tribal peoples, children, and mental patients. On December 20, the artist delivered his now legendary "Anticultural Positions" lecture at the Club, codifying his ideas in a six-point artistic manifesto.[17]

He aligned himself with "the so-called primitive man" and opposed the entrenched rational values of Western culture, professing a belief in the continuity of existence, "in a real similitude between man and trees and rivers." Not surprisingly for an artist emerging from a European surrealist environment, Dubuffet declared his interest in altered states of consciousness, and asserted that art has more to do with madness than with reason and logic. He preferred prerational thought to ideas, synthesis to analysis. "Our culture," he observed, "is based on an enormous confidence in language—especially written language," and he proceeded to demolish the authority of the word and to elevate painting as a more concrete, and therefore more effective, instrument of thought. Finally, he attacked the concept of the beautiful and its corollary, the ugly: "I refuse absolutely to assent to this idea that there are ugly persons and ugly objects." Dismantling a conventional aesthetic hierarchy, Dubuffet opened infinite possibilities to art, insisting that "any object of the world is able to become for any man a way of fascination and illumination." The impact of his speech was astounding, for it confirmed the doubts already held by a generation of artists in Chicago who, having seen the horrors of World War II, found the traditional decorous concerns and subjects of artistic activity inadequate to their experience.[18]

Although the irony of the sophisticated Frenchman in his formal attire—with black silk stockings, patent-leather shoes, and the additional affectation of a long cigarette holder—arguing for "savage values" was not lost on some audience members that night, Dubuffet's liberating ideas impressed the artist-veterans of the Monster Roster as well as younger artists at the School of the Art Institute, where typescript copies of The Arts Club lecture circulated.[19] Affirming for these students the already established interests of influential teachers Kathleen Blackshear and Whitney Halstead in pre-Renaissance and non-Western art as worthy models, Dubuffet's impassioned speech had important ramifications for art-making as well as for collecting in the city. In a sense, this famous lecture is exemplary of The Arts Club's own role through the years: in an atmosphere of elegance and erudition, provocation and experiment are staged, and the impact often reverberates beyond the immediate present to become the stuff of legend in the future.

17. The lecture has since been published in *Dubuffet and the Anticulture* (New York: Richard L. Feigen and Co., 1969) and in *Arts Magazine* 53 (April 1979): 156–57.

18. For an insightful account of the context and reception of Dubuffet's ideas in Chicago, see Dennis Adrian, "The Artistic Presence of Jean Dubuffet in Chicago and the Midwest," in *Jean Dubuffet: Forty Years of His Art* (Chicago: David and Alfred Smart Gallery, University of Chicago, 1984), 27–30.

19. See Katharine Lee Keefe's interview with Don Baum, Roger Brown, Philip Hanson, Ed Paschke, Christina Ramberg, Barbara Rossi, and Ray Yoshida in *Some Recent Art from Chicago* (Chapel Hill, N.C.: Ackland Art Museum, University of North Carolina at Chapel Hill, 1980), 28–29. Baum has debated the extent of Dubuffet's specific influence in Chicago, but acknowledged an affinity of ideas in his catalogue introduction to the exhibition of works by self-taught artists he curated at The Arts Club in 1990, *Visions: Expressions beyond the Mainstream from Chicago Collections.*

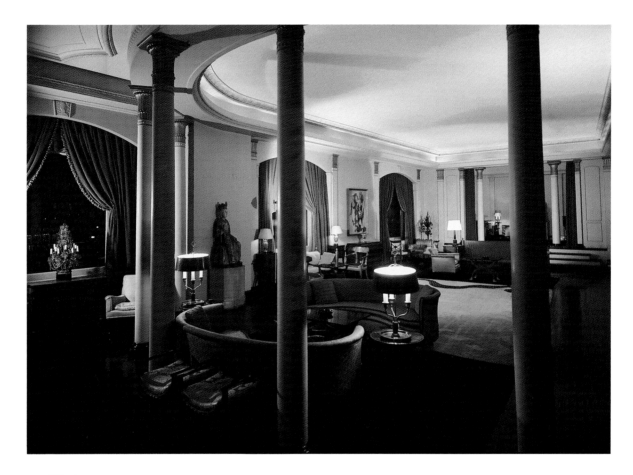

Fig. 4. Sitting room of The Arts
Club at 400 North Michigan
Avenue in November 1937. One
Chinese bodhisattva and Léopold
Survage's 1925 *Fisherwomen* are
visible at right.

A Collection to Remember

SOPHIA SHAW

ON NOVEMBER 3, 1915, a small group of Chicagoans met in the trustees room of the Art Institute of Chicago, for "the purpose of discussing the formation of an arts club."[1] By the following November, three hundred people attended the formal opening of The Arts Club of Chicago on the fifth floor of the Fine Arts Building at 410–12 South Michigan Avenue.[2] In galleries and sitting rooms overlooking Grant Park and Lake Michigan, musicians, writers, artists, patrons, and critics alike viewed and discussed art. It was a propitious beginning for an organization founded, according to the Club's mission statement, to "promote the mutual acquaintance of art lovers and art workers."[3] Over the course of four generations of members, nearly nine hundred exhibitions, and seven headquarters,[4] The Arts Club's diverse art collection developed slowly and serendipitously. As exhibitions and social gatherings occurred more regularly, the Club purchased art to make its environment more inviting. As the organization's reputation grew, so did the number of works acquired through donations, bequests, and memorials; often the excitement surrounding the exhibition of a new artist's work generated a purchase or gift. The works of art that form the remarkable collection of The Arts Club of Chicago are the subjects of numerous recorded and unrecorded histories.

The exact moment at which The Arts Club was first conceived remains unknown, but in a 1950 article in *Townsfolk* magazine, sculptor Nancy Cox-McCormack (later Mrs. Charles T. Cushman) recounted:

> …[American Impressionist] Lawton Parker, who had a studio over mine at 19 East Pearson Street, knocked on my door, saying he had an idea about a new club to bring artists and patrons together for mutual benefit and for the stimulation of Chicago Art appreciation. If he could get a plan on paper he thought he could manage to find an appropriate organizer and first president. We worked out a list of names and chose his good friend, Mrs. Robert [Grace] McGann [1867–1949], painter as well as social leader. Mr. Parker laid the plans before her and she then took over the project.[5]

After the 1915 organizational meeting, McGann became president, and Parker vice president. Two founding members, Rue Winterbotham Carpenter and Arthur Heun, assumed leadership of the decorating committee, charged with preparing the first headquarters. In November 1916, when the Club opened with the paintings of John Singer Sargent and Henry Golden Dearth, its members enjoyed a gallery with "gray walls and a floor painted deep blue. [Another] room had turquoise walls: and encircling seats, upholstered in Roman striped satin, made a very effective dining-room for the Chianti, salami, and ravioli served by Italian waiters."[6] During the following exhibition, in December, of paintings by American Ashcan School artists Robert Henri, George Bellows, and John Sloan, the "enterprising promoters of The Arts Club sent out 'sandwich men' upon the streets of Chicago to herald the fact that the public was welcome to come to see the paintings. The police, however, did not understand the altruism of such proceedings and confiscated the placards and arrested the valiant men carrying them."[7]

1. The "Committee of Organization" included: Arthur Aldis, a realtor and Art Institute trustee instrumental in bringing the Armory Show to Chicago; Carter H. Harrison; Charles L. Hutchinson, President of the Corn Exchange National Bank and of the Art Institute's board of trustees; American impressionist painter Lawton S. Parker; and collector and Art Institute trustee Martin A. Ryerson. Other founding members included Frederic Clay Bartlett, an artist, collector, and benefactor of the Art Institute, and Dr. Frederick Stock, Director of the Chicago Symphony Orchestra. Bound volume, minutes 1916–19, Arts Club of Chicago Papers, Newberry Library, Chicago. Subsequent references to this archive will be noted as "Newberry Papers."

2. Before securing the lease on the fifth floor of the Fine Arts Building, beginning in 1916, the nascent Arts Club shared an office and gallery space with the Artists' Guild in the same building. The relationship of the two organizations was intended to continue two years, at which point the Guild would be absorbed into the Club. The amiable breakup occurred in June 1918 with the split between fine-art and craft members. Painters stayed in the Club; craft workers remained in the Guild through which they could sell their wares. It was at this time that The Arts Club moved to 610 South Michigan Avenue and the Guild remained in the Fine Arts Building, which was to become, according to Arts Club minutes of 1916–19, a "craft community."

3. Ibid.

4. The Arts Club has had headquarters at: 410 South Michigan Avenue (March–November 1916), with the Artists' Guild; fifth floor,

410 South Michigan (1916-1918); fourth floor, 610 South Michigan (1918–1924); second floor, 410 North Michigan (Wrigley Building north tower, 1924–1936); second and third floors, 400 North Michigan (Wrigley Building south tower, 1936–1947); entrance and second floor, 109 East Ontario Street (1951–1995); ground floor, 222 West Superior Street (1995–1996). On April 4, 1997, members inaugurated the Club's eighth locale at 201 East Ontario.

5. Alice Gerstenberg, "When the Arts Club Was Born," *Townsfolk,* May 1950, p. 16.

6. Ibid. Food was not served regularly at the Club until 1917.

7. Ibid.

8. Member Mrs. John Paul Welling, in conversation with Celia Hilliard, 1986.

9. Minutes of the Board of Directors—Special Meeting, January 29, 1932, p. 2, Newberry Papers.

10. Joseph Scanlan, ed., *A History of the Renaissance Society: The First Seventy-Five Years* (Chicago: Renaissance Society at the University of Chicago, 1993), introduction.

11. Richard R. Brettell and Sue Ann Prince, "From the Armory Show to the Century of Progress: The Art Institute Assimilates Modernism," in Prince, ed., *The Old Guard and the Avant-Garde: Modernism in Chicago, 1910-1940* (Chicago: University of Chicago Press, 1990), p. 219.

12. Report of Chairman of the Exhibition Committee—Alice F. Roullier, presented at The Arts Club annual meeting, May 17, 1923. Newberry Papers.

13. Ibid.

In 1918, the Club underwent several important transitions. In late winter, McGann resigned. She had understood the Club's goal to be the promotion of Chicago art, but many of its directors, including Carpenter and Alice Roullier, were determined to make its scope more broadreaching.[8] Carpenter (1876–1931), a painter, interior decorator, wife of modern composer and musician John Alden Carpenter, and head of the art committee since 1916, was elected Club president in March, a position she would occupy until her death. Alice F. Roullier (1883–1963), director of the Albert Roullier Galleries, became chairman of the exhibition committee, a position she would hold until 1941. Under their leadership, the Club redefined its agenda.[9] World travelers and friends of numerous artists and dealers abroad, Carpenter and Roullier wanted to bring vitality to the arts in Chicago. Together with the Renaissance Society, founded in 1915 at the University of Chicago "in response to what was then seen as a modern cultural renaissance in Europe,"[10] The Arts Club hoped to introduce contemporary European art, music, and literature, as well as Asian art, to local audiences. In December, they relocated to a new headquarters with more exhibition space on the fourth floor of 610 South Michigan Avenue.

The Arts Club's exhibition schedule complemented the relatively traditional programing of the Art Institute and eventually augmented the museum's collection with works by modern artists. Even though the Art Institute had shown a portion of the notoriously controversial Armory Show in 1913, its collection as late as 1921 had only two works by twentieth-century European artists—salon paintings in the nineteenth-century academic tradition.[11] The impressionist and post-impressionist paintings for which the Art Institute is now known had yet to be donated by Frederic Clay Bartlett, Annie Swan Coburn, Arthur Jerome Eddy, Bertha and Potter Palmer, and Mr. and Mrs. Martin A. Ryerson (Bartlett, Martin Ryerson, and Bertha Palmer were Arts Club officers). The Club began exhibiting in a gallery at the Art Institute in December 1922 with the hopes of extending their "sphere of usefulness,"[12] as Roullier reported at the Club's annual meeting the following year. In this room, which they maintained until the end of 1927, the Club featured the works of artists such as Auguste Rodin and Pablo Picasso in 1923, and, in 1924, Georges Braque and Henri de Toulouse-Lautrec (his first exhibition in the United States). With their installations at the Art Institute, Roullier and her colleagues found themselves "reaching a large and democratic Sunday public which materially broaden[ed their] educational field."[13]

The Club's first acquisitions were in behalf of metropolitan museums—the Art Institute and Field Museum. In 1923, the Club's executive committee established an Arts Club Gift Purchase Fund, with which they immediately bought a bronze by Rodin for the Art Institute. Club members contributed to this fund (in operation until 1932), which was supplemented from commissions on sales from an important 1926 exhibition of sixteenth- and seventeenth-century Persian carpets. The Club's purchases for the Art Institute continued in 1927 with a pen-and-ink drawing by Henri Matisse and a watercolor-and-pencil drawing by Francis Picabia, in 1932 with a watercolor by Georges Rouault, and in 1940 with a wood sculpture by Raymond Duchamp-Villon. The Club gave over fifty works in total to the Art Institute and ten African, Asian, and Oceanic objects to the Field Museum, including a seventeenth-century Chinese screen. In 1990, the Club sold and partially gifted Constantin Brancusi's masterpiece, *Golden Bird* (fig. 1), to the Art Institute. The sculpture had been purchased in 1927 from Brancusi's first Chicago exhibition, with the intention of someday presenting it

to the museum.[14] That Carpenter would have devised such a strategy for building Chicago's contemporary art collections is not surprising; in 1921 her father, Joseph Humphrey Winterbotham (1852–1925), a great supporter of his daughter's passion for the arts, had endowed a fund at the Art Institute for the acquisition of recent European paintings.[15]

Despite a primary emphasis on a strong exhibition program and the development of local public collections, the Club began to acquire art for itself, mostly for decoration. Creating an enticing meeting spot was part of the unwritten strategy for gaining acceptance for modern art in Chicago—in its rooms, the Club was simultaneously able to entertain and acquaint Chicagoans with works by new artists or unfamiliar cultures. Formal teas accompanying exhibition openings, where female members and wives of male members poured tea and coffee, were among the most important of these social events. A typical newspaper notice would read like the one written after the opening of Brancusi's exhibition:

> The galleries of the Arts Club housed an interesting modern exhibition of sculpture by Brancusi, and a more understandable display of Persian antiquities for the opening of its latest exhibition yesterday afternoon. The lounge, where tea was served from a long refectory table, was a popular place for sociabilities. Mrs. Rockefeller McCormick, who poured for a time, wore black satin with flowing sleeves of royal blue chiffon embroidered with gold thread, and Mrs. George F. Porter, who was at the other end of the table, was in gray satin with a gray felt hat run around with gold ribbons.[16]

But, for all the discussion of dress, an exhibition often inspired a purchase by a member, visitor, or the Club itself, as in this case, when the Club acquired *Golden Bird*. The earliest gifts to the Club were portraits of Carpenter and Katherine Dudley (an artist member described in the *Chicago Post* of April 27, 1926 as having a "flair for the newest and most chic thing in clothes") drawn by Paul Thévenaz during his 1921 visit to Chicago in conjunction with an exhibition of his paintings, watercolors, and decorations at The Arts Club. Thévenaz had drawn a portrait of Carpenter two years before, which he gave to her daughter, Genevieve (later Mrs. Patrick C. Hill), who bequeathed the work to The Arts Club in 1976. The first work the Club purchased for itself was Picasso's *Head of a Woman*, a chalk drawing acquired for $350 from an exhibition in The Arts Club's gallery at the Art Institute.

When the Club opened on the second floor of the Wrigley Building's north tower (410 North Michigan Avenue) in autumn 1924, Carpenter had more than a dozen works of art in the Club's collection to install in the new space. Planned by Heun and decorated by Carpenter, the rooms featured arched entryways, curtains in rich orange and red, divans, and French gilded furniture, some with embroidered upholstery. An all-American exhibition, including works by Bellows, Thomas Eakins, and Rockwell Kent, inaugurated the larger of the Club's two new exhibition spaces. In 1925, Carpenter purchased a seventh-century tomb sculpture from the notable dealer of Chinese art, Cheng-Tsai Loo (1880–1957), and probably relied on his advice when she acquired three Yuan dynasty bodhisattvas during a trip to China in 1931. Loo was an advisor to the Club for Chinese art in the mid-1920s, bringing many works, including jades, to the attention of Chicago audiences for the first time. Loo also donated, in 1934, the modern bases for the three bodhisattvas in memory of Carpenter.[17] Exhibitions of modern European paintings and Asian or African art often ran concurrently.

In the late 1920s, The Arts Club's collecting reflected its well-publicized and highly

14. See Margherita Andreotti, "Brancusi's Golden Bird: A New Species of Sculpture," *The Art Institute of Chicago Museum Studies* 19:2 (1993): 134–53.

15. See Lyn Delliquadri, "A Living Tradition: The Winterbothams and Their Legacy," *The Art Institute of Chicago Museum Studies* 20:2 (1994): 102–10.

16. *Chicago Tribune*, January 5, 1927. Press clippings, Newberry Papers.

17. Elinor Pearlstein, "Archival Perspectives on the Sonnenschein Collection," unpublished paper prepared for the 18th Percival David Foundation Colloquy on Art and Archaeology in Asia, "Chinese Jades." London, July 1995.

attended programs of Russian dance and music, and exhibitions of works by Russians living in France or the United States. From his exhibition in 1929, Alexander Archipenko presented a drawing of a mother and child; Léopold Survage's 1925 *Fisherwomen*, the earliest of eight works by the artist in the Club's collection, was purchased in 1926 and immediately included in a group exhibition of modern paintings in The Arts Club's galleries at the Art Institute. In 1927, Carpenter notified Roullier by mail during a lengthy trip through Europe that she had commissioned Natalia Goncharova, who had exhibited her paintings and stage designs with Mikhail Larionov at the Club in 1922, to make a floor screen; and in 1931, Ossip Zadkine's 1920 *Head of a Boy* was purchased from the artist out of an exhibition of his sculptures. In 1933, the Archipenko and Zadkine, together with four other works from the collection, were included in an *Exhibition of Modern Sculpture and Drawings by Sculptors* assembled in the Club's galleries as a tribute to the landmark Century of Progress Exposition.

Many of the acquisitions of the late 1920s and early 1930s resulted from relationships made by Roullier or Carpenter, and the latter's successor, Elizabeth "Bobsy" Goodspeed;[18] these affiliations and friendships often led to purchases from artists or their dealers or to gifts from the artists themselves. For example, the Club purchased a sculpture by John Storrs in 1928, following the artist's second exhibition at the Club; Storrs, originally a Chicagoan, was on the membership and exhibition committees in 1936 and, after moving to Paris, informally advised the Club by finding works for exhibitions. Isamu Noguchi gave his *Portrait of Marion Greenwood* in 1930, after his exhibition the same year, and in 1932, The Arts Club purchased his 1930 ink-and-brush drawing of a Buddhist monk. Further acquisitions were inspired by the 1934 Louis Marcoussis exhibition, which included etchings of Gertrude Stein and Alice B. Toklas. Stein's lecture at the Club that year drew 225 people, including Roullier, who would later purchase impressions of these two etchings.

In 1936, after unsuccessfully attempting to expand into the adjacent Caxton Club and the Kilgen Organ Company, and then finally losing their lease to WBBM radio, The Arts Club moved once again, next door onto the second and third floors of the Wrigley Building's south tower (400 North Michigan Avenue). Sixty percent larger than the previous space, the rooms were planned by Heun and decorated by Goodspeed. Six hundred people attended the opening, walking out of the elevator on the second floor into a "rich blue and soft rose" entryway, then through an anteroom, "its walls bright with Pompeian designs" into a foyer in "two tones of terracotta, edged and pillared in the softest possible gray."[19] A large lounge featured most of the furniture from the previous quarters and works from the growing collection, including the bodhisattvas (see fig. 4), and a tapestry of Braque's *Still Life with Pipe*, which Harold F. McCormick, one of the founding officers of the Club, had helped acquire from an exhibition of modern tapestries in 1936. This tapestry had been Goodspeed's inspiration for the room's color scheme.[20] Also on this floor were a small library and three galleries (where, often, three separate exhibitions would take place concurrently), paneled with wood, and hung for the opening with a loan exhibition of modern European paintings owned by Joseph Winterbotham, Jr., Carpenter's brother. An intricate white wrought-iron staircase led upstairs to a kitchen, two dining rooms (one pale blue and white) with views of the Chicago River and Lake Michigan, and a cocktail lounge decorated with the theme of shells and seahorses (including a seahorse chandelier).

In 1940, Goodspeed resigned and moved to New York, where she continued to be active

18. Mrs. Charles Barnett Goodspeed, neé Fuller, later Mrs. Gilbert W. Chapman. (Robert Storr, a contributor to this book, is her nephew.)

19. Press clippings, 1947, Newberry Papers.

20. India Moffet, "New Quarters of Arts Club are Charming," Chicago *Daily Tribune*, December 10, 1936.

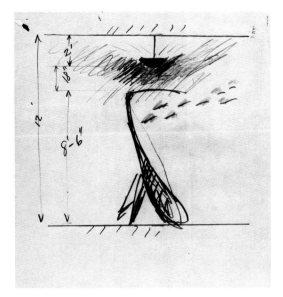

Fig. 5. Alexander Calder, *Study for Red Petals* (March 23, 1942), graphite and red pencil, 27.9 x 21.5 cm (11 x 8½ in.), detail showing the dimensions of the room for which he was designing the sculpture. Newberry Library, Chicago.

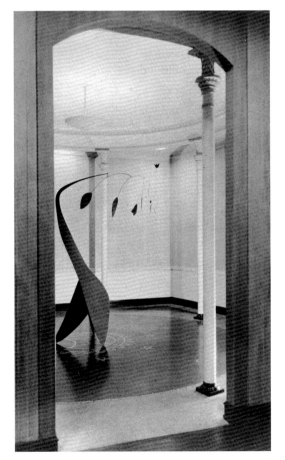

Fig. 6. Original installation of Alexander Calder's *Red Petals*, 1942, commissioned for this octagonal room at 400 North Michigan Avenue, photographed June 10, 1943. Newberry Library, Chicago.

in the arts, at the Museum of Modern Art, Metropolitan Opera, and American Ballet Theater. In November, Carpenter's thirty-five-year-old niece and namesake, Rue Winterbotham Shaw (1905–1979), was elected president of the Club, after the short interim presidency of Mrs. William B. Hale. Throughout her thirty-nine year presidency, Shaw fully dedicated herself to The Arts Club, running it, according to current vice president Helen Harvey Mills, "with an iron hand, but also appreciating wit, humor, and imagination."[21] Shaw promptly redecorated many of the rooms (including the cocktail lounge), and in March 1942 invited her friend John Cage (a guest lecturer at László Moholy-Nagy's School of Design [later the Institute of Design] in Chicago), his wife, Xenia, and eight percussionists to perform "Music for Percussion Orchestra," in which his troupe broke a beer bottle, beat on brake drums and iron pipes, and Cage played the piano with his elbows. Shaw also programed the lecture and performance schedules and curated, along with exhibition committee chairmen William Eisendrath (1941–54) and Everett C. McNear (1954–74) and other Club members including Mills and collector Joseph Randall Shapiro (1905–1996), important introductions of European artists to Chicago. In Shaw's first year, she staged the premier exhibitions in Chicago of Max Beckmann, Salvador Dalí, and Oskar Kokoschka.

Shaw's first acquisition for The Arts Club was her 1942 commission of a sculpture from Alexander Calder, with funds bequeathed by Elizabeth "Mabel" Johnston Wakem in 1941.[22] Calder's first exhibitions in Chicago had taken place in January and February 1935—mobiles at the Renaissance Society and then at The Arts Club. Shaw and "Sandy" became friends during this and his subsequent exhibitions at the Club, and

21. Helen Harvey Mills, interviewed by Valerie Shields of Shields Communication, 1996.

22. In previous publications, Mrs. Wakem's name has been incorrectly spelled Wakeham.

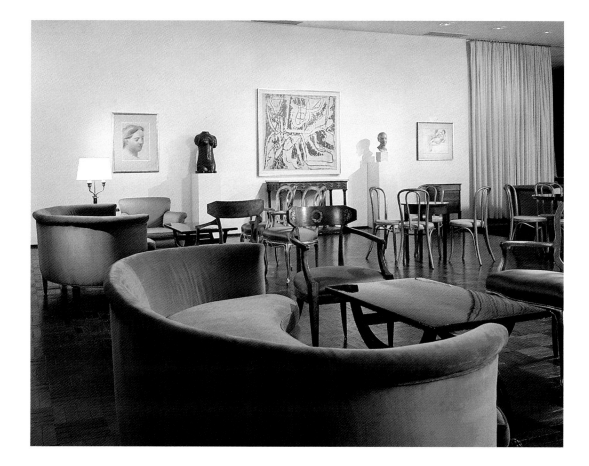

Fig. 7. Sitting room of The Arts Club at 109 East Ontario Street, 1995. Works in the collection by Picasso, Bourdelle, Prassinos, Despiau, and Matisse are visible. Photo by Shimer © Hedrich-Blessing.

23. Many of their letters may be found in the Rue Winterbotham Shaw correspondence, Newberry Papers.

24. Rue Shaw, quoted in Richard Christiansen, "Rue Shaw, Arts Lose Loyal and Longtime Supporter," *Chicago Tribune,* February 4, 1979.

they would carry on a correspondence throughout their lives.[23] Shaw's instructions to Calder for The Arts Club installation were tailored to the existing interior design, specifying that the mobile be self-supporting, not suspended from the ceiling, that it be constructed from a durable material, that it would stand in the octagonal room at the center of a circle on the floor, and that it complement the Club's beige, ivory, and wood walls, black baseboards, and gray terrazzo floor (figs. 5 and 6). Shaw recalled having to defend her commission of *Red Petals,* Calder's 8 ½-foot red and black steel sculpture, from constant criticism. "I got so many silly remarks," she later recounted, "that finally I just told [one skeptic], 'Oh, shut up.'"[24]

In 1946, the will of Arthur Heun (1866–1946) bequeathed over 130 paintings and drawings to the Club, together with additional funds for the continued purchase of art. One of the Club's founding members, Heun was an interiors architect of mostly North Shore, Prairie Avenue, and Michigan homes. He committed almost his entire estate to philanthropic institutions, including the University of Chicago, Art Institute, Orchestral Association of Chicago, and several local hospitals. Heun's art collection was shown at the Club in the winter of 1947 as the final exhibition at 400 North Michigan Avenue, accompanied by a catalogue by Arthur Meeker, Jr. In the spring of 1952, the Club's directors offered for sale more than a hundred paintings and drawings from Heun's collection at the Main Street Gallery and Book Store at 642 North Michigan Avenue. The Club retained many of the most significant works, including Tsuguhara Foujita's *Portrait of Girl with Red Hair,* Paul Klee's *Submersion and Separation* and *Sicilian Flora in September,* Marie Laurencin's *Seated Figure,* and a char-

Fig. 8. Dining room of The Arts Club at 109 East Ontario Street, 1995. The three Yuan dynasty bodhisattvas are at left. Photograph by Shimer © Hedrich-Blessing.

coal nude by Matisse. Several unsold works were donated to the Art Institute. The income generated from the sale augmented the initial monetary bequest, thus establishing the Arthur Heun Memorial Purchase Fund in 1947, allowing the Club to make important acquisitions in the late 1950s, including works by Jean Arp and Picabia.

Shortly after Heun's bequest, The Arts Club lost its lease to Columbia Broadcasting, initiating a four-year search for a new site, during which time the Club maintained only an office space, holding programs at the Fortnightly and Casino Clubs.[25] The entire collection was put into storage and new acquisitions ceased. Local art critics, including Clarence J. Bulliet (1883–1952) of the *Chicago Post's Magazine of the Art World* and later the *Chicago Daily News,* speculated that the organization, which at one time flourished "like the green bay tree" would forever remain in "mothballs."[25] Bulliet, who was one of the only critics supporting Modernism in Chicago during the 1930s, had become disillusioned by what he viewed as the growing complacency of formerly activist organizations. He discerned in Shaw "the family spirit of the Winterbothams," but believed that the acceptance of modern art into the mainstream in the late 1940s, "depriv[ed] her of the cause that made [her predecessors] so notable."[26] His opinion probably served to motivate the Club president. Soon, she had recruited Ludwig Mies van der Rohe, who had moved to Chicago in 1938 and was head of the architecture department at the Illinois Institute of Technology, to design the interior of a new Club headquarters. Shaw and her architect husband, Alfred P. Shaw, had become friends of the German émigré, an Arts Club member, and in 1947, according to an interview, she "took Mies to lunch one day and asked him if he would do the new Club. He said 'sure,'

25. C. J. Bulliet, "Arts Club Closes," December 15, 1947, Newberry Papers.

26. Ibid.

27. Rue Shaw, quoted in Richard Christiansen, "Chicago's Arts Club at Sixty: A Genteel Pioneer Celebrates," *Chicago Daily News,* November 15–16, 1976.

28. I wish to thank Kathleen Hess for research on the architectural history of the 109 East Ontario Street building project.

29. Club minutes, 1969 to 1971, Newberry Papers.

30. For more information, see Lynne Warren, ed., *Art in Chicago, 1945–1995* (Chicago: Museum of Contemporary Art, 1996), particularly Barbara Jaffee, "Pride of Place," and Dennis Adrian, "Private Treasures, Public Spirit."

and that's all there was to it. We paid for the material and work, of course, but he never charged us a cent for his services."[27] Planning and opening this new headquarters gave the Club an energizing boost, and in 1955, Bulliet's widow and son carried out the critic's wish that an etching, Picasso's *Mother Combing Her Hair,* be donated to the Club in his memory.

Mies designed the new headquarters on the ground and second floors of 109 East Ontario Street, in a building by the architectural firm of Leichenko and Esser, one of the first constructed north of the Chicago River after World War II.[28] In a distinct change from previous Club interiors, Mies used plain white walls and floor-to-ceiling raw-silk curtains of black, smoke gray, and saffron-yellow to define the interior areas. The Club re-opened in June 1951 with *Paris Masters, 1941–1951,* an exhibition organized by Eisendrath. Such temporary exhibitions were installed in the large gallery at the top of Mies's famous steel and travertine staircase, and works owned by the Club were distributed throughout: in the sitting room, library, dining room, restrooms, office, and actors' dressing rooms, along with the antiques that Carpenter had purchased for earlier Club decors (see figs. 7 and 8). Shaw noted after the purchase of Karel Appel's lithograph *The Kick,* expressly for the men's bathroom, "masculine members are very pleased to have a more cheerful room."[29]

Throughout the 1950s, 1960s, and 1970s, The Arts Club continued to present important exhibitions to Chicago—a group show of Ben Shahn, Jackson Pollock, and Willem de Kooning in 1951, Le Corbusier in 1956, Franz Kline in 1961, Robert Rauschenberg and Enrico Baj in 1966, Louise Nevelson in 1968 (who gave an untitled collage after the exhibition)—but the cultural landscape in Chicago was changing, and the Club invested more resources in the lecture and music programs for its stage. No longer was there a need to convince Chicagoans that contemporary art was worthwhile, and, with the inauguration of the Museum of Contemporary Art in 1967, some of the Club's active members, including Shapiro, an officer of the Club who had organized *Surrealism Then and Now* in 1958, became invested in this major new exhibition venue. Additionally, the range and number of commercial galleries in Chicago grew considerably in these years; the Art Institute became more willing to exhibit works by contemporary artists, especially in its Annual Exhibition of American Art, which in 1947 controversially examined abstraction and Surrealism in American art. Even the mayor, Richard J. Daley, supported an unjuried exhibition at Navy Pier in 1957 and 1958.[30]

During these years, however, The Arts Club's collection did grow substantially, with acquisitions resulting from many exhibitions. Exhibition committee chairman McNear and his wife, Ann, donated Henry Moore's large silkscreen *Two Standing Figures* in 1963, three years after it had been exhibited at the Club. In 1986, many years after her husband's death, Ann McNear gave Mario Prassinos's ink drawing *August 15, 1968,* which had been included in a 1969–70 show of his drawings and tapestries. From the Fine Arts Purchase Fund, established in November 1962, the Club acquired works by Emile-Antoine Bourdelle, Pierre Alechinsky, and Pierre Soulages. Many drawings previously owned by Roullier became part of the collection, either informally or, after her death in 1963, through the generosity of her cousin, Josephine R. (Mrs. Norman) Harris, a musician member. The Friends of Alice Roullier Fund, created in 1963, together with money from The Arts Club Purchase Fund, allowed the Club to purchase Joan Miró's 1942 gouache *Personage and Birds in Front of the Sun* in 1965.

Shaw also donated pictures to the Club, as did other members of the Winterbotham family. Theodora Winterbotham Brown gave four works, including an impression of Braque's

lithograph *Athena* in 1933 in memory of her aunt Rue Carpenter, and a charcoal-and-water-color still life by Larionov in 1980, in memory of her sister, Rue Shaw, who had died the year before. Anne M. Reynolds (Mrs. John H.) Winterbotham gave a sepia nude by André Derain in 1962. Also in 1962, Ellen W. Waller, the second wife of composer John Alden Carpenter, donated Robert Edmond Jones's sketches for the costumes and sets of Carpenter's ballet *Skyscrapers.* Friends of Elizabeth Goodspeed Chapman, a fund initiated by Eleanore (Mrs. William) Wood-Prince in memory of the Club's former president, purchased Bernard Boutet de Monvel's *Study for a Portrait of Elizabeth Chapman* and a Kurumban antelope headdress from the sale of the Chapman collection at Phillips Auctioneers in 1982. Other contributors include Mrs. Robert Muckley, who gave Braque's *Green Head* in 1976; Raymond Merritt from New York, who in 1990 gave Ralph Gibson's *Hand in the Doorway* in memory of Arthur Cowen, Jr.; Grover Hermann, who donated Etienne Hajdu's *Milly*; and John Palmer, who gave an Iranian album page and an Indian miniature painting in 1965.

In January 1979, Shaw succumbed to lung cancer, and Neil (Mrs. Roger) Barrett, an artist member and chairman of the exhibition committee, became interim president of the Club for five months before James Phinney Baxter IV was elected, serving two years. In 1981, Stanley M. Freehling, the Club's current president, was elected. Freehling, a limited partner with the Freehling Division of Cowen and Company, an investment firm, is a longtime advocate of the arts.[31] Carrying on The Arts Club tradition of strong leadership and insightful long-range thinking, Freehling recognized early in his presidency two challenges facing the future of the Club: dwindling financial resources and the possibility of losing the lease at 109 East Ontario Street. After careful deliberation, in 1990 the board of directors agreed to sell Brancusi's *Golden Bird.* Maintaining the Club's commitment to Chicago art collections, Freehling negotiated the sale and partial gift of the sculpture to the Art Institute. After exploring numerous options for a future location, Freehling coordinated an extensive search for an architect to design a new freestanding headquarters on land purchased by the Club on the southeast corner of Ontario and Saint Clair Streets. In March 1995, the architectural selection committee members James N. Wood (Director and President of the Art Institute), architect Carter Manny, Jr. (Director Emeritus of the Graham Foundation), and the late Myron Goldsmith (an architect, engineer, and professor at Illinois Institute of Technology), chose John Vinci of Vinci/Hamp Architects, Inc. An award-winning modernist architect, exhibition designer, and noted advocate of architectural preservation, Vinci was also a leader in the unsuccessful effort to gain landmark status for the Mies-designed Club. The upcoming demolition of The Arts Club residence at 109 East Ontario Street led to an impassioned call for the preservation of Mies's staircase and, to retain an essential part of the Club's modern heritage, Vinci integrated the staircase into his design, reinstalling it at the heart of the new building at 201 East Ontario Street.

After vacating 109 East Ontario Street in late March 1995, the Club, under the artistic direction of Kathy Cottong, maintained offices and an exhibition space in the River North gallery district, at 222 West Superior Street, while awaiting the construction of its new home. As in the 1947–51 interim, many programs were held at the Casino Club, but lunch and noon-time lectures continued to engage the membership at the Club's temporary location. The Calder stabile, which had greeted visitors for years at the Ontario Street entrance, was on view at the David and Alfred Smart Museum of Art at the University of Chicago, where

31. Freehling is currently chairman of the Twentieth-Century Committee and a life trustee of the Art Institute, trustee of the University of Chicago, and lifetime trustee of the Ravinia Festival. Previously, he has been chairman of the Illinois Public Art Commission and the Illinois Arts Council, and member of the President's Committee on the Arts and Humanities under Ronald Reagan.

an exhibition of selected drawings from The Arts Club was mounted in the spring of 1996. During this time, members have donated several outstanding works. Stanley and Joan Freehling presented a drawing by Germaine Richier, which Freehling recalls was coveted by Shaw for the Club. Sue (Mrs. Harold) Florsheim, a long-standing member, gave a canvas by Nicolas de Staël. Helen Mills, curator of two Arts Club photography exhibitions, and daughter of two Club members, gave a drawing by Walt Kuhn and a sculpture by Barbara Hepworth. Recently, Marilynn Alsdorf presented a drawing of her late husband, James W. Alsdorf, by Alberto Giacometti and a lithograph by Claes Oldenburg. A 1991 installation during the seventy-fifth anniversary year gave rise to the acquisition of photographs by Andy Goldsworthy, whom the Club had commissioned to create sculptural works and photographs in the Michigan-dune and Illinois-woodland properties of Club members Mr. and Mrs. Norman Perman and Patrick Shaw, respectively. With the acquisitions committee, director Cottong has continued the tradition of obtaining works from Arts Club exhibitions with the purchase of a watercolor by Malcolm Morley from among those shown in 1996 at 222 West Superior.

The publication of this book coincides with the inauguration of the first Arts Club headquarters that is owned, not leased. Three times the Club has been evicted and now, with its new two-story building at 201 East Ontario Street, the institution—and its collection—can comfortably claim to have a permanent home. What better time to remember the works of art that make up the Club's collection and to anticipate the additions to come.

I would like to thank Richard Francis, Stanley M. Freehling, Mary Sue Glosser, Anne Badger Gray, Celia Hilliard, Adam Jolles, Helen Harvey Mills, Patricia Scheidt, Patrick Shaw, and James M. Wells for reading and contributing valuable comments to this essay.

BIBLIOGRAPHY

Drawings 1916–1966: An Exhibition on the Occasion of the Fiftieth Anniversary of The Arts Club of Chicago. Chicago: Arts Club of Chicago, 1966.

An Exhibition of Cubism on the Occasion of the Fortieth Anniversary of The Arts Club of Chicago. Chicago: Arts Club of Chicago, 1955.

Lyon, Jeff. "State of the Art." *Chicago Tribune,* October 12, 1986.

Prince, Sue Ann, ed. *The Old Guard and the Avant-Garde: Modernism in Chicago 1910–1940.* Chicago: University of Chicago Press, 1990.

Sixty Years on The Arts Club Stage: A Souvenir Exhibition of Portraits. Chicago: Arts Club of Chicago, 1975.

Taylor, Sue. "Rue Winterbotham Carpenter." In *Historical Encyclopedia of Chicago Women.* Bloomington: Indiana University Press, forthcoming.

Wells, James M. "Introduction." In The Arts Club of Chicago, *Seventy-Five Anniversary Exhibition 1916–1991.* Chicago: Arts Club of Chicago, 1992.

———. "Portrait of an Era: Rue Winterbotham Carpenter and The Arts Club of Chicago 1916–1931." In *Portrait of an Era: Rue Winterbotham Carpenter and The Arts Club of Chicago, 1916–1931, Seventieth Anniversary Exhibition.* Chicago: Arts Club of Chicago, 1986.

Collection Highlights

Pierre Alechinsky

Belgian, born 1927

No Explanation (Pas d'Explication), 1960

Ink on tan wove paper mounted on linen
132.1 x 148.6 cm
(52 x 58½ in.)
Arts Club Purchase Fund, 1965.

ALONG with Karel Appel and Asger Jorn, Pierre Alechinsky was a founding member in the late 1940s of the European collaborative group CoBrA, named after the native cities of the contributing artists—COpenhagen, BRussels, and Amsterdam. Departing from the earlier, ordered geometries of the Dutch de Stijl, CoBrA was concerned with an antirational, expressionist art. Shortly after the group disbanded in 1951, Alechinsky began to experiment with calligraphy, an interest that culminated in his 1955 journey to Japan to prepare a film on the topic. This encounter with the decorative art of writing was so decisive for Alechinsky that he later intertwined the technique with his own drawing, which he redefined as "writing unraveled and raveled anew."[1]

Alechinsky's large ink drawings of the early 1960s were produced during the waning years of American Abstract Expressionism, some of whose practitioners, such as Franz Kline and Willem de Kooning, had been equally enthralled by the apparent spontaneity of calligraphic techniques and the powerful austerity of black ink on white paper. Some of the Abstract Expressionists had also adopted the habit of painting their canvases flat on the floor rather than upright on an easel. A photograph of Alechinsky at colleague Walasse Ting's studio in 1961 preparing a sizeable abstract ink drawing suggests that the artist probably executed No Explanation in a similar fashion, standing on the enormous sheet of paper, which was held down at the corners by tools.

No Explanation was drawn in 1960, probably in the Oise, just outside of Paris, where the artist had purchased the former public school of La Bosse as a weekend retreat. As Alechinsky later recalled, the new working environment, a precious bottle of ink, the fortuitous discovery of suitable drawing implements, and the collaboration of fellow artist Reinhoud combined to produce a fertile moment unprecedented in his artistic practice:

Ting has given me a bottle of ink which has the fragrance of pine and camphor. I possess a fine, old brush and, beneath the slates of the roof, I have found a piece of oak, dry and supple, alive, irreplaceable like a pen. Reinhoud peels oranges with a knife…and lets rind coil in twists and loops. Each piece of rind unfolds, curls up, and acquires its own personality, settles into it. We draw them. Working sessions with models.…I have never drawn so much in my life. Why did I wait so long? I could have drawn before. I have the knack.

The Arts Club purchased No Explanation from the 1965 exhibition Pierre Alechinsky: Paintings, Encres, and Watercolors, organized and traveled by the Club with the assistance of the Lefebre Gallery, New York. This exhibition, which brought together many of the artist's works from private collections around the country, was Alechinsky's first in the United States outside of New York. He demonstrated his gratitude by dedicating a lithograph, The Last Day, to Arts Club president Rue Winterbotham Shaw.

The Last Day was originally prepared in the summer of 1964 as a large oil painting roughly ten by sixteen feet. The composition, dominated in the center by a giant, leering death's head, was editioned as a lithograph the following year in preparation for The Arts Club exhibition, and subsequently reproduced across the inside front and back covers of the exhibition catalogue. The Arts Club's impression bears the tender, aforementioned handwritten dedication: "To Madame Shaw with much friendship/thank you for having given me the possibility of seeing again here my paintings dispersed like lost dogs and now reunited thanks to you."

Adam Jolles

1. Pierre Alechinsky, *Pierre Alechinsky* (New York: Harry N. Abrams, 1977), p. 24. The following quotation is from p. 206.

The Last Day, 1964

Color lithograph
20.3 x 48.9 cm
(8 x 19¼ in.)
Gift of the artist, 1965.

Alexander Archipenko

American, born Russia, 1887–1964

Untitled, c. 1928
Graphite on paper
45.7 x 54 cm
(18 x 21¼ in.)
Gift of the artist, 1929.

Born and reared in Kiev, Alexander Archipenko left the Ukraine for Paris at the age of twenty, where he avoided academic study to draw from the archaic Greek, Egyptian, and Assyrian sculpture on display in the Louvre. While in Paris, Archipenko joined the Section d'Or (Golden Section), a group of Cubists that also included Albert Gleizes, Juan Gris, Jean Metzinger, and Léopold Survage; Archipenko regularly contributed plaster and polychromed sculptures to Section d'Or exhibitions, until the society disbanded in 1914. Although he was highly successful in Europe following World War I, Archipenko decided to sail for New York in 1923, opening an art school in upstate Woodstock the following year. American audiences had earlier been exposed to his work in the 1913 Armory Show, but Archipenko found it difficult at first to generate much interest in his art in the United States. His breakthrough came in 1928, with the opening of a one-person show at the Anderson Galleries in New York, and the unveiling of his patented, moveable-painting machine, *Archipentura.*

Archipentura was, as the artist described it in his preface to the exhibition catalogue, an "Apparatus for Displaying Changeable Pictures" that functioned by threading sheets of canvas on motorized rollers through shutters on either side of a large,

steel box seven feet tall. Although Archipenko may have hoped to find a commercial application for his device—as an animated display case for store windows, perhaps—it remained in his basement until it was accidentally thrown out by a janitor in 1935.

The Arts Club drawing may have numbered among those in Archipenko's *Archipentura* exhibition, at which eighteen untitled drawings were shown. The show traveled, in modified form, to the Braxton Gallery in Hollywood, California, and then to The Arts Club. Archipenko presented this drawing, depicting a modern-day madonna and child, from the Chicago venue as a gift to the Club. Like almost all his sculpture, the handsome rendering with its deft hatching and sensitive line betrays the artist's enduring preoccupation with the female form. The studied pose of the two figures, and the woman's chiseled features, may relate to his interest in fashion display at the time. Following the exhibition tour, Archipenko's desire to work in a commerical setting was satisfied when he was commissioned to design and install a series of window displays for Saks and Company, New York.

Adam Jolles

Jean (Hans) Arp, designer
French, 1887–1966

Shadow of Fruits
(Ombre de fruits),
1952
Woven by Tabard Frères et
Soeurs, Aubusson;
editioned by
Galerie Denise René, Paris
Slit tapestry weave of
cotton warp, wool weft
163.1 x 132.7 cm
(64¼ x 52¼ in.)
Arthur Heun Memorial
Purchase Fund, 1953.

JEAN OR HANS ARP as he was known, depending whether one addressed him in French or German, was born in Strasbourg in Alsace. A student in 1904 at the School of Applied Art in Strasbourg, he very nearly left the field, as his training involved copying stuffed birds and half-dead flowers. Seeking more significant study, he became a pupil of Ludwig von Hoffmann at the Weimar Art School from 1905 to 1907, and the following year enrolled at the Académie Julian in Paris. In Switzerland in the teens, Arp became one of the founders of the progressive artist group called the "Moderne Bund," and also of Dada in Zurich, exhibiting with the Blue Rider in Munich and making the important acquaintances of Robert Delaunay, Max Ernst, Wassily Kandinsky, and Amedeo Modigliani. In 1915, he met Sophie Täuber, his future wife, and the two began collaborating on tapestries and *papiers déchirés* or torn-paper collages.

Shapes from these collages and from Arp's reliefs and, later, freestanding sculpture ultimately find their way into tapestries such as The Arts Club's *Shadow of Fruits,* a prime example of this form of artistic expression. Controlled as these shapes are, they lend themselves superbly to the tapestry medium, and other examples can be found today in museum collections, including the striking *Gray, Black,* *Red* (*Gris, Noir, Rouge,* 1958) at the Art Institute of Chicago. *Shadow of Fruits* is an "easel tapestry," that is, derived from an oil painting of the same title (1930, private collection), showing two abstract shapes in black against a faded mauve background. The stark black shapes are created by using black and brown wool simultaneously in the patterning threads, the wefts. This is a common manner in which weavers intensify black areas.

Such woven "limited edition series" made Arp's tapestries affordable to individual collectors and museums and introduced the weaving establishment—in this case the Tabard Studio in Aubusson—as an important collaborator in the creation of the work of art. Indeed, the studio's emblem, rather than Arp's signature, appears in the lower right-hand corner of *Shadow of Fruits,* while the artist's name (along with the work's title, dimensions, and the full name of the studio as well as its location) is relegated to a piece of fabric stitched to the reverse of the tapestry. As successful and striking as this tapestry is, it represents the waning of such woven interpretations, reproductions of another art form but nevertheless a significant chapter, however brief, in the history of textiles in the first half of the twentieth century.

Christa C. Mayer Thurman

Emile-Antoine Bourdelle

French, 1861–1929

Torso of Pallas (Torse de Pallas), cast in 1901 from a model of 1889
Bronze
66 cm (26 in.)
Arts Club Purchase Fund, 1963.

AFTER attending classes at the Ecole des Beaux-Arts in Toulouse, Emile-Antoine Bourdelle in 1885 trained under Alexandre Falguière at the Ecole des Beaux-Arts in Paris. He worked in the studio of another academic sculptor, Jules-Aimé Dalou, before he entered the atelier of Auguste Rodin, the pioneer of early modern French sculpture, in 1893. As an assistant who carved the master's plasters in stone, Bourdelle felt the deep influence of Rodin. Following Rodin's lead, he eschewed the smooth finish and anatomical correctness that characterized the official sculpture of the Second Empire and Third Republic for a varied modeling of surfaces and simplification of forms.

In 1900, however, Bourdelle broke away from the loose, impressionistic rendering that reflected the impact of Rodin: he began to sculpt with compact masses, utilizing a tighter structural organization of forms and closed, continuous contours. The result was an aesthetic reconstruction of the body that was an essential development in the shift of early modernist sculpture from naturalism to abstraction. Bourdelle frequently turned to a self-consciously archaizing style in his many major public commissions, evincing an appreciation of preclassical Greek sculpture—notably in stylized details such as patterned hair and slightly stiff, seemingly awkward poses—with richly modeled surfaces that dematerialize natural shapes into light-catching bumps and depressions.

An important compositional format, one learned from Rodin, was the sculptural fragment, in which the partial human figure and parts of the body—such as the torso—are conceived not as *membra disjecta* but as complete forms and independent sculptures in themselves. The blocklike and stable shape of *Torso of Pallas* exemplifies this direction in Bourdelle's work, for it may have originally been conceived as part of a full figure—there is a "mask" of Pallas Athena dating from 1889. This may account for a controversy in the dating of The Arts Club bronze: the model from which it was cast has been ascribed to 1889 but also to 1901; the variance may indicate the sculptor's dis-memberment and reworking of the full figure at the later date.

Bourdelle's intense commitment to the idea of the monumental in sculpture is unmistakable in *Torso,* which despite its natural scale has the feeling of the over-life-size. Equally clear is his belief in the possibility of pure beauty in the fragment. Despite the classical reference in its title, the torso is an unabashedly "modern" work, stripped of the anecdotal or literary. Nor does it betray the overt archaism or archaeological overtones of Bourdelle's public monuments. It is, first and foremost, intended for the enjoyment of its modeled surfaces and forthright silhouette, and shows the artist at his least melodramatic.

Richard A. Born

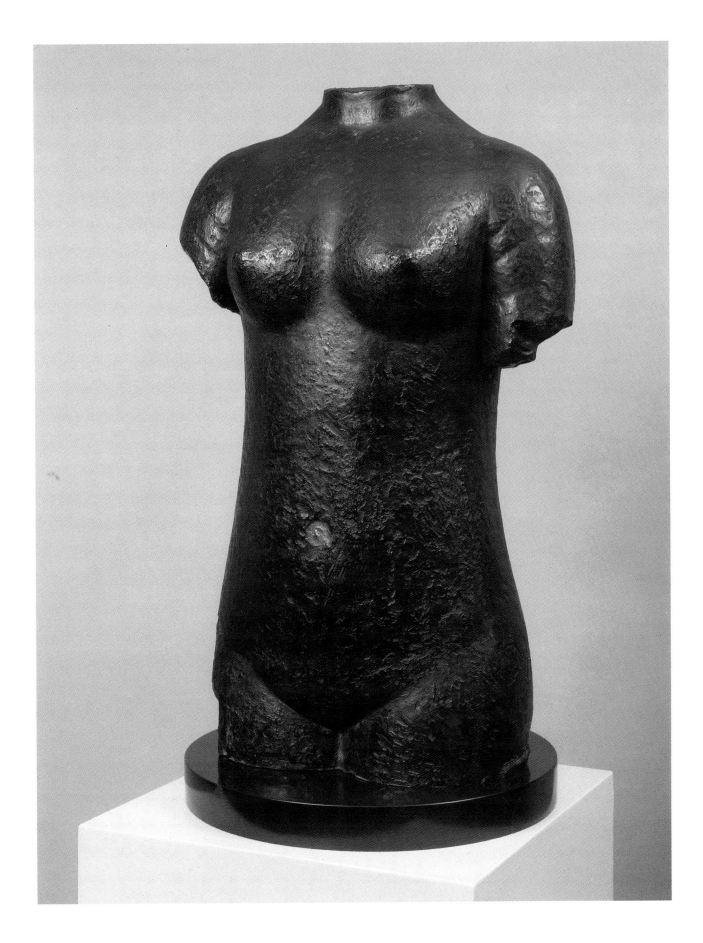

Georges Braque

French, 1882–1963

Athena (Athenée),
1932
Color lithograph on Arches
paper
39.4 x 32.4 cm
(15½ x 12¾ in.)
Gift of Theodora
Winterbotham Brown
in memory of Rue
Winterbotham Carpenter,
1933.

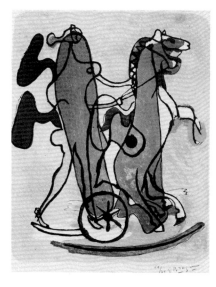

*Green Head (Tête
verte),* 1950
Color etching on Arches
paper
36.2 x 23.2 cm
(14¼ x 9⅛ in.)
Gift of Mrs. Robert
Muckley, 1976.

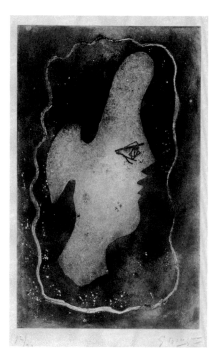

GEORGES BRAQUE began experimenting with print-making in 1912, when he produced a small number of cubist still lifes in drypoint. His military service in World War I and his extended convalescence following a severe head wound prevented him from further developing his work in this medium until 1921, when he printed his first color lithograph, a demanding process that called for a separate stone to be prepared for each color in the print. In 1931, Braque's dealer, Ambroise Vollard, commissioned him to illustrate a new edition of Hesiod's *Theogony,* the poetic genealogy of the ancient Greek pantheon. By the following year, Braque had prepared sixteen etchings—Bauhaus-inspired, meandering line portraits of the deities patterned with varying shades of crosshatching. Around the same time, he began incising finely rendered drawings of subjects from classical Greek mythology into plaster tablets, which he then painted black.

In 1932, following a ten-year hiatus from color lithography, Braque printed *Athena,* in six colors. *Athena* retains the weaving lines of the Hesiod illustrations, as well as the interest in Greek mythology, but replaces the hatchmark shading appropriate to intaglio with solid blocks of color. Goddess of war, peace, and wisdom, Athena is portrayed riding nude in a chariot, shrouded in amorphous opaque gray shapes that may represent her armor. Braque used the composition of *Athena* again between 1946 and 1948 as the model for a series of six color lithographs of the Greek sun god Helios riding through the sky on his chariot.

The much later *Green Head* demonstrates Braque's sustained interest in classical Greek motifs, during a time when many of his contemporaries had given up figurative representation. One of a number of profiles that point to his fascination with Greek vase painting, *Green Head* is noteworthy for both its extreme degree of distortion, as well as its oxidized green hue, which Braque may have intended—along with the dappled texture of the aquatint—to evoke the corroded surface of an ancient coin or medallion.

Adam Jolles

STILL LIFE WITH PIPE dates from 1935–36 and is based on a Georges Braque painting of the identical subject from 1928 (collection Mr. and Mrs. Daniel Saidenberg, New York). The transfer from painting to tapestry was supervised and guided by Marie Bordes Cuttoli (1879–1973), a renowned art patron and collector, friend of such painters as Braque, Raoul Dufy, Henri Matisse, Pablo Picasso, and Georges Rouault, among others. In April 1936, she introduced *Still Life with Pipe,* along with fifteen other tapestries derived from paintings by French artists, in an historic exhibition at the Bignou Gallery in New York. Cuttoli had "edited" this series of tapestries, most of which were woven at the ateliers of Delarbre, Simon, and Legoueix in Aubusson, a town known for centuries as one of the leading tapestry-weaving centers in Europe. After their debut in New York, the tapestries traveled to Chicago, where they were shown at The Arts Club from May 1 through 9.

Out of this exhibition, *Modern French Tapestries Designed by Modern Painters,* The Arts Club acquired *Still Life with Pipe.* The scene is woven in browns and off-whites, light green, traces of blue and yellow, ochre, and black. Highlights in silk are introduced throughout. The piece represents the skillful weaving that was capable of translating the painting medium remarkably well, capturing shading and textures and even imitating the picture's wooden frame so that the onlooker may look twice before realizing the object is not in fact a painting. At the time, however, the ateliers in both Aubusson and Beauvais (another long-established center) had been suffering from economic depression, and the contemporary weaving carried out there—if it was carried out at all—lacked creativity. Cuttoli's project represented a new direction, inspired by Jean Lurçat (1892–1966), trained as a painter but with a special interest in tapestry production. It was Lurçat who suggested that Cuttoli approach a number of artists to supply her with paintings that could be transposed into cartoons, from which weavers would then create wall hangings in the ancient "tapestry-weave" technique. Rouault was the first to respond to Cuttoli's request, in 1928, and soon others followed, including the friends mentioned above.

Thus the concept of the so-called tapestry-in-limited-edition was born, as usually more than one example was woven from the same cartoon or sketch. Ironically however, Lurçat, when he saw the results of the painting-turned-wall-hanging,

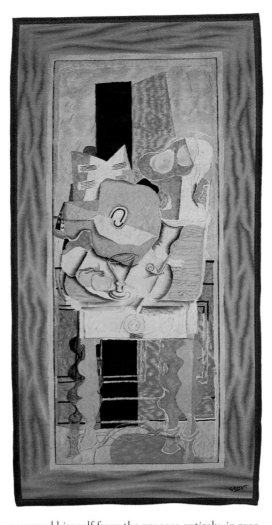

removed himself from the process entirely: in reaction, he developed his own theory, namely, that the true tapestry-woven wall hanging had to grow out of its own vocabulary. He returned to the medieval concept of the tapestry mural composition, which utilized pure color and eliminated perspective and other devices associated with painting. Lurçat ultimately became known as "the father of modern tapestry"; his insistence that the medium be taken fully into account ushered in a renaissance, so to speak, in which artists and designers would come forth to create for the medium itself, and move away from translating paintings into tapestries. The issue was not resolved in regard to Cuttoli's highly successful undertaking, a turning point in the history of tapestry, but out of this situation Lurçat learned the most and set the stage for extraordinary turns of events in tapestry production in succeeding decades. By the 1960s, the path was clearly marked, and today woven copies of paintings are only occasional occurrences.

Christa C. Mayer Thurman

Still Life with Pipe (Nature morte à la pipe), 1935–36
Woven by Aubusson; editioned by the House of Marie Cuttoli, Paris
Slit tapestry weave of cotton or linen warp, wool weft with silk highlights
210.7 x 112.8 cm (83 x 44⅝ in.)
Arts Club Purchase Fund and gift of Mr. and Mrs. Harold F. McCormick, 1936.

Alexander Calder

American, 1898–1976

Red Petals, 1942

Plate steel, steel wire, sheet
aluminum, soft-iron bolts,
and aluminum paint
259.1 cm (102 in.)
Arts Club commission,
Elizabeth Mabel Johnston
Wakem Bequest Fund,
1942.

Fig. 1. Alexander Calder, sketch for
Red Petals in a letter to Rue Shaw,
March 6, 1942, pen and graphite
on paper, 27.9 x 21.5 cm (11 x 8½
in.), Newberry Library, Chicago.

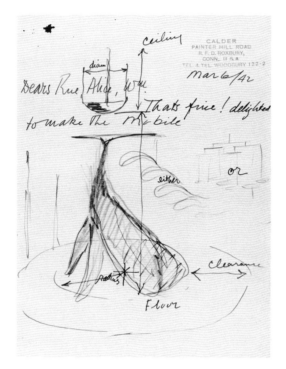

"DON'T be alarmed!!!," cautioned Alexander Calder in a letter of March 6, 1942, "…the sketches will necessarily be rough—for I never bring the thing to any definite point until doing the actual work." The first page of his enthusiastic reply accepting the commission for a mobile for The Arts Club's sculpture gallery carries a sketch with two versions of possible armatures (fig. 1). "As I see it at the moment I would like to make it a combination of a sturdy simple stabile near the floor which would become attenuated and slender towards the top and have an armature from which to suspend a delicate mobile element." Requesting additional dimensions of the room, Calder promised more sketches for this "monster," stating, "I would like to make the main part of sheet steel, painted black particularly as the room is light and clear and slender (columns)."

Collected in the Newberry Library, the engaging correspondence between Calder and, on behalf of The Arts Club, Rue Shaw, William Eisendrath, and Alice Roullier begins with a letter of agreement, specifying the purchase committee's wish for a floor piece of durable material appropriate to the octagonal sculpture gallery, whose rosewood walls were topped by painted beige panels and whose floors were mainly dark gray. From these letters, we gather valuable insights not only into the working process of a major figure in modern art but also into the patronage of The Arts Club and the instrumental role Rue Shaw played in the acquisition of an artwork that would become an emblem of the institution. At the time, Calder had already established an important international reputation and was represented by Pierre Matisse Gallery, New York, to whom copies of The Arts Club contract were sent. The artist's work was also appreciated in Chicago, since early exhibitions of his mobiles and drawings had been held (respectively) at the Renaissance Society in 1935 and the Katharine Kuh Gallery in 1938. In July of 1941, according to the will of Elizabeth Mabel J. Wakem, a bequest was made to The Arts Club for the purchase of either a picture or statuary to remain in the Club rooms. It is this legacy that enabled the commission of *Red Petals* for $850.

The commission proceeded briskly, and much of the correspondence between Rue Shaw in Chicago and Sandy Calder from the farm he had purchased in Roxbury, Connecticut was conducted

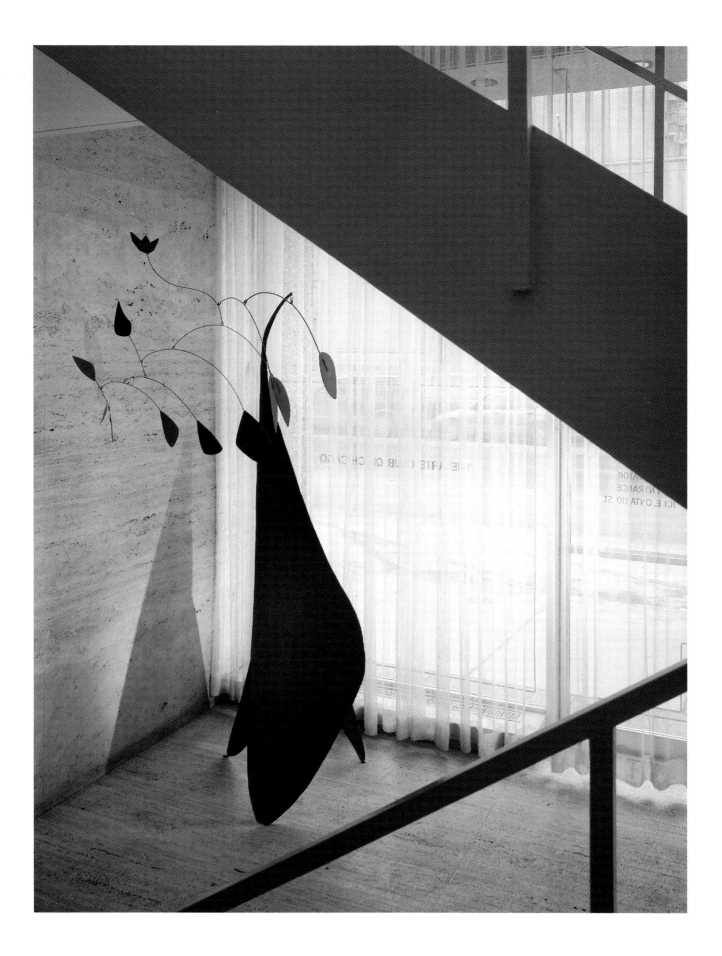

Alexander Calder

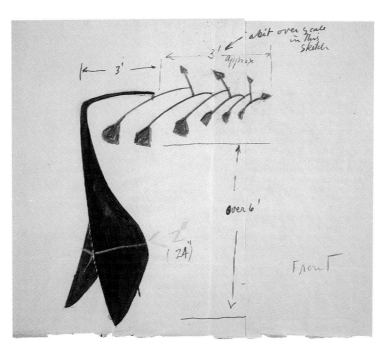

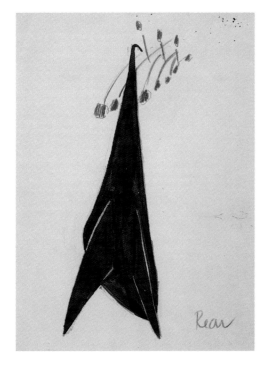

on a first-name basis between friends. The sculptor's wit and enthusiasm animates his letters as he describes ideas and fabrication; his sketches and notes—the piece should be able to "clear a six-foot gent's head, weigh about 75 to 100 pounds and rest quite solidly on the floor"—keep his Chicago patrons properly informed of his decisions (figs. 2, 3). While he suggests fabricating the larger stabile elements in New York, the "feathers," he notes, he

will make "all by myself." Shaw responds that the committee very much likes the design and asks if a base would add the desired height. Emphatic when he writes back, Calder insists that the piece rest directly on the floor: "I really actively dislike bases or frames if it is possible to avoid them."

The wartime steel scarcity forced Calder, convinced that "limitations impose a primitive quality on the result," to build the work from metal scraps, which he believed would be quite interesting. Happily by the end of May, Calder had located an old boiler plate, the "texture of elephant hide," in a Waterbury junkyard and requested $100 from Shaw in order to continue. "The beastie is now finished and in his bed," writes Calder on July 6, 1942, "with the door closed and completely decorated with the names of everyone in Chicago. I trust you will find him pleasant and suitable for your exhibition room." By October, the piece was in Chicago, assembled and installed according to the artist's instructions (see fig. 5, p. 25). Many years later, in his 1966 autobiography, Calder revised or perhaps editorialized on the development of *Red Petals* for the rosewood room at The Arts Club:

As I become professionally enraged when I see dinky surroundings, I did my best to make this object big and bold—to dwarf these surroundings. As it was during the war, I went to a junkyard and bought a big chunk of an old boiler. It had a pebble

grain due to the action of the water in the boiler, which gave it a very fancy surface. I cut out a big somewhat leaf-shape, which standing on end came to seven feet high, with an arm standing out at the top. This was held vertical by two leaf-shape legs behind it. From the arm overhead, I hung some red aluminum leaves—they might well have been remnants of the boat of the Roxbury pond.[1]

The cramped space to which Calder alluded was, of course, dramatically remedied when The Arts Club moved to new modern quarters designed by Mies van der Rohe on Ontario Street, and in 1951, Calder, in a note to Shaw, seemed pleased that the famous architect had reinstalled *Red Petals* in the foyer.

Soon after The Arts Club commission, curator James Johnson Sweeney applauded the sculptor as a distinctly American artist, heir to a frontier heritage because of his exuberance, strength, inventive turn of mind, and "a sensibility to materials that induces new forms and an insatiable interest in fresh patterns of order."[2] Sweeney's perceptive remarks, in an essay accompanying the major Calder exhibition at the Museum of Modern Art in 1943, constitute an immediate recognition of an artist whose work was to become a classic of American Modernism, although fueled in large part by European experimentation. After engineering studies at Stevens Institute for Technology and classes at the Art Students League, Calder, the son and grandson of prominent sculptors, had initially traveled to Paris in 1926. Here he first absorbed, then synthesized European Modernism with his own intuitive grasp of form and imaginative understanding of theater and performance. Adept at carving, he turned to wire sculpture, actually more like wire drawing, for his circus animals and his tiny acrobats, which provided him with his first success. As word spread in the Parisian avant garde of 1930, artists such as Joan Miró and Piet Mondrian came to his presentations. Calder's long friendship with the Catalan painter and his visit to the Dutch artist's studio proved to be influential; for a brief period, he joined a group of abstract artists including Theo van Doesburg, Jean Hélion, and Hans Arp, who named the stationary works "stabiles." In 1931 at Galerie Percier in Paris, Calder first exhibited a group of stabiles and a year later, abandoning his witty representational work, he combined flat, colored geometric shapes that moved rhythmically, activated by small motors or simple gravity, around a fixed element. While the strict lessons of Russian Constructivism were acknowledged and Mondrian credited with inspiring Calder's leap into abstraction, his moving constructions were inflected by dada notions of chance. Not surprisingly, it was Marcel Duchamp who first called them "mobiles," an apt characterization of Calder's whimsical formal inventions. These enchanting early wire sculptures became steps toward more expansive compositions whose movements were first mechanized, then driven by occasional breezes or gusts of wind. Manipulating planes and lines in space, Calder brilliantly shifted from the antics of his circus, presented in Chicago in 1935 on his first visit, to the performative aspect of his later sculpture.

A consummate solution integrating problems of stability and movement in one work, *Red Petals* is simultaneously graceful and monumental, both flora and fauna. With delicate leaf forms that spring and seem to drop naturally from a bowing nine-foot stem, the piece is weighted perfectly, as if tiptoeing on three large leaf-shaped points. Calder fondly referred to his creation as "beastie" and to its red elements as "feathers," suggesting that an animal analogy was as appropriate as the floral for this tree-like aggregate whose fixed trunk anchors the arching thrust of branches. *Red Petals* becomes a literal demonstration of mobility, avoiding the pedestal the artist so strenuously rejected in his note to Shaw. Moreover, the temporal and performative sense of the work and its placement at the entry of The Arts Club designed by Mies seemed predestined, the open elegant setting for which *Red Petals* had been waiting and where it remained until 1995. In 1996, with the opening of Chicago's new Museum of Contemporary Art, an entire gallery was dedicated to Calder's sculptures by a generous gift of Ruth Horwich, and now, fifty-five years after Shaw and Calder began their correspondence, The Arts Club celebrates a new building, a new context for *Red Petals*. "No use throwing it a passing glance," Jean-Paul Sartre wrote of a Calder mobile long ago. "You must live with it and be fascinated by it. Then and only then will you feel the beauty of its pure and changing forms, at once so free and so disciplined …something midway between matter and life."[3]

Judith Russi Kirshner

1. Alexander Calder, *Autobiography with Pictures* (New York: Pantheon Books, 1966), p. 186.

2. James Johnson Sweeney, *Alexander Calder* (New York: Museum of Modern Art, 1943), p. 7.

3. Quoted in Jean Lipman, *Calder's Universe* (New York: Viking Press in cooperation with the Whitney Museum of American Art, 1976), p. 261.

Tomb Sculpture

Sui dynasty (589–618)
Glazed earthenware
25 cm (9⁷/₈ in.)
Arts Club Purchase Fund,
1925.

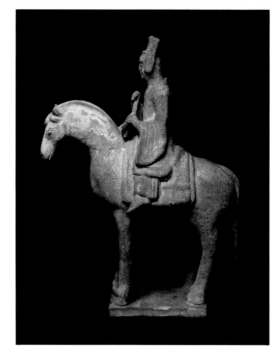

Fig. 1. Attributed to Yan Liben
(d. 673), *The Thirteen Emperors*
(detail), second half of 7th century;
handscroll: ink, color, and gold on
silk, 51.3 x 531 cm. (20³/₁₆ x 209
in.). Denman Waldo Ross
Collection, Courtesy Museum of
Fine Arts, Boston.

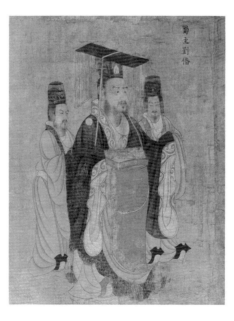

1. See *Great Museums of the World:
Museum of Fine Arts, Boston* (New
York: Newsweek Books, 1969), p. 23.

TOMB sculptures of this type are well known from Sui dynasty (589–618) sites in north and northwest China. The combination of the stylized posture and modeling of the horse and rider, and the abraded, straw-colored glaze, are typical of Sui funerary sculptures. It is likely that this example was originally one of a group of similar ceramic figures, designed as an ensemble to accompany a deceased official or noble person into the afterworld.

Ceramic tomb sculptures had three essential functions in ancient China: to remind the dead of the people, objects, and sights they had known in life; to serve their spirits in the afterworld; and to operate as status symbols for their surviving families. Because such objects were normally carried in public funeral processions before being interred in the tomb, their variety and quantity were key indicators of the filial piety and affluence of the living relatives of the deceased occupant of the tomb.

The gentleman riding this horse is dressed in the robes and hat of a scholar-official. The cylindrical baton he holds in both hands may be a symbol of his secular rank. Similar figures are often found among surviving Sui dynasty tomb sculptures. As a type, this figure is also comparable to the attendants accompanying the late Six Dynasties Period (sixth century) emperors shown in the famous handscroll painting attributed to Yan Liben, *The Thirteen Emperors* in the Museum of Fine Arts, Boston (fig. 1).[1] Figures of this type are particularly useful for their realistic portrayals of specific modes of dress and deportment in ancient China. Because part of their function was to represent aspects of the tomb occupant's former life, such ceramic sculptures enable scholars to reconstruct significant details of early Chinese material culture.

The neck, legs, and tail of the horse have been broken (probably as a result of centuries of burial) and repaired. The dark, straw-colored glaze has abraded in many areas, especially along the face, neck, and mane of the horse, revealing the pale buff color of the low-fired earthenware clay underneath.

Stephen Little

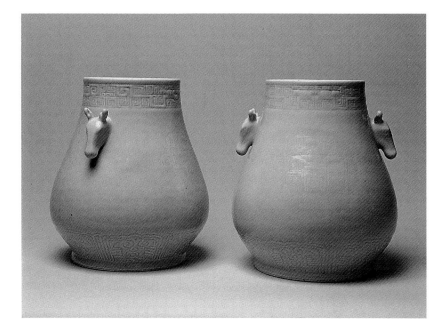

Pair of Archaistic Vases
Qing dynasty, 19th century
Porcelain with celadon glaze
29.1, 29.2 cm
(11^7/$_{16}$, 11^1/$_2$ in.), respectively
Provenance unknown.

THE shape of these tall, elegant vases is derived from the *hu* vase of the late Shang dynasty (thirteenth–eleventh century B.C.) of China's Bronze Age. The revival of ancient shapes and designs is one of the leitmotifs of Chinese art history, and is a tendency known today as archaism. The Qing dynasty (1644–1911) witnessed a tremendous revival of archaeological and epigraphical studies of ancient Chinese culture. The study of the function and design of ancient bronzes and jades was widespread from the reign of Qianlong (1736–95) onward, and archaistic designs are commonplace in mid and late Qing dynasty ceramics. The shape of The Arts Club vases first appeared in Qianlong period porcelains designed for use in imperial rituals, and continued until the end of the Qing dynasty in 1911.

The gently swelling body of each vase is punctuated by the low, splayed foot-rings and two handles in the shape of deer heads. The surface of each vase is decorated with designs molded and incised into the body when the clay was still wet, before glazing. These designs are themselves archaistic, based on patterns found on early Chinese bronze vessels and jades. A horizontal register comprised of stylized dragons against a background of squared spirals (the "thunder pattern" or *leiwen*) surrounds the neck of each vase, while a ring of stylized lotus lappets surrounds the base just above the foot-ring. On two sides of each vase is a roundel with a stylized Chinese character reading *Shou* (Longevity), superimposed on a thunder-pattern ground.

The exterior of each vase is covered with a transparent celadon glaze. This too is an archaistic feature, representing a conscious attempt to imitate the famous Longquan celadon glazes of the Song dynasty (960–1279). The characteristic green color results from small amounts of iron oxide in the glaze, fired in a reducing atmosphere in which the oxygen in the kiln is kept to a minimum. This green glaze extends about four centimeters down the interior wall of each vase. Within the raised, beveled foot-rings, the recessed bases are covered with a transparent glaze. At the center of the base on each vessel is an incised six-character standard script mark of the Qianlong emperor, reading *Da Qing Qianlong nian zhi*, "Made in the Qianlong Reign of the Great Qing (dynasty)." Comparison of the slightly wobbly calligraphy with genuine Qianlong examples in the former imperial collection, now in the National Palace Museum, Taipei, suggests that the vases were made and inscribed sometime after the Qianlong period. The Qianlong mark was, in fact, often copied on nineteenth-century Chinese porcelains. On the basis of the vessels' proportions and the shape of the dragons around the necks, it is possible to attribute the vases to the early nineteenth-century reign of Daoguang (1821–50).

Stephen Little

Chinese

Bodhisattvas

Yuan dynasty (1260–1368)
Wood with traces of pigment
left to right, 116.8, 121.9,
129.5 cm (46, 48, 51 in.)
Arts Club Purchase Fund,
1931.

1. René-Yvon Lefebvre d'Argencé and
Diana Turner, eds., *Chinese, Korean,
and Japanese Sculpture in the Avery
Brundage Collection* (San Francisco:
Asian Art Museum of San Francisco,
1974), p. 149.

2. Personal communication from
Laurence Sickman, October 1978.

THESE sculptures depict bodhisattvas, enlightened beings of the Buddhist Mahayana (Greater Vehicle) pantheon, who vowed to defer their own entry into Nirvana—the undifferentiated Void out of which all reality emerges—until all other sentient beings have experienced enlightenment. The presence of bodhisattvas as saviors in the sacred and phenomenal worlds is one of the defining characteristics of Mahayana Buddhism, which entered China in the first century A.D. The bodhisattva's role is articulated in texts such as the important *Lotus Sutra,* where, for example, the role of Avalokiteshvara (in Chinese, Guanyin), the Bodhisattva of Compassion, is described in detail.

A complex pantheon of innumerable Buddhas and bodhisattvas evolved in Mahayana Buddhism; every eon of time and every universe had its own Buddha. This was in contrast to the teachings of the earlier Theravada Buddhism, which emphasized asceticism and focused on the teachings of the historical Buddha. In addition to Shakyamuni (Shijiamuni), the principal Buddhas of the Mahayana pantheon included Amitabha (Amituofo), while the most important bodhisattvas were Avalokiteshvara, Samantabhadra (Puxian, the Bodhisattva of Benevolence), and Manjushri (Wenshu, the Bodhisattva of Wisdom).

In Buddhist art, Buddhas are usually depicted flanked by bodhisattvas, often in triads, while more complicated groupings also appear. The three wooden bodhisattvas in The Arts Club collection may have once been part of a larger group comprised of Buddhas, bodhisattvas, and lesser beings, organized in a three-dimensional mandala, or sacred diagram, on a large altar in a temple. While the removal of these remarkable sculptures around 1930 from their original context precludes any deeper speculation regarding their initial siting and placement, comparison with surviving Liao (907–1125), Jin (1115–1234), and Yuan dynasty (1260–1368) sculptural programs in temples in Shanxi Province gives some hint of the types of figural groups in which such sculptures may have played a role.

Each bodhisattva in The Arts Club collection sits in a dignified posture, and is dressed in long flowing robes, crowns, and jewelry. The bodhisattvas display different mudras, or sacred gestures; future research may lead to the identification of the figures on the basis of these mudras. Comparison with other known sculptures of Manjushri, for example, suggests that he is represented here by the central figure, who appears to sit on a lion (the vehicle of Manjushri). On the basis of the sculptural multiblock technique and the overall style of the carving, these bodhisattvas can be dated to the Yuan dynasty. In part, this can also be postulated from the figures' proportions, which reflect the greater stylization and somewhat stiffer postures that characterize Chinese Buddhist sculpture of the Yuan dynasty, a period of increasing influence from Tibet and Nepal. As heirs to the pacification of huge areas of Asia under Genghis Khan, the Mongol emperors of the Yuan dynasty (beginning with Genghis's grandson Kubhilai Khan) facilitated overland access to China for many foreigners, including Persians, Tibetans, and Central Asians. Close political ties between China and Tibet established in the late thirteenth century led to a surge of Tibetan influence in Chinese Buddhist art of this period. Comparison of The Arts Club figures with a Yuan or early Ming dynasty wooden sculpture of Samantabhadra in the Asian Art Museum of San Francisco (fig. 1) presents several similarities, including proportions, the stylized treatment of the face, the shape and style of the crown, and the presence of the now-missing animal mounts.[1] In particular, the proportions of the bodhisattvas' faces, crowns, and jewelry reflect Tibetan canons of design, which were especially influential in China in the late thirteenth and fourteenth centuries.

The wood surfaces of the sculptures reveal some traces of gesso and pigment, most of which has worn off. The pupils of the figures' eyes are inlaid with black glass. The iron nails that are occasionally visible date to the fourteenth or fifteenth centuries. All three sculptures were fitted with rectangular cavities at the centers of their backs, designed to hold sacred offerings; these cavities are now empty. Similar cavities are found on a Yuan dynasty wooden bodhisattva in the Nelson-Atkins Museum of Art, Kansas City.[2] Although all three sculptures have suffered damage and evidence old repairs, it is clear that each bodhisattva originally sat on an animal mount, two of which were conceivably the lion and the elephant, the respective vehicles of Manjushri and Samantabhadra.

Stephen Little

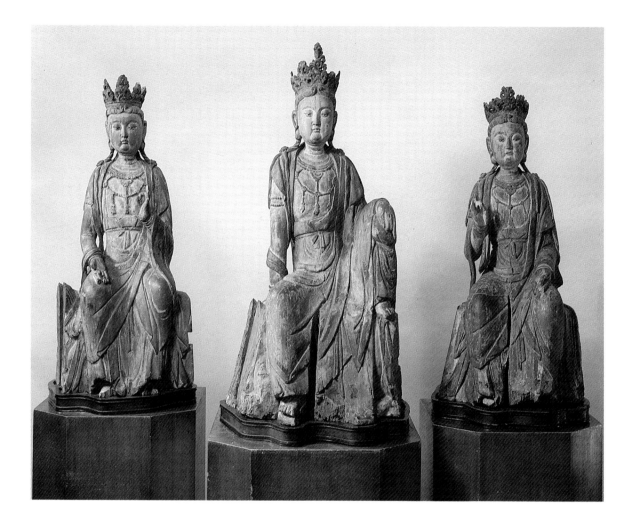

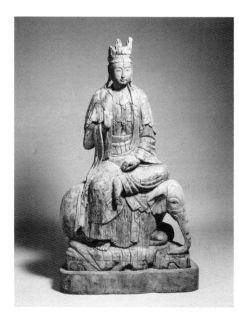

André Derain
French, 1880–1954

Untitled, c. 1929
Red chalk on paper
52.7 x 44.5 cm
(20 ¼ x 17 ½ in.)
Gift of Anne M. Reynolds
(Mrs. John H.)
Winterbotham, 1962.

ANDRÉ DERAIN, fauvist proponent of pure color, produced monochromatic drawings alongside his brilliant paintings, seeking a pared-down expression. Drawing could complement color in the quest to "purify the transfer of nature to canvas," he wrote in 1906. "I see nothing in the future for me but composition."[1] Indeed, Derain viewed this process as manifestly spiritual:

> Drawing is a spiritual rhythm which goes constantly from container to contained, from contained to container. It is the rhythm of limitation, and the process of integration of entities of light. Light is therefore the sign of the sum which allows one to rediscover the elements which don't count in immediate appearance but which are nevertheless one with the spirit.[2]

While it never supplanted painting for Derain, drawing consistently supplemented color and canvas in his search for transcendence attained through the artistic process.

Although Derain had investigated the figure as subject matter early in his career, he largely abandoned it between 1910 and 1913, and did not produce a single nude during that time. He returned to painting the nude after the First World War, however, and in the early 1920s began the task of recording femininity with prolific enthusiasm. When art dealer Daniel Kahnweiler asked Derain in 1922 to supply him with some nudes, the painter obliged with a wide scope and variety that suggested the subject had occupied him mentally even during his painting hiatus. By the late 1920s, Derain's primary concern was drawing, and he sketched constantly from the model posed in the studio; his drawings were widely reproduced in journals, and sold as works in their own right. René Gimpel recorded a visit to Derain's studio in June of 1928, in which the artist carted out boxes of sketches, four or five hundred studies from the previous winter, all of the same woman. The reason for this obsession? "'To find a certain position,' Derain told us, 'and I haven't found it.'"[3]

This red chalk drawing of circa 1929 is one of many similar nude studies. All executed in sanguine, a favorite medium of Old Masters, these sketches are the products of careful, selective observation of the female model. The focus of The Arts Club's drawing is just that: Derain has rendered the face smudged and anonymous, but his treatment of the torso—where the arm meets the chest, the muscles around the breast—is thoughtful and deliberate. The ephemeral effect of the red chalk, so different from his vivid painting, hints at Derain's spirituality of drawing.

Elizabeth Siegel

1. André Derain, cited in Gaston Diehl, *André Derain,* trans. A. P. H. Hamilton (New York: Crown Publishers, 1964), p. 42.

2. André Derain, "A Metaphysic of Painting: The Notes of André Derain," trans. Rosanna Warren, *Georgia Review* 32:1 (Spring 1978): 141.

3. René Gimpel, *Diary of an Art Dealer,* trans. John Rosenberg (New York: Farrar, Straus, and Giroux, 1966), p. 347.

THE son and grandson of master plasterers, Charles Despiau at age sixteen left his provincial birthplace of Mont-de-Marsan to attend the Ecole des Arts Décoratifs in Paris. There he studied under a former pupil of the well-known Second-Empire sculptor Jean-Baptiste Carpeaux. Subsequently, Despiau entered the atelier of Louis-Ernest Barrias in the prestigious Ecole des Beaux-Arts. In 1898, he exhibited for the first time in the Salon des Artistes Français, submitting a plaster bust, and another in 1900. By this time he was recognized as a junior member of the circle of the most prominent and influential French sculptors—among them Emile-Antoine Bourdelle and Camille Claudel —established around Jules-Aimé Dalou, Constantin Meunier, and the formidable Auguste Rodin.

Although his early works included full-figure studies of men and women in contemporary clothing, Despiau tempered such topical reference with an interest in psychological mood. The characterization of his sitters led him away from precise description, as he gradually abandoned verisimilitude in the details for more purely sculptural effects achieved through a simplification of forms. Public success was not immediate; it was only in 1906 that he received his first portrait commission. The following year, like Alexandre Charpentier and Bourdelle before him, he was hired to work in Rodin's atelier as a *practicien*, translating terracotta and plaster maquettes into stone. This workshop experience brought Despiau into firsthand, daily contact with the sculptural methods and aesthetic philosophy of the elder Rodin, whom he would always cite when asked to discuss his own work in later life.

In the 1920s and 1930s, Despiau worked almost exclusively in the genre of portrait busts, and it is for these that he is primarily remembered today. His numerous commissions included portraits of leading social and artistic personalities of interwar Paris, from the painter Dunoyer de Segonzac and the wives of André Derain and Othon Friesz respectively, to Mrs. Charles Lindbergh. The Arts Club bust of the French actress Maria Lani (1906–1954) was executed during this prolific period of public acclaim. The sitter was apparently of special interest to Despiau for he executed a second version of her portrait, with eyelids closed.[1] In 1929, each bust of Lani was cast in bronze in an edition of eight, and The Arts Club

Portrait of Maria Lani,
c. 1927
Plaster
55.9 cm (22 in.)
Arts Club Purchase Fund,
1930.

plaster is probably the original maquette for the first version. The sculptor's exploration of changes in expression and mood between the two states of awareness follows his central artistic vision that the bust serve as a sculptural metaphor of the moral as well as physical characteristics of the sitter.

Despiau has reduced the actress's portrait to the head and bare neck ending at the shoulder, a classical format reestablished in the Renaissance and reinvigorated in neoclassical sculpture around 1800. Without reference to clothing or other identifying attributes, the sculptural and emotional effect of this work depends on Despiau's extreme care in the simplification of details, such as the tightly drawn hair, and the slight tipping of the head forward and to the side. This minor adjustment of pose activates the bust and captures the sitter's engagement with her surroundings.

Richard A. Born

1. This "paupières baissées" version of 1928 is illustrated in Gustave Kahn, "Charles Despiau," *L'Art et Les Artistes* 124 (February 1932): 165.

Tsuguhara Foujita

French, born Japan, 1886–1968

Portrait of Girl with Red Hair, 1926
Ink and watercolor on coated paper mounted on canvas
33 x 26 cm (13 x 10¼ in.)
Bequest of Arthur Heun, 1947.

WITH the dual influences of Japanese roots and Parisian Modernism, Tsuguhara Foujita created a style at once delicate of touch and vibrant with the subjects of modern Western life. More restless than his name would suggest (Tsuguhara means "heir to peace" and Foujita "field of wisteria"), Foujita studied art in Japan, but left for France in 1913 at the age of twenty-seven. In Paris, he found a like-minded community of émigré artists such as Alexander Archipenko, Jacques Lipchitz, Amedeo Modigliani, and Chaim Soutine, and discovered the work of Picasso and Braque. Foujita exhibited regularly at the Salon d'Automne beginning in 1919, and, as his fame spread to his native Japan, he began as well to exhibit at the Tokyo Imperial Salon in the early 1920s. His notoriety was due, in part, to his flamboyant character: with a watch tattooed on his wrist, earrings in both ears, and once, at the opera, a lampshade for a hat, Foujita cut a striking figure even in the streets of Paris.

Central to his life and art was his love for women. Married three times, Foujita also found women irresistible subjects for his work, painting and drawing nudes, society portraits, leisurely women with cats (another favorite motif), and female heads. He delineated them with a thin black brushstroke or pen-mark, subordinating color to the effect of his line, creating fluid studies that combined Eastern and Western sensibilities. The woman in this 1926 watercolor is sparingly defined, her blouse and stately profile sketched in with the barest indications of line and color; all attention is reserved for her long auburn hair, braided around her head like a halo. Foujita was sufficiently intrigued by this image to reproduce it in a lithograph that same year (a reverse image, showing that he copied it directly onto the stone), somewhat heavier in the treatment of the hair, collar, and eyes.[1] The watercolor and ink drawing has the advantage of color, highlighting Foujita's interest in the unusual, distinctly Western hue of the woman's plaited coiffure.

Elizabeth Siegel

1. The lithograph is illustrated as *Tête de Femme* in Sylvie Buisson and Dominique Buisson, *La Vie et l'oeuvre de Léonard-Tsuguharu Foujita* (Paris: ARC Edition, 1987), no. 26.50.

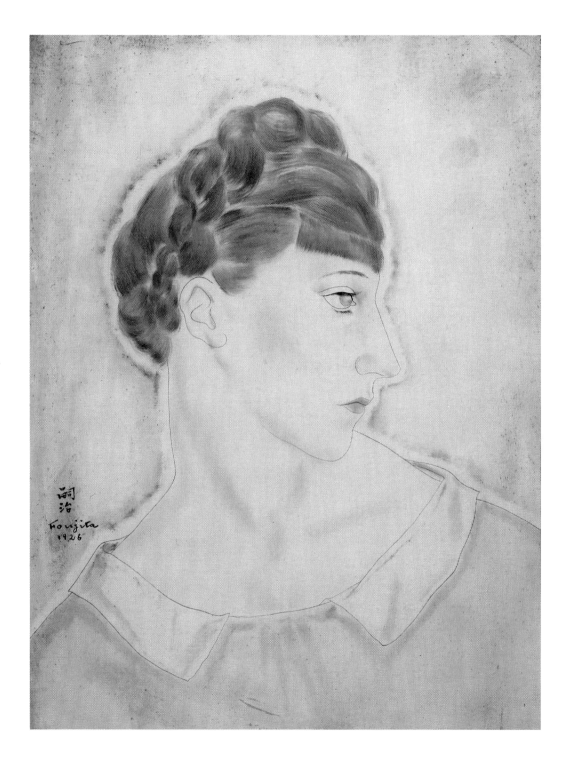

Alberto Giacometti
Swiss, 1901–1966

Portrait of James W. Alsdorf, 1955
Pencil on paper
31.8 x 24.8 cm
(12½ x 19¾ in.)
Gift of Marilynn Alsdorf, 1997, in honor of Joan and Stanley Freehling's Fiftieth Wedding Anniversary.

Fig. 1. Alberto Giacometti, *Marilynn Alsdorf*, 1955, pencil on paper, 31.8 x 24.8 cm (12½ x 19¾ in.), Collection of Marilynn Alsdorf, Winnetka, Illinois.

WHILE visiting Paris in the summer of 1955, Chicagoans Marilynn and James Alsdorf called on Pierre Matisse, the youngest son of painter Henri Matisse and a successful art dealer and gallery owner. The Alsdorfs, who would soon begin accumulating their important collection of Asian sculpture, were also interested in acquiring modern art. Matisse invited the couple to join him on a visit to the tiny studio shared by sculptor Alberto Giacometti and his artisan brother, Diego, on the rue Hippolyte-Maindron.

Alberto was at the time the subject of three simultaneous retrospective exhibitions, in New York, London, and three cities in Germany. Born in Switzerland in a small town near the Italian border, Giacometti had arrived in Paris in 1922 after studying art in Geneva. After three years of life drawing and sculpture classes with Emile-Antoine Bourdelle at the popular Académie de la Grande Chaumière, the artist spent another four years rendering the figure from memory. In 1929, Giacometti joined the Surrealists, with whom he exhibited his often kinetic sculptures until late 1934, when he was expelled from the group for working from the live model, a practice antithetical to the surrealist emphasis on automatism. Perpetually concerned with representing the distance between himself and his sitters and with more general problems of perception, Giacometti alternated between model and memory throughout the duration of his career. At the time of the Alsdorfs' visit, the artist had been relying on Annette, his wife, and Diego as the principal models for his paintings and sculptures, although he frequently made drawings of friends and acquaintances, including Jean-Paul Sartre (1946), Georges Bataille (1947), Paul Eluard (1947), Henri Matisse (1954), and Jean Genêt (1954–55).

According to Marilynn Alsdorf, although Giacometti and the Alsdorfs did not share a common language, they became friends, first over lunch and then—the artist still dressed in his studio attire—during dinner at the Ritz. Giacometti remarked on Marilynn's likeness to Amedeo Modigliani's portraits (of which she and her husband would collect several exceptional examples) and proceeded to draw the couple over much of the following day. It was mid-July and raining, and with water dripping through the roof of his studio, he executed approximately fifteen individual portraits, spending over an hour on each. Giacometti found it much easier to draw Mrs. Alsdorf than her husband, even though they sat in several of the same positions. The artist was strongly taken by her striking features and the line of her long neck, emphasizing these particular aspects in his drawings of her (fig. 1), but was frustrated in his repeated efforts to render Mr. Alsdorf satisfactorily. It was Jim's eyes, the attribute Giacometti believed most important to his portraits, that continued to elude him, even as he characteristically erased and reworked the drawings, rapidly sketching the planes and contours of his subject's face, and suggesting the off-center tilt of the head with stray lines pointing toward the upper-left corner of the page in this particular example. Eventually pleased, Giacometti shared half the drawings with his sitters and encouraged the Alsdorfs to return to the studio whenever they found themselves again in Paris.

Sophia Shaw

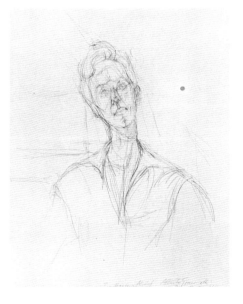

Andy Goldsworthy
English, born 1956

Day, Forest Dunes, Michigan, August 24, 1991
Dye-coupled silver gelatin prints
74.9 x 74.9 cm
(29½ x 29½ in.)
Arts Club commission, 1991.

West Dundee, Illinois, August 30, 1991
Dye-coupled silver gelatin prints; 68.6 x 94 cm
(27 x 37 in.)
Arts Club commission, 1991.

1. Quoted in Andy Goldsworthy, *Hand to Earth: Andy Goldsworthy Sculpture, 1976–1990* (New York: Harry N. Abrams, 1993), p. 9.

2. Francis Bacon, "Of Gardens," in *The Essays,* ed. by John Pitcher (Harmondsworth: Penguin Books, 1985), p. 197. The following quotation is from ibid., p. 286.

WE might say the photographs that Andy Goldsworthy makes of his ephemeral sculptures are all that is left of his real works. He agrees, and compares them to Yves Klein's monochrome paintings, which the artist described as "only title deeds to my property which I have to produce when I am asked to prove that I am a proprietor."[1] Of Goldsworthy's real works—his initial creations in natural materials—we might say they relate to the 1970s land art of Michael Heizer, Richard Long, Robert Smithson, or to Christo's installations, for they ask us to consider whole environments as both stage and medium of artistic thought. But these comparisons also lead to an important distinction: Goldsworthy's works are most often made by hand and therefore do not achieve the gigantic scales possible with machines. Thus, we might say that he moves through the natural environment not with the overarching stride of a surveyor, but rather with the delicate tread of a gardener.

Taking this distinction as a point of departure, we might remove ourselves to the early seventeenth century and read Francis Bacon's essay "Of Gardens." Here the philosopher describes a predictable character for the work in view but at the same time suggests why works like Goldsworthy's may not have evolved much earlier:

> God Almighty first planted a garden. And indeed it is the purest of human pleasures. It is the greatest refreshment to the spirits of man, without which buildings and palaces are but gross handyworks; and a man shall ever see that when ages grow to civility and elegancy, men come to build stately sooner than to garden finely, as if gardening were the greater perfection.[2]

Bacon goes on to make a long list of which plants are appropriate to each season, just as Goldsworthy's work is essentially season-bound in its use of summer-beach sand or pond leaves, autumnal foliage, or ice shards. But the cyclic renewal implicit in Bacon's well-planned garden is not part of our sculptor's work. His constructions are meant to decay, then disappear. Acknowledging the caducity of any message wedded to a physical medium, we are reminded by the erosion of Goldsworthy's sand sculptures of the earlier lamentations of writers, poets, and prophets. From Bacon we read of mankind "Who then to frail mortality shall trust, /But limns the water, or but writes in dust."

If we venture that Goldworthy's respect for natural objects and settings indicates his acceptance of their conditions, we must also be mindful that gardeners graft roses to different root stock, force germination, breed colors, and place annuals for happy effect. No gardener is resigned to what is given, and thoughtful intrusions seem to be the requirement of the most inventive. Goldsworthy's own remarkable intrusions go beyond mere playful pranks. They raise significant questions about the character of structural engineering compared to that of organic stasis and decay: are they at odds or just different expressions of the same forces? Questions of human invention/intervention vis-à-vis natural discovery/determination that stimulated Bacon, Descartes, Pascal, and Newton in the seventeenth century now return to us in a more delightful form.

Universal as such questions are, each generation seems compelled to find new formats and affinities for whatever answers they produce. As old answers become comfortable historical curiosities, new ones signal the identity of another age. When Goldsworthy joins in this quest, it is not so much his ideas—of alteration and impermanence—that we judge to be so marvelous, but his peculiar yet graceful demonstration of them, that is, the decided relief he creates against all else. But that is the way it is for great mathematical proofs or musical scores, for cubist canvases or love sonnets. It is in the demonstration that the art occurs.

Even if we can admire only a fraction of the beauty of Goldsworthy's original shocks and fluencies through his photographs, we may still ask: Why the huge effort and extravagance? We might as well ask if nature is God's planting, why do we make our gardens of our own? There is only room for a short reply, which itself teases us like this gardener's own sleight-of-hand: in every age as in every person, we have our answers as we have our needs.

David B. Travis

Natalia Goncharova
French, born Russia, 1881–1962

Spring (Printemps),
1927/28
Five-panel floor screen, oil
on canvas stretched over
frame
Each panel 243.8 x 81.3 cm
(96 x 32 in.)
Arts Club commission,
1927–28.

Untitled,
late 1920s/1930s
Graphite on paper
51.3 x 36.1 cm
(20 1/4 x 14 1/4 in.)
Provenance unknown.

1. It is interesting to note that Rue
Winterbotham, Carpenter's niece
and namesake (who would become
Arts Club president in 1940), stud-
ied painting with Goncharova in
the early 1920s.

2. Personal communication to the
author September 19, 1996. I am
grateful to Professor Parton for
responding so generously to my
queries about Goncharova's life and
work.

BORN in 1881 in Nechaevo, Russia, Natalia Goncharova originally trained as a sculptor. Her initial forays into painting and drawing were in French styles popular at the time, Impressionism and Pointillism, followed by a period of experimentation with forms inspired by such traditional Russian folk art as hand-colored prints and signboards. In 1912, she and Mikhail Larionov conceived of Rayonism (or Rayism), in which vectors of color depicting refracted rays suggest the vibrant play of light on surfaces. This style synthesized the color theories of Orphism with the intersecting planes and lines of Cubism and the celebration of modern technology in Futurism.

By 1914, Goncharova was dedicating more time to theater design, receiving broad accolades for the curtains, scenery, and costumes she designed for *Le Coq d'or,* a Russian opera-ballet staged at the Paris Opera by Serge Diaghilev, director of the Compagnie des Ballets Russes. After World War I, Goncharova left Russia, reunited with Diaghilev and Larionov (who had served in the war), and traveled through Europe with Diaghilev's troupe, preparing designs for their productions. In 1919, Goncharova and Larionov settled in Paris—in an apartment they would share until the end of their lives; by 1923, they had exhibited their paintings and theater designs throughout Europe, as well as in Tokyo, New York, and Chicago, where Goncharova installed an exhibition at The Arts Club in winter 1922.

During a trip to Europe five years later, Rue Winterbotham Carpenter commissioned Goncharova to make a screen for The Arts Club's rooms in the north tower of the Wrigley Building.[1] The Club president explained in an undated letter to Alice Roullier, back in Chicago: "[Goncharova] will paint a screen for us for $1000—we can order whatever we want....If you write from the Club giving her the commission I can see sketches, colors etc. when I go back to Paris in April. I thought a screen of spring would be lovely—flowers—Cubist of course...." Following Carpenter's visit, Goncharova sent a sketch to Chicago with specific mounting instructions; the screen arrived by late November 1928, and was included in an exhibition of modern paintings in January 1929.

Floor screens saw a broad resurgence in popularity as functional and aesthetic objects in the 1920s, although the commissioning of screens from prominent painters had been on the rise since 1870, initially influenced by decorative paneling imported from Japan and China. Around 1900, several Jugendstil artists in Germany, including Wassily Kandinsky, Paul Klee, and Franz Marc, began painting folding screens and furniture; the synthesis of utilitarianism and aesthetics was also central to the Dutch de Stijl and Russian formalist movements. Most similar in spirit to Goncharova's screens, however, were the Italian Futurist Giacomo Balla's set designs for the Stravinsky-Diaghilev ballet *Fireworks* (1916–17), where landscape was represented in a manner reminiscent of Rayonism and dancers were replaced by constantly changing and flashing lights, intensifying a sense of motion. Balla also painted a number of screens contemporaneously with Goncharova, including one in 1918–19 that captured the movement of a passing car with what the artist called "velocity lines."

Goncharova produced many designs for folding and freestanding screens during this period. The most famous, the similarly five-paneled *Espagnoles* (1920, collection Sophia Loren, Rome) depicting five Spanish dancers in a geometrically simplified style, was show at The Arts Club in 1928. The subject of the Club's screen is not unusual for the artist, for she painted blossoming flowers throughout her career—from her rayonist period, when she and Larionov titled several of their paintings *Spring,* through the early 1920s, when she decorated the Parisian home of Russian conductor Sergei Kussevitsky with ten panels representing the four seasons, and after the Depression, when she supported herself by selling flower paintings.

The untitled Goncharova drawing of poplars in The Arts Club's collection is one of many such landscapes she executed both in Russia and France. It may have belonged to either Carpenter or Roullier and been bequeathed to the Club with the works each left behind. Art historian Anthony Parton has suggested that because of the bold handling of the graphite in this work, it probably numbers among the many drawings Goncharova made in the late 1920s and 1930s, during the summers she spent in the south of France.[2]

Sophia Shaw

Barbara Hepworth

British, 1903–1975

Pierced Round Form,
1959/60
Polished bronze
21.6 x 10.8 x 21.6 cm
(8½ x 4¼ x 8½ in.)
Gift of Helen Harvey Mills,
1996.

ONE of Britain's leading twentieth-century sculptors, Barbara Hepworth combined expert carving skills, learned while in Italy, and a familiarity with the work of contemporary leading modernist artists to produce striking and elegantly worked forms in alabaster, wood, marble, and, later, cast bronze. A visit to the studio of Constantin Brancusi in Paris in 1932 encouraged Hepworth's interest in the unity of form and material in her sculpture, and the presence of Naum Gabo in London during the war resulted in a fruitful exchange of ideas and a long-term friendship. Hepworth in fact associated with a remarkable group of international artists, all proponents of abstraction in painting and sculpture: Jean Arp and Sophie Täuber-Arp, Piet Mondrian, Henry Moore (who had been her classmate both at Leeds and the Royal College of Art), and Ben Nicholson (to whom she was married from 1939 to 1951).

Despite her connections to Europe and a modernist style, Hepworth is inextricably associated with the small fishing town of St. Ives in Britain's far southwest corner of Cornwall. The artists' colony that had been established in St. Ives from the mid-nineteenth century was Hepworth's home from 1939 until her death in 1975. Here she reinterpreted abstraction in terms of her interest in nature, inspired by the coastal landscape; the "hand-held" size of sculptures like *Pierced Round Form* encourages a comparison with some smoothed, natural form found on a beach. Such small objects, however, demonstrate only one aspect of Hepworth's concern with scale; the twenty-one foot bronze *Single Form (Memorial to Dag Hammarskjöld)* (1962–63, United Nations Plaza, New York) represents the monumental side of her aesthetic. Both these forms, large and small, are "pierced," deploying negative space as a fundamental element in sculpture, as important as mass, weight, and texture: always crucial to Hepworth's approach, in fact, was the use of space as an abstract form in and of itself. The prototype for these pierced works was the remarkable *Pierced Form* of 1931,[1] carved in pink alabaster, destroyed during the war but preserved in photographs the artist took with her to Paris the following year to show to Arp, Picasso, and her great model of simplicity and sculptural integrity, Brancusi.

Jessica Morgan

1. Illustrated in Herbert Read, *A Concise History of Modern Sculpture* (London: Thames and Hudson, 1964), p. 194.

*Women Drawing
Water from a Well,*
late 18th/early 19th century
Ink and colors on paper
11.4 x 17.8 cm (4½ x 7 in.)
Gift of John Palmer, 1965.

PAINTED in a style inspired by Mughal court painting of the seventeenth century, this elegant work depicts women drawing water from a well. The setting for this genre scene is a landscape of rolling green hills at dusk. The foreground is taken up with a platform built around a well head, with an attached tank in the lower right corner. Three young women are shown on the terrace: one pours water into a jar, another draws water from the well, and the third pours water from a ewer into a bowl lifted up by a fourth woman, at the far left. Three others are shown either walking or seated on the ground, with capacious jars for carrying water. Two aristocratic gentlemen also approach the platform. The older man, at the upper left, holds up a bowl as if to take a drink, while the younger one, in the lower foreground, waits for his bowl to be filled.

The painting is characterized by delicately balanced harmonies of green, orange, yellow, pink, lavender, and gray pigments. There is extensive use of gold, with particularly effective highlights in the sky, the large water jars, and textiles. While the attention to detail seen in this work is characteristic of earlier Mughal painting, the stylized composition and rather static figures point to a date in the late eighteenth or early nineteenth century.[1]

Stephen Little

1. Compare, for example, the similarly dated paintings from Lucknow and Basohli illustrated in Linda York Leach, *Indian Miniature Paintings and Drawings* (Cleveland: Cleveland Museum of Art, 1986), nos. 48, 106ii.

Khosrow and Shirin in a Pavilion, illustration from the *Khamseh of Nezami,* 16th century
Ink and colors on paper
17.8 x 11.1 cm (7 x 4³/₈ in.)
Gift of John Palmer, 1965.

A CLASSIC example of Persian painting, this work depicts a scene from the famous love story *Khosrow o-Shirin,* "Khosrow and Shirin," the second of five epic poems in the *Khamseh,* or "Quintuplet," compiled by the poet Nezami (c. 1141–1209). The influence of Nezami's *Khamseh* was such that it gave rise to a host of literary imitations by other poets. *Khosrow o-Shirin* is based on the life of the Sasania Emperor Khosrow II (r. 590-628) and his love for his Armenian Christian wife, Shirin.[1] In the painting, the couple is shown seated in an ornate tent, accompanied by servants and, at the left, a partially dressed young man, perhaps a religious mendicant. The six servants are all female, and the similarities in their dress and headgear suggest they are the personal attendants, possibly Armenian, to Shirin. The rather rigid postures and repeated poses of the seated figures is characteristic of early Persian painting. The landscape setting is comprised of a delicately painted garden, with blue and yellow hills, and stylized trees, rocks, and grass. The fine waves of flowing water in the stream at the lower left corner are painted in meticulous detail. In the background is a gold sky.

This painting was originally a page in an album almost certainly depicting all five poems in Nezami's *Khamseh.* Many illustrated versions of this work were created in Persia, Central Asia, and northern India. The balanced composition and relaxed integration of figures and landscape are characteristic of Persian painting of the late sixteenth century. In style, this work is comparable to other surviving Persian paintings of the period between 1550 and 1600.[2]

Stephen Little

1. See *Encyclopaedia Britannica: Micropaedia* (Chicago: Encyclopaedia Britannica, 1994), pp. 666, 830–831, 842; for a full account, see Sir Percy Sykes, *A History of Persia,* vol. 1, 3rd ed. (London: MacMillan, 1969).

2. See, for example, Glenn D. Lowry and Susan Nemazee, *A Jeweler's Eye: Islamic Arts of the Book from the Vever Collection* (Washington, D.C.: Smithsonian Institution, Arthur M. Sackler Gallery, 1988), no. 35.

Paul Klee

Swiss, 1879–1940

Submersion and Separation (Senkung und Scheidung), 1923
Graphite and watercolor on paper
24.8 x 31.8 cm
(9 ³/₄ x 12 ¹/₂ in.)
Bequest of Arthur Heun, 1947.

IN his "Creative Credo" of 1918–20, Paul Klee maintained, "Art does not reproduce the visible but makes visible."[1] Klee put this belief into practice as both an artist and a teacher at the German Bauhaus (which he joined in 1921), where he sought to make visible abstract concepts such as musical rhythm and movement through pictorial space. Although he had abandoned a musical career for painting while in his twenties, Klee continued to incorporate music into his compositions. Linked by notions of rhythm and time, music and painting for Klee both employed elements in repetition and variation. Music took the form of a contrapuntal scheme in his painting and drawing, with line played against line and color chords in contrast for effects of tension and harmony.

Klee adopted an elaborate sign system to render visible the formative process of a painting and the viewer's progress through it. A picture became a mapped-out world where line was movement, where the viewer traveled and paused over articulated lines, undulating waves, and series of schematic arches. Crucial to Klee's strategy were tone and directional signs like the arrow. An increase in tone, he wrote in his notebooks, indicated an increase in energy—dark tones signified action, emanating from a neutral white. Likewise, the arrow symbolized increase, an extension of the artist or viewer into an ideal world. Klee remarked on the pictorial function of arrows in his notebooks:

> Common to the arrow and all its offspring are: the linear motion and the length of the trajectory in relation to the size of the projectile. The father [arrow] is all spirit, all idea, all thought. Its motion can be mathematically straight, unaffected by obstacles, without friction because it has no body; it can be as long as it pleases, finite or infinite.[2]

The unencumbered arrow provided the mathematical and spiritual possibility of transcendence, the spirit made visible.

Klee's 1923 *Separation and Submersion,* made while he was at the Bauhaus, draws upon these musical and schematic influences. Its repetition of overlapping lines and rectangles speaks to a pervasive rhythm, with tonal energy flowing from the lighter center out to the dark edges. The three arrows urge the viewer into the heart of the image; the smaller, blue arrows encounter some resistance, but the central black one proceeds straight down with a vigorous intensity of purpose. Klee had explored this theme the previous year in a watercolor titled *Separation in the Evening* (private collection, Switzerland), employing similar devices—arrows, gradated tonal striations—to visualize separation. His later effort, with its interlocking and oppositional pattern, reveals a more complex investigation into the problem of making visible.

Elizabeth Siegel

1. Paul Klee, "Creative Credo," *The Thinking Eye,* Paul Klee Notebooks, vol. 1, ed. Jürg Spiller, trans. Ralph Manheim (Woodstock, N. Y.: Overlook Press, 1992), p. 76.

2. Ibid., p. 407.

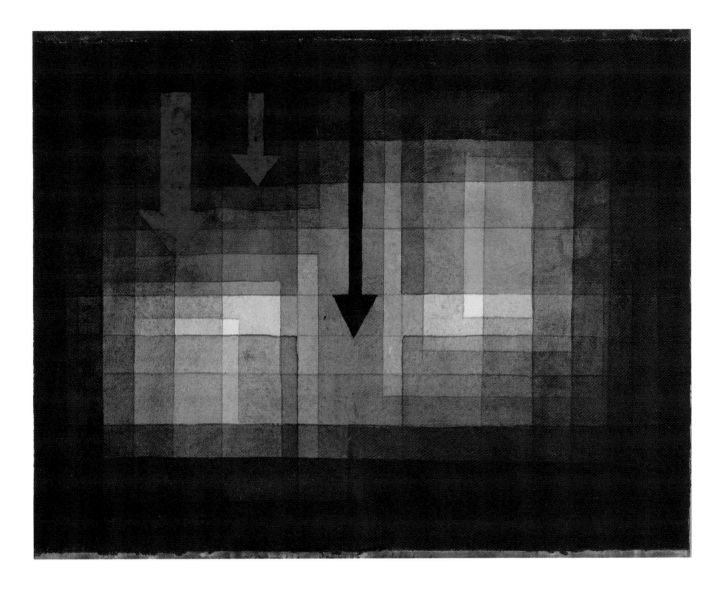

Paul Klee

Swiss, 1879–1940

Sicilian Flora in September (Sizilische Flora im September),
1924
Graphite and watercolor on paper
22.2 x 28.6 cm
(8³/₄ x 11¹/₄ in.)
Bequest of Arthur Heun, 1947.

Fig. 1. Paul Klee, *Collage of Pressed Flowers from Sicily,* 1931, Paul-Klee-Stiftung, Kunstmuseum Bern (photo by Peter Lauri).

1. Paul Klee, "Ways of Studying Nature," as quoted in Richard Verdi, *Klee and Nature* (New York: Rizzoli, 1985), p. 17.

PAUL KLEE was an avid naturalist and collector of zoological and botanical specimens. As a youth, he compiled three zoological notebooks (1895–96), filled with drawings, pasted-in images, and scientific descriptions and classifications. He amassed a large collection of plants and flowers, which he brought home and pressed, as well as natural curiosities which he mounted and labeled. Klee's fascination with the forms of nature continued into his mature, artistic life; his notebooks are filled with cross sections of plants and investigations into the formal relationship between kernel and shell. For Klee, plants—with their blossoms, fruit, leaves, and seed-pods—were deeply enmeshed in the processes of life.

Klee made the workings of the natural world the focus of his 1923 lecture "Ways of Studying Nature," published for the first Bauhaus festival and exhibition. Examining nature intimately was essential to both the learning and teaching process; as Klee propounded in his lecture, "For the artist, dialogue with nature remains a *conditio sine qua non.*"[1] Students were to understand plant and animal forms not as they appeared superficially, but through a dissecting, penetrating vision that would permit the grasping of their essence. This exploration illustrated the botanical principle that the flower was simply a repetition of the plant as a whole, and the entire form could be understood by examining a small piece.

Klee collected exotic specimens during his travels. In the summer of 1924, he spent six weeks in Sicily, where he viewed temples, ruins, and excavations; after his return to Germany, he came to think longingly of the island as pure, abstract landscape. A collage of taped, pressed flowers and unusual leaves he assembled in Sicily, either on this trip or on his second visit in 1931, reveals Klee's continued fascination with the aesthetics of nature in miniature (fig. 1). It is likely that he translated specimens such as these into his 1924 composition *Sicilian Flora in September.* Set against an imaginative rocky landscape, the plant forms of this drawing seem at once the products of careful botanical scrutiny and artistic invention. The blooming yellow and purple flowers and myriad leaf forms attest to the enduring forces of life: growth, sexual attraction and reproduction, and rebirth.

Elizabeth Siegel

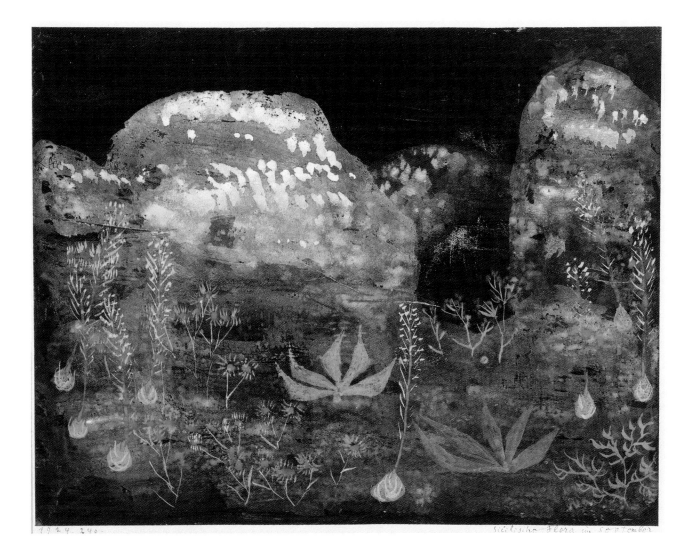

1924. 240. Sicilische Flora im September

Walt Kuhn

American, 1877–1949

Study for Trio,

c. 1937
Graphite and watercolor on
tan wove paper
27.6 x 15.2 cm (10⅞ x 6 in.)
Gift of Helen Harvey Mills,
1995.

Fig. 1. Walt Kuhn, *Trio*, 1937, oil
on canvas, 182.9 x 127 cm (72 x 50
in.), Colorado Springs Fine Arts
Center, Gift of the El Pomar
Foundation.

1. Philip Rhys Adams, *Walt Kuhn,
Painter: His Life and Work*
(Columbus: Ohio State University
Press, 1978), p. 265.

2. Ibid., p. 177.

WALT KUHN is generally associated with the organization of the famous International Exhibition of Modern Art of 1913—as secretary for the Association of American Painters and Sculptors, he was among the artists, including Arthur B. Davies, George Bellows, and William Glackens, who negotiated for the use of the armory of the Sixty-Ninth National Guard Regiment in New York. Kuhn traveled to Chicago for the Art Institute installation later that year and visited again during each of his three exhibitions at The Arts Club, becoming friends with many Club members. In his own work, Kuhn eschewed the experimental, quasi-abstract European styles represented in the Armory Show in favor of a solid realism. He continued to paint still lifes, landscapes, and portraits of people in costume or uniform, such as clowns or wrestlers, until his death in 1949.

The Arts Club's drawing is one of at least three studies for one of Kuhn's largest and most celebrated works, *Trio* (1937, fig. 1), his first successful multifigure composition. In this study, Kuhn depicts the acrobats standing with their arms crossed over their chests, the figure on the left bisected by the edge of the paper. In the final painting, the direction of the acrobats' gazes is altered; the colors of the costumes shift from orange, yellow, orange to a more intense red, white, red; and the three figures are centered on the canvas. Kuhn also eliminated the pointed cap of the central character, emphasizing the similarity of the men's height and proportions. This experimentation with color and composition was typical for Kuhn's working method. For each painting, he made numerous studies, many of which, like The Arts Club's, are cropped, creased, torn, or drawn on both sides of the sheet.

The subjects of *Trio* were professional acrobats, from left to right, Frank Landy, Mario Venendi, and Ben Benson.[1] Kuhn frequently invited performers to pose for him in his New York studio and had a wardrobe of costumes and props from which his subjects could choose. A story often recounted by Kuhn's biographers describes the scene:

> When the three models, who were not a
> working act but were all veteran acrobats,

appeared for the start of the project their physical presence was a bit overpowering. Kuhn admitted that he was disconcerted and unsure of how to begin. Then he asked them what they proposed. Mario Venendi, the center figure, said, "Hup!" and they instantly took the inevitable pose.[2]

Kuhn was attracted to the challenge of painting clowns, acrobats, and showgirls, subjects traditionally charged with saccharine sentimentality. In fact, he drew attention to his sitters' opaque masks of make-up, caricatured costumes, and muscular bodies, while, interestingly, depicting none of the athletic movement that characterized their professions.

Sophia Shaw

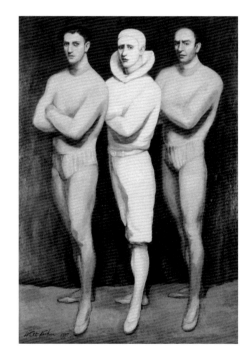

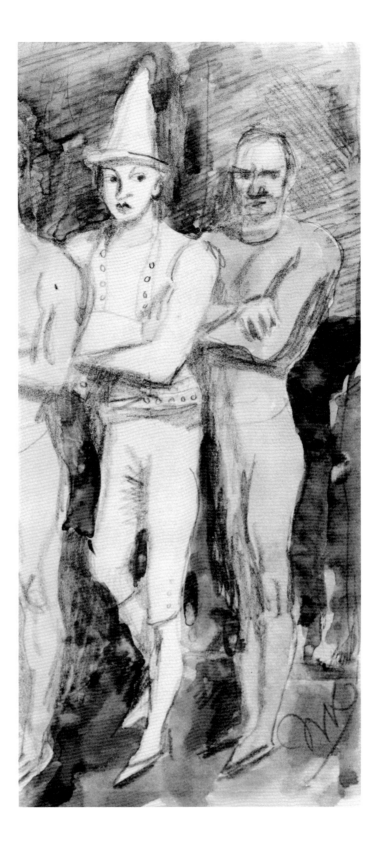

Adone (Antelope Headdress), c. 1920s
Wood painted with white, blue, and reddish pigments
104.1 cm (41 in.)
Gift in memory of Elizabeth Goodspeed Chapman by her friends, 1981.

AFRICANS maintain the relationship between the living and the dead through ritual sacrifices performed in personal or lineage shrines and in public arenas or private homes. These sacrifices honor the dead and renew or strengthen the bond between the two entities. Since ancestors occupy the ontological position between the spirit and the living, they are among the most important instruments used to reach the High God. They are revered because they protect the living from evil and reward goodness. At the same time, many African societies believe that those who do not receive honorable funeral and postburial ceremonies to prepare them for the long and arduous journey to the ancestral world become wandering, homeless, discontented, and evil spirits. These spirits may return to punish their relatives for failing to honor them; their sanctions are manifested by illnesses, fatal or near-fatal accidents, miscarriages, childlessness, infant mortality, poor harvests, and other disasters.

Belief in the afterlife symbolically unites the living and the dead and serves to maintain order. This union is preserved through offerings in the form of sacrifices, prayer, libation, and the erection of ancestral memorials. Elaborate rituals including the sacrifice of live animals at the homes, grave sites, tombs, or shrines of the dead are undertaken to honor or to placate them. Much food and fanfare often accompany these rituals to show the dead how much they are loved. Masks and masquerades donned by those participating in the ceremonies represent ancestors returned from heaven to restore order, stability, and prosperity. Ancestors are memorialized in various forms. Fetishes, twin figures, masks, reliquary figures, stools, shrines, and altars illustrate the interdependent relationship between the human and ancestral world. To the makers and users of African art, these objects constitute a lifesource and a constant reminder that life is an ongoing and continuous process that does not stop with physical death.

The Kurumba of Burkina Faso have developed complex rituals to honor ancestors. Kurumba artists carve a variety of wooden masks, their best known being the antelope headpiece like the one illustrated here. The antelope is a revered totem because it is said to have saved the life of the founding father of the Kurumba, and the masks are often very beautifully decorated in geometric patterns, believed to represent major events in the origin myths of the lineage or clan. Masks are used: 1) when escorting the corpses of male and female elders; 2) at postburial ceremonies honoring the deceased and equipping them to travel to the world of ancestors; and 3) at public ceremonies honoring the spirits of ancestors and clan totems. Kurumba adone masks are traditionally carved to be worn as crests on top of the head; some are made with a visorlike extension to cover the performer's face. Regional and artistic styles are common, but The Arts Club's piece is a classic example of a typical Kurumba antelope mask.

Chapurukha M. Kusimba

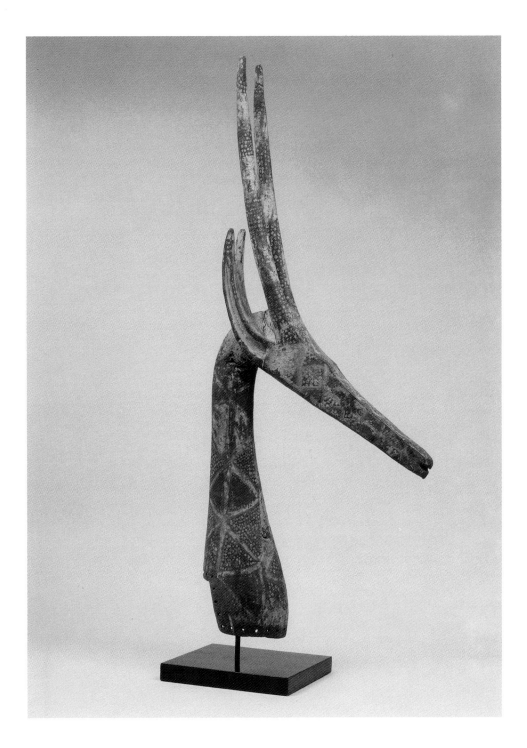

Mikhail Fyodorovich Larionov

French, born Russia, 1881–1964

Costume Design for Karagueuz, 1926/27

Pen and ink and watercolor on paper
31.8 x 21.6 cm
(12¹/₂ x 8¹/₂ in.)
Provenance unknown.

Untitled, c. 1922

Charcoal and watercolor on paper
41.9 x 50.8 cm
(16¹/₂ x 20 in.)
Gift of Theodora Winterbotham Brown in memory of Rue Winterbotham Shaw, 1980.

1. Anthony Parton, *Mikhail Larionov and the Russian Avant-Garde* (Princeton, N.J.: Princeton University Press, 1993), p. 197.

2. See *Mikhail Larionov Designs for the Ballet "The Adventures of Karaguez,"* (Syracuse, N. Y.: Everson Museum of Art, 1978).

3. Correspondence with the author, September 19, 1996.

MIKHAIL LARIONOV prepared this ink-and-watercolor costume design for a ballet adaptation of Julie Sazonova's marionette performance *Karagueuz, Gardien de l'Honneur de Son Ami.* Sazonova was a Russian puppeteer and director of the Marionette Theater of Petrograd, which she had started in 1916. Like Larionov and Natalia Goncharova, she emigrated to France during the Russian Revolution. For her 1924 Christmas program, Sazonova commissioned her two compatriots to design and stage two puppet performances at the Théâtre du Vieux Colombier in Paris, one of which was *Karagueuz.* Larionov wrote the libretto and solicited a Turkish score from Romanian composer Marcel Mihalovîci, while Goncharova designed the stages, curtains, and puppets.

Larionov scholar Anthony Parton describes the plot of *Karagueuz,* which is derived from an ancient Turkish shadow-puppet theater tradition:

> In the Sultan's absence Karagueuz is employed as chaperone to [the Sultan's] wife Zouleika. Karagueuz poses as a lady of the harem but Zouleika exchanges clothes with an odalisque and Karagueuz follows the wrong lady. At night the false Zouleika crosses a bridge in the arms of an officer. To teach her a lesson Karagueuz disguises himself as a dragon but frightens the woman to death. The Sultan returns to charge Karagueuz with Zouleika's death, but she appears and the Sultan learns that she has been the most faithful of his wives.[1]

The Arts Club's drawing is one of Larionov's costume designs for Karagueuz in disguise. Dressed in a full-length cloak and carrying a fan, he veils his face in the traditional Muslim yashmak, leaving only his eyes exposed. Although the puppet show was never performed in Paris, Larionov continued to work on it, and, in 1926, Adolph Bolm, a choreographer with the Chicago Allied Arts Company, agreed to stage a four-act ballet version the following March, *The Adventures of Karagueuz.* The Arts Club drawing numbers among a group of at least twenty-six other known costume and stage designs for *Karagueuz* now in the Adolph Bolm Collection of Ballet Designs, Syracuse University Art Collection, New York.[2] Bolm may have originally brought the drawings to Chicago to help raise support for his ballet production, which nevertheless had to be canceled when the company closed in December. The image was later editioned as a lithograph of identical dimensions, *Karagueuz Disguised as a Lady of the Harem,* published in the folio *Voyage en Turquie* (c. 1928), and was also included in the cover design for a 1930 edition of Mihalovîci's original score.

Larionov probably gave The Arts Club's untitled still life to Rue Winterbotham Carpenter on one of her periodic trips to Paris. Though similar to several other still lifes Larionov prepared in watercolor, charcoal, and graphite, the work is unique in that it is dated. Since the sheet is signed twice, however, it seems more likely that the inscribed "3-V-22" records the occasion Larionov presented the drawing to Carpenter rather than the day he painted it. Much of Larionov's work after World War I was executed in watercolor—a preference, according to Parton, that may have stemmed from injuries the artist sustained in the war and his inability to concentrate for extensive periods on oil compositions.[3]

Sophia Shaw

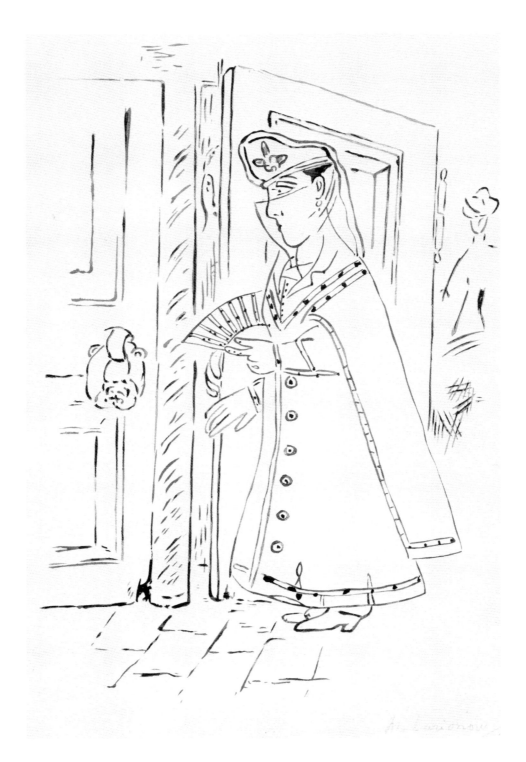

Louis Marcoussis

French, born Poland, 1883–1941

*Gertrude Stein and
Alice B. Toklas,* 1934
Etching
47 x 34.3 cm
(18½ x 13½ in.)
Arthur Heun Memorial
Purchase Fund, 1957.

Gertrude Stein, 1934
Drypoint and burin (9th
and final state)
37.5 x 27.9 cm (14¾ x 11 in.)
Gift of Alice Roullier, 1957.

A CHARTER member of the group of cubist painters who (unlike their predecessors Braque and Picasso) gathered together to exhibit publicly beginning in 1912, Louis Marcoussis was also an adept print-maker. Cubist portraits and cafe still lifes dominated his printmaking activity through the early 1920s; by the end of the decade, however, Marcoussis fol-lowed many of his colleagues in the Parisian avant garde in a *rappel à l'ordre,* or return to tradition, abandoning the formal disjunctions of Cubism in favor of a new stylistic simplicity.

Marcoussis maintained close friendships with writers and poets such as Max Jacob, Guillaume Apollinaire, André Salmon, and Paul Eluard throughout his career. In 1934, he paid homage to Gertrude Stein, the émigré American poet and pio-neering art collector, in three prints that featured the likenesses of Stein and her companion Alice Toklas. Stein's just-published memoir, *The Auto-biography of Alice B. Toklas,* captured for the author worldwide attention and unexpected fame. Capi-talizing on the success of the book, Stein and Toklas traveled to the United States for the first time in thirty years for a well-publicized lecture tour dur-ing the winter and spring of 1934–35. Stein's arrival in Chicago coincided with the local debut of the opera on which she and Virgil Thomson had col-laborated, *Four Saints in Three Acts,* with sets and costumes designed by Florine Stettheimer. Staying at the home of Mrs. Charles Goodspeed, Stein lectured at The Arts Club, and accepted University of Chicago president Robert Maynard Hutchins' challenge to return later in the month to conduct a Great Books seminar.

Various states and impressions Marcoussis's portraits of Stein and Toklas were shown at The Arts Club in the fall of 1934 in an exhibition of eighty-eight of his prints. Rendered in a purified, neoclassical style, Stein's profile, especially in the double portrait, assumes the character of a Roman republican poet or sage. Indeed, in the third print of the series, in which the plate for the double por-trait was recut, Marcoussis added a crown of lau-rels to Stein's great head.

Daniel Schulman

72

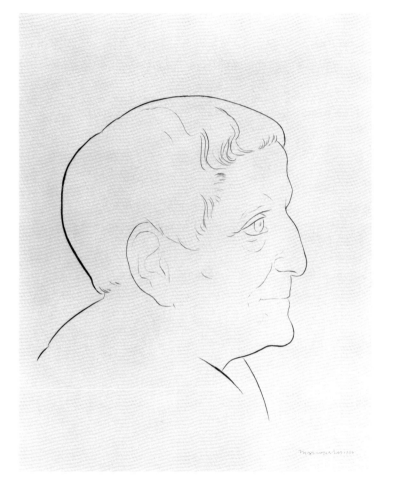

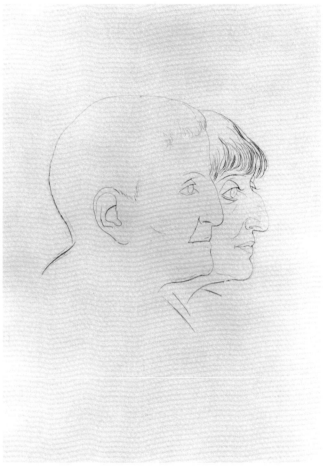

Henri Matisse

French, born Russia, 1869–1954

Untitled, c. 1922
Charcoal on ivory laid paper
45.7 x 59.7 cm
(18 x 23¹/₂ in.)
Bequest of Arthur Heun,
1947.

KNOWN for the vibrant color and loose brushstroke of the fauvist painting he helped innovate, Henri Matisse was also a prolific draftsman. He learned to draw as a traditional prerequisite to painting, but his later works on paper were seldom actual studies for paintings; instead, they stood as aesthetic statements in their own right, explorations of line and shading. For Matisse, drawing was a process of remembering, of capturing a gesture as it happened. Direct and immediate, drawing could best transmit the artist's emotion to the viewer:

> I have never considered drawing as an exercise of particular dexterity, rather as principally a means of expressing intimate feelings and describing states of mind, but a means deliberately simplified so as to give simplicity and spontaneity to the expression which should speak without clumsiness, directly to the mind of the spectator.[1]

The spontaneous marks in his sketches were also rigorous tools of composition, giving structure to a painting or allowing a drawing to take shape with only the most necessary lines.

The Arts Club's drawing was probably executed while Matisse was in Nice, where, beginning in 1921, he would spend part of every year. Intrigued by the effects of Mediterranean light, Matisse began to focus on tonal values instead of color, producing a large number of charcoal drawings. During his Nice period, Matisse turned to the female figure as a consistent theme, drawing exotically costumed women in decorated interiors. The medium of charcoal, which he used extensively between 1922 and 1924, allowed him to concentrate on both the expression of the model and the tonal qualities of the surrounding light and atmosphere without the distractions of color.

This particular drawing differs from Matisse's other figure studies of the period in its simplicity, with the model and background suggested by a minimum of line and shading. Matisse sought to imbue the female body with formal elegance, while "condens[ing] the meaning of this body by seeking its essential lines."[2] These essential lines trace a pose that Matisse would explore in later work: with her right arm crooked, hand at her head, and left hip thrust out, this reclining nude prefigures those seen in such works as *Pink Nude* of 1935 (Baltimore Museum of Art). The Arts Club drawing reveals not only a clarified gesture recorded in charcoal, but also Matisse's continual fascination with the aesthetic possibilities he discovered in the contours of women.

Elizabeth Siegel

1. Henri Matisse, cited in Jack D. Flam, ed., *Matisse on Art* (Los Angeles: University of California Press, 1995), p. 81.

2. Ibid., p. 36.

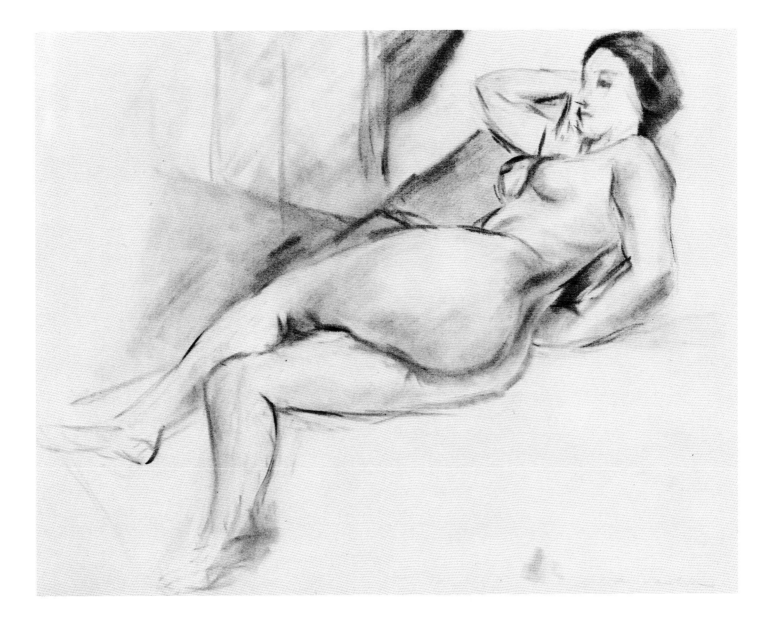

Ludwig Mies van der Rohe

German, 1886–1969

Main Staircase for
The Arts Club of
Chicago, 1948–51
Steel, travertine marble
359.4 x 458.8 x 609.3 cm
(141$\frac{1}{2}$ x 180$\frac{5}{8}$ x 239$\frac{7}{8}$ in.)
Arts Club commission,
1948–51.

THE celebrated staircase of The Arts Club did not spring *ex nihilo* from Mies van der Rohe's brain. Its formative route took more than several turns, following a path typical of the architect's famous habit of endlessly working and reworking an idea. It was not until 1989, when a full study of the thousands of drawings in the Mies Archive of the Museum of Modern Art was completed, that the two hundred sheets representing The Arts Club were subjected to serious examination. Among their most revealing disclosures was a plan for an independent, one-story structure with no need of a staircase (fig. 1). Since the Club's space had been secured in an already existing structure, it is virtually certain that such a project was purely theoretical. Even so, Mies worried at length over it, and over the two-story plan that was eventually constructed.

The latter reveals several concepts of the stair, laid down in varying places and configurations. The final siting, on the north side of the building, was elected only after several efforts were made to situate it near or along the south elevation. Some drawings show it with 90-degree turns or none at all, as distinct from the form it finally took, which features 180-degree turns at two landings. There is little evidence in the drawings of the labor expended on the angles, dimensions, and proportions of the stair, although it seems safe to assume that Mies was as mindful of those problems as of all the others he explored in designing the remainder of the interior.

Once constructed, the stair became the single most memorable component of The Arts Club space. Not only was it visible from the street, but its disarmingly elegant simplicity together with the patrician character of its materials—stringers and railings painted white, treads carpeted in black, the enclosing foyer clad in travertine of the highest order—gave it place among the handsomest passages in the architect's catalogue.

The stair was saved by The Arts Club following the razing of the old space at 109 East Ontario Street. A committee composed of Art Institute Director James N. Wood, former Graham Foundation Director Carter H. Manny, Jr., and the late architect Myron Goldsmith, was later empowered to choose an architect for the Club's new home. After John Vinci was selected, he decided to incorporate the stair in his design, and recessed it from the street so that visitors would reach it only after passing through the exhibition gallery. While the stair is literally the same steel as the old one, much of the original travertine was lost in the demolition process. Vinci made a special trip to quarries in Italy to secure replacements of comparable quality.

Franz Schulze

Fig. 1. Ludwig Mies van der Rohe, *The Arts Club of Chicago,* floor plan, 1948–51, pencil, colored pencil (red) on paper, 47 x 79.3 cm (18$\frac{1}{2}$ x 31$\frac{1}{4}$ in.), Mies van der Rohe Archive, The Museum of Modern Art, New York, gift of the architect.

109 East Ontario Street, photo by Robert McCullough.

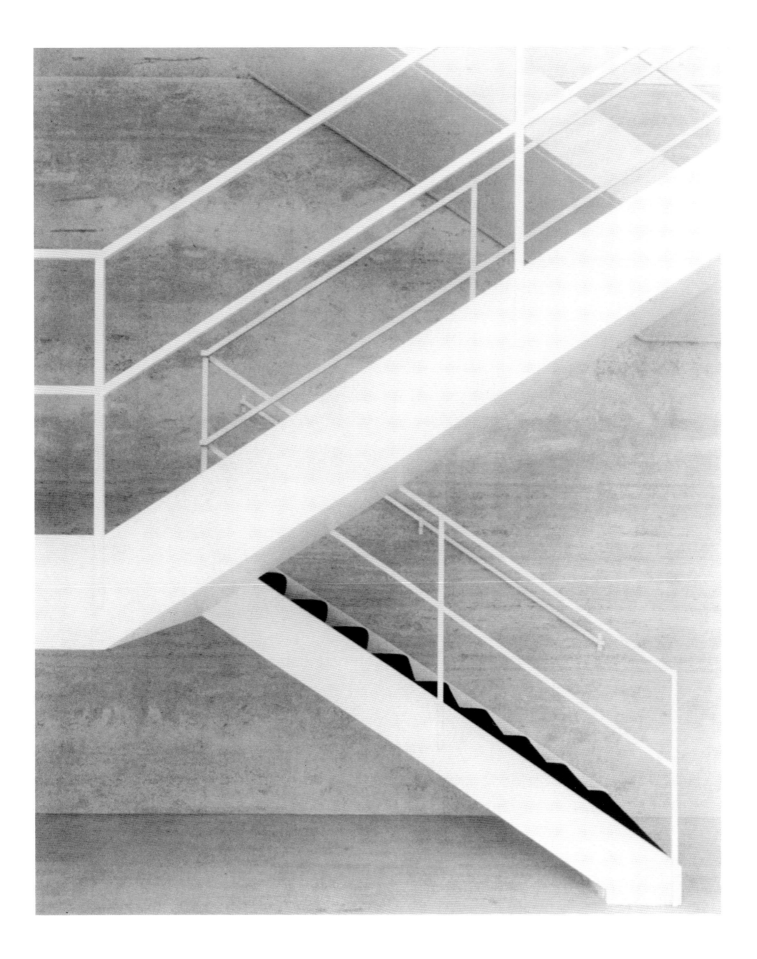

Joan Miró

Spanish, 1893–1983

Personage and Birds in Front of the Sun (Personnage et oiseaux devant le soleil), 1942
Ink and gouache on paper
47 x 64.1 cm
(18½ x 25¼ in.)
Friends of Alice Roullier and Arts Club Purchase Fund, April 1965.

1. Joan Miró, cited in Margit Rowell, ed., *Joan Miró: Selected Writings and Interviews,* trans. Paul Auster and Patricia Matthews (Boston: G. K. Hall, 1986), p. 166. The quotation in the following paragraph is from ibid., p. 207.

A NATIVE of Catalonia, Joan Miró spent many years in Paris, where he took part in surrealist exhibitions and developed the automatic techniques he would employ throughout his career. With highly symbolic and suggestive forms, Miró depicted the edges of a dream world accessible only through artistic exploration.

In July of 1936, the Spanish Civil War broke out, followed by World War II in 1939. Devastated by the tragedy of war, Miró tried through his art to escape and transcend it. In 1939, he formulated his position as an artist in wartime: "The forms expressed by an individual who is part of society must reveal the movement of a soul trying to escape the reality of the present, which is particularly ignoble today, in order to approach new realities, to offer other men the possibility of rising above the present."[1] Forced to flee their home in Normandy by the advance of German troops in 1940, Miró and his family returned to Spain and settled in Palma de Mallorca, where they remained for two years. In near solitude, Miró industriously continued work on his *Constellations,* a series of twenty-three gouaches begun the previous year, inspired by the transcendent qualities of stars, music, and the night.

In the *Constellations,* Miró took up themes that would recur in future work, incorporating into his heavens schematic forms signifying women and birds. The shapes would occur spontaneously, even accidentally, as Miró worked—once during this period he used spilled blackberry jam as a jumping off point for his composition. Though not immediately recognizable, these forms were never without a referent, as Miró explained in a 1948 interview: "For me a form is never something abstract; it is always a sign of something. It is always a man, a bird, or something else. For me painting is never form for form's sake."

This gouache drawing was executed in Barcelona in October 1942, a year in which Miró painted and drew exclusively on paper (he resumed painting on canvas in 1944). Miró returned to his recurrent motifs of women, birds, and stars, substituting here, as he often did, a more generic personage for the woman and the sun for the star, and distilling the shapes he had earlier explored into a few solid, elemental forms. Eliminating shading altogether and limiting his palette to green, black, red, and yellow, he simplified his composition to represent a glimpse of an ideal world, far from the grim realities of war.

Elizabeth Siegel

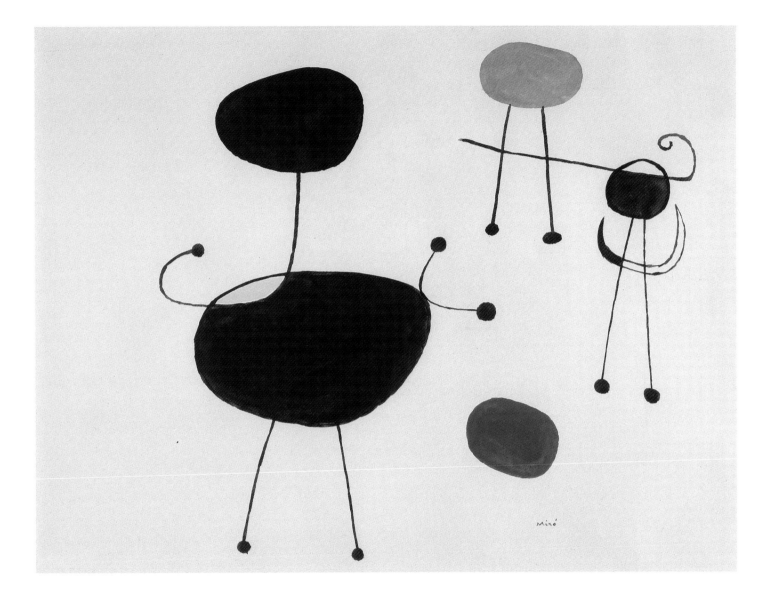

Henry Moore
British, 1898–1986

Two Standing Figures, 1949
Silkscreen on linen mounted on panel
264.2 x 182.9 cm
(104 x 72 in.)
Gift of Ann and Everett C. McNear, 1963.

HAVING endeared himself to his compatriots with his sympathetic drawings of civilians sheltering in underground train tunnels during the German bombing of London, Henry Moore proceeded to establish himself as the pre-eminent British post-war sculptor, producing major public works throughout Britain and, later, internationally. Like many artists of the early twentieth century, Moore was greatly influenced by non-Western art, in particular Aztec and Toltec sculpture and East African masks. The other significant influence on his work was Picasso—in particular the Spanish artist's similarly African-influenced "bone drawings" of the late 1920s.

Moore developed these drawings into three-dimensional forms whose rounded, hollowed bodies echoed the gently rolling landscapes for which they were envisioned. *Two Standing Figures* repre-sents a development of these generally female figures. Moore was a prolific draughstman, producing numerous studies for possible sculptures and re-working designs for different locations, but the silkscreen medium of this work makes it quite unusual. The image bears a strong resemblance to a sculpture in London's Battersea Park, *Three Standing Figures*, from 1947–48. Both works represent closely grouped figures of similar height and form, standing on a circular base. The upright figures are a departure from Moore's typically reclining female forms, whose undulant contours reflect the artist's ideal of the earth goddess/mother; they were most probably produced to work with an attribute of the landscape while referencing the Three Graces motif.

Jessica Morgan

Figures (Minoans),
1982
Watercolor on paper
38.1 x 48.3 cm (15 x 19 in.)
Arts Club Purchase Fund,
1996.

MALCOLM MORLEY, who was born in London but has lived in the United States since 1958, uses watercolor to record places and events when he takes a trip or is on vacation, somewhat in the tradition of Victorian travelers and amateur artists. Often small, the watercolors are made on the spot, usually with great speed, reflecting the precise place and time of day. They act as a notebook of ideas and memories of especially significant subjects. Morley has characteristically taken the watercolors back to the studio where they become the subjects for his larger paintings and where several subjects may be combined and co-exist in the same large painting.

Figures (Minoans) was painted from a case of objects in the archaeological museum at Heraklion, Crete. It is one of several watercolors of sculptures made by Morley on this 1982 visit to Greece. The artist remembers being harassed by the museum's guards when he made this work; he realized later that it was customary to offer bribes to enable peaceful progress of such study.[1] Morley painted the series of watercolors because of his great interest in Greek civilization, and the beauty and hieratic forms of the ancient objects.

Morley incorporated this painting and several other subjects in what he now calls the "Greek" pictures of the 1980s. The bull figures appear for example in *Albatross* (1985, formerly Gerald S. Elliott collection, Chicago) and in *Cradle of Civilization with American Woman* (1982, Musée National d'Art Moderne, Paris), alongside a torso, a portrait bust, and the profile form of a helmet.

Richard Francis

1. Malcolm Morley in conversation
with the author, August 1996.

Louise Nevelson
American, born Russia, 1899–1988

Untitled, 1966
Photo-screenprints on
paper, orthochromatic film
positives, cut and taped on
ivory 2-ply rag board
66 x 50.8 cm (26 x 20 in.)
Gift of the artist and Pace
Gallery, New York, 1968.

1. Jean Lipman, *Nevelson's World*
(New York: Hudson Hills Press in
association with the Whitney
Museum of American Art, 1983),
p. 179.

2. Hilton Kramer, "The Sculpture
of Louise Nevelson," *Arts* 32 (June
1958): 26–29.

3. Quoted in Lipman, *Nevelson's
World,* p. 182.

KNOWN principally as one of the foremost sculptors of the twentieth century, Louise Nevelson also produced a noteworthy body of works on paper—drawings, prints, and collages. Indeed, the artist asserted that drawing informed all her work, and that collage was her way of thinking.[1] Collage is the two-dimensional medium that most approximates Nevelson's signature working method in sculpture.

In the late 1950s, Nevelson began to accumulate found wood objects, which she used to create her now-famous monumental painted black assemblages, the earliest of which she called *Sky Cathedrals*. Writing in 1958, Hilton Kramer noted that these sculptures "violate our received ideas on the limits of sculpture [and] seem to promise something entirely new in the realm of architectural sculpture by…postulating a sculptural architecture."[2] This last observation is relevant to a discussion of The Art's Club's collage for two reasons. First, *Untitled* is composed of a group of overlaid, photographically reproduced fragments of one of Nevelson's important early "Walls," *Homage to 6,000,000 I* (1964), created as a memorial to the victims of the Holocaust (fig. 1). In the collage, she arranged these fragments—rotating the orientation of the sculpture ninety degrees, counterclockwise—in a manner that suggests the soaring verticality of the architecture that chokes the Manhattan skyline. Secondly, the "Walls" were conceived as enormous, room-filling installations that significantly altered the viewers' conception of freestanding sculpture. In this respect, Nevelson's "Walls" may relate to her awareness of Kurt Schwitters' 1923 Hanover *Merzbau*. Similarly, *Untitled* derives much of its

visual punch from the artist's manipulation of scale through image, format, and cropping.

Although *Untitled* obtains its imagery from a sculpture, it is contemporaneous to the twelve screenprints in Nevelson's *Facade Portfolio* (1966). Like *Untitled*, the prints were made from collaged photographic reproductions of earlier sculptures, and it is possible that *Untitled* (whose dimensions are very close to the prints' sheet size) was created as a model for a work to be included in the portfolio. However, each image in *Facade*—an homage to Edith Sitwell—bears the title of a Sitwell poem, while The Arts Club's collage remains untitled. The portfolio prints evoke relief or pop-up sculpture, the images virtually jumping off of their grounds; by comparison, *Untitled* is resolutely flat. And while the portfolio prints are as animated and whimsical as Sitwell's poems, *Untitled*, though dynamic in its overlapping planes of transparent and opaque elements, is devoid of whimsy. Although it is not clear that Nevelson intended it, one might be tempted to offer as solemn a reading of the collage as is suggested by the sculpture it reproduces.

Nevelson frequently reused the same ideas and materials, motifs and techniques, each time revising and revitalizing them. Of this process, the artist stated, "I don't let anything escape from me. You don't throw out a thing, you just reorient it."[3] *Untitled* occupies a position central to this line of thinking, and thus is simply, yet powerfully, a manifestation of the artist's penchant for recycling her images, and a testament to preservation and renewal.

Mark Pascale

Fig. 1. Louise Nevelson, *Homage to 6,000,000 I,* 1964, sixty pieces of wood with black paint, 274 x 548.6 x 25.4 cm (107 7/8 x 216 x 10 in.), courtesy PaceWildenstein, New York (photo by Randy Batista).

Isamu Noguchi
American, 1904–1988

*Portrait of Marion
Greenwood,* 1929
Graphite on paper
42.2 x 26.7 cm
(16 ⁵/₈ x 10 ¹/₂ in.)
Gift of the artist, 1930.

Isamu Noguchi 1929

Fig. 1. Isamu Noguchi, *Marion
Greenwood,* 1929, cast iron, 41.9
cm (16¹/₂ in.), Isamu Noguchi
Foundation, New York.

1. Isamu Noguchi, "Guggenheim
Proposal," in Diane Apostolos
Cappadona and Bruce Altshuler,
eds., *Isamu Noguchi: Essays and
Conversations* (New York: Harry N.
Abrams, 1994), p. 16.

2. Isamu Noguchi, *A Sculptor's
World* (New York: Harper and Row,
1968), p. 19.

BORN to the Japanese poet Yone Noguchi and American writer Leonie Gilmour, Isamu Noguchi spent his childhood in Japan and his adolescence in the United States. After academic training as a sculptor in New York, Noguchi applied for a Guggenheim grant in 1926 for study in Paris and, seeking to "view nature through nature's eyes," the Far East.[1] He arrived in Paris in the spring of 1927 and worked as a studio assistant for Constantin Brancusi, learning under the latter's direction to carve directly in wood and stone. From Brancusi Noguchi also acquired a reverence for the intrinsic qualities of natural materials and for the tools used to shape them, and began a lifelong engagement with abstracted, three-dimensional form.

When his grant was not renewed at the end of 1928, Noguchi returned to New York, where he turned to portraiture for subsistence. He sculpted busts in clay, five at a time, of wealthy sitters as well as artists and intellectuals such as Berenice Abbott, Buckminster Fuller, George Gershwin, and Martha Graham. The challenge of portraiture for Noguchi, he later wrote, lay in "the confluence of personality and sculpture, where the concentration of charac-

teristics and identity, of sensibility and type, of style, even, belonged…more to the sitter or his race, than to the sculptor. Or if to the sculptor only as the medium of expression, limited in form, as is a sonnet."[2] Attentive to these problems, Noguchi made twenty-four portrait heads in 1929; the following year, he and Fuller drove to Chicago with sixteen of them loaded in Fuller's station wagon for an exhibition at The Arts Club.

While Noguchi's drawings functioned independently from his sculpture, it was not unusual for him to make sketches before executing his three-dimensional work. This drawing of the painter Marion Greenwood is most likely a sketch for the 1929 cast-iron portrait Noguchi made of her in New York and exhibited at The Arts Club in 1930 (fig. 1). Also living in Paris in 1928, Greenwood attended classes at the Académie de la Grande Chaumière, where Noguchi often went in the afternoons to draw. She spent the early 1930s in Mexico, where she painted murals, including one alongside Noguchi. Upon her return to the United States in 1936, Greenwood joined the WPA's Federal Art Project and later became a teacher. This portrait, tempered by the simplicity Noguchi had learned from Brancusi, depicts a woman of both contemplation and determination. Using his charcoal like a chisel, Noguchi allowed the figure to emerge from the paper, providing enough information of features and expression to sculpt his own interpretation.

Elizabeth Siegel

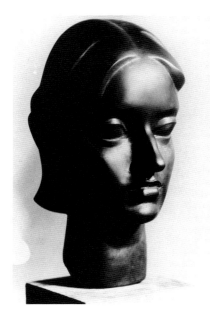

ISAMU NOGUCHI sought consciously to fuse his Eastern and Western heritages in his sculpture and drawing; along with his encounters with the Modernism of New York and Paris, his experience of Asian traditions, especially the Japanese house and garden, would influence projects for years to come. By 1930, Noguchi had raised enough money from his sculpted portraits to travel to China and Japan. He arrived in Beijing in the summer of that year, having journeyed from Paris through Moscow on the Trans-Siberian Railroad, and remained there for seven months.

Under the tutelage of the seventy-year-old master Qi Baishi, Noguchi learned Chinese brush-and-ink painting, producing about one hundred figure studies in this manner. "I made enormous drawings with fantastic brushes and expressionist flourishes upon their incredibly beautiful paper," Noguchi recalled. "I did figure drawings, because that was what I knew how to do."[1] His images were of local models, including children, young men, and couples. While some drawings, like this one of a Buddhist monk, are composed of delicate contour lines, others display ink washes and thick calligraphic brushstrokes.

Although Noguchi had produced a series of abstract, black-and-white gouaches in Paris in 1927, many of which were related to his sculptures, the China drawings represented his first foray into traditional Asian techniques. Along with the Paris abstractions, these brush drawings constituted the only large group of drawings Noguchi intended for the public, and fifteen of the Beijing works, including this one, were exhibited at The Arts Club in March of 1932. Noguchi employed a Chinese approach to the presentation of his drawing, mounting it, probably in China, on a hanging scroll. Unlike his portrait sketches, these figure studies stand independent of Noguchi's sculpture. Here, the sparse elegance of line, not shading, is the important instrument of investigation. Noguchi's concentration on distinctly Asian subject matter—the Buddhist monk with shaved head and loose robes—indicates his enduring fascination with that part of his own heritage rooted deeply in Eastern traditions.

Elizabeth Siegel

Untitled, 1930
Black crayon on paper
mounted to masonite
177.8 x 91.4 cm (70 x 36 in.)
Arts Club Purchase Fund,
1932.

1. Isamu Noguchi, *A Sculptor's World* (New York: Harper and Row, 1968), p. 20.

Francis Picabia

French, 1879–1953

This Thing Is Made to Perpetuate My Memory (Cette Chose est faite pour perpétuer mon souvenir), 1915
Ink, gouache or watercolor, and silver and bronze paint on board
99 x 101.6 cm (39 x 40 in.)
Arthur Heun Memorial Purchase Fund, 1955.

"Almost immediately upon coming to America it flashed on me that the genius of the modern world is machinery," Francis Picabia declared to a journalist on arriving in New York for his second visit in 1915.[1] Picabia's machine-pictures of 1913 to 1923, of which *This Thing Is Made to Perpetuate My Memory* is a prime example, bear him out. One of the two principal trans-Atlantic links between New York Dada and its continental European mentors —Marcel Duchamp was the other—Picabia counts among Modernism's most eclectic and intellectually perverse exponents, and because of that has become one of Postmodernism's guiding spirits in recent decades.

The version of the engine-driven brave new world that Picabia offers in this work is typically cryptic and disconcerting. It is a far cry from the bright dynamos of his cubist contemporary Fernand Léger, or from the monumental gears and levers of Russian Constructivists such as Vladimir Tatlin, Alexander Rodchenko, and Alexandra Exter, who laid claim to such imagery in the name of revolution. Taking the picture's title into account, we are a long way too from Marcel Proust's mnemonic *madeleine,* the plain French cookie that prompted that author's multivolume novel of reverie and recollection.

Thoughts of the past presented in a futurist style appeared before in Picabia's work, most notably in a large-scale painting of 1914, *I See Again in Memory My Dear Udnie,* exhibited the following year at Alfred Steiglitz's Gallery 291 in New York, and now in the collection of the Museum of Modern Art. Turbulent and airless, the canvas is animated by flesh-toned shapes rudely coupling with gray, quasi-mechanical variations of the same organic forms. (To contemporary Sci-Fi-literate generations accustomed to the idea of "bionic" hybrids of sinew and metal, the premise of this painting may no longer seem shocking, but Picabia's depiction retains an undiminished violence and unpleasantness.) *This Thing Is Made to Perpetuate My Memory* has, by contrast, an almost classical aspect. Flat, essentially symmetrical in design with four circular elements linked and bracketed by linear tubing, it holds the hermetic fascination of an antique emblem rephrased in the idiom of the industrial age. In all probability based on schematic engineering plans, like many similar works, it is, in effect, a graphic readymade, akin to Duchamp's appropriated-object sculptures of the period.

The text inscribed above this abstract configuration defies the viewer to make sense of the enigma: "This thing is made to perpetuate my memory /Read/ It is clear as day/ They turn/ You have ears, and you will not listen." It helps to know, however, that in Picabia's parallel universe, the machine as archetype is inherently feminine. The creation of men, it is, he claimed, a "daughter born without a mother." Also important is the artist's infatuation with speed—during his lifetime Picabia was the owner of no fewer than 127 cars—and the erotic significance that he, like his worldly dada confederate Duchamp, attached to otherwise inexplicable mechanisms of their own devising. With these clues, the opaque frontality of the images begins to give way to possible, although ultimately ambiguous, meanings: sentiments as systems; sex as a coolly played game in which sterile control replaces reciprocity and possession; memory as a perpetual-motion device working backward in time. The irony of Picabia's metaphorical equation includes the element of sound, since the noisy turbines of memory—"They turn/ You have ears, and you will not listen"—are static, pictorial, and inaudible. Absent the dreamlike qualities of illusionistic Surrealism in its classic form of the late 1920s and 1930s, Picabia's dada vision of 1915 is if anything stranger, a technical illustration of solipsistic desire and a grotesque visual pun on the elegiac "remembrance of things past."

Robert Storr

1. Francis Picabia quoted in "French Artists Spur On American Art," *New York Tribune,* October 24, 1915. For the context of this interview, see William A. Camfield, "The Machinist Style of Francis Picabia," *Art Bulletin* 48:3–4 (September–December 1966): 309.

Pablo Picasso

Spanish, 1881–1973

Mother Combing Her Hair (La Toilette de la mère), printed in 1913 from a zinc plate of 1905
Etching
24.1 x 19.1 cm
(9 1/2 x 7 1/2 in.)
Gift of Mrs. Clarence J. Bulliet and L. J. Bulliet, in memory of Clarence Joseph Bulliet, 1955.

1. Guillaume Apollinaire, trans. and quoted in Harry E. Buckley, *Guillaume Apollinaire as an Art Critic* (Ann Arbor, Mich.: UMI Research Press, 1981), p. 149.

MOTHER COMBING HER HAIR is from of a group of thirteen prints made in 1905 that are closely related to Picasso's rose-period masterpiece of the same year, the *Family of Saltimbanques* (National Gallery of Art, Washington, D.C.). Although few impressions of these prints were pulled at the time of their execution, in 1913 they were published by Picasso's dealer Ambroise Vollard under the title *Les Saltimbanques.* The Arts Club example is from this edition.

Picasso's identification and life-long fascination with itinerant performers and commedia dell'arte characters first surfaced in his blue-period works of 1901. In *Mother Combing Her Hair,* the impulsive and clever trickster, Harlequin, is shown backstage with a child in his arms, watching a nude woman—presumably his real-life Columbine—regarding her image in a mirror as she combs her luxuriant tresses. His stage antics and magic are stilled before the powerful self-absorption of this beautiful model. Picasso's poet friend Guillaume Apollinaire shared the artist's enthusiasm for the metaphorical possibilities of the saltimbanque theme. When Picasso exhibited a watercolor rendering of the same figures in 1905, Apollinaire responded with this description: "In a square room, paternity transfigures the harlequin, while his wife bathes herself with cold water and admires her figure, as frail and slim as her husband, the puppet...."[1]

Daniel Schulman

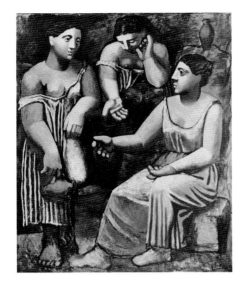

DELICATE yet monumental, *Head of a Woman,* Pablo Picasso's red and black chalk drawing of 1922, is a work of resonant beauty and historical significance (illus. p. 91). It exemplifies the full flowering of the artist's Neoclassicism, the style he had been exploring concurrently with—and in counterpoint to—his ongoing investigation of Cubism. The drawing is one of a series of large-scale works on paper of similar subject and medium that Picasso developed in the months after completing his ambitious *Three Women at the Spring* (fig. 1). Painted at Fontainebleau during the summer of 1921, this canvas marked the culmination of his recent experimentation with classical idioms. Its subject underscores the artist's active engagement with art history: it is the time-honored French theme "La Source," the iconography of women at a spring issuing from a subterranean origin signifying the "source" of artistic inspiration and the stream of artistic accomplishment that feeds it. Picasso thus evokes the French classical tradition represented by Jean-Auguste-Dominique Ingres, whose own *La Source* (1856), enshrined in the Louvre, exemplified the balance, clarity, order, and sparing use of line and color that were the hallmarks of the neoclassical style in the early nineteenth century.

Ingres had indeed been the source of Picasso's classicism as it emerged during World War I, in portraits shocking to those who regarded his pioneering cubist style as striking a mortal blow to the traditional order Ingres embodied. Picasso's embrace of tradition has been explained as a reaction to the war and the chaos engulfing Europe. Similarly, the subsequent blossoming of the artist's classical

vision has been linked to events in his personal and professional life: his visit to Italy in 1917; his marriage the following year to Russian ballerina Olga Khokhlova that brought with it an unprecedented domesticity and a life in fashionable society; his alliance with Paul Rosenberg, a dealer specializing in the works of the Impressionists and Postimpressionists; and, finally, Olga's pregnancy and the birth of their son Paulo early in 1921.

If Picasso's Cubism marked a break with the past, his Neoclassicism insisted on its continuity. Increasingly, he put his neoclassical style in the service of defining his position within the history of art. Accordingly, his vision of classicism broadened out, reaching back to the Renaissance and to truly classical sources including Greek sculpture and Pompeian frescoes. Wide-ranging and in constant evolution, Picasso's style also drew upon more recent practitioners of the classical tradition, including muralist Puvis de Chavannes, sculptor Aristide Maillol, and—as Picasso explicitly acknowledged in the catalogue to a 1919 exhibition of his neoclassical drawings—Pierre-Auguste Renoir. Indeed, Picasso so admired the Impressionist's late-career, classicizing paintings featuring robust, larger-than-life female nudes that during the 1910s and early twenties, he acquired a group of them for his own collection.[1]

Variously described as "giant" and "elephantine," the female figures that inhabit some of Picasso's most ambitious works of 1921—including the enormous goddesses depicted in *Three Women at the Spring*—find their sources in both art history and the artist's life; with their swollen forms, associated with archaic stone sculpture and Olga's pregnancy, they seem to embody their own gestation, as if bloated by the many influences that have fed their creation. The Arts Club's *Head of a Woman* descends directly from this remarkable sisterhood. Yet, the drawing already exhibits significant differences from the generic "portraits" that inaugurated the series of pastel heads produced in the immediate aftermath of the large painting.

The drawings of 1921, though realized in a medium whose perceived fragility had fostered long-standing associations with the evanescence of youthful beauty, appear, as William Rubin has observed, almost to be carved from tinted stone.[2] Insistently sculptural, weighty like the painted figures from which they derive, these heads seem

Fig. 1. *Three Women at the Spring,* Summer 1921. Oil on canvas. 203.9 x 174 cm (80 1/4 x 68 1/2 in.). The Museum of Modern Art, New York. Gift of Mr. and Mrs. Allan D. Emil.

1. On this question and the larger issue of Picasso's Neoclassicism as it pertains to The Arts Club drawing, see William Rubin, ed., *Picasso and Portraiture* (New York: Museum of Modern Art, 1996), especially the essays by Rubin, "Reflections on Picasso and Portraiture," pp. 12–109, and Michael Fitzgerald, "Neoclassicism and Olga Khokhlova," pp. 296–335.

2. Rubin, "Reflections on Picasso," p. 44.

Pablo Picasso

Head of a Woman
(Tête de femme), 1922
Red and black chalk with
chalk wash on tan laid
paper, laid down on light-
weight Japanese paper
62.1 x 48.2 cm
(24⁷/₁₆ x 19 in.)
Arts Club Purchase Fund,
1923.

3. Ibid., p. 47. For the general dis-
cussion of Olga/Sara, see pp. 44ff.

4. I am indebted to John Richardson
for this suggestion. Dance impresario
Serge Diaghilev evidently included
among his friends, beginning in the
1890s, Prince Vladimir Argutinsky-
Dolgorukov, a "diplomat and collec-
tor of beautiful objects." It requires
further research to determine whether
this figure is to be connected with
the W. Argotinsky who helped
organize the The Arts Club exhibi-
tion. See Richard Buckle, *Diaghilev*
(London: Weidenfeld and Nicolson,
1978), pp. 30, 128, 326.

5. Letter from W. Argotinsky to
Robert Harshe, Paris, January 19,
1923, Arts Club archives at the
Newberry Library. Argotinsky noted
"Picasso wants all his drawings not
to be framed, but put under a glass
bordered with a little band of paper
and all drawings mounted on a piece
of paper (or cardboard) larger than
the drawing itself. As to the color of
mounts, Picasso wants the drawings
made on white paper to be put on a
cream color mount, and those which
are made on tinted paper to be put
on white mounts....Picasso thinks
that it would be preferable to inter-
mingle black drawings with aquarelles
and other colored drawings."

6. For details regarding the hanging,
installation, and pricing of the works,
see the two-page list "EXPOSITION DES
OUVRES [sic] EN AMERIQUE," 1923, in
The Arts Club archives, Newberry
Library. Listed at $420, *Head of a
Woman* or *Woman's Head* was one of
eight drawings priced over $400.
Given the control Picasso clearly
wished to exercise, it is reasonable
to assume his involvement in these
financial details.

similarly impassive and austere, their unblinking
stare at once all-seeing and insensate. By contrast,
The Arts Club *Head of a Woman* attests to the shift
in Picasso's classical vision after 1921: the drawing
is more lyrical, the modeling looser. This new del-
icacy is also reflected in the conception of the
female type. Downcast, the expressive eyes under
the noble brow soften the chiseled features, sug-
gesting a refinement of feeling, a melancholy and
an inward life notably absent from the earlier
heads. Here, as in Picasso's contemporary neoclas-
sical works, we sense a great tenderness.

The shift in sensibility is echoed in the media
Picasso used in The Arts Club drawing. That
Picasso was sensitive to the historical associations
of drawing media is evident in the neoclassical
works on paper he had produced to date. Executed
in hard graphite, his portraits of the mid-teens pro-
claimed their affiliation with the portrait drawings
for which Ingres was famous. In choosing pastel
for the heads of 1921, Picasso worked consciously
and provocatively against expectation, creating an
image of obdurate womanhood in a medium whose
powdery softness had ensured its traditional use in
the expression of a vaporous, yielding vision of
femininity. Now, in working with the combination
of red and black chalk in *Head of a Woman* and
related works, Picasso evoked the legacy of rococo
draftsmanship that unambiguously celebrated
female beauty, the tradition rooted in the work of
Antoine Watteau and recently revived in the red
chalk drawings of Renoir.

The suggestion of a rococo wistfulness in *Head
of a Woman* can be considered in terms of Picasso's
stylistic restlessness and the stimulus of Rosenberg's
collection of French eighteenth-century masters.
However, shifts in the emotional tenor of Picasso's
work can often be linked to changes in his person-
al life. The apparent relationship between *Head of
a Woman* and the maternal figure in *Mother and
Child,* another monumental painting from the sum-
mer of 1921 (Art Institute of Chicago), might sug-
gest that the new tenderness Picasso expressed in
the drawing relates to his experience of Olga with
young Paulo. Apparently, however, the tense and
fastidious Olga found it expedient to leave her son
largely in the hands of governesses. The maternal
qualities that seem now to have moved Picasso were
those demonstrated by Sara Murphy, an American
he met—along with her husband, painter Gerald

Murphy—in the second half of 1921. Wealthy and
unconventional, the Murphys were compelling
personalities providing novelist F. Scott Fitzgerald
the models for Dick and Daisy Diver, the protago-
nists of *Tender Is the Night.* Sara's beauty, warmth,
and intelligence apparently captivated Picasso as
they did Fitzgerald and Ernest Hemingway. Her
presence can first be detected, as Rubin has demon-
strated, in Picasso's images of women made in the
winter of 1921–22, signaled by the more delicate
features and the wavy long hair tied back and gently
cascading down the neck. Olga, with her brittle
good looks and dark hair pinned tightly to her head,
had been the presiding muse of Picasso's Neo-
classicism during the period 1918 to 1921; over the
next two years, her image blurs with that of Murphy
as Picasso fashions a paradigm of woman by "sub-
suming echoes of both Olga and Sara into a classi-
cal apotheosis of the ideal mother/wife."[3] *Head of a
Woman* of 1922 portrays this ideal.

Within a year of its completion, *Head of a
Woman* featured in the landmark exhibition held at
the Art Institute under the aegis of The Arts Club,
the first the major showing of Picasso's work in the
United States. Like the artist's inaugural exhibition
of 1919 at Paul Rosenberg Gallery, The Arts Club
exhibition that opened in March of 1923 was
devoted to drawings and focused on Picasso's
recent neoclassical work, chosen to reflect the
range of both his subjects and media. In Paris, the
exhibition was coordinated by a certain Prince
Argotinsky, a figure who, though absent from the
Picasso literature, was probably a member of the
White Russian community in Paris with which the
artist became familiar following his marriage to
Olga.[4] As Argotinsky's correspondence with Art
Institute director Robert Harshe reflects, Picasso
was himself very involved with the project, both
"helping" to select the fifty-three drawings, and
providing detailed instructions regarding their pre-
sentation and hanging.[5] Thus *Head of a Woman,*
mounted on white paper and flanked by a circus
subject of 1917 in graphite and a still life in the
same medium of 1919, made its first public
appearance in Chicago, and the high price the
artist now set on it reflected its importance in
Picasso's oeuvre.[6]

Douglas W. Druick

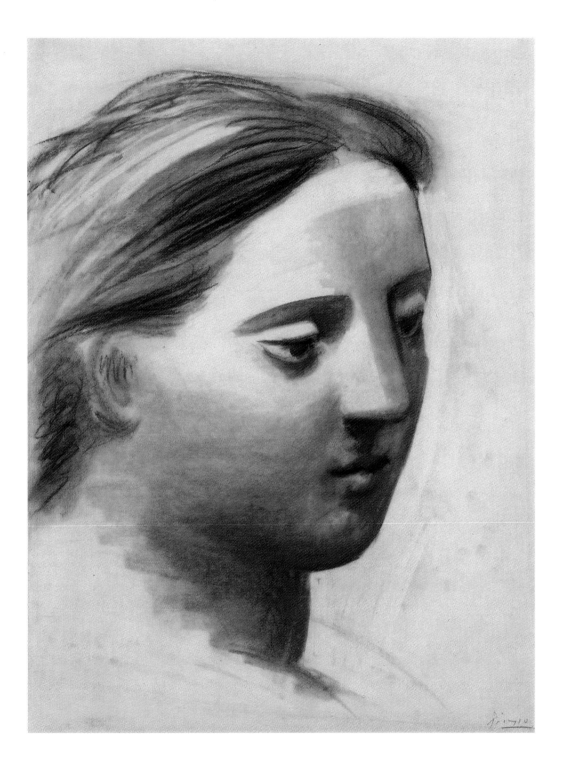

Mario Prassinos

French, born Turkey, 1916

August 15, 1968
(15 Août 68), 1968
Ink on paper
149.9 x 100.3 cm
(59 x 39 ¹/₂ in.)
Gift of Ann (Mrs. Everett
C.) McNear, 1986.

1. Mario Prassinos in *Catalogue raisonné de la Donation Mario Prassinos* (Saint-Rémy de Provence: FMP Donation Mario Prassinos, 1990), p. 22.

2. Mario Prassinos in *Prassinos: Rétrospective de l'oeuvre peint et dessiné,* (Aix-en-Provence: Presence Contemporaine, 1983), p. 31.

MARIO PRASSINOS was born to Greek parents living in Turkey, in what was at the time the city of Constantinople. He is the lesser-known, older brother of the surrealist author Gisèle Prassinos, and associated with many of the same artists and writers. Fleeing the persecution of Greeks under the regime of Ataturk, the Prassinos family moved to Paris in 1922. Ten years later, Mario began drawing in black ink and gouache, training in various ateliers while studying foreign languages at the Sorbonne, and occasionally exhibiting with the Surrealists. In the days preceding the outbreak of World War II, he became a French citizen and enlisted in the army. Prassinos returned to drawing following the war, evoking the automatism of his surrealist predecessors with his sinewy lines and scattered trails of ink. He befriended several existentialist writers in the 1950s, producing an edition of color engravings for Jean-Paul Sartre's novel *The Wall,* and in 1951, began his long-standing association with the Aubusson textile factory, preparing a series of tapestry cartoons.

Beginning in 1968, Prassinos undertook a number of large-scale ink drawings of a range of craggy hills, known as Les Alpilles, just south of his studio in Eygalières, near Provence. Each work from this series, including the drawing belonging to The Arts Club, bears as its title the date of its execution. The inscription at lower right, "/2," indicates that this drawing was the second of three Prassinos executed that day. In *August 15, 1968,* ink lines of varying thickness and length trace what appears to be the outline of a bent and barren tree at center, behind which lies the mountainous hillside of Les Alpilles. Across the landscape and extending into the sky, the artist has painted a thin haze of ink droplets. Downward running rivulets of ink indicate that the work was painted on an easel. On the topic of this series and his depiction of nature, Prassinos later wrote:

> Line is only an ideal frontier between the object and that which surrounds it. It exists only as the interior of our system of representation: each line all but separates the hills from the sky. They are only two different objects. Line thus conventionally indicates a change of nature in the spectacle. This is why I have replaced the suggestion of depth and contour by the accumulation of signs or their superimposition.[1]

In constructing his landscapes in a wide array of hatchmarks, lines, scribbles, and drops of ink, Prassinos distinctly avoided linking his work to calligraphy, a comparison invited by other Western European artists working in this medium around the same time (for example, Pierre Alechinsky). Instead, Prassinos sought to refine his "phonology of visual language" and to render the countryside in the panorama of notational "graphemes" he believed comprised the fundamental marks of the medium.[2]

Adam Jolles

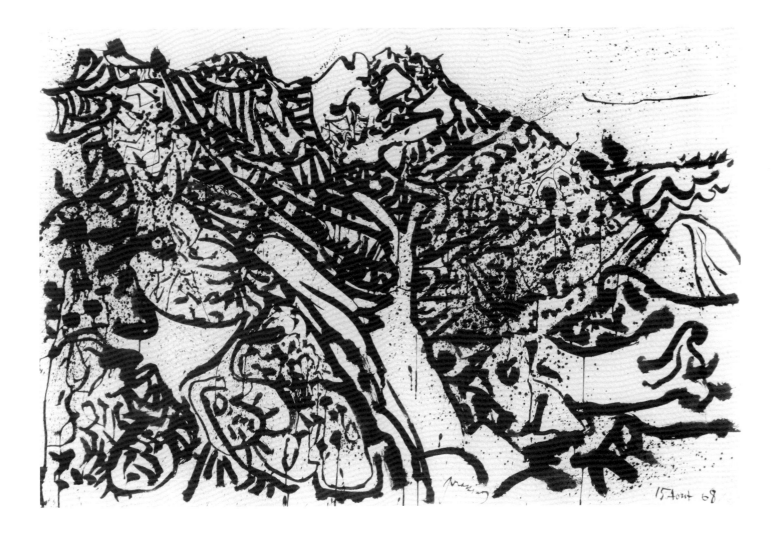

Germaine Richier

French, 1904–1959

Study after Le Diabolo, 1952

Pencil and chalk on paper
58.4 x 24.8 cm (23 x 9 ¾ in.)
Gift of Mr. and Mrs. Stanley
M. Freehling, 1996.

Fig. 1. Germaine Richier, *Le Diabolo*, 1950 (cast 1994), bronze, 160 cm (63 in.), Tate Gallery, London (photograph by Gill Selby).

1. For the smaller sculpture, see Jean-Louis Prat, *Germaine Richier Rétrospective* (Saint-Paul, France: Fondation Maeght, 1996), cat. no. 40.

GERMAINE RICHIER emerged in the late 1940s and early 1950s as a leading existentialist artist in post-war France. Her sculptures, drawings, and prints present a fantastic world populated by fearsome and menacing personages; human bodies are united with animal and insect heads and extremities, and the physical world seems metamorphosed into an apparition of generation and decay. Like the contemporary sculptures of Alberto Giacometti, Richier's forms are etiolated, limbs thinned, and bodies slashed and pitted, so that her figures are reminiscent of desiccated corpses. This grim, despairing vision of the human condition was fostered by the devastation of World War II and the uncertainties of nuclear annihilation during the Cold War era. Close examination of Richier's oeuvre, however, reveals textures and shapes derived from the living and growing organisms of nature. An integration of human, insect, and plant life establishes a pantheistic concept of mankind as indistinguishable from the rest of the world.

In addition to making drawings for new sculptures, Richier also executed studies after her own sculptural compositions, in a creative reprocessing of formal ideas and themes. Included in the artist's one-person exhibition at The Arts Club in 1966, this sheet from 1952 is a study after one of two bronzes from 1950, the larger, life-size version titled *Le Diabolo* (fig. 1), and the smaller one, simply *Diabolo*.[1] The model in both cases was a teenage girl who lived in the artist's house for a time and posed for several sculptures. Both bronzes exemplify a dialectical opposition frequently found in Richier's art between the solid earthbound figure and the fragile, airy object held in the hands. The title refers to this object and the feat of balance in which the figure is engaged: a diabolo is a piece of wood in the shape of an hourglass and gives its name to the game in which the diabolo is spun, tossed, and caught by means of a pair of sticks with a cord stretched between. In each sculpture, the model holds two diabolos, an impossible situation in this game.

The Arts Club drawing is derived from the larger bronze where the unnaturally attenuated figure holds the sticks in one hand and the bobbin in the other; the number of strings has multiplied, and they are no longer tied logically only to the ends of the rods but are affixed as well to points on the base—like an expanded cat's cradle. In both bronze and drawing, the human model has been metamorphosed into a ghostly, fragile image of a solitary insect-headed female. Once the logic of this simple children's game has been subverted, the gossamer, weblike object held in the hands and tied to the ground seems both to arm and bind. The child's toy and action of the game has now taken on a sinister tone, since the game master is less a human than a demonic creature. The pale pencil and crumbly chalk lines, as well as the emptiness of the left half of the paper, seem to serve as metaphors of the impermanence of humanity, caught in cycles of life and death, growth and decay—an image underscored by the game of chance (of one's fate?) that so engrosses this otherwordly personage.

Richard A. Born

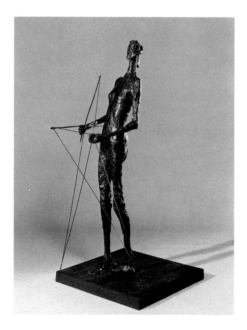

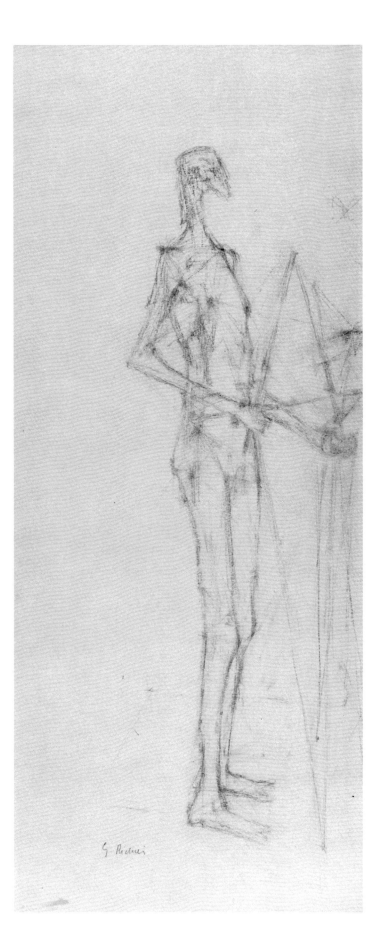

Thomas Rowlandson

English, 1756–1827

After the Ball, 1798
Pen and ink and watercolor
on light gray laid paper
20.3 x 26.7 cm (8 x 10 1/2 in.)
Gift of W. Russell Button
Gallery, 1963.

THOMAS ROWLANDSON, best known for caricatures of his contemporaries' preoccupations with food, drink, and the pleasures of the flesh, was perhaps the most prolific and successful chronicler of life in late Georgian England. However, as the noted English poet and critic Osbert Sitwell observed, Rowlandson deserves equally to be known as "the greatest master of pure line that England has ever had the good fortune to produce."[1] This subtle and quickly executed drawing illustrates Sitwell's point perfectly, for in it Rowlandson rather uncharacteristically understates himself, largely through a restrained and essential use of line.

In *After the Ball,* the artist depicts four women in various states of exhaustion apparently following an evening's entertainment. Although lacking any particularly mordant observation, the scene is suggestively sexual. The massive couch presses very close to the picture plane, a stage upon which two women are presented to our "front-row" view; Rowlandson sparks our sensual interest especially in the young woman at far left, who fixes us with her gaze. She attracts partly by obvious and conventional signals—open bodice, parted lips, flushed cheeks, and unbound hair—but also by her alertness, which contrasts with the unconsciousness of her sleeping companions. Another significant factor in Rowlandson's picture of an inviting woman is the graceful way one of her feet touches the floor, a common feature in many of his more frankly erotic drawings.

Stylistically, Rowlandson' s work usually confronts us with more energetic, calligraphic line and vibrant color. This rather unassuming drawing is all the more valuable a testament to the artist's ability to compose quickly and surehandedly with an economical use of the pen. Rowlandson here has foregone all but the most basic of his accustomed pencil underdrawing (visible only faintly in the headdresses of the two women at left) in favor of long sinuous pen strokes; the muted watercolor wash does not intrude upon what is primarily a linear presentation. It is this subtlety of graphic conception, especially in the languor and repose created by the lines in the womens' gowns, which most profoundly impresses upon us the sensuality of the scene.

Andrew Weislogel

1. Osbert Sitwell, "Thomas Rowlandson," in *Sing High! Sing Low!* (London: MacMillan and Co., 1944), p. 132.

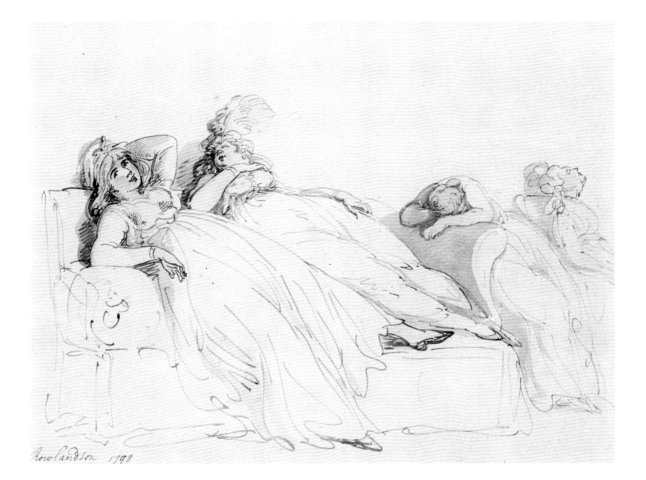

Rowlandson 1798

Pierre Soulages
French, born 1919

October 28, 1963
(28 Octobre 1963),
1963
Oil on canvas
159.1 x 201.9 cm
(62 5/8 x 79 1/2 in.)
Arts Club Purchase Fund
and Seymour Oppenheimer,
1968.

PIERRE SOULAGES was among a group of French artists, including Nicolas de Staël, who emerged in the 1940s during the rise of Abstract Expressionism in New York. Responding positively to the new, non-representational work being done in the United States, these artists were responsible for importing similar artistic concerns to the Continent in the 1950s and 1960s. Soulages developed his signature style in the 1950s, when he decisively turned from an energetic and spontaneous brand of painting to an increasingly restrained and composed format. His earlier freeflowing brushwork was replaced with severe and angular planes of color applied with a palette knife, a leather scraper, and a large spatula. He began to work reductively on his canvases, scraping away layers of paint until he was satisfied with the composition. Although carefully structured, his large canvases were executed without premeditation: "What I am making," the artist claimed, "teaches me what I am looking for. Painting always precedes reflexion."[1] Soulages has come to be identified by this austere abstract style, with its limited palette and architectonic combinations of horizontal and vertical blocks of paint. Indeed, he once attributed his decision to become a painter to an architectural experience: contemplating the somber interior of the Romanesque abbey church of Ste. Foy de Conques, some twenty-five miles from his hometown of Rodez, in the south of France.[2]

October 28, 1963 is one of the first in a series of primarily black compositions Soulages produced from 1963 through 1970, each titled by the day it was painted. As he recounted about his color choice, "Black has always been the base of my palette. It is the most intense, the most violent absence of color, that gives an intense appearance to colors with it, even to white, as a tree makes the sky blue." The few strokes of white paint at the lower left of *October 28, 1963* stand out in bright contrast to the dominant presence of the black mass at center, lending only the slightest sense of depth to the canvas. The golden hue that is most visible on the right edge of the painting offers something of a middle ground in relation to the two other bold colors. "Painting is a play of opacities and transparencies," Soulages asserted, suggesting that his canvases seek to convey varying degrees of depth through their juxtaposition of dark and light colors and the tonal relationships created by their correspondences.

Adam Jolles

1. Pierre Soulages, quoted in James Johnson Sweeney, *Soulages: Paintings since 1963* (New York: M. Knoedler and Co., 1968), p. 7.

2. Ibid. Subsequent citations are from pp. 12 and 8, respectively.

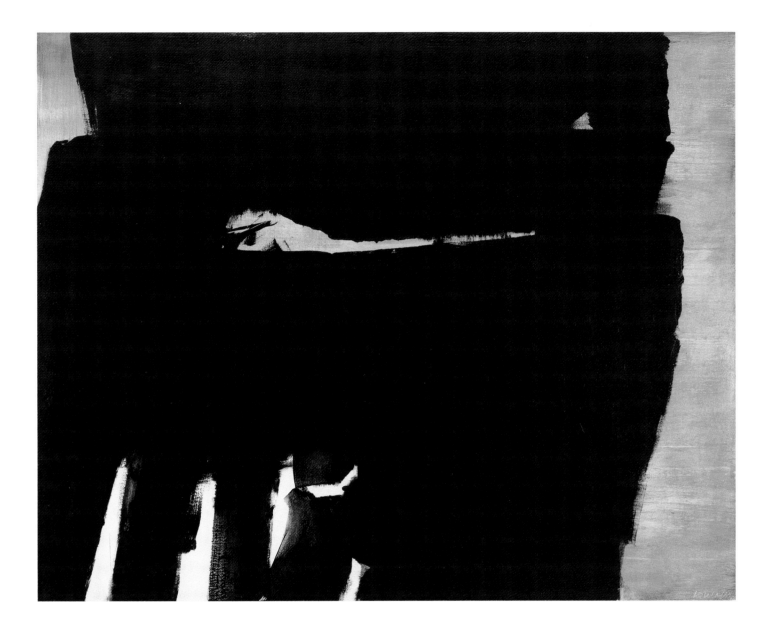

Nicolas de Staël

French, born Russia, 1914–1955

White and Yellow Flowers (Fleurs blanches et jaunes),
1953
Oil on canvas
129.5 x 88.9 cm (51 x 35 in.)
Gift of Mrs. Harold Florsheim, 1996.

NICOLAS DE STAËL is often considered the last great painter of the School of Paris, a somewhat loosely defined group of French and émigré artists working in Paris during the first half of the twentieth century. Born the son of a Russian baron in St. Petersburg in 1914, Nicolas was appointed at birth to become a page in the imperial court of Czar Nicolas II. Forced by the Revolution to leave Russia, the de Staël family lived in Poland until 1922 when, following the successive deaths of both parents, Nicolas and his two sisters were sent to Belgium to live with wealthy Russian expatriates. He studied at the Académie Royale des Beaux-Arts in Brussels during the early 1930s. Later that decade, he traveled extensively before settling in Paris in 1938, where he worked briefly in Fernand Léger's studio and befriended Jean Arp, Georges Braque, André Breton, Le Corbusier, Sonia Delaunay, and Wassily Kandinsky.

De Staël is best known for the adroit palette-knife technique he developed in the late 1940s, in which images and forms are built up through dense, almost sculptural concretions of oil paint. He is also known for his passion for vibrant color. His mature style developed in a somewhat unconventional manner—his paintings of the mid-forties to early fifties, which paralleled the abstractions of postwar European proponents of *art informel* or *tachisme,* such as Hans Hartung, André Lanskoy, and Serge Poliakoff, gradually gave way to a greater emphasis on representation. By 1955, de Staël's work had evolved—or descended, according to certain critics who lambasted his new style—into painterly seascapes, landscapes, and still lifes. The harsh reaction to his new approach, coupled with his own belief that he had encountered an artistic impasse, led to the artist's tragic suicide in 1955, at the age of forty-one.

White and Yellow Flowers elucidates de Staël's stylistic transition. Painted in 1953, the year in which he most successfully balanced abstract and representational elements, this composition demonstrates his ability to impart a geometric order to an arrangement of variously colored planes. The vase of flowers, brought to life through a series of deftly applied vertical and near-vertical patches of bright cadmium white, is set off against a curious red and blue passage on the right side, perhaps representing a view of nature through a window or doorway. The left two-thirds of the background is executed in more somber layers of gray-green and black, probably suggesting a domestic interior. Select dabs of gold and blue paint complete the composition, giving the work an almost mosaiclike luminosity.

Although de Staël and his colleagues have typically been overshadowed by their American contemporaries—principally the Abstract Expressionists—there has been a growing interest in European postwar abstraction, due, in part, to its influence on subsequent generations of painters, especially those working in Great Britain and Germany.

Dean Sobel

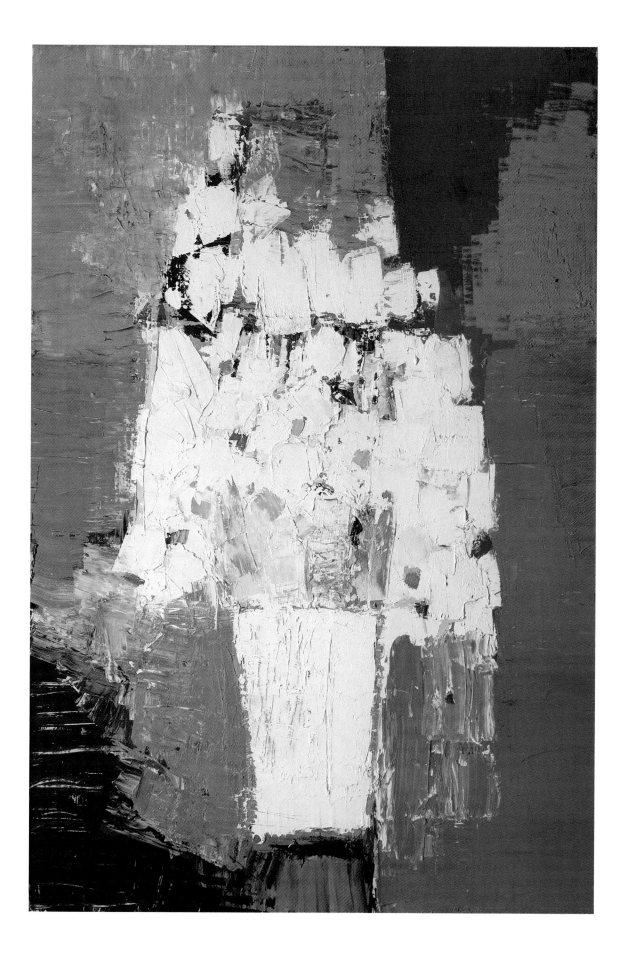

John Storrs

American, 1885–1956

Study in Form No. 3,
c. 1924
Bronze, copper, stainless
steel, and vulcanite
76.8 cm (30¼ in.)
Arts Club Purchase Fund,
1928.

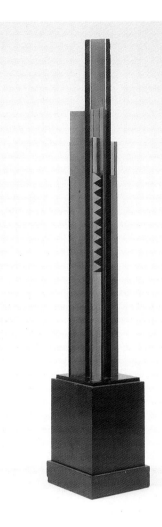

1. Although The Arts Club's sculpture was for many years exhibited and published as *Forms in Space No. 2,* recent research by Adam Jolles has uncovered letters from Alice Roullier to both John Storrs and the Brummer Gallery, New York, indicating that the correct title of the piece is *Study in Form No. 3.*

THE son of an architect and real estate developer, the Chicago-born sculptor John Storrs lived in Europe from 1905 to 1907, studying first with the German sculptor Arthur Bock and then in several art academies in Paris. He also visited Egypt, Greece, Turkey, Italy, and Spain, where he was introduced to the art of antiquity. Upon his return to Chicago, Storrs enrolled in evening classes at the Chicago Academy of Fine Arts and the School of the Art Institute of Chicago, and after brief periods in art schools in Boston and Philadelphia, he returned to Paris in 1911 to study with Auguste Rodin. This pattern of dividing his time between Europe and the United States was to endure throughout his professional life.

Storrs enjoys a special place within early American Modernism, as one of the first native-born sculptors to develop a completely non-objective style. Around 1923, while living in New York, he moved beyond figurative bronzes and plasters executed in a modified cubist idiom to carve his first

abstract sculptures. These have the appearance of small, nonfunctional architectural models or decorative units for some unbuilt monument. Their inspiration is diverse, from Storrs' interest in architecture, the towering Manhattan skyline, and the Prairie School designs of Frank Lloyd Wright in Chicago, to ancient Greek and native-American art.

Related to these towerlike works in stone is a series of mixed-media sculptures that Storrs was creating by 1924. However inventive formally, the earlier pieces remain traditional in medium, whereas the subsequent group, such as The Arts Club's *Study in Form No. 3,*[1] were assembled from woods and various materials that were at the time more proper to industry than fine art—aluminum, stainless steel, and vulcanite, a form of hardened rubber. Although in its conception this series of constructions places Storrs in the forefront of American avant-garde sculptors, its fabrication by assistants from wood models and drawings is rooted in the studio procedure of the *practicien.* The nineteenth-century academic tradition valued the creativity of the sculptor over the physical realization of the idea, and the execution of full-sized sculptures was generally reserved for skilled artisans. Early modernist sculptors, on the other hand—particularly those associated with the direct carving movement like Robert Laurent and William Zorach in America or Barbara Hepworth and Henry Moore in England—linked conception with execution and privileged the mark of the artist's hand as a sign of a work's integrity. Storrs' use of drawings from which the sculptures were constructed by others also recalls the industrial drafting office, which would not have been unfamiliar to this son of an architect.

Looking like building clusters and models for skyscrapers, these sculptures, with their silhouettes of staggered forms and setbacks, have a metaphorical resonance with modern architecture in shape, materials, and construction techniques. Sleek and shiny surfaces, precise craftsmanship, and pure, geometric forms present a utopian vision of modern urban life and a positivist regard for contemporary technology, hallmarks of functional international and Art Deco design between the wars.

Richard A. Born

ACCLAIMED as a sculptor, John Storrs also executed paintings, drawings, and prints at various stages in his career. In 1930, he took up painting seriously, possibly because the early years of the Depression in America led to no new commissions, and there was little commercial market for his sculptures. In his paintings, Storrs deals with abstract forms as though they were freestanding sculptures or shallow reliefs. An important point of departure were the 1920s purist paintings of Fernand Léger, and dada and surrealist art.

After completing several architectural relief commissions for the 1933 Century of Progress Exposition in Chicago, Storrs produced independent abstract sculptures between 1934 and 1938, and continued to paint and draw. Both as working studies for sculptural projects and as independent compositions, his drawings, such as The Arts Club's *Rebus I,* exhibit an essentially cubist structure inflected by swelling curves and jagged shapes. Frequently there are implied connections with the human body, or forms have the look of machine imagery or elements from buildings.

The date incorporated into the upper right of *Rebus I* has previously been read as 1955, but Storrs' paintings and drawings from this later period are figurative. The Arts Club drawing is most related formally to sculptures and works on paper from the mid-1930s, and the year 1933 is consistent with the chronology of his oeuvre. For instance, about 1936 Storrs had begun a series of abstract reliefs in bronze, stone, and polychromed terracotta that combine organic and geometric forms, recalling the cubist reliefs of Jacques Lipchitz or the still-life paintings of Picasso and Braque in the late teens. *Rebus I* likewise evinces a cubist idiom in its schematic, interpenetrating planar motifs, stylized hatching suggestive of shadows in a shallow relief, and references to music or to the artist's studio in the curved object pierced by a circular hole—which might be the sound box of a stringed instrument or a painter's palette.

The Arts Club drawing is filled with hermetic content. There is the somewhat hidden name "Alice" encoded diagonally across the composition. The reference is to Alice Roullier, one of the founders of The Arts Club and chairman of its exhibition committee, as well as director of the Roullier Galleries in Chicago, when this drawing was executed. Moreover, the notion of a rebus—a repre-

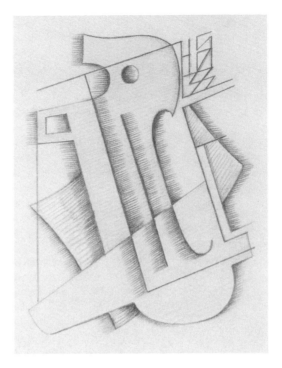

Rebus I, 1933
Graphite and colored
pencil on paper
15.5 x 12.4 cm
(6 1/8 x 4 7/8 in.)
Gift of Alice Roullier.

sentation of words or syllables by pictures of objects whose names resemble the intended words or syllables in sound—comes into play with the interaction of two French words, *roulier* and *roulure*. Both the French-speaking Roullier and Storrs, who spent extended periods of time in France, would have understood and appreciated the word play here. *Roulure* means a wind cup (or wind shake) in a timber, and the drawing's central motif—brownish in hue and accentuated by its simulated wood grain—is notable for its marked "French-curve" profile, visually evoking the separated strata of rings in a weathered wooden object. All this considered, the drawing becomes a sophisticated and witty abstract portrait of Alice Roullier.

There may be allusions in the design not only to wood but also to stone and paper, all materials that feature prominently in Storrs' work from the period. The forms and letters making up the image suggest as well the flutings on columns and the architect's T-square, notational symbols of the arts of sculpture and architecture. Since Storrs' initials, JHS, are a prominent device at the upper right of the composition, the drawing may also serve as a conceptual image of the sculptor Storrs and his activities.

Richard A. Born

Léopold Survage (Leopold Sturzwage)

French, born Russia, 1879–1968

The Pink City (La Ville rose), 1915
Oil on board
63.5 x 79.7 cm
(25 x 31³/₈ in.)
Gift of Alice Roullier.

Fisherwomen (Pêcheuses), 1925
Oil on canvas
130 x 90 cm
(51³/₁₆ x 38³/₁₆ in.)
Arts Club Purchase Fund, 1926.

JUDGING from his long exhibition record, Léopold Survage was one of the most durable modernist painters in France. One of many Russian émigré artists to settle in the Montparnasse quarter of Paris before World War I, Survage came to the attention of art critic Guillaume Apollinaire through a fellow Russian, Baroness Hélène d'Oettingen, principal supporter of Apollinaire's journal of art and poetry, *Les Soirées de Paris.* Making his artistic debut in the "Cubist room" at the 1911 Salon d'Automne, Survage took part in the first organized public display of Cubism by the followers of Picasso and Braque. Applying the abstract principles of music to painting (Survage supported himself in his early days in Paris as a piano tuner), the artist soon began to experiment with total abstraction, and in 1914 he contacted both the Gaumont Film Studio and the French Academy of Science to propose the idea of an abstract, animated film. Although his

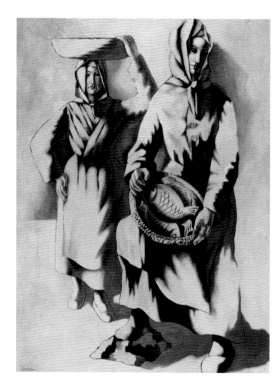

innovative plans were aborted by the war, the patronage of the Baroness d'Oettingen allowed Survage to spend the duration of the conflict basking in the Côte d'Azur, where he created a series of abstract cityscapes that represent the most original and satisfying work of his career.

In the stylized landscape of *The Pink City,* Survage depicted the sunbaked, simplified architectural forms of southern France isolated on a meadow and encircled by azure sky and water. Like all his wartime works, this scene is realized in a synthetic cubist mode, most evident in the buildings which are presented as a series of wafer-thin, interlocking planes. Exhibited in Paris in 1917, Survage's cityscapes must have influenced Fernand Léger's upbeat, mechanistic postwar paintings. Yet, behind the decorative harmony of color and shape of *The Pink City*—in the silhouetted figures that populate the scene—there lurks a slightly sinister element which anticipates both the surrealist anxiety of René Magritte and the postmodern ironies of Roger Brown.

Through the support of Alice Roullier and others associated with The Arts Club, Survage exhibited frequently in Chicago, and his distinctive cubist style influenced many vanguard artists here, including Flora Schofield, Frances Badger, and Rudolph Weisenborn. In addition to his Nice-period *Pink City,* The Arts Club owns a number of Survage's paintings and drawings: a study for *The Escaping Bull* (1927, location unknown), whose shimmering and rhythmical modeling anticipates the work of Léger in the early 1940s; several pictures, including the large 1925 *Fisherwomen,* that reflect the general turn to classicism in French painting of the 1920s; as well as surrealist-inspired works that also bear striking similarities to Picasso's 1928 Dinard beach scenes.

Daniel Schulman

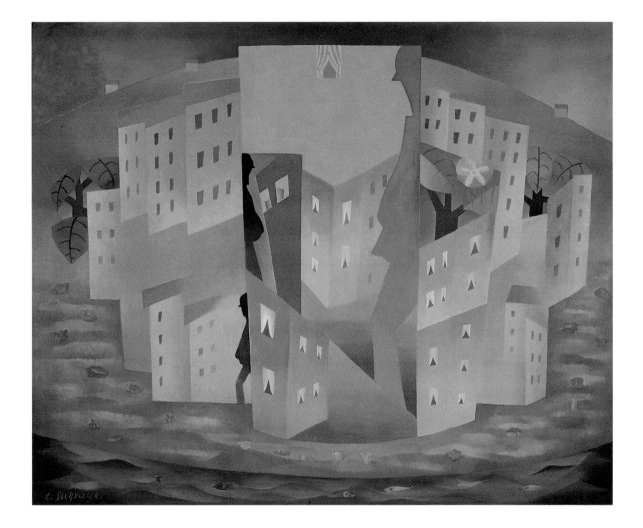

Pavel Tchelitchew

American, born Russia, 1898–1957

Portrait of Alice Roullier, January 1935
Ink on paper
40.6 x 27.3 cm
(16 x 10 ³⁄₄ in.)
Gift of Josephine R. (Mrs. Norman) Harris, 1964.

PAVEL TCHELITCHEW found his early creative passions in fashion and theater, producing designs for costumes and stage sets before beginning serious easel painting. Infused with that sense of spectacle, Tchelitchew's subjects moved from acrobats and clowns at the circus to "interior landscapes" inspired by the human body's metamorphoses. But it was his interest in the human face—and what lay behind it—that sustained the artist throughout his changing obsessions with form.

Tchelitchew began making portraits in Paris in 1923, producing nearly one hundred over the next twenty-five years. He told stories and relayed gossip for the amusement of his sitters, who included James Joyce, George Platt Lynes, Helena Rubenstein, Edith Sitwell, and Gertrude Stein. Complex psychological studies, these portraits often veer into the realm of fantasy, incorporating surreal backgrounds and props to elucidate the sitter's personality. In February 1938, The Arts Club held an exhibition devoted to Tchelitchew's portraiture, which featured the likenesses of his close friends Sitwell, Lincoln Kirstein, Charles Henri Ford, and Ruth Ford.

This portrait of Alice Roullier, made while Tchelitchew was in Chicago for his first exhibition at The Arts Club in January 1935, was perhaps a token of gratitude for her role in that exhibit's realization. A founding member of The Arts Club, Roullier grew up in a French-speaking home, the daughter of a successful art dealer with ties to leading French artists and dealers (thus the *"un peu de Paris"* [a little bit of Paris] of Tchelitchew's inscription at the lower right of the drawing). As chairman of the exhibition committee from 1918 to 1941, Roullier implemented The Arts Club's policy of bringing contemporary work to a broader public in Chicago. In this sensitive depiction of her, Tchelitchew abandoned his fantastic colors in favor of the brooding darkness of ink wash and the simplicity of line, achieving a skillful rendering of an exterior likeness. With closed mouth and heavy lids, Roullier seems inscrutable, but the touch of a smile around her lips hints at Tchelitchew's investigation of interior drama.

Elizabeth Siegel

CHICAGO DAILY NEWS art critic C. J. Bulliet opened his glowing 1935 profile of Julia Thecla by referring to the artist as "the mystery girl of Chicago art."[1] Thecla, who concealed both her origin (Delavan, Illinois), and her age from the critic, came to Chicago in the early 1920s where she studied at the School of the Art Institute and worked as a restorer of antiques. Shortly after she began to exhibit her jewellike works at the Art Institute's international watercolor exhibitions, she joined the Chicago No-Jury Society of Artists in the early 1930s and began to show with the commercial galleries operated by Albert Roullier and Katharine Kuh. Thecla enjoyed four years of employment in the easel painting section of the Federal Art Project of the WPA and, by the mid-1940s, gained exhibition opportunities in New York, Pittsburgh, San Francisco, and Washington, D.C. Her work, however, remained resolutely personal, imbued with private fantasy and a quality of fairytale.

Lady on a Journey, with its intense hues of rose, violet, and blue, heightened with splashes of brilliant white and gold, perfectly exemplifies Thecla's extraordinary technique. Applied in layers of an almost pastellike thickness, her watercolors attain the richness and depth of the French masters of pastel, Redon and Degas, on a miniaturist's scale. Thecla's heroine and alter-ego, clad here in black velvet cape and booties, and translucent harem pants, sits astride a docile, chimerical mount. Her riding gear includes a long, tasseled afghan, a huge heart-shaped locket, and a pink-tulle tutu. With an expression of quiet determination, she sets off from her castle home as an emissary of peace, magic, and the power of dreams.

Daniel Schulman

Lady on a Journey, 1945
Opaque watercolor, charcoal
on cardboard
21 x 15.6 cm (8¼ x 6⅛ in.)
Bequest of Arthur Heun,
1947.

1. C. J. Bulliet, "Artists of Chicago, Past and Present," *Chicago Daily News,* November 23, 1935.

Ossip Zadkine

French, born Russian, 1890–1967

Head of a Boy,

unrecorded cast of 1920
from a terracotta of 1919
Bronze
34.5 x 20.5 x 19.5 cm
(13 ⁵/₈ x 8 ¹/₁₆ x 7 ¹¹/₁₆ in.)
Arts Club Purchase Fund,
1931.

BORN in Vitebsk, Russia, Ossip Zadkine settled in Paris in 1910, after studying sculpture in England and France. His considerable oeuvre contains over two hundred sculptures, displaying a continually changing approach to the human figure. From a romantic realism indebted to the pervasive influence of Auguste Rodin, his style changed between 1914 and 1918 to an Expressionism concerned with the elongation and deformation of the figure and a stylization of facial features. Another obvious change occurred after World War I (during which Zadkine served in the French army), and his sculpture of the 1920s shows a greater receptivity to Cubism; he acknowledged his debt to the paintings of Picasso and Braque, while also embracing influences as diverse as Orthodox icons and folk idols from his native Russia and African and Oceanic sculpture. There are interesting parallels in his work during this ten-year period with that of both native French and other émigré sculptors living in Paris, in particular Henri Laurens, Jacques Lipchitz, and Joseph Czaky. Zadkine's activity at the time established him as a prominent member of the emergent School of Paris, which included painters, sculptors, and poets and writers centered in Montparnasse, such as his friend Max Jacob.

Zadkine fabricated the original terracotta from which The Arts Club bronze was cast during this fecund and decisive moment of transition, and *Head of a Boy* seems poised stylistically between a lingering primitivism and an incipient cubist idiom.[1] An important source for this and other direct carvings of human heads in stone and wood in the immediate postwar period is a group of twenty-five primitivistic stone heads and figures carved by the Italian émigré Amedeo Modigliani from about 1909 to 1915/16. Zadkine had met Modigliani before the war, but it was only in 1918, when they chanced to meet again, that a friendship developed.[2] In his memoirs, Zadkine recalls how by this time Modigliani had become dissatisfied with his sculptural heads and related caryatid drawings; perceiving them as an artistic digression, without future promise, from his painting, he had returned to his brushes and palette. What is noteworthy here is that Zadkine—although he himself professes not to have taken these sculptures seriously since for him Modigliani was essentially a painter—cites the influence of Constantin Brancusi on this body of work and also specifically mentions

Modigliani's full-figure stone caryatid carved around 1914 (Museum of Modern Art, New York).

The Arts Club head is related formally to the attenuated, masklike, crowned visage of the monumental wood *Prophet* (Musée de Peinture et de Sculpture, Grenoble), which Zadkine dated 1914 on the base but is now thought to have been carved around 1917/18. The inspiration for both sculptures seems to lie in Modigliani's stone heads with their elongated shapes, simplified features, and textural play between the smooth surfaces of the faces and the schematized crowns of hair defined by shallow incised lines—elements frequently attributed to the impact of African sculpture. But behind both sculptors' works is indeed the example of the stone heads of Brancusi, and The Arts Club bronze is tellingly close in conception, for example, to the Romanian's lost stone *Head of a Girl* (1907), with the distinctive shapes of nose, mouth, and brow and the organization of this ensemble, the contrast between smoothly worked areas of flesh and the roughly chiseled thick cap of hair, and the distortion of the head into an egg-shaped ellipse.[3] The routes of influence here are complex, since all these artists were interested in tribal sculpture and the arts of ancient cultures, and the similarity between Zadkine and Brancusi in this instance may also be attributed to a common respect for pre-Roman Gaulish carving. Finally, the flattening of the skull of *Head of a Boy,* as though intended to support some unseen object, points again to Modigliani's caryatids, while recalling the headdresses found on ancient Egyptian and Khmer sculpture. Zadkine's original contribution in this and related primitivistic carvings in the years just after the war lies in the assured synthesis of such diverse sources, the ancient and the modern, the tribal/folk and the European avant-garde. This process of assimilation and creative transformation defines the unambiguous modernity of his early sculptures.

Richard A. Born

1. Although this object has sometimes been cited as *Head of a Man,* its title is properly *Head of a Boy,* according to correspondence from Ossip Zadkine in The Arts Club's archives in the Newberry Library, Chicago.

2. Ossip Zadkine, *Le Maillet et le ciseau: Souvenirs de ma vie* (Paris: Editions Albin Michel, 1968), pp. 89–90. Zadkine affectionately refers to Modigliani thoughout these memoirs as "Modi."

3. Illustrated in Sidney Geist, "Brancusi," in William Rubin, ed., *"Primitivism" in 20th Century Art: Affinity of the Tribal and the Modern,* vol. 2 (New York: Museum of Modern Art, 1984), p. 346.

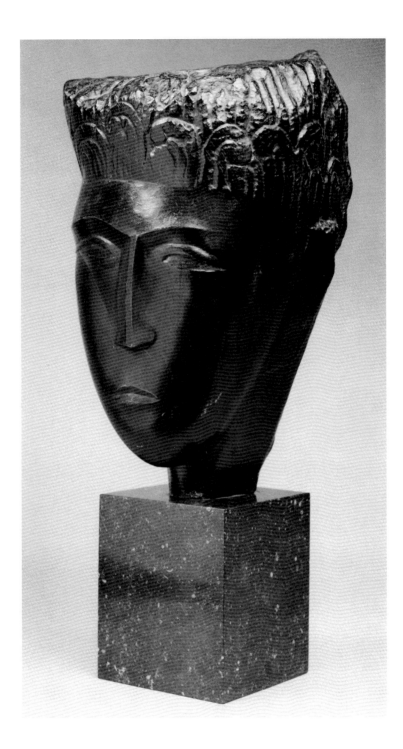

Catalogue

ADAM JOLLES

NOTE TO THE READER: Dimensions are given in centimeters followed by inches in parentheses; height precedes width precedes depth. For works on paper, dimensions indicate sheet (as opposed to image) size. Titles of frequently cited Arts Club exhibitions and publications are abbreviated as follows:

Drawings = Drawings 1916/1966 (1966)
Drawings and Sculpture Privately Owned = Loan Exhibition of Modern Drawings and Sculpture Privately Owned by Chicagoans (1930)
Heun Collection = Exhibition of the Arthur Heun Collection of Modern Paintings and Drawings Bequeathed to the Arts Club (1947)
Portrait of an Era = Portrait of an Era: Rue Winterbotham Carpenter and The Arts Club of Chicago, 1916–1931, Seventieth Anniversary Exhibition (1986)
Seventy-Fifth = Seventy-Fifth Anniversary Exhibition, 1916–1991 (1992)
Sixty Years on Stage = Sixty Years on The Arts Club Stage: A Souvenir Exhibition of Portraits (1975–76)

A ◆ following the title of a work of art indicates that it is illustrated in the "Collection Highlights" section of this volume. Please note that as an important and integral aspect of members' and visitors' experience of The Arts Club, objects in the collection cannot be made available for loan.

Pierre Alechinsky
Belgian, born 1927
No Explanation (Pas d'Explication),◆ 1960
Ink on tan wove paper mounted on linen; 132.1 x 148.6 (52 x 58¹/₂)
Signed, lower left: *Alechinsky*

PROVENANCE: Sold by the artist to the Lefebre Gallery, New York, by 1963; Arts Club Purchase Fund, 1965.

EXHIBITIONS: Stedelijk Museum Amsterdam, *Alechinsky+Reinhoud*, 1961, exh. traveled to Rotterdam Kunstring, no. 40 (illus.), as *Sans Explication (Zonder Uitleg)*. Fundação Bienal de São Paulo, *VII Bienal de São Paulo*, 1963, no. 5, as *Sem Explicação*. Buenos Aires, Centro de Artes Visuales, Instituto Torcuato Di Tella, *Dos artistas belgas: Alechinsky y Reinhoud*, 1964, no. 5, as *Sin explicación*. Arts Club of Chicago, *Pierre Alechinsky: Paintings, Encres, and Watercolors*, 1965, exh. traveled to Minneapolis, University Gallery, University of Minnesota; New York, Jewish Museum, no. 11.

REFERENCES: Arts Club of Chicago, *Drawings*, 1966, exh. cat., n. pag., as *Encre*. Idem, *Sixty Years on Stage*, 1975–76, exh. cat., 19, as *Encre*. Idem, *Seventy-Fifth*, 1992, exh. cat., 41, erroneously as Miro's *Encre*.

The Last Day,◆ 1964
Color lithograph; 20.3 x 48.9 (8 x 19¹/₄)
Printed at Permild and Rosengreen, Copenhagen
Numbered and signed, lower right: *2/100 / Alechinsky*
Inscribed, upper center: *À Madame Shaw, avec beaucoup d'amitié / Alechinsky*
Inscribed and dated, upper right: *Chicago / le 26 II 65*
Inscribed, middle left: *Merci de m'avoir / donné la / possibilité / de revoir ici / mes tableaux / dispersés / comme des / chiens perdus / et maintenant / réunis grace / à vous*

PROVENANCE: Gift of the artist, 1965.

REFERENCES: Arts Club of Chicago, *Pierre Alechinsky: Paintings, Encres, and Watercolors*, 1965, exh. cat., n. pag., front and back inside cover (detail illus.).

Karel Appel
Dutch, born 1921
The Kick (Le Coup de pied), 1969
Color lithograph; 76.2 x 56.5 (30 x 22¹/₄)
Signed and dated, lower right: *Appel / 69*
Numbered, lower left: *14/75*

PROVENANCE: Richard Gray Gallery, Chicago; Arts Club Purchase Fund, 1970.

REFERENCES: Arts Club of Chicago, *Sixty Years on Stage*, 1975–76, exh. cat., 23. Idem, *Seventy-Fifth*, 1992, exh. cat., 70.

Alexander Archipenko
American, born Russia, 1887–1964
Untitled,◆ c. 1928
Graphite on paper; 45.7 x 54 (18 x 21¹/₄)
Signed, lower right: *Archipenko*

PROVENANCE: Gift of the artist, 1929.

EXHIBITIONS: Possibly New York, Anderson Galleries, *Archipenko: Catalogue of Exhibition and Description of Archipentura*, 1928, no. 100–17, as *Drawing*. Arts Club of Chicago, *Sculpture and Paintings by Alexander Archipenko*, 1929, no. 45–48, as *Drawing*. Arts Club of Chicago, *Loan Exhibition of Drawings by Sculptors Privately Owned by Chicagoans*, 1932, no. 4, as *Woman and Child*. Arts Club of Chicago, *Exhibition of Modern Sculpture and Drawings by Sculptors*, 1933, no. 73, as *Woman and Child*. New York, Zabriskie Gallery, *Archipenko: Polychrome Sculpture*, 1977, exh. traveled to The Arts Club of Chicago, no. 7 under "Works on Paper" (Chicago only).

Jean (Hans) Arp, designer
French, 1887–1966
Shadow of Fruits (Ombre de fruits),◆ 1952
Woven by Tabard Frère et Soeur, Aubusson; editioned by Galerie Denise René, Paris
Slit tapestry weave of cotton warp, wool weft; 163.1 x 132.7 (64¹/₄ x 52¹/₄)
Inscribed, lower right, with symbol for Tabard Studio.
Inscribed, on reverse, on label: *"OMBRE DE FRUITS"*

/H1m60 L1m35=2mq16 / carton de Jean Arp / édité par Tabard Frères et Soeurs / AUBUSSON

PROVENANCE: Galerie Denise René, Paris; Sidney Janis Gallery, New York; Arthur Heun Memorial Purchase Fund, May 1, 1953.

EXHIBITIONS: Paris, Galerie Denise René, *Douze Tapisseries inédites executées dans les ateliers Tabard à Aubusson*, 1952, no. cat. New York, Sidney Janis Gallery, *Aubusson Tapestries by Twelve Abstract Artists*, 1952, no. 1. Arts Club of Chicago, *Aubusson Tapestries Executed at Tabard Studios*, 1953, no. 1.

REFERENCES: Arts Club of Chicago, *An Exhibition of Cubism on the Occasion of the Fortieth Anniversary of The Arts Club of Chicago*, 1955, exh. cat., 7. Galerie Denise René, *Tapisseries récentes réalisées dans les ateliers Tabard à Aubusson*, Paris, 1964, exh. cat., n. pag. (illus.). Arts Club of Chicago, *Drawings*, 1966, exh. cat., n. pag. Galerie Denise René, *Tapisseries d'Aubusson*, Paris, 1974, exh. cat., no. 12 (illus.). Arts Club of Chicago, *Sixty Years on Stage*, 1975–76, exh. cat., 15. Idem, *Seventy-Fifth*, 1992, exh. cat., 39.

Salcia Bahnc
American, born Poland, 1898–?
Turmoil, 1947
Hand-colored lithograph; 35.2 x 24.5 (13⁷/₈ x 9⁵/₈)
Signed, lower left: *Salcia Bahnc*
Titled, lower center: *Turmoil*
Dated, lower right: *(1947)*

PROVENANCE: Theodora Winterbotham Brown, Chicago.

Seated Figure, early 1940s
Oil on panel; 13.3 x 9 (5¹/₄ x 3¹/₂)
Signed, upper left: *Salcia Bahnc*

PROVENANCE: Bequest of Arthur Heun, Chicago, 1947.

EXHIBITIONS: Arts Club of Chicago, *Heun Collection*, 1947, no. 6.

Negress, 1947
Etching, 19 x 24.5 (7 1/2 x 9 5/8)
Signed, lower left: *Salcia Bahnc*
Inscribed, lower center: *"Negress"*
Dated, lower right: *Dec. 1947*

PROVENANCE: Alice Roullier, Chicago.

François Baschet
French, born 1920
Bernard Baschet
French, born 1917
Merry-Go-Round, c. 1969
Aluminum and stainless steel; 75.6 (29³/4)

PROVENANCE: Gift of the artists, 1969.

EXHIBITIONS: Arts Club of Chicago, *Musical Sculptures by François and Bernard Baschet,* 1969, not in cat.

REFERENCES: Arts Club of Chicago, *Sixty Years on Stage,* 1975–76, exh. cat., 23. Idem, *Seventy-Fifth,* 1992, exh. cat., 70.

Fletcher Benton
American, born 1931
Rolling Disc, 1979
Graphite and watercolor on graph paper; 30.2 x 30.2 (11⁷/8 x 11⁷/8)
Signed, titled, and dated, lower right: *Fletcher Benton* FLETCHER BENTON ROLLING DISC *1979*

PROVENANCE: Gift of the artist, 1979.

EXHIBITIONS: Milwaukee Art Center, *Fletcher Benton: New Sculpture,* 1979–80, exh. traveled to The Arts Club of Chicago, Oakland Museum, Newport Harbor Art Museum, Portland Art Museum, exh. cat., n. pag., as *Rolling Disk #15, 16, 17, 18, 19,* or *20.*

Emile-Antoine Bourdelle
French, 1861–1929
Torso of Pallas (Torse de Pallas),◆ cast in 1901
from a model of 1889
Bronze; 66 (26)
Inscribed, on base: *Bourdelle* © *by Bourdelle*

PROVENANCE: Main Street Gallery, Chicago; Arts Club Purchase Fund, January 4, 1963.

EXHIBITIONS: Buenos Aires, Museo Nacional de Bellas Artes, *Antoine Bourdelle,* 1960, no. 10.

REFERENCES: Ionel Jianou and Michel Dufet, *Bourdelle,* Paris, 1965, no. 26. Arts Club of Chicago, *Drawings,* 1966, exh. cat., n. pag., as *Torso.* Idem, *Sixty Years on Stage,* 1975–76, exh. cat., 19, as *Torso.* Tokyo Metropolitan Teien Art Museum, *Bourdelle/ Dufet,* 1987, no. 3, fig. 3, 161. Arts Club of Chicago, *Seventy-Fifth,* 1992, exh. cat., 41.

Bernard Boutet de Monvel
French, 1884–1949
Study for a Portrait of Elizabeth Chapman, c. 1927
Graphite on paper; 32.7 x 21 (12⁷/8 x 8¹/4)
Inscribed and signed, lower left: *A Bobsy / Bernard*

PROVENANCE: Elizabeth Goodspeed Chapman, Chicago; Phillips, New York, March 3–4, 1981, no. 75; gift of Mr. James Alsdorf, Mr. William McCormick Blair, Mr. Leigh B. Block, Mrs. Allerton Cushman, Mrs. Eugene Davidson, Mrs. Donald B. Douglas, Mrs. Robert D. Graff, Mrs. C. Phillip Miller, Mrs. William H. Mitchell, Mrs. Curtis B. Munson, Mrs. Walter Paepcke, Mrs. Ruth Page, Mrs. William Wood-Prince, Mrs. Edward B. Smith, and Mrs. John Welling, in memory of Elizabeth Goodspeed Chapman by her friends, 1981.

Georges Braque
French, 1882–1963
Athena (Athenée),◆ 1932
Color lithograph on Arches paper; 39.4 x 32.4 (15¹/2 x 12³/4)
Printed by Berdon
Signed, lower right: *G. Braque*
Numbered, lower right: *65/75*

PROVENANCE: Alice Roullier, Chicago; sold to Theodora Winterbotham Brown, Chicago, 1933; gift of Theodora Brown in memory of Rue Winterbotham Carpenter, 1933.

EXHIBITIONS: Arts Club of Chicago, *Georges Braque Retrospective Exhibition,* 1939, exh. traveled to San Francisco Museum of Modern Art, no. 24, as *Decoration.* Washington, D. C., Phillips Memorial Gallery, *Georges Braque Retrospective Exhibition,* 1939–40, no. 48, as *Decoration.* Arts Club of Chicago, *Georges Braque: Painter, Printmaker,* 1954, no. 17. Arts Club of Chicago, *The Horse as Motif, 1200 B.C.–1966 A.D.,* 1975, no. 67 (illus.).

REFERENCES: Christian Zervos, "Georges Braque," *Cahiers d'art* 10 (1935), 25 (illus.), as *Lithographie en couleurs.* Buchholz Gallery, *Contemporary Prints,* New York, 1945, exh. cat., n. pag. (illus.). Lawrence Campbell, "Reviews and Previews," *Art News* 56 (Feb. 1958), 10. Musée d'Art et d'Histoire, *Georges Braque: Oeuvre graphique original,* Geneva, 1958, exh. cat. by Edwin Engelberts, no. 13 (illus.). Gerd Hatje, *Georges Braque: His Graphic Work,* New York, 1961, intro. by Werner Hofmann, no. 15 (illus.). Fernand Mourlot, *Braque lithographe,* Paris, 1963, preface by Francis Ponge, no. 3 (illus.). Massimo Carrà and Marco Valsecchi, *L'opera completa di Braque dalla scoposizione cubista al recupero dell'oggetto, 1908–1929,* Milan, 1971, G 13 (illus.). Galerie Wünsche, *Georges Braque: Das Lithographische Werk,* Bonn, 1971, exh. cat., no. 3 (illus.). Château-Musée de Dieppe, *Braque: Donation Laurens II,* 1974, preface by Pierre Bazin, no. 4 (illus.). Galerie du Centre Culturel, *Georges Braque: Eaux-fortes, lithographies,* Argenteuil, 1982, exh. cat., n. pag. Dora Vallier, *Braque: L'Oeuvre gravé, catalogue raisonné,* Paris, 1982, no. 19 (illus.).

Green Head (Tête verte),◆ 1950
Color etching on Arches paper; 36.2 x 23.2 (14¹/4 x 9¹/8)
Printed by Signovert; published by Maeght
Signed, lower right: *G. Braque*
Numbered, lower left: *12/30*

PROVENANCE: Gift of Mrs. Robert Muckley, 1976.

REFERENCES: Arts Club of Chicago, *Georges Braque: Painter, Printmaker,* 1954, exh. cat., no. 39, as *Woman's Head (Green).* Galerie Maeght, *Derrière le miroir: Dix ans d'édition, 1946–1956,* Paris, 1956, no. 17 (illus.). Musée d'Art et d'Histoire, *Georges Braque: Oeuvre graphique original,* Geneva, 1958, exh. cat. by Edwin Engelberts, no. 38 (illus.). Gerd Hatje, *Georges Braque: His Graphic Work,* New York, 1961, intro. by Werner Hofmann, no. 40 (illus.). Château-Musée de Dieppe, *Braque: Donation Laurens II,* 1974, preface by Pierre Bazin, no. 13 (illus.). Dora Vallier, *Braque: L'Oeuvre gravé, catalogue raisonné,* Paris, 1982, no. 58 (illus.). Kulturhaus der Stadt Graz, Kulturamt der Stadt Klagenfurt, Galerie im Stadthaus Salzburger Landessammlungen Rupertinum, *Georges Braque: Das Druckgraphische Werk,* 1987, exh. cat., no. 23, fig. 44. Fondation Pierre Giannada, Martigny, *Georges Braque,* exh. cat. by Jean-Louis Prat, 1992, no. 88 (illus.). Arts Club of Chicago, *Seventy-Fifth,* 1992, exh. cat., 70.

Georges Braque, designer
Still Life with Pipe (Nature morte à la pipe),◆ 1935–36
Woven by Aubusson; editioned by the House of Marie Cuttoli, Paris
Slit tapestry weave of cotton or linen warp, wool weft with silk highlights; 210.7 x 112.8 (83 x 44⁵/8)
Signed, lower right: *G. Braque*

PROVENANCE: Marie Cuttoli, Paris; Arts Club Purchase Fund and gift of Mr. and Mrs. Harold F. McCormick, 1936.

EXHIBITIONS: New York, Bignou Gallery, *Modern French Tapestries by Braque, Raoul Dufy, Léger, Lurçat, Henri-Matisse, Picasso, Rouault from the Collection of Madame Paul Cuttoli,* 1936, no. 1. Arts Club of Chicago, *Modern French Tapestries Designed by Modern Painters,* 1936, no. 1. Arts Club of Chicago, *Georges Braques Retrospective Exhibition,* 1939, exh. traveled to San Francisco Museum of Modern Art, no. 23. Washington, D.C., Phillips Memorial Gallery, *Georges Braque Retrospective Exhibition,* 1939–40, no. 8. Arts Club of Chicago, *Modern Tapestries Designed by Modern Painters, Executed under the Direction of Madame Paul Cuttoli,* 1941, no. 3.

REFERENCES: Eleanor Jewett, "Weaver's Loom Captures Art of the Painter," *Chicago Sunday Tribune,* June 7, 1936, 18. "Modern Artists Find A Sensational New Medium for Their Designs in French Tapestry Weaving," *Vogue,* June 15, 1936, 45 (illus.). Arts Club of Chicago, *An Exhibition of Cubism on the Occasion of the Fortieth Anniversary*

of The Arts Club of Chicago, 1955, exh. cat., 4. Idem, *Drawings*, 1966, exh. cat., n. pag. Art Institute of Chicago, *Braque: The Great Years*, 1972, exh. cat. by Douglas Cooper, 60 n. 3. Arts Club of Chicago, *Sixty Years on Stage*, 1975–76, exh. cat., 11 (illus.). Idem, *Portrait of an Era*, 1986, exh. cat., n. pag. (illus.). Idem, *Seventy-Fifth*, 1992, exh. cat., 10. *The New Encyclopaedia Brittanica*, vol. 17, Chicago, 1994, pl. 6, as *Le Table et le pipe*.

Alexander Calder

American, 1898–1976
Red Petals,♦ 1942
Plate steel, steel wire, sheet aluminum, soft-iron bolts, and aluminum paint; 259.1 (102)

PROVENANCE: Arts Club commission, Elizabeth Mabel Johnston Wakem Bequest Fund, 1942.

EXHIBITIONS: New York, Museum of Modern Art, *Alexander Calder*, 1943, exh. cat. by James Johnson Sweeney, no. 81, 48 (illus.), 61. New York, Museum of Modern Art, *Art in Progress: A Survey Prepared for the Fiftieth Anniversary of The Museum of Modern Art*, 1944, no cat. nos., 145 (illus.), 219. Paris, Musée National d'Art Moderne, *L'Oeuvre du XXe siècle: Peintures, Sculptures*, 1952, no. 118, pl. 16. London, Tate Gallery, *Twentieth-Century Masterpieces: An Exhibition of Paintings and Sculpture*, 1952, exh. cat. by James Johnson Sweeney, no. 99, pl. XI. London, Tate Gallery, *Alexander Calder: Sculptures, Mobiles*, 1962, exh. cat. by James Johnson Sweeney, no. 26. Art Institute of Chicago, Apr. 23, 1973. University of Chicago, David and Alfred Smart Museum of Art, 1995–97.

REFERENCES: "Arts Club Shows Wire 'Sculpture' at Tea on Friday," *Chicago Daily News*, Oct. 14, 1942, 18. Maude Riley, "The Modern Opens Retrospective Show of Calder's Light-Hearted Art," *Art Digest* 18 (Oct. 1, 1943), 6 (illus.). "People Are Talking About," *Vogue*, Nov. 1, 1943, 74 (illus.), as *Mobile*. Rosamund Frost, "Calder Grown Up: A Museum-Size Show," *Art News* 42 (Nov. 1–14, 1943), 11 (illus. on cover). Arts Club of Chicago, *Twenty-Eighth Annual Exhibition by the Professional Members*, 1944, exh. cat. (illus. on cover). Ministério da Educação e Saude and São Paulo, Museu de Arte, *Alexander Calder*, Rio de Janeiro, 1948, exh. cat., n. pag. (illus.). James Johnson Sweeney, *Alexander Calder*, New York, 1951, 50 (illus.), 74. Leslie Katz, "Venice: This Year's Biennale," *Art News* 51 (Sept. 1952), 33 (illus.). Arts Club of Chicago, *An Exhibition of Cubism on the Occasion of the Fortieth Anniversary of The Arts Club of Chicago*, 1955, exh. cat., 6. George Rickey, "Calder in London," *Arts Magazine* 36 (Sept. 1962), 22–27 (illus.). David Sylvester, ed., *Modern Art: From Fauvism to Abstract Expressionism*, Great Art and Artists of the World, vol. 8, New York, 1965, 239 (illus.). Alexander Calder, *Calder: An Autobiography with Pictures*, New York, 1966 (2d ed., Boston, 1969), 185–86. H. Harvard Arnason and Pedro Guerrero, *Calder*, Princeton, 1966, 94 (illus.), 95, 100. Arts Club of Chicago, *Drawings*, 1966, exh. cat., n. pag. Giovanni Carandente, *Calder: Mobiles*

and Stabiles, Milan, 1968, 23. *The World Book Encyclopedia*, Chicago, 1969, 200 (illus.), 201, 203. Frank J. Roos, *An Illustrated Handbook of Art History*, 3d ed., London, 1970, 317, fig. G. H. Harvard Arnason, *Calder*, New York, 1971, 41. Sam Hunter, *American Art of the Twentieth Century*, New York, 1972, 232, fig. 433. Arts Club of Chicago, *Sixty Years on Stage*, 1975–76, exh. cat., 13. Whitney Museum of American Art, *Calder's Universe*, New York, 1976, exh. cat. by Jean Lipman and Ruth Wolfe, 333. Jane Allen and Derek Guthrie, "Rue Shaw: 35 Years at the Arts Club," *New Art Examiner* 3 (Jan. 1976), 8. T. Walter Wallbank, Alastair M. Taylor, Nels M. Bailkey, and George F. Jewsbury, *Civilization Past and Present*, 5th ed., Glenview, 1978, pl. 30. *Encyclopedia*, vol. 3, Princeton, 1980, 25 (illus.). Arts Club of Chicago, *Mies van der Rohe: Interior Spaces*, 1982, exh. cat. by Franz Schulze, 35 (illus.). James L. Reidy, *Chicago Sculpture*, Chicago, 1983, 173–74 (illus.). Dale G. Cleaver, *Art: An Introduction*, 4th ed., San Diego, 1985, 390–91, fig. 19-42. H. H. Arnason, *History of Modern Art: Painting, Sculpture, Architecture, Photography*, 3d rev. ed., New York, 1986, 524, fig. 804. Jeff Lyon, "State of the Art," *Chicago Tribune Magazine*, Oct. 12, 1986, 10 (illus.), 15. Bruce Cole and Adelheid Gealt, *Art of the Western World: From Ancient Greece to Post-Modernism*, New York, 1989, 308, 310 (illus.). Ann Kelleher, "One World, Many Voices," *Liberal Education* 77 (Nov.–Dec. 1991), 3. Joan M. Marter, *Alexander Calder*, Cambridge, 1991, 205–207, fig. 140. Henry Hanson, "A Moveable Feast," *Chicago Magazine*, Apr. 1992, 78 (illus.), 81. Arts Club of Chicago, *Seventy-Fifth*, 1992, exh. cat., 38.

Chinese, Sui dynasty (589–618)

Tomb Sculpture♦
Glazed earthenware; 25 (9⅞)

PROVENANCE: Cheng-Tsai Loo, Beijing; Arts Club Purchase Fund 1925.

Chinese, Yuan dynasty (1260–1368)

Bodhisattvas♦
Wood with traces of pigment; 116.8, 121.9, 129.5 (46, 48, 51), respectively

PROVENANCE: Cheng-Tsai Loo, Beijing; Arts Club Purchase Fund, 1931.

EXHIBITIONS: Arts Club of Chicago, *Portrait of an Era*, 1986, no. 1 (illus.).

REFERENCES: Arts Club of Chicago, *Seventy-Fifth*, 1992, exh. cat., 39.

Chinese, Qing dynasty (1644–1911)

Pair of Archaistic Vases,♦ 19th century
Porcelain with celadon glaze; 29.1, 29.2 (11⁷/₁₆, 11½), respectively

PROVENANCE: Unknown.

Colombian, Quimbaya region

Seated Slab Figure, 1000/1500 A.D.
Unslipped orange earthenware with black patina; 18.5 x 15.6 x 6.2 (7¼ x 6⅛ x 2 ⁷/₁₆)

PROVENANCE: Unknown.

Robert Cottingham

American, born 1935
Art, 1991–92
Color lithograph on Rives BFK; 116.8 x 116.8 (46 x 46)
Published by Landfall Press, Chicago
Numbered 1/60

PROVENANCE: Gift of Isaac Goldman, Chicago, 1996.

REFERENCES: Milwaukee Art Museum, *Landfall Press: Twenty-Five Years of Printmaking*, 1996, 123, pl. 20 (illus. on cover).

Pierre Courtin

French, born 1921
Alliance, 1966
Embossed intaglio; 29.8 x 28 (11¾ x 11)
Dated, titled, inscribed, and signed, lower right: *29 juin 1966—Alliance. épreuve d'état unique— Pierre Courtin*

PROVENANCE: Theodore Schempp and the Berggruen Gallery, New York; Arts Club Purchase Fund, 1967.

EXHIBITIONS: Arts Club of Chicago, *Pierre Courtin*, 1967, no. 36.

REFERENCES: Arts Club of Chicago, *Sixty Years on Stage*, 1975–76, exh. cat., 23. Idem, *Seventy-Fifth*, 1992, exh. cat., 70.

André Derain

French, 1880–1954
Untitled,♦ c. 1929
Red chalk on paper; 52.7 x 44.5 (20¾ x 17½)
Signed, lower right: *a Derain*

PROVENANCE: Anne M. Reynolds (Mrs. John H.) Winterbotham, Chicago, by 1930; gift of Anne Winterbotham, 1962.

EXHIBITIONS: Arts Club of Chicago, *Drawings and Sculpture Privately Owned*, 1930, no. 117, as *Young Woman*. Arts Club of Chicago, *Drawings and Small Sculpture: Barlach, Brown, Derain, Frasconi, Giacometti, Greco, Janicki, Kolbe, Lachaise, Manolo, Marshall, Nadelman, Perlin, Pozatti*, 1958–59, no. 22, as *Torso*. University of Chicago, David and Alfred Smart Museum of Art, *Drawings from the Collection of The Arts Club of Chicago*, 1996, no cat.

REFERENCES: "'Young Woman'—Andre Derain," *Chicago Evening Post Magazine of the Art World*, Jan. 14, 1930 (illus.). Arts Club of Chicago, *Drawings*, 1966, exh. cat., n. pag. Idem, *Sixty Years on Stage*, 1975–76, exh. cat., 19.

Charles Despiau

French, 1874–1946
Portrait of Maria Lani,♦ c. 1927
Plaster; 55.9 (22)
Inscribed, on base: *Despiau*

PROVENANCE: Brummer Gallery, New York; Arts Club Purchase Fund, 1930.

EXHIBITIONS: Arts Club of Chicago, *Loan Exhibition of Sculpture by Charles Despiau,* 1932, no cat. no., n. pag. Arts Club of Chicago, *Exhibition of Modern Sculpture and Drawings by Sculptors,* 1933, no. 17, as *Head of Maria Lani.* New York, Brummer Gallery, *Despiau,* 1934, no. 22, as *Mme Maria Lany.*

REFERENCES: Brummer Gallery, *Portraits of Maria Lani by Fifty-one Painters,* New York, 1929, exh. traveled to The Arts Club of Chicago, no. 11, as *Despiau* (bronze). A.-H. Martinie, "Charles Despiau," *L'Amour de l'Art* 10 (Nov. 1929), 386 (illus.), as *Madame Maria Lany.* Ernest L. Heitkamp, "Despiau Works at Arts Club Win High Praise," *Chicago American,* May 17, 1932, 17 (illus.).

Wilhelm Hunt Diederich

American, born Hungary, 1884–1953
Three Boxers One Bullfighter, n.d.
Four paper cutouts; 18.7 x 22.9 (7³/₈ x 9), 18.7 x 22.9 (7³/₈ x 9), 20.3 x 27.9 (8 x 11), 19.1 x 23.9 (7¹/₂ x 9³/₈), respectively
Each signed, lower right: *Hunt Diederich*

PROVENANCE: Bequest of Arthur Heun, Chicago, 1947.

Alfeo Faggi

American, born Italy, 1885–?
Portrait of Alice Roullier, c. 1925
Bronze; 20.3 (8)

PROVENANCE: Gift of the artist to Alice Roullier, Chicago; bequeathed to Josephine R. (Mrs. Norman W.) Harris, Chicago, 1957; gift of Josephine Harris, 1964.

REFERENCES: Galleries of Chester H. Johnson, *An Exhibition of Sculpture and Original Drawings by Alfeo Faggi,* Chicago, 1926, no. 16, as *Miss Alice Roullier.*

Serge Férat

French, born Russia, 1881–1958
Little Guitar Fantasy (Petite Fantasie à la guitare), 1927
Gouache on paper; 16.5 x 9.2 (6¹/₂ x 3⁷/₈)
Signed and dated, lower right: *FERAT*/27

PROVENANCE: Bequest of Arthur Heun, Chicago, 1947.

EXHIBITIONS: Chicago, Main Street Gallery, *Exhibition of the Arthur Heun Collection of Modern Paintings and Drawings,* 1947, no. 28. Arts Club of Chicago, *Heun Collection,* 1947, no. 32.

Untitled, 1920s
Graphite on paper; 27.3 x 19.1 (10³/₄ x 7¹/₂)
Signed, lower right: *FERAT*

PROVENANCE: Bequest of Arthur Heun, Chicago, 1947.

EXHIBITIONS: Chicago, Main Street Gallery, *Exhibition of the Arthur Heun Collection of Modern Paintings and Drawings,* 1947, no. 30, as *Eight Drawings.* Arts Club of Chicago, *Heun Collection,* 1947, no. 34, as *Eight Drawings.*

The Circus (Le Cirque), 1920s
Graphite on paper; 27.7 x 18.8 (10⁷/₈ x 7³/₈)
Signed, lower right: *S. FERAT*

PROVENANCE: Albert Roullier Art Galleries, Chicago; Arthur Heun, Chicago; bequest of Arthur Heun, 1947.

EXHIBITIONS: Chicago, Main Street Gallery, *Exhibition of the Arthur Heun Collection of Modern Paintings and Drawings,* 1947, no. 30, as *Eight Drawings.* Arts Club of Chicago, *Heun Collection,* 1947, no. 34, as *Eight Drawings.*

Woman, Child, and Dog (Femme, enfant, et chien), 1920s
Gouache on paper; 12.1 x 9.2 (4³/₄ x 3⁵/₈)
Signed, lower right: *FERAT*

PROVENANCE: Albert Roullier Art Galleries, Chicago.

Jean-Michel Folon

Belgian, born 1934
The Chair, 1972
Watercolor and pencil on paper; 25.1 x 17.5 (9⁷/₈ x 6⁷/₈)
Signed, lower right: *Folon*

PROVENANCE: Gift of the artist, 1972.

EXHIBITIONS: Arts Club of Chicago, *Folon and Topor,* 1972, exh. traveled to Iowa City, University of Iowa, Museum of Art; and Minneapolis, University of Minnesota, University Gallery, no. 41.

REFERENCES: Arts Club of Chicago, *Sixty Years on Stage,* 1975–76, exh. cat., 23. Idem, *Seventy-Fifth,* 1992, exh. cat., 70.

Tsuguhara Foujita

French, born Japan, 1886–1968
Portrait of Girl with Red Hair,♦ 1926
Ink and watercolor on coated paper mounted on canvas; 33 x 26 (13 x 10¹/₄)
Signed and dated, lower left: [monogram]/*Foujita*/1926

PROVENANCE: Reinhardt Galleries, New York, by 1931; Arthur Heun, Chicago; bequest of Arthur Heun, 1947.

EXHIBITIONS: Possibly New York, Reinhardt Galleries, *Exhibition of Drawings, Paintings, and Watercolors by Picasso, Matisse, Derain, Modigliani, Braque, Dufy, Utrillo, Vlaminck, Laurencin, Henri Rousseau, Gauguin, Redon, and Others,* 1929, no. 2

or 3, as *Head of a Girl.* Arts Club of Chicago, *Paintings and Drawings by Tsuguhara Foujita,* 1931, no. 44, as *Portrait of Girl with Red Hair.* Arts Club of Chicago, *Heun Collection,* 1947, no. 35, as *Auburn Haired Girl.* Arts Club of Chicago, *Portrait of an Era,* 1986, no. 18, as *Portrait of a Girl with Red Hair.* University of Chicago, David and Alfred Smart Museum of Art, *Drawings from the Collection of The Arts Club of Chicago,* 1996, no cat.

REFERENCES: Arts Club of Chicago, *Seventy-Fifth,* 1992, exh. cat., 38.

Mary Frank

American, born England, 1933
Hand with Figures, 1975
Ceramic; 9.2 x 24.4 x 12.5 (3⁵/₈ x 9⁵/₈ x 4¹⁵/₁₆)

PROVENANCE: Zabriskie Gallery, New York; Charlotte Picher Purcell, Chicago, 1976; bequeathed to W. S. Picher, Chicago; gift of W. S. Picher, in memory of Charlotte Picher Purcell, 1981.

EXHIBITIONS: Arts Club of Chicago, *Mary Frank: Sculptures, Drawings, and Monoprints,* 1976, no. 25.

Alberto Giacometti

Swiss, 1901–1966
Portrait of James W. Alsdorf,♦ 1955
Pencil on paper; 19¹/₂ x 13 (49.5 x 33)
Inscribed, lower right: *Pour. J. W. Alsdorf. Alberto Giacometti/Paris, 19 Juillet 1955*

PROVENANCE: Gift of the artist to Marilynn Alsdorf, Winnetka; gift of Marilynn Alsdorf, 1997.

EXHIBITIONS: Arts Club of Chicago, *Drawings and Small Sculpture: Barlach, Brown, Derain, Frasconi, Giacometti, Greco, Janicki, Kolbe, Lachaise, Manolo, Marshall, Nadelman, Perlin, Pozatti,* 1958–59, no. 33, as *J. W. Alsdorf.* Chicago, Museum of Contemporary Art, *Twentieth-Century Drawings from Chicago Collections,* 1973, no cat. nos., n. pag.

Ralph Gibson

American, born 1939
Hand in the Doorway, from the series *The Somnabulist,* 1968
Silver gelatin print; 30.2 x 20.3 (11⁷/₈ x 8)
Artist's proof, from an edition of 25

PROVENANCE: Gift of Raymond W. Merritt, New York in memory of Arthur Cowen, Jr., 1990.

EXHIBITIONS: New York, International Center for Photography, *Tropism: Photographs by Ralph Gibson,* exh. traveled to The Arts Club of Chicago, 1989.

REFERENCES: Aperture Foundation, *Tropism: Photographs by Ralph Gibson,* New York, 1987, 21 (illus.). Arts Club of Chicago, *Seventy-Fifth,* 1992, exh. cat., 70.

Andy Goldsworthy
English, born 1956
Pond Earth and Leaves, 1991
Hickory leaves, peat, and hawthorn thorns mounted on paper in three panels; 121.9 x 213.4 (48 x 84)
Titled, signed, and dated, lower right

Forest Dunes, Michigan, August 21, 1991
Dye-coupled silver gelatin prints; 68.6 x 111.8 (27 x 44)
Titled, signed, and dated, lower right: FOREST DUNES, MICHIGAN. ANDY GOLDSWORTHY, 21 AUGUST 1991
Inscribed, lower left: DAMP SAND BROUGHT TO AN EDGE / TO CATCH THE EARLY MORNING LIGHT / FOLLOWING THE LAKE SIDE / ERODED BY LAPPING WATER / REWORKED UNSUCCESSFULLY
Inscribed, lower right: SAND RIDGES / SHORELINES / TO CATCH THE SETTING SUN ALONG EDGES / HAZY / NEEDED A STRONGER LIGHT

Map of Michigan Dunes Sand Project, August 21–26, 1991
Pen and ink on printed map; 38 x 35.4 (15 x 13^{15}/$_{16}$)
Inscribed: SAND / MICHIGAN DUNES / 21–26 AUGUST 1991 / A PROJECT COMMISSIONED BY THE CHICAGO ARTS CLUB

Forest Dunes, Michigan, August 22, 1991
Dye-coupled silver gelatin prints; 68.6 x 132.1 (27 x 52)
Titled, signed, and dated, lower right: FOREST DUNES, MICHIGAN. ANDY GOLDSWORTHY, 22 AUGUST 1991
Inscribed, lower left: SAND PRESSED TO AN EDGE / COMING OUT OF A HOLE / FILLING WITH WATER ON THE LARGER WAVES
Inscribed, lower left center: SHORELINE EDGES / CUT, DUG AND PILED / ERODING
Inscribed, lower right center: WET AND DRY SAND THROWS
Inscribed, lower right: WET SAND / WORKED IN AND OUT OF THE LAKE / PARTLY SMOOTHED AWAY BY WAVES

Day, Forest Dunes, Michigan,♦ August 24, 1991
Dye-coupled silver gelatin prints; 74.9 x 74.9 (29^{1}/$_{2}$ x 29^{1}/$_{2}$)
Titled, signed, and dated, lower right: DAY. FOREST DUNES, MICHIGAN. ANDY GOLDSWORTHY, 24 AUGUST 1991

Forest Dunes, Michigan, August 24, 1991
Dye-coupled silver gelatin prints; 68.6 x 160 (27 x 63)
Titled, signed, and dated, lower right: FOREST DUNES, MICHIGAN. ANDY GOLDSWORTHY, 24 AUGUST 1991
Inscribed, lower left: HOLE AND SLIT / FOR A SETTING YELLOWING MOON / OCCAISIONAL [SIC] CLOUDS / A LONG NIGHT
Inscribed, lower center: FOR THE EARLY MOONLIGHT / SCRAPED OUT BOULDERS OF SAND / PART SAND BED, PART PILED AND COMPACTED / WET SAND
Inscribed, lower right: REVISITED IN DAYLIGHT / HOLLOWED OUT THE BOULDERS / MADE HOLES / THE NIGHT INSIDE / ERODED BY SUN AND WIND FOR SEVERAL DAYS

Moon, Forest Dunes, Michigan, August 24, 1991
Dye-coupled silver gelatin prints; 74.9 x 76.2 (29^{1}/$_{2}$ x 30)
Titled, signed, and dated, lower right: MOON. FOREST DUNES, MICHIGAN. ANDY GOLDSWORTHY, 24 AUGUST 1991

Wind, Forest Dunes, Michigan, August 24, 1991
Dye-coupled silver gelatin prints; 74.9 x 74.9 (29^{1}/$_{2}$ x 29^{1}/$_{2}$)
Titled, signed, and dated, lower right: WIND. FOREST DUNES, MICHIGAN. ANDY GOLDSWORTHY, 24 AUGUST 1991

Forest Dunes, Michigan, August 25, 1991
Dye-coupled silver gelatin prints; 68.6 x 205.7 (27 x 81)
Titled, signed, and dated, lower right: FOREST DUNES, MICHIGAN. ANDY GOLDSWORTHY, 25 AUGUST 1991
Inscribed, lower left: HOLLOWED OUT FOR A RISING MOON / SMOOTHED AND SPRINKLED WITH DRY LIGHT SAND / REVISITED THE FOLLOWING MORNING / RISING SUN
Inscribed, lower left center: SAND SPIRE FOR THE MOON / BUILT STEEPLY / COLLAPSED TWICE UNDER THE WEIGHT OF WET SAND / MADE AT NIGHT TO ERODE IN THE DAY / SUN AND WIND
Inscribed, lower right center: LINES TO FOLLOW COLOURS IN STONES
Inscribed, lower right: WET SAND / THROWN INTO A HAZY SKY

Forest Dunes, Michigan, August 26, 1991
Dye-coupled silver gelatin prints; 68.6 x 99.1 (27 x 39)
Titled, signed, and dated, lower right: FOREST DUNES, MICHIGAN. ANDY GOLDSWORTHY, 26 AUGUST 1991
Inscribed, lower left: CUT LINE / SPRINKLED WITH DRY SAND / WASHED AWAY FROM ONE END
Inscribed, lower center: HOLLOWED OUT SAND / TURNED TOWARDS THE LAKE
Inscribed, lower right: DRY SAND THROWN INTO AN EVENING SKY / GOING DARK / MY LAST WORK FOR THE LAKE

Map of Illinois Woods Leaves Project, August 28–September 3, 1991
Pen and ink on printed map; 38 x 35.4 (15 x 13^{15}/$_{16}$)
Inscribed: LEAVES / ILLINOIS WOODS / 28 AUGUST–3 SEPTEMBER 1991 / A PROJECT COMMISSIONED BY THE CHICAGO ARTS CLUB

West Dundee, Illinois, August 28, 1991
Dye-coupled silver gelatin prints; 68.6 x 104.1 (27 x 41)
Titled, signed, and dated, lower right: WEST DUNDEE, ILLINOIS. ANDY GOLDSWORTHY, 28 AUGUST 1991
Inscribed, lower left: FIRST DAY IN A NEW PLACE / A WORK FOR THE PATCHY FOREST LIGHT / BUT IN A PLACE TOO DARK / FOUND A CLEARING MADE BY A FALLEN TREE / TO WORK THE FOLLOWING DAY?
Inscribed, lower center: YELLOW LEAVES / TORN STRIPS / STITCHED TO GREEN LEAVES WITH TWIGS / LAID ON WATER
Inscribed, lower right: LEAF THROW

West Dundee, Illinois, August 29, 1991
Dye-coupled silver gelatin prints; 68.6 x 70.5 (27 x 27^{3}/$_{4}$)
Titled, signed, and dated, lower right: WEST DUNDEE, ILLINOIS. ANDY GOLDSWORTHY, 29 AUGUST 1991
Inscribed, lower left: STARTED EARLY / RETURNED TO PLACE FOUND YESTERDAY / WORKED TOWARDS THE MIDDAY SUN / WHEN THE CLEARING WOULD BE LIT / OAK LEAVES / TORN DOWN CENTRE VIEW / PINNED TO ARCHED STICKS WITH THORNS
Inscribed, lower right: LEAF PILE / FOLLOWING THE COLOURS / MAINLY WILD CHERRY

West Dundee, Illinois,♦ August 30, 1991
Dye-coupled silver gelatin prints; 68.6 x 94 (27 x 37)
Titled, signed, and dated, lower right: WEST DUNDEE, ILLINOIS. ANDY GOLDSWORTHY, 30 AUGUST 1991
Inscribed, lower left: OAK LEAVES / CREASED TO CATCH THE LIGHT / PINNED TO TREE WITH THORNS
Inscribed, lower right: STICKS STACKED AROUND TWO TREES

West Dundee, Illinois, August 31, 1991
Dye-coupled silver gelatin prints; 68.6 x 121.9 (27 x 48)
Titled, signed, and dated, lower right: WEST DUNDEE, ILLINOIS. ANDY GOLDSWORTHY, AUGUST 31, 1991
Inscribed, lower left: LEAF THROWS / WINDY
Inscribed, lower right: LINE TO FOLLOW COLOURS IN LEAVES / SLOWLY FED OUT TO MAKE A LINE / FLOATING DOWN STREAM

West Dundee, Illinois, September 1, 1991
Dye-coupled silver gelatin prints; 68.6 x 99.1 (27 x 39)
Titled, signed, and dated, lower right: WEST DUNDEE, ILLINOIS. ANDY GOLDSWORTHY, 1 SEPTEMBER 1991
Inscribed below left photograph: RASPBERRY LEAVES IN GRASS / AT NIGHT / WHITE UNDERSIDES / CATCHING THE HALF MOONLIGHT
Inscribed below center photograph: RETURNED TO PLACE FOUND A FEW DAYS AGO / TO WORK THE LIGHT AND SHADOWS / A SLIT MADE ALONG THE TORN EDGE OF LEAVES / REVISITED TWO DAYS LATER / WASHED AWAY BY HEAVY RAIN
Inscribed below right photograph: HOLE IN LEAVES / FLOATING ROUND / COLLECTING DEBRIS

West Dundee, Illinois, September 2, 1991
Dye-coupled silver gelatin prints; 68.6 x 116.8 (27 x 46)
Titled, signed, and dated, lower right: WEST DUNDEE, ILLINOIS. ANDY GOLDSWORTHY, 2 SEPTEMBER 1991
Inscribed, lower left: ROCK / WRAPPED WITH GREEN LEAVES / HELD WITH WATER

Inscribed, lower center: *LINES TO FOLLOW COLOURS IN LEAVES / FIRST TOUCHES OF AUTUMN*

***West Dundee, Illinois**,* September 3, 1991
Dye-coupled silver gelatin prints; 68.6 x 38.1 (27 x 15)
Titled, signed, and dated, lower center: *WEST DUNDEE, ILLINOIS. ANDY GOLDSWORTHY, 3 SEPTEMBER 1991*
Inscribed, lower center: *DAY OF LEAVING / HAVING BREAKFAST / BEGAN TO RAIN / SLOWLY / LAY DOWN OUTSIDE / FOR A LONG TIME / BEFORE RAINED ENOUGH TO LEAVE / A SHADOW*

PROVENANCE: Arts Club commission 1991.

EXHIBITIONS: Arts Club of Chicago, *Andy Goldsworthy: Sand Leaves—Michigan Dunes, August 1991 / Illinois Woods, September 1991*, 1991, no cat. nos., n. pag. (some illus.).

Natalia Goncharova
French, born Russia, 1881–1962
***Spring (Printemps)**,*◆ 1927/28
Five-panel floor screen, oil on canvas stretched over frame; each panel 243.8 x 81.3 (96 x 32)

PROVENANCE: Arts Club commission, 1927–28.

EXHIBITIONS: Arts Club of Chicago, *Screen by Natalia Goncharova*, 1928. Arts Club of Chicago, *Loan Exhibition of Modern Paintings Privately Owned by Chicagoans*, 1929, no. 69, as *Screen*. Arts Club of Chicago, *Paintings by Three Women Painters: Hermine David, Natalie Gontcharova, Alice Halicka*, 1935, no. 25, as *Screen*. Arts Club of Chicago, *Portrait of an Era*, 1986, no. 20 (illus.).

REFERENCES: Jeff Lyon, "State of the Art," *Chicago Tribune Magazine*, Oct. 12, 1986, 17.

***Untitled**,*◆ late 1920s/1930s
Graphite on paper; 51.3 x 36.1 (20¹/₄ x 14¹/₄)
Signed, lower left: *N. Gontcharova*

PROVENANCE: Unknown.

Etienne Hajdu
French, born Romania, 1907
***Milly**,* 1960
Black marble; 74.9 (29¹/₂)
Signed and dated, on base: *60*

PROVENANCE: Galerie Jeanne Bucher, Paris; M. Knoedler and Co., New York; gift of Grover Hermann, Chicago, 1963.

EXHIBITIONS: New York, M. Knoedler and Co., *Hajdu*, 1962–63, exh. traveled to Cincinnati, Contemporary Arts Center; Arts Club of Chicago, no. 17 (illus.).

REFERENCES: R. V. Gindertael, "Situations Actuelles de la Sculpture dans le Cadre de l'Ecole de Paris," *Quadrum* (Brussels) 12 (1961), p. 28 (illus.). Etienne Hajdu, "I Carve to Live," *Chicago Daily News Panorama*, Feb. 2, 1963 (illus.). Arts Club of Chicago, *Drawings*, 1966, exh. cat., n. pag., as *Millie*. Idem, *Sixty Years on Stage*, 1975–76, exh. cat., 19, as *Millie*.

***Regnes**,* 1961
Text by Pierre Lecuire; printed by Marthe Fequet and Pierre Baudier
Thirteen inkless intaglios and twenty pages of text set in Elzevir ancient type, on Auvergne paper; 41.3 x 36.8 (16¹/₄ x 14¹/₂)
Numbered: 33/98

PROVENANCE: Gift of the artist, 1963.

EXHIBITIONS: Arts Club of Chicago, *Books Illustrated by Painters and Sculptors, from 1900*, 1980, no. 30.

REFERENCES: Arts Club of Chicago, *Drawings*, 1966, exh. cat., n. pag. Idem, *Sixty Years on Stage*, 1975–76, exh. cat., 19.

Barbara Hepworth
British, 1903–1975
***Pierced Round Form**,*◆ 1959/60
Polished bronze; 21.6 x 10.8 x 21.6 (8¹/₂ x 4¹/₄ x 8¹/₂)
Number 8 from an edition of 10

PROVENANCE: Gimpel Fils, London; Dr. Gerhard Straus, Milwaukee; B. C. Holland, Chicago; Helen Harvey Mills, Chicago, 1971; gift of Helen Harvey Mills, 1996.

REFERENCES: J. Hodin, *Barbara Hepworth*, New York, 1961, catalogue by Alan Bowness, 170, no. 272. Whitechapel Art Gallery, *Barbara Hepworth: An Exhibition of Sculpture from 1952–1962*, London, 1962, exh. cat., no. 52.

Margo Hoff
American, born 1912
***Picasso's 'Bather,'** * 1977
Color lithograph; 47 x 36.2 (18¹/₂ x 14¹/₄)
Signed, lower right: *M. Hoff*
Numbered, lower left, in pencil: *61/200*

PROVENANCE: Gift of Gould, Inc., Rolling Meadows, Illinois, 1977.

Indian, Provincial Mughal
***Women Drawing Water from a Well**,*◆ late 17th/early 18th century
Ink and colors on paper; 11.4 x 17.8 (4¹/₂ x 7)

PROVENANCE: Hassan Khan Monif, New York; gift of John Palmer, Chicago, 1965.

EXHIBITIONS: Possibly Boston, Messrs. Doll and Richard, *Important Exhibition and Private Sale of Rare Near East Antiquities from the Collection of Mr. Hassan Khan Monif*, 1925, no cat. nos., n. pag. Possibly Arts Club of Chicago, *Rare Persian Antiquities from the Collection of Mr. H. Khan Monif*, 1927.

REFERENCES: Arts Club of Chicago, *Drawings*, 1966, exh. cat., n. pag. Idem, *Sixty Years on Stage*, 1975–76, exh. cat., 19.

Iranian, Safavid period
***Khosrow and Shirin in a Pavilion**,*◆ illustration from the *Khamseh of Nezami*, 16th century
Ink and colors on paper; 17.8 x 11.1 (7 x 4³/₈)

PROVENANCE: Hassan Khan Monif, New York; gift of John Palmer, Chicago, 1965.

EXHIBITIONS: Possibly Chicago, O'Brien Galleries, *The R. Khan Monif Collection of Rare Persian Antiquities*, 1919, no. 12, as *Timurid school, Khosraw and Shiryn*. Possibly Boston, Messrs. Doll and Richard, *Important Exhibition and Private Sale of Rare Near East Antiquities from the Collection of Mr. Hassan Khan Monif*, 1925, no cat. nos., n. pag. Possibly Arts Club of Chicago, *Rare Persian Antiquities from the Collection of Mr. H. Khan Monif*, 1927.

REFERENCES: Arts Club of Chicago, *Drawings*, 1966, exh. cat., n. pag. Idem, *Sixty Years on Stage*, 1975–76, exh. cat., 19.

Robert Edmond Jones
American, 1887–1954
***Costume Design for Lady Quenchthirst**,* for the play *Edward IV*, 1918
Gouache and pencil on paper; 62.2 x 43.2 (24¹/₂ x 17)
Signed and dated, lower right
Inscribed, upper left: *Lady Quenchthirst / (Edward IV 1461–83)*

PROVENANCE: Bequest of Arthur Heun, Chicago, 1947.

***Six Costume Designs for the Ballet** Skyscrapers,* 1918

Solo Dancer, Coney Island
Pencil, ink, and watercolor on paper; 33.7 x 26.7 (13¹/₄ x 10¹/₂)
Inscribed, right: *Solo Dancer Coney Island / (1+4) / Red flannel undershirt / Black satin sash / Exaggerated trousers*
Inscribed, left: *Exaggerated / top-hat of / black oilcloth → / Celluloid / Collar + cuffs / Lemon yellow cotton / gloves much too large*

Untitled (Woman in Slacks)
Ink and colored crayon on paper; 25.4 x 19.1 (10 x 7¹/₂)

Workmen
Pencil, ink, watercolor, and colored crayon, with fabric and pin on paper; 33.7 x 26 (13¹/₄ x 10¹/₄)
Inscribed, right: *Workmen / (14) Boys / Masks / Grey overalls / with pockets / of dull silva / cloth (stiffened)*
Inscribed, left: *Red Rubber / Elbow-gloves / (large)*

White-Wings (Trash Collector)
Pencil, ink, and watercolor on paper; 33.7 x 26.7 (13¹/₄ x 10¹/₂)
Inscribed, right: *White-Wings / (1) / no wings / no flowers*

Untitled (Woman with Animal Stole)
Pencil, ink, and colored crayon on paper; 25.4 x 19.1 (10 x 7 1/2)

Sandwich-Men, Coney Island
Ink, watercolor, and pencil on paper; 33.7 x 26.4 (13 1/4 x 10 3/8)
Inscribed, right: (12) / outside sup / Old broken high hat / with placard / ← scarf / ← Old over-shoes, / much too large
Inscribed, left: *Sandwich-Men / Coney Island / Masks →/ Old coat (too loose)* →

PROVENANCE: John Alden Carpenter, Chicago; gift of Ellen W. Waller, Chicago, 1962.

REFERENCES: Arts Club of Chicago, *Drawings*, 1966, exh. cat., n. pag. Idem, *Sixty Years on Stage*, 1975–76, exh. cat., 19.

Paul Klee
Swiss, 1879–1940
Submersion and Separation (Senkung und Scheidung),◆ 1923
Graphite and watercolor on paper; 24.8 x 31.8 (9 3/4 x 12 1/2)
Titled, lower center: *Senkung und Scheidung*
Inscribed, lower center: *1923/130*

PROVENANCE: Arthur Heun, Chicago, by 1930; bequest of Arthur Heun, Chicago, 1947.

EXHIBITIONS: Munich, Galerie Hans Goltz, *Paul Klee, 2.Gesamtausstellung, 1920/1925*, 1925, no. 96. Arts Club of Chicago, *Drawings and Sculpture Privately Owned*, 1930, no. 53, as *Submission and Parting*. Arts Club of Chicago, *Loan Exhibition of Modern Paintings and Drawings from Private Collections in Chicago*, 1938, no. 62, as *Submission*. Arts Club of Chicago, *Paul Klee Memorial Exhibition*, 1941, no. 76, as *Submission and Parting*. Arts Club of Chicago, *Heun Collection*, 1947, no. 51, as *Submission*. Arts Club of Chicago, *Paul Klee*, 1956, no. 41, as *Submission*. Arts Club of Chicago, *Paul Klee*, 1962, no. 14, as *Submission*. Chicago, Museum of Contemporary Art, *Art in a Turbulent Era: German and Austrian Expressionism*, 1978, no cat. nos., 28, as *Submission*. Des Moines Art Center, *Paul Klee: The Bauhaus Years, 1921–1931*, 1973, no. 18 (illus.), 8. Chicago, Worthington Gallery, *Paul Klee, 1879–1940: A Tribute in Celebration of the Artist's Centennial Year*, 1979, no. 10. Arts Club of Chicago, *Seventy-Fifth*, 1992, no cat. nos., 28 (illus.), 38, 102. University of Chicago, David and Alfred Smart Museum of Art, *Drawings from the Collection of The Arts Club of Chicago*, 1996, no cat. Museum of Contemporary Art, Chicago, *Negotiating Rapture: The Power of Art to Transform Lives*, 1996, no. 35 (illus.), 114–15.

REFERENCES: Buchholz Gallery and Willard Gallery, *Paul Klee Exhibition*, New York, 1940, exh. cat., n. pag. Andrew Kagan, *Paul Klee: Art and Music*, Ithaca, 1983, 112–13, fig. 52. Arts Club of Chicago, *Seventy-Fifth*, 1992, exh. cat., 38.

Sicilian Flora in September (Sizilische Flora im September),◆ 1924
Graphite and watercolor on paper; 22.2 x 28.6 (8 3/4 x 11 1/4)
Signed, upper left: *Klee*
Titled, lower right: *Sizilische Flora im September*
Inscribed, lower left: *1924/240*

PROVENANCE: Arthur Heun, Chicago, by 1930; bequest of Arthur Heun, Chicago, 1947.

EXHIBITIONS: Munich, Galerie Hans Goltz, *Paul Klee, 2.Gesamtausstellung, 1920/1925*, 1925, no. 186. Arts Club of Chicago, *Modern Drawings and Sculpture Privately Owned*, 1930, no. 52, as *Sicilian Sands*. Arts Club of Chicago, *Loan Exhibition of Modern Paintings and Drawings from Private Collections in Chicago*, 1938, no. 63, as *Sicilian Flora*. Arts Club of Chicago, *Paul Klee Memorial Exhibition*, 1941, no. 75, as *Sicilian Sands*. Arts Club of Chicago, *Heun Collection*, 1947, no. 50, as *Sicilian Flora*. Arts Club of Chicago, *Paul Klee*, 1956, no. 42. Arts Club of Chicago, *Paul Klee*, 1962, no. 17. Chicago, Museum of Contemporary Art, *Art in a Turbulent Era: German and Austrian Expressionism*, 1978, no cat. nos., 24–25 (illus.), 28. Chicago, Worthington Gallery, *Paul Klee, 1879–1940: A Tribute in Celebration of the Artist's Centennial Year*, 1979, no. 13. University of Chicago, David and Alfred Smart Museum of Art, *Drawings from the Collection of The Arts Club of Chicago*, 1996, no cat.

REFERENCES: Buchholz Gallery and Willard Gallery, *Paul Klee Exhibition*, New York, 1940, exh. cat., n. pag., as *Sicily*. Peter Selz, *Art in a Turbulent Era*, Ann Arbor, 1985, 90. Arts Club of Chicago, *Seventy-Fifth*, 1992, exh. cat., 38.

Walt Kuhn
American, 1877–1949
Study for Trio,◆ c. 1937
Graphite and watercolor on tan wove paper; 27.6 x 15.2 (10 7/8 x 6)
Signed, lower right: *WK*

PROVENANCE: Gift of Helen Harvey Mills, Chicago, 1995.

Kurumban, Burkina Faso
Adone (Antelope Headdress),◆ c. 1920s
Wood painted with white, blue, and reddish pigments; 104.1 (41)

PROVENANCE: Elizabeth Goodspeed Chapman, Chicago; Phillips, New York, March 3–4, 1981, no. 469 (illus.); gift of Mr. James Alsdorf, Mr. William McCormick Blair, Mr. Leigh B. Block, Mrs. Allerton Cushman, Mrs. Eugene Davidson, Mrs. Donald B. Douglas, Mrs. Robert D. Graff, Mrs. C. Phillip Miller, Mrs. William H. Mitchell, Mrs. Curtis B. Munson, Mrs. Walter Paepcke, Mrs. Ruth Page, Mrs. William Wood-Prince, Mrs. Edward B. Smith, and Mrs. John Welling, in memory of Elizabeth Goodspeed Chapman by her friends, 1981.

REFERENCES: Arts Club of Chicago, *Seventy-Fifth*, 1992, exh. cat., 70.

Jean-Emile Laboureur
French, 1877–1943
Untitled, n.d.
Graphite on paper; 25.6 x 16.7 (10 1/16 x 6 9/16)

PROVENANCE: Unknown.

Mikhail Fyodorovich Larionov
French, born Russia, 1881–1964
Costume Design for Karagueuz,◆ 1925/26
Pen and ink and watercolor on paper; 31.8 x 21.6 (12 1/2 x 8 1/2)
Signed, lower right: *M. Larionov*

PROVENANCE: Unknown.

Untitled,◆ c. 1922
Watercolor on paper; 41.9 x 50.8 (16 1/2 x 20)
Signed, upper right: *M. L.*
Inscribed, lower left: *À cher Madame Carpenter / M. Larionov Paris 3-V-22*

PROVENANCE: Gift of the artist to Rue Winterbotham Carpenter, Chicago, May 3, 1922; bequeathed to Theodora Winterbotham Brown, Chicago, 1931; gift of Theodora Brown in memory of Rue Winterbotham Shaw, 1980.

Marie Laurencin
French, 1885–1956
Seated Figure, c. 1924
Watercolor, pastel, and charcoal on paper; 47.5 x 32.6 (18 3/4 x 12 7/8)
Signed, lower right: *Marie Laurencin*

PROVENANCE: Bequest of Arthur Heun, Chicago, 1947.

EXHIBITIONS: Arts Club of Chicago, *Drawings and Sculpture Privately Owned*, 1930, no. 58, as *Seated Figure*. Arts Club of Chicago, *Heun Collection*, 1947, no. 55, as *Girl with Cat*.

Louis Marcoussis
French, born Poland, 1883–1941
Gertrude Stein and Alice B. Toklas,◆ 1934
Etching; 47 x 34.3 (18 1/2 x 13 1/2)
Signed, lower right: *Marcoussis*
Inscribed, lower left: *2e état 3/5*

PROVENANCE: Alice Roullier, Chicago; Arthur Heun Memorial Purchase Fund, 1957.

EXHIBITIONS: Arts Club of Chicago, *Sixty Years on Stage*, 1975–76, no. 98.

REFERENCES: Arts Club of Chicago, *Original Etchings by Louis Marcoussis*, 1934, exh. cat., nos. 84–85 (different states). New York, M. Knoedler and Company, *Original Etchings and Engravings by Louis Marcoussis*, 1935, exh. cat., no. 71. Palais des Beaux-Arts, *Louis Marcoussis: Gravures, eaux-fortes*, Brussels, 1936, exh. cat., no. 131. Jean Lafranchis, *Marcoussis: Sa vie, son oeuvre*, Paris, 1961, no. G.

108, 223–24. Musée National d'Art Moderne, *Louis Marcoussis,* Paris, 1964, exh. cat. by Antoinette Huré, no. 175. Arts Club of Chicago, *Drawings,* 1966, exh. cat., n. pag. Bibliothèque Nationale, *Marcoussis: L'Ami des poètes,* Paris, 1972, exh. cat. by Anne-Marie Mousseigne de Leyritz, no. 53. Arts Club of Chicago, *Sixty Years on Stage,* 1975–76, exh. cat., 15. Solange Milet, *Louis Marcoussis: Catalogue raisonné de l'oeuvre gravé,* Copenhagen, 1991, no. 154 (illus.), 552–53, 555–57. Arts Club of Chicago, *Seventy-Fifth,* 1992, exh. cat., 38.

Gertrude Stein,♦ 1934
Drypoint and burin (9th and final state); 37.5 x 27.9 (14³/₄ x 11)
Signed and dated, lower right: *Marcoussis 1934*
Signed, lower right, on paper mount: *Marcoussis*
Inscribed, lower left, on paper mount: *4/10*

PROVENANCE: Gift of Alice Roullier, Chicago, 1957.

EXHIBITIONS: Arts Club of Chicago, *Original Etchings by Louis Marcoussis,* 1934, no. 83. Arts Club of Chicago, *Sixty Years on Stage,* 1975–76, no. 98.

REFERENCES: New York, M. Knoedler and Company, *Original Etchings and Engravings by Louis Marcoussis,* 1935, exh. cat., no. 70. Palais des Beaux-Arts, *Louis Marcoussis: Gravures, eaux-fortes,* Brussels, 1936, exh. cat., no. 115. Galerie La Hune, *L'Oeuvre gravé de Louis Marcoussis, 1912–1941,* Paris, 1945, exh. cat., no. 20. Alice Halicka, *Hier: Souvenirs,* Paris, 1946, facing 96 (illus.). Jean Lafranchis, *Marcoussis: Sa vie, son oeuvre,* Paris, 1961, no. G. 107, 161 (illus.), 223–24. Alice Halicka-Marcoussis, "Louis Marcoussis und das 'Bateau-Laboir,'" *Die Kunst und das schöne Heim* 63 (Oct. 1964), 8 (illus.). Nouveau Musée du Havre, *Marcoussis: L'Ami des poètes,* 1966, exh. cat., no. 53. Jean-Paul Crespelle, *La Folle époque des ballets russes au surréalisme,* Paris, 1968, 102 (illus.). Bibliothèque Nationale, *Marcoussis: L'Ami des poètes,* Paris, 1972, exh. cat. by Anne-Marie Mousseigne de Leyritz, no. 52. Nihonbashi Mitsukoshi, *Le Bateau-Lavoir,* Tokyo and Osaka, 1977, exh. cat. by Jeanine Warnod, no. 89. Solange Milet, *Louis Marcoussis: Catalogue raisonné de l'oeuvre gravé,* Copenhagen, 1991, no. 153 (illus.), 552–54, 556–58.

Henri Matisse
French, 1869–1954
Untitled,♦ c. 1922
Charcoal on ivory laid paper; 45.7 x 59.7 (18 x 23¹/₂)
Signed, lower right: *Henri Matisse*

PROVENANCE: Arthur Heun, Chicago, by 1930; bequest of Arthur Heun, 1947.

EXHIBITIONS: Arts Club of Chicago, *Modern Drawings and Sculpture Privately Owned,* 1930, no. 51, as *Nude.* Arts Club of Chicago, *Exhibition of Modern Sculpture and Drawings by Sculptors,* 1933, no. 95, as *Reclining Nude.* Arts Club of Chicago, *Loan Exhibition of Modern Paintings and Drawings from Private Collections in Chicago,* 1938, no. 79, as

Nude. New York, Museum of Modern Art, *Modern Drawings,* 1944, exh. cat. by Monroe Wheeler, no cat. nos., 94, as *Reclining Nude.* Arts Club of Chicago, *Heun Collection,* 1947, no. 63, as *Nude.* Arts Club of Chicago, *Drawings,* 1966, no. 66 (illus.), as *Reclining Figure.* Chicago, B. C. Holland Gallery, *Matisse Drawings,* 1967, no cat. University of Chicago, David and Alfred Smart Museum of Art, *Drawings from the Collection of The Arts Club of Chicago,* 1996, no cat.

REFERENCES: "Drawing by Henri Matisse," *Chicago Evening Post Magazine of the Art World,* Dec. 24, 1929 (illus.), as *Charcoal Drawing.* Museum of Modern Art, *Matisse: His Art and His Public,* New York, 1951, exh. cat. by Alfred H. Barr, Jr., 558. Arts Club of Chicago, *Seventy-Fifth,* 1992, exh. cat., 38.

Ludwig Mies van der Rohe
German, 1886–1969
Main Staircase for The Arts Club of Chicago,♦ 1948–51
Painted steel, travertine marble; 359.4 x 458.8 x 609.3 (141¹/₂ x 180⁵/₈ x 239⁷/₈)

REFERENCES: Philip C. Johnson, *Mies van der Rohe,* 2d ed., New York, 1953, 177 (illus.). Arts Club of Chicago, *Mies van der Rohe: Interior Spaces,* 1982, exh. cat. by Franz Schulze, no. 18, 34–35, 43 (illus.). Franz Schulze, *Mies van der Rohe: A Critical Biography,* Chicago, 1985, 270–71 (illus.). Museum of Contemporary Art, Chicago, *Mies van der Rohe in Chicago: A Guide,* 1986, n. pag. (illus.). Franz Schulze, ed., *The Mies van der Rohe Archive: An Illustrated Catalogue of the Mies van der Rohe Drawings in The Museum of Modern Art, Part II: 1938–1967, The American Work, Volume 14: Algonquin Apartment Buildings, The Arts Club of Chicago, and Other Buildings and Projects,* New York, 1992, 224–26 (illus.), 330, 333–45. Blair Kamin, "Arts Club's Interior Gets a Reprieve," *Chicago Tribune,* Oct. 6, 1994 (illus.). Paul Goldberger, "Ah, Chicago: Build New Landmarks, Bash Old Ones," *New York Times,* Oct. 19, 1994 (illus.). Alf Siewers, "Arts Club Loses Survival Bid," *Chicago Sun-Times,* Oct. 20, 1994 (illus.). Franz Schulze, "Protest: Mies-Designed Interior Faces Demolition," *Architecture* 83 (Dec. 1994), 37 (illus.). Charles Storch and Blair Kamin, "Arts Club to Build New Home; Fate of Mies Staircase Still Floating," *Chicago Tribune,* Jan. 5, 1995. Blair Kamin, "Creative Opportunity Knocks: New Arts Club Homes Presents a Chance to Be Bold," *Chicago Tribune,* Jan. 15, 1995 (illus.). Cheryl Kent, "They All Fall Down: In Chicago Even a Mies van der Rohe Design Isn't Enough to Stop the Wrecking Ball," *Progressive Architecture* 76 (Apr. 1995), 39 (illus.). M. W. Newman, "Arts Club's Famed Stairs May Rise Again: Plan Calls for Display in Group's New Home," *Chicago Tribune,* July 7, 1995 (illus.).

PROVENANCE: Arts Club commission, 1948–51.

Joan Miró
Spanish, 1893–1983
Personage and Birds in Front of the Sun (Personnage et oiseaux devant le soleil),♦ October 20, 1942
Ink and gouache on paper; 47 x 64.1 (18¹/₂ x 25¹/₄)
Signed, lower right: *Miró*
Inscribed, verso, upper left center: *6 / Joan Miró / Personnage et oiseaux devant le soleil / x / Barcelona, 20-10-1942 / JM 456*

PROVENANCE: Sold by the artist to Pierre Matisse Gallery, New York, 1947; Friends of Alice Roullier and Arts Club Purchase Fund, April 1965.

EXHIBITIONS: New York, Pierre Matisse Gallery, *Miró: Pastels, Gouaches, Drawings, Sculptures, 1933–1943,* 1949, no. 25. University of Chicago, David and Alfred Smart Museum of Art, *Drawings from the Collection of The Arts Club of Chicago,* 1996, no cat.

REFERENCES: Arts Club of Chicago, *Drawings,* 1966, exh. cat., n. pag. Idem, *Sixty Years on Stage,* 1975–76, exh. cat., 19. Museum of Fine Arts, *Miró in America,* Houston, 1982, exh. cat. by Barbara Rose, 141. Arts Club of Chicago, *Seventy-Fifth,* 1992, exh. cat., 41.

Henry Moore
British, 1898–1986
Two Standing Figures,♦ 1949
Silkscreen on linen mounted on panel; 264.2 x 182.9 (104 x 72)
Signed and dated, lower right: *Moore/49*
Numbered, lower left: *1/30*

PROVENANCE: Ascher, Ltd., London; gift of Ann and Everett C. McNear, Evanston, October 1963.

EXHIBITIONS: Arts Club of Chicago, *Henry Moore: Sculpture and Drawings from Chicago Collections,* 1959–60, no. 81.

REFERENCES: Buchholz Gallery, *Ascher Panels Designed by Henri Matisse and Henry Moore,* New York, 1949, exh. cat., no. 4 (illus. on cover). Arts Club of Chicago, *Drawings,* 1966, exh. cat., n. pag. Idem, *Sixty Years on Stage,* 1975–76, exh. cat., 19. Jeff Lyon, "State of the Art," *Chicago Tribune Magazine,* Oct. 12, 1986 (illus.). Arts Club of Chicago, *Seventy-Fifth,* 1992, exh. cat., 70.

Malcolm Morley
British, born 1931
Figures (Minoans),♦ 1982
Watercolor on paper; 38.1 x 48.3 (15 x 19)

PROVENANCE: Michael Klein Gallery, New York; Arts Club Purchase Fund, 1996.

EXHIBITIONS: New York, Michael Klein Gallery, *Malcolm Morley: Selected Drawings, 1977–1995,* 1995–96, no cat. Arts Club of Chicago, *Malcolm Morley: A Selection of Watercolors from 1976 to 1995,* 1996, not in cat.

Louise Nevelson

American, born Russia, 1899–1988
Untitled,◆ 1966
Photo-screenprints on paper, and orthochromatic film positives, cut-and-taped on ivory 2-ply rag board; 66 x 50.8 (26 x 20)
Signed, lower left: *Nevelson*

PROVENANCE: Gift of the artist and Pace Gallery, New York, 1968.

REFERENCES: Arts Club of Chicago, *Sixty Years on Stage*, 1975–76, exh. cat., 23. Idem, *Seventy-Fifth*, 1992, exh. cat., 70.

Isamu Noguchi

American, 1904–1988
Portrait of Marion Greenwood,◆ 1929
Graphite on paper; 42.2 x 26.7 (16⅝ x 10½)
Signed and dated, lower left: *Isamu Noguchi 1929*

PROVENANCE: Gift of the artist, 1930.

EXHIBITIONS: Arts Club of Chicago, *Loan Exhibition of Drawings by Sculptors Privately Owned by Chicagoans*, 1932, not in cat. Arts Club of Chicago, *Exhibition of Modern Sculpture and Drawings by Sculptors*, 1933, no. 102, as *Head*. Arts Club of Chicago, *Drawings*, 1966, no. 86, as *Girl's Head*. University of Chicago, David and Alfred Smart Museum of Art, *Drawings from the Collection of The Arts Club of Chicago*, 1996, no cat.

REFERENCES: Robert Andrews, "Arts Club to Keep Show Open for Another Week," *Chicago Daily News*, June 2, 1932, as *Head*.

Untitled,◆ 1930
Black crayon on paper mounted to masonite; 177.8 x 91.4 (70 x 36)
Signed and dated, lower right: *Isamu 30*

PROVENANCE: Arts Club Purchase Fund, 1932.

EXHIBITIONS: New York, Demotte Gallery, *Brush Drawings by Isamu Noguchi*, 1932, no cat. Arts Club of Chicago, *Brush Drawings and Sculpture by Isamu Noguchi*, 1932, as one of fifteen *Brush Drawings*. Arts Club of Chicago, *Noguchi: Sculpture and Scroll Drawings*, 1955, no. 37, as *Figure*. Arts Club of Chicago, *Portrait of an Era*, 1986, no. 22 (illus.). University of Chicago, David and Alfred Smart Museum of Art, *Drawings from the Collection of The Arts Club of Chicago*, 1996, no cat.

Claes Oldenburg

American, born Sweden, 1929
Chicago Stuffed with Numbers, 1977
Lithograph on Arches Cover, mold-made
119.4 x 77.5 (47 x 30½)
Signed, lower right: *Oldenburg*
Numbered, lower left: 4/85

PROVENANCE: Commission, Art Institute of Chicago, 1977; sold to Marilynn Alsdorf, Winnetka, 1977; gift of Marilynn Alsdorf, 1997.

REFERENCES: Minneapolis, Walker Art Center, *Tyler Graphics: Catalogue Raisonné, 1974–1985*, 1987, 280–81, no. 477:CO1 (illus.). Minneapolis, Walker Art Center, *Tyler Graphics: The Extended Image*, 1987, 136–38 (illus.).

Francis Picabia

French, 1879–1953
This Thing Is Made to Perpetuate My Memory (Cette chose est faite pour perpétuer mon souvenir),◆ 1915
Ink, gouache or watercolor, and silver and bronze paint on board; 99 x 101.6 (39 x 40)
Signed, lower left: *Picabia*
Inscribed: *Cette Chose Est Faite Pour Perpetuer Mon Souvenir/Lis / C'est Clair Comme Le Jour / Ils Tournent / Vous avez des Oreilles Et Vous N'Entendrez Pas*

PROVENANCE: Gabrielle Buffet-Picabia, Paris, by 1946. Rose Fried Gallery, New York; Arthur Heun Memorial Purchase Fund, April 1955.

EXHIBITIONS: New York, Modern Gallery, *Picabia Exhibition*, 1916, no. 2. Paris, Grand Palais des Champs-Elysées, Société des "Artistes Indépendants," *Trente-et-unième Exposition*, 1920, no. 3550, as *Cette Chose est clair comme le jour*. Paris, Au Sans Pareil, *Exposition Dada: Francis Picabia*, 1920, no. 5, as *C'est clair comme le jour*. Paris, Galerie Colette Allendy, *Francis Picabia, oeuvres de 1907 à 1924*, 1946, no. 5, as *Les Disques*. New York, Galerie Chalette, *Construction and Geometry in Painting: From Malevich to "Tomorrow,"* 1960, exh. traveled to Cincinnati, Contemporary Art Center; Arts Club of Chicago; and Minneapolis, Walker Art Center, no. 30 (illus.), as *Discs*. Buffalo, Albright-Knox Art Gallery, *Plus by Minus: Today's Half-Century*, 1968, no. 152 (illus.), as *The Disks*. New York, Solomon R. Guggenheim Museum, *Francis Picabia*, 1970, exh. cat. by William A. Camfield, no. 44 (illus.), 24. Paris, Galeries Nationales du Grand Palais, Centre Georges Pompidou, *Francis Picabia*, 1976, exh. cat. by Jean-Hubert Martin and Helene Seckel, no. 50 (illus.), 17, 48, 77–78. Chicago, Richard Gray Gallery and New York, Adler/Castillo, *Picabia: Paintings and Drawings, 1913–1922*, 1982, exh. cat. by William A. Camfield, no. 3 (illus.). Chicago, Museum of Contemporary Art, *Dada and Surrealism in Chicago Collections*, 1984–85, exh. cat. published as *In the Mind's Eye: Dada and Surrealism*, no cat. nos., 203 (illus.). Los Angeles County Museum of Art, *The Dada and Surrealist Word-Image*, 1989–90, no cat. nos., 28–29, fig. 19. Art Institute of Chicago, 1995–97.

REFERENCES: "Current News of Art and the Exhibitions," *Sun* [New York], Jan. 16, 1916. "Happening in the World of Art," *Sun* [New York], Jan. 23, 1916. "Eighteen Reproductions of the Work of Francis Picabia," *The Little Review* 8 (Spring 1922), n. pag. (illus.). "Kritikpreisausschreiben des Kunstblattes," *Das Kunstblatt* 14 (Mar. 1930), 71 (illus.), as *C'est clair comme le jour*. Arts Club of Chicago, *An Exhibition of Cubism on the Occasion of the Fortieth Anniversary of The Arts Club of*

Chicago, 1955, exh. cat., 7, as *Les Disques*. William A. Camfield, "The Machinist Style of Francis Picabia," *Art Bulletin* 48 (Sept.–Dec. 1966), 316, fig. 16, as *Les Disques (Cette chose est fait* [sic] *pour perpétuer mon souvenir)*. Arts Club of Chicago, *Drawings*, 1966, exh. cat., n. pag., as *Les Disques*. Marc Le Bot, *Francis Picabia et la crise des valeurs figuratives, 1900–1925*, Paris, 1968, 127, 192, as *C'est clair comme le jour*. Galleria Civica d'Arte Moderna, *Francis Picabia: Mezzo secolo di avanguardia*, Turin, 1974–75, exh. cat. by Maurizio Fagiolo dell'Arco, as *Cette chose est faite pour perpétuer mon souvenir—Les Disques*. Arts Club of Chicago, *Sixty Years on Stage*, 1975–76, exh. cat., 15, as *Les Disques*. Solomon R. Guggenheim Museum, *Twentieth-Century American Drawing: Three Avant-Garde Generations*, New York, 1976, 15 (illus.). Carla Gottlieb, "'Something Else' in Self-Portraiture," *Colóquio/Artes* 39 (Dec. 1978), 28, 30 (illus.). William A. Camfield, *Francis Picabia: His Art, Life, and Times*, Princeton, 1979, no. 120 (illus.), 88–89. Maria Lluïsa Borràs, *Picabia*, New York, 1985, no. 180, 157, 159 nn. 20 and 22, 212 n. 41, 213 n. 54, 460 n. 27, fig. 289. Salas Pablo Ruiz Picasso, *Francis Picabia (1879–1953)*, Madrid, 1985, exh. traveled to Barcelona, Centro Cultural de la Caixa de Pensions, 77 (illus.). Andreas Vowinckel, *Surrealismus und Kunst*, Studien zur Kunstgeschichte, vol. 44, Hildesheim, 1989, no. 37 (illus.). Henry Hanson, "A Moveable Feast," *Chicago Magazine*, Apr. 1992, 80 (illus.). Arts Club of Chicago, *Seventy-Fifth*, 1992, exh. cat., 38–39. Francis M. Naumann, *New York Dada, 1915–23*, New York, 1994, 63 (illus.), 64.

Pablo Picasso

Spanish, 1881–1973
Mother Combing Her Hair (La Toilette de la mère),◆ printed in 1913 from a zinc plate of 1905
Etching; 24.1 x 19.1 (9½ x 7½)

PROVENANCE: Albert Roullier Galleries, Chicago, by 1930; gift of Mrs. Clarence J. Bulliet and L. J. Bulliet, Chicago, in memory of Clarence Joseph Bulliet, 1955.

REFERENCES: Clarence J. Bulliet, *Apples and Madonnas: Emotional Expression in Modern Art*, New York, 1927, 76 (illus.) (2d ed., 1930, 80 [illus.]), as *La Famille de l'arlequin*. Arts Club of Chicago, *An Exhibition of Cubism on the Occasion of the Fortieth Anniversary of The Arts Club of Chicago*, 1955, exh. cat., 7. Hans Bolliger and Bernhard Geiser, *Picasso: Fifty-five Years of His Graphic Work*, trans. Lisbeth Gombrich, New York, 1955, no. 5 (illus.). Arts Club of Chicago, *Drawings*, 1966, exh. cat., n. pag. Los Angeles County Museum of Art, *Picasso, Sixty Years of Graphic Works: Aquatints, Drypoints, Engravings, Etchings, Linoleum Cuts, Lithographs, Woodcuts*, 1966, exh. cat., no. 20 (illus.), as *The Mother Dressing*. Musée des Beaux-Arts de Zurich, *Pablo Picasso: Catalogue of the Printed Graphic Work, 1904–1967*, 1968, exh. cat. by Georges Bloch, no. 13 (illus.). Arts Club of Chicago, *Sixty Years on Stage*, 1975–76, exh. cat.,

15. Daniel Gervis, *Picasso: L'Oeuvre gravé, 1899–1972*, 1984, no. 13 (illus.). Bernhard Geiser with Brigitte Baer, *Picasso peintre-graveur, tome 1: Catalogue raisonné de l'oeuvre gravé et lithographié et des monotypes, 1899–1931*, Bern, 1990, no. 15 (illus.).

Head of a Woman (Tête de femme),♦ 1922
Red and black chalk with chalk wash on tan laid paper, laid down on lightweight Japanese paper; 62.1 x 48.2 (24 ⁷/₁₆ x 19)
Signed, lower right: *Picasso*

PROVENANCE: Arts Club Purchase Fund, from the artist, through W. Argotinsky, Paris, 1923.

EXHIBITIONS: Art Institute of Chicago, *Arts Club Exhibitions at The Art Institute of Chicago: Original Drawings by Pablo Picasso*, 1923, no. 50 as *Woman's Head*. New York, Museum of Modern Art, *Painting in Paris from American Collections*, 1930, no. 71. Arts Club of Chicago, *Exhibition of Modern Sculpture and Drawings by Sculptors*, 1933, no. 103, as *Sepia Head*. Arts Club of Chicago, *Drawings*, 1966, no. 89 (illus.). Art Institute of Chicago, *Picasso in Chicago: Paintings, Drawings, and Prints from Chicago Collections*, 1968, no. 83 (illus.), 57, as *Classical Head*. Art Institute of Chicago, *Master Drawings by Picasso*, 1981, no. S-19, as *Classical Head*. Arts Club of Chicago, *Portrait of an Era*, 1986, no. 14 (illus.). Arts Club of Chicago, *Seventy-Fifth*, 1992, no cat. nos., 19 (illus.), 103. West Palm Beach, Norton Gallery of Art, *Pablo Picasso: A Vision*, 1994, no. 16 (illus.), 17. University of Chicago, David and Alfred Smart Museum of Art, *Drawings from the Collection of The Arts Club of Chicago*, 1996, no cat.

REFERENCES: *New York Evening Post Saturday Gravure*, Jan. 18, 1930 (illus.). Arts Club of Chicago, *Paintings by Pablo Picasso*, 1932, exh. cat., n. pag. (illus. on cover). Museum of Modern Art, *Picasso: Forty Years of His Art*, New York, 1939, exh. cat. by Alfred H. Barr, Jr., 194. Christian Zervos, *Pablo Picasso, vol. 30, supplément aux années 1920–1922*, Paris, 1975, no. 380 (illus.). Jeff Lyon, "State of the Art," *Chicago Tribune Magazine*, Oct. 12, 1986, 11 (illus.), 15. Henry Hanson, "A Moveable Feast," *Chicago Magazine*, Apr. 1992, 79 (illus.).

Mario Prassinos
French, born Turkey, 1916
August 15, 1968 (15 Août 68),♦ 1968
Ink on paper; 149.9 x 100.3 (59 x 39 ¹/₂)
Signed, lower center: *Prassinos*
Titled and dated, lower right: *15 Août 68*
Inscribed, lower right: */2*

PROVENANCE: Gift of the artist and Galerie de France, Paris, to Everett C.McNear, Chicago, December 1969; bequeathed to Ann McNear, Chicago; gift of Ann McNear, January 1986.

EXHIBITIONS: Marseille, Musée Cantini, *Prassinos*, 1968, no. 54, as *Colline, 15 Août 1968—II*. Arts Club of Chicago, *Mario Prassinos*, 1969–70, no. 19 (illus.).

REFERENCES: Arts Club of Chicago, *Seventy-Fifth*, 1992, exh. cat., 70.

Pedro Pruna
Spanish, born 1904
Lady in Cloak, 1926
Oil on canvas; 101.6 x 83.8 (40 x 33)
Signed and dated, lower right: *Pruna /26*

PROVENANCE: Alice Roullier, Chicago.

Head of a Woman, 1930
Oil monotype on green paper; 17.9 x 12.7 (7 ¹/₁₆ x 5)
Signed, lower right: *30/Pruna*
Signed, lower center: *Pruna 30*

PROVENANCE: Bequest of Arthur Heun, Chicago, 1947.

EXHIBITIONS: Arts Club of Chicago, *Loan Exhibition of Modern Paintings and Drawings from Private Collections in Chicago*, 1938, no. 120, as *Head*. Arts Club of Chicago, *Heun Collection*, 1947, no. 79.

Germaine Richier
French, 1904–1959
Study after Le Diabolo,♦ 1952
Pencil and chalk on paper; 58.4 x 24.8 (23 x 9 ³/₄)

PROVENANCE: Allan Frumkin Gallery, Chicago; Mr. and Mrs. Stanley M. Freehling, Highland Park, Illinois, 1966; gift of Mr. and Mrs. Stanley M. Freehling, 1996.

EXHIBITIONS: Possibly Chicago, Allan Frumkin Gallery, *The Sculpture of Germaine Richier: First American Exhibition*, 1954, not in cat. Boston University School of Fine and Applied Arts, *Sculpture by Germaine Richier*, 1959, no. 25. Arts Club of Chicago, *Germaine Richier*, 1966, no. 55, as *Study for Diabolo*. University of Chicago, David and Alfred Smart Museum of Art, *Drawings from the Collection of The Arts Club of Chicago*, 1996, no cat.

Sir Francis Cyril Rose
Scottish, born 1909
May There Be?, 1934
Ink and wash on paper; 26.7 x 19.1 (10¹/₂ x 7¹/₂)
Signed and dated, lower right: *Francis Rose/1934*
Inscribed, lower left: *May There Be?*

PROVENANCE: Unknown.

Thomas Rowlandson
English, 1756–1827
After the Ball,♦ 1798
Pen and ink and watercolor on light gray laid paper; 20.3 x 26.7 (8 x 10¹/₂)
Signed and dated, lower left: *Rowlandson 1798*

PROVENANCE: Gift of W. Russell Button Gallery, Chicago, 1963.

EXHIBITIONS: Arts Club of Chicago, *Wit and Humor*, 1962, no. 20.

REFERENCES: Arts Club of Chicago, *Drawings*, 1966, exh. cat., n. pag. Idem, *Sixty Years on Stage*, 1975–76, exh. cat., 19.

Pierre Soulages
French, born 1919
October 28, 1963, (28 Octobre 1963),♦ 1968
Oil on canvas; 159.1 x 201.9 (62 ⁵/₈ x 79 ¹/₂)
Signed and dated, lower right: *Soulages /63*

PROVENANCE: Mr. and Mrs. Samuel M. Kootz Collection, New York; M. Knoedler and Co., New York; Arts Club Purchase Fund and Seymour Oppenheimer, 1968.

EXHIBITIONS: New York, Kootz Gallery, *New Paintings by Soulages*, 1964, no cat. nos., n. pag. (illus.). Paris, Musée National d'Art Moderne, *Soulages*, 1967, exh. cat. by Bernard Dorival, no. 61 (illus.). New York, M. Knoedler and Co., *Soulages: Paintings since 1963*, 1968, exh. traveled to Pittsburgh, Museum of Art, Carnegie Institute, and Buffalo, Albright-Knox Art Gallery, exh. cat. by James Johnson Sweeney, no. 3 (illus.).

REFERENCES: Musée d'Art Contemporain; Musée du Québec, *Soulages*, Montreal, 1968, exh. cat., n. pag. (illus.). James Johnson Sweeney, *Soulages*, Greenwich, Conn., 1972, pl. 90, 27. Arts Club of Chicago, *Sixty Years on Stage*, 1975–76, exh. cat., 23. Pierre Daix and James Johnson Sweeney, *Pierre Soulages*, Neuchâtel, 1991, 36 (illus.), 114 (illus.). Arts Club of Chicago, *Seventy-Fifth*, 1992, exh. cat., 70. Pierre Encrevé, *Soulages: L'Oeuvre complet, peintures. II. 1959–1978*, Paris, 1995, 16, 126, 137, 315–16, 330, no. 523 (illus.), as *Peinture 159 x 202 cm, 28 octobre 1963*.

Nicolas de Staël
French, born Russia, 1914–1955
White and Yellow Flowers (Fleurs blanches et jaunes),♦ 1953
Oil on canvas; 129.5 x 88.9 (51 x 35)
Signed, lower left: *stael*

PROVENANCE: Paul Rosenberg, New York, by 1954; Mrs. Harold Florsheim, Highland Park, Illinois, 1979; gift of Mrs. Harold Florsheim, 1996.

EXHIBITIONS: New York, Paul Rosenberg, *Recent Paintings by Nicolas de Staël*, 1954, no. 5.

REFERENCES: *Nicolas de Staël*, intro. by André Chastel, letters annotated by Germain Viatte, catalogue raisonné by Jacques Dubourg and Françoise de Staël, Paris, 1968, no. 666 (illus.), and 318.

John Storrs
American, 1885–1956
Study in Form No. 3,◆ c. 1924
Bronze, copper, stainless steel, and vulcanite; 76.8 (30¼)

PROVENANCE: Arts Club Purchase Fund, 1928.

EXHIBITIONS: Arts Club of Chicago, *Sculpture by John Storrs*, 1927, no. 3, as one of twelve *Studies in Form*. New York, Brummer Gallery, *Storrs Exhibition*, 1928, no. 3, as one of twelve *Studies in Form*. Arts Club of Chicago, *Annual Exhibition by the Professional Members*, 1930, no. 89, as *Study in Form*. Renaissance Society of The University of Chicago, *Exhibition of Drawings by Sculptors and Small Sculpture*, 1932, no. 121, as *Abstraction*. New York, Downtown Gallery, *John Storrs*, 1965, no. 27, as *Forms in Space No. 2*. Pittsburgh, Museum of Art, Carnegie Institute, *Forerunners of American Abstraction*, 1971–72, exh. cat. by Herdis Bull Teilman, no. 117, as *Forms in Space No. 2*. Chicago, Museum of Contemporary Art, *John Storrs: A Retrospective Exhibition of Sculpture*, 1976–77, no cat. nos., 10, 17, as *Forms in Space No. 2*. Art Institute of Chicago, *Centennial Exhibition: 100 Artists, 100 Years*, 1979–80, exh. cat. by Katharine Kuh, no. 98, 12–13 (illus.), as *Forms in Space No. 2*. Arts Club of Chicago, *Portrait of an Era*, 1986, no. 16 (illus.), as *Forms in Space No. 2*. Arts Club of Chicago, *Seventy-Fifth*, 1992, no cat. nos., 95 (illus.), 103, as *Forms in Space No. 2*.

REFERENCES: Jeff Lyon, "State of the Art," *Chicago Tribune Magazine*, Oct. 12, 1986, 15.

Rebus I,◆ 1933
Graphite and colored pencil on paper; 15.5 x 12.4 (6⅛ x 4⅞)
Signed and dated, upper right: *JHS / 33*
Inscribed across image: ALICE

PROVENANCE: Gift of Alice Roullier, Chicago.

EXHIBITIONS: Arts Club of Chicago, *Portrait of an Era*, 1986, no. 17, as *Rebus I—Drawing for Alice*. University of Chicago, David and Alfred Smart Museum of Art, *Drawings from the Collection of The Arts Club of Chicago*, 1996, no cat.

Léopold Survage (Leopold Sturzwage)
French, born Russia, 1879–1968
The Pink City (La Ville rose),◆ 1915
Oil on board; 63.5 x 79.7 (25 x 31⅜)
Signed, lower left: *L. Survage*

PROVENANCE: Gift of Alice Roullier, Chicago.

EXHIBITIONS: Possibly Paris, Chez Madame Bongard, *Peintures de Léopold Survage, dessins et aquarelles d'Irène Lagut*, 1917, as one of six *Villes*. Possibly Renaissance Society of The University of Chicago, *Memorial to Chester H. Johnson: Exhibition of Paintings by Léopold Survage and Raoul Dufy*, 1934, no. 25, as *Oil*. Paris, Musée d'Art Moderne de la Ville de Paris, *Comparaisons: Peinture, sculpture*, 1958, traveled to Mexico City, Palais des Beaux-Arts de Mexico, no. 318, as *Le Citadin*.

REFERENCES: Musée d'Art Moderne, *Survage: L'Années heroiques*, Troyes, 1993, exh. cat. by Daniel Abadie, exh. traveled to Musée Matisse du Cateau-Cambrésis, 170.

Fisherwomen (Pêcheuses),◆ 1925
Oil on canvas; 130 x 97 (51³/₁₆ x 38⁵/₁₆)
Signed and dated, lower left: *Survage / 25*

PROVENANCE: Arts Club Purchase Fund, 1926.

EXHIBITIONS: Paris, Galerie Percier, *Léopold Survage*, 1925. Possibly London, Mayor Gallery, *Advanced French Art*, 1926. Art Institute of Chicago, *Catalogue of a Loan Exhibition of Some Modern Paintings*, 1926–27, no. 15. Renaissance Society of The University of Chicago, *Memorial to Chester H. Johnson: Exhibition of Paintings by Léopold Survage and Raoul Dufy*, 1934, no. 28, as *Oil*.

REFERENCES: "L'Actualité Artistique," *L'Art Vivant* 1 (June 1925), 21 (illus.). E. O. Hoppe, "Notes on Four European Painters," *Artwork* 2 (Jan.–Mar. 1926), 115 (illus.). Samuel Putnam, *The Glistening Bridge: Léopold Survage and the Spatial Problem in Painting*, New York, 1929, 119 n. 3 (illus. as frontispiece). C. J. Bulliet, "Putnam Expounds His Philosophy and Survage's: 'Glistening Bridge' Last of Manifestoes," *Chicago Evening Post*, Dec. 10, 1929 (illus.). Louis Cheronnet, "II.—Les Peintres Oniriques," *L'Amour de l'Art* 15 (Mar. 1934), 328, fig. 429, as *Les Marchands de poisson*. Maximilien Gauthier, *Survage*, Paris, 1953, 52 (illus.).

Untitled, 1926
Graphite on paper; 32.8 x 49.7 (12⅞ x 19⁹/₁₆)
Signed and dated, lower right: *Survage 26*

PROVENANCE: Alice Roullier, Chicago; bequeathed to Josephine R. (Mrs. Norman W.) Harris, Chicago, 1957; gift of Josephine Harris, 1964.

Untitled, 1927
Graphite on paper; 32.5 x 52.1 (12¹³/₁₆ x 20½)
Signed and dated, lower right: *Survage / 27*

PROVENANCE: Alice Roullier, Chicago; bequeathed to Josephine R. (Mrs. Norman W.) Harris, Chicago, 1957; gift of Josephine Harris, 1964.

Study for The Crucifixion, 1929
Graphite on paper; 35.8 x 28.5 (14⅛ x 11¼)
Signed and dated, lower right: *Survage / 29*
Inscribed on verso, lower center: *The Crucifixion*

PROVENANCE: Alice Roullier, Chicago; bequeathed to Josephine R. (Mrs. Norman W.) Harris, Chicago, 1957; gift of Josephine Harris, 1964.

Untitled, 1929
Oil on canvas; 21.6 x 26.7 (8½ x 10½)
Signed and dated, lower right: *Survage / 29*
Inscribed on label on back: *N. 8. Survage / Pour Alice / Roullier*

PROVENANCE: Gift of the artist to Alice Roullier, Chicago; bequeathed to Josephine R. (Mrs. Norman W.) Harris, Chicago, 1957; gift of Josephine Harris, 1964.

EXHIBITIONS: Possibly Renaissance Society of The University of Chicago, *Memorial to Chester H. Johnson: Exhibition of Paintings by Léopold Survage and Raoul Dufy*, 1934, no. 37, as *Oil*.

Leaves and Hand (Feuilles et main), 1931
Gouache on paper; 9.5 x 14.6 (3¾ x 5¾)
Signed, lower right: *LS*
Inscribed, verso: *Pour Monsieur Robert Allerton / tous nos voeux pour / l'an 1931 / Germaine et Linfold Survage*

PROVENANCE: Gift of the artist to Robert H. Allerton, Chicago.

Untitled, 1948
Gouache on wood; 3 x 7 (1⁷/₁₆ x 2¾)
Signed and dated, bottom edge: *Survage 48*

PROVENANCE: Alice Roullier, Chicago; bequeathed to Josephine R. (Mrs. Norman W.) Harris, Chicago, 1957; gift of Josephine Harris, 1964.

EXHIBITIONS: Possibly Paris, Galerie des Deux-Iles, *Survage: Miniatures*, 1949, no cat.

Pavel Tchelitchew
American, born Russia, 1898–1957
Portrait of Alice Roullier,◆ January 1935
Ink on paper; 40.6 x 27.3 (16 x 10¾)
Signed, lower right: *Tchelitchew*
Inscribed, lower right: *a Alice qui / m'a donné un / peu de Paris / a Chicago / Pavlik 1935 / janvier / Chicago*

PROVENANCE: Gift of the artist to Alice Roullier, Chicago, January 1935; bequeathed to Josephine R. (Mrs. Norman W.) Harris, Chicago, 1957; gift of Josephine Harris, 1964.

EXHIBITIONS: Arts Club of Chicago, *Drawings*, 1966, no. 107 (illus.). Arts Club of Chicago, *Portrait of an Era*, 1986, no. 23 (illus.). Arts Club of Chicago, *Seventy-Fifth*, 1992, no cat. nos., 55 (illus.), 103. University of Chicago, David and Alfred Smart Museum of Art, *Drawings from the Collection of The Arts Club of Chicago*, 1996, no cat.

REFERENCES: Arts Club of Chicago, *Sixty Years on Stage*, 1975–76, exh. cat., 19. Jane Allen and Derek Guthrie, "Duchamp Letters Found," *New Art Examiner* 1:6 (Mar. 1974), 1 (illus.).

Julia Thecla
American, 1896–1973
Lady on a Journey,◆ 1945
Opaque watercolor, charcoal on cardboard; 21 x 15.6 (8¼ x 6⅛)
Signed and dated, lower left: *Julia Thecla 1945*

PROVENANCE: Bequest of Arthur Heun, Chicago, 1947.

EXHIBITIONS: Arts Club of Chicago, *Heun Collection*, 1947, no. 94. Springfield, Illinois State Museum, and Chicago, State of Illinois Art Gallery, *Julia Thecla: 1896–1973*, 1984–86, exh. cat. by Maureen A. McKenna, no. 35 (illus. as frontispiece), 19.

Paul Thévenaz

American, born Switzerland, 1891–1921
Portrait of Rue Winterbotham Carpenter, 1919
Graphite and watercolor on paper; 53.3 x 40.6
(21 x 16)
Inscribed, signed, and dated, lower right: *To Mrs.
J. Carpenter/Paul Thévenaz /1919*

PROVENANCE: Gift of the artist to Genevieve
Carpenter Hill, 1919; gift of Genevieve Hill, 1976.

EXHIBITIONS: Arts Club of Chicago, *Paintings, Water-
colors, and Decorations by Paul Thévenaz,* 1921, no.
20, as *Portrait of Mrs. John Alden Carpenter.* Arts
Club of Chicago, *Portrait of an Era,* 1986, no. 10.

Portrait of Rue Winterbotham Carpenter, 1921
Charcoal on paper; 74.9 x 38.7 (29 1/2 x 15 1/4)
Signed and dated, lower right: *Paul Thevenaz /1921*

PROVENANCE: Gift of the artist, 1921.

Portrait of Katherine Dudley, 1921
Charcoal on paper; 74.9 x 38.7 (29 1/2 x 15 1/4)
Signed and dated, lower left: *Paul Thevenaz /1921*

PROVENANCE: Gift of the artist, 1921.

Mark Turbyfill

American, 1896–?
Lyric, n.d.
Gouache on paper; 14.9 x 10.2 (5 7/8 x 4)
Signed, lower right: *Mark Turbyfill*

PROVENANCE: Gift of Devorah (Mrs. Saul) Sherman,
Chicago.

REFERENCES: Arts Club of Chicago, *Sixty Years on
Stage,* 1975–76, exh. cat., 23. Idem, *Seventy-Fifth,*
1992, exh. cat., 70.

Carl van Vechten

American, 1880–1964
Gertrude Stein, January 24, 1935
Gelatin-silver print; 24 x 18.4 (9 7/16 x 7 1/4)
Inscribed on mat, lower right: *For Alice Roullier
So much /love and so much pleasure/in being
together/ Gertrude Stein*
Inscribed on back, upper center: *Jan. 24, 1935/
Number XXIVG: 43*

PROVENANCE: Alice Roullier, Chicago.

Ulfert Wilke

American, born Germany, 1907
The Funnels (Die Trichter), 1977
Poem by Christian Morgenstern
Monotype; 37.5 x 55.5 (14 3/4 x 21 7/8)
Inscribed: *Zwei Trichter wandern durch die Nacht /
durch ihren Rümpfe verengern Schacht /fliesst weisses
Mondlicht / still und heiter/ auf ihrem Waldveg/UW*
Inscribed, on back (typed on label): *Two funnels
are wandering through /the night/through the nar-
rowed shaft of their/ bodies /flows white moonlight/
quietly and cheerfully /on their forest path/ UW*

PROVENANCE: Gift of the artist, 1977.

John Willenbecher

American, born 1936
Study for Gurre-Lieder (3), 1979
Acrylic on masonite; 25.4 x 39.4 (10 x 15 1/2)
Signed and dated, lower left: *Willenbecher 79*

PROVENANCE: Gift of the artist in memory of Rue
Winterbotham Shaw, 1981.

Ossip Zadkine

French, born Russian, 1890–1967
Head of a Boy,♦ unrecorded cast of 1920 from a
terracotta of 1919
Bronze; 34.5 x 20.5 x 19.5 (13 5/8 x 8 1/16 x 7 11/16)

PROVENANCE: Arts Club Purchase Fund, from the
artist, 1931.

EXHIBITIONS: Arts Club of Chicago, *Sculpture by
Ossip Zadkine,* 1931, no. 3. Philadelphia, Crillon
Galleries, *Zadkine,* 1931, no. 3. Renaissance Society
of The University of Chicago, *Exhibition of Draw-
ings by Sculptors and Small Sculpture,* 1932, no.
123. Arts Club of Chicago, *Exhibition of Modern
Sculpture and Drawings by Sculptors,* 1933, no. 70.

REFERENCES: Arts Club of Chicago, *Ossip Zadkine
Exhibition,* 1942, exh. cat., n. pag. (illus. on cover).
Léon Gischia and Nicole Védrès, *La Sculpture en
France depuis Rodin,* Paris, 1946, 118, no. 14 (ter-
racotta illus.), as *Tête.* Sylvain Lecombre, *Ossip
Zadkine: L'Oeuvre sculpté,* Paris, 1994, 115, no. 70
(terracotta illus.).

Chronology of Exhibitions

1916

Paintings by John Singer Sargent and Henry Golden Dearth, November 6–[29?]

Paintings by Robert Henri, George W. Bellows, and John Sloan, December 1–[16?]

Exhibition of Works by the Professional Members, December 18, 1916– January 12, 1917

1917

Antique Color Prints from the Collection of Frank Lloyd Wright, November 12–December 15 (catalogue)

Exhibition of Paintings Selected from the Collection of Mrs. Potter Palmer/ Paintings by William Penhallow Henderson in [New] Mexico, December 17–29 (catalogue)

1918

"Loan Portrait" Exhibition, December 7–21 (catalogue)

Polish Dolls from the Collection of Mme. Ignace Paderewski, December 16–[?]

Exhibition of Paintings by Robert Jones, December 30, 1918– January 11, 1919

Exhibition of Paintings by Mary Foote, December 30, 1918– January 11, 1919

1919

Exhibition of Paintings by Members, January 13–25 (catalogue)

An Exhibition of Sculpture by the Macdougal Alley Sculptors, January 29–February 12 (catalogue)

Exhibition of Paintings by Mary Rogers, January 29–February 12

Exhibition of American Modernists, February 18–28

Exhibition of Paintings by Canals and Andre, February 18–28

Theatrical Designs by Mr. Hermann Rosse, February 28–[?]

Exhibition of Paintings by Ross Moffett, March 10–24

Exhibition of Sculpture by Emil Zettler and Stanislaw Szukalski, March 10–24

Exhibition of French Post-Impressionists, April 9–23

Exhibition of Watercolors by George Inness, April 9–23

Bible Illustrations by Abel Pann, May [?]

War Paintings, Interiors, and Portraits by Mortimer Block, May 1–16

Exhibition of Paintings by Joseph Stella, Oscar Bluemner, and Jennings Tofel, May 2–16

Exhibition of Sculpture by Hunt Diederich and Gaston Lachaise, May 2–16

Collection of Craftwork under the Auspices of The Art Alliance of America, June [?]

Early American Furniture Loaned by Mr. John Wanamaker, November 8–22

Exhibition of Early American Portraits and Miniatures by Copley, Stuart, and Other Eminent Painters, November 8–22

Modern Paintings by Branchard, Friedman, van Gogh, Rodin, Stella, and Sterne, Sculpture by P. Auguste Renoir, Statuettes by Derujinsky, December 15–31

Exhibition of Modern Painting and Sculpture by Gleb Derujinsky and P. Auguste Renoir, December 15–31

Exhibition of Sculpture by Alfeo Faggi, December 15–31

Moroccan Leather Articles, December 23–[?]

1920

Exhibition of Cuban, Mexican, and Indian Paintings by Randall Davey, January 7–21

Exhibition of Tempera Paintings Mexican in Character by Adolfo Best-Maugard, January 7–21

Exhibition of Decorative Flower Paintings by Mabel Key, January 26–February 5

Exhibition of Interiors by Ethel Folsom, January 26–February 5

Annual Exhibition of the Professional Members, February 10–29

Exhibition of Decorative Screens and Panels by Robert W. Chanler, March 3–17

Exhibition of Watercolors and Still Lifes by Hayley Lever, March 3–17

Exhibition of Old Italian Needlework Loaned by Miss Elizabeth D. McCormick, March 24–31

Exhibition of Paintings by Robert La Montagne St. Hubert, April 5–19

Exhibition of a Group of Paintings by William J. Glackens, Robert Henri, Ernest Lawson, and Maurice Prendergast, April 5–19

Exhibition of American Paintings from the Collection of Mr. Paul Schulze, April 21–28

Exhibition of Paintings by Ignace Zuloaga, April 21–28

Exhibition of Recent Paintings by Bror Nordfeldt, April 21–28

Exposition of French Modern Art, May 10–31 (catalogue)

Exhibition of Paintings by William Simon Mondzain, June 5–19

Exhibition of Czechoslovak Watercolors by Jan Matulka, June 5–19

Exhibition of Indian Watercolors by Awa Tsireh, June 5–19

Exhibition of Line Drawings by Ananda Coomaraswamy, June 5–19

Exhibition of Paintings and Drawings by Leon Bakst, November 12–26 (catalogue)

Exhibition of Drawings by Ilya Repin and Watercolors by Foujita, December 6–15

Exhibition of Old Masters Loaned by Ehrich Galleries, December 16–31

1921

Annual Exhibition of Paintings, Etchings, and Miniatures by the Professional Members, January 10–31

Exhibition of Sculpture and Wood Engravings by John Storrs, January 21–February 4 (catalogue)

Exhibition of French Paintings Loaned by Durand Ruel, February 4–22

Exhibition of Paintings by Birger Sandzen, February 4–22

Works by the Students at Hull House, February 4–22

Works of Art by Georg Schrimpf, February 4–22

Exhibition of Paintings by Ambrose McEvoy, February 4–22

Paintings, Watercolors, and Decorations by Paul Thévenaz, April 15–30 (catalogue)

Annual Exhibition of The Chicago Society of Miniature Painters, April 15–30

Exhibition by a Group of Introspective Artists, May 6–June 1

International Watercolors, June 9–20

Drawings by Vivian Forbes, November [?]

Exhibition of Artistic and Unusual Craftwork by Members of The Artists' Guild, November 7–18,

A Selected Group of American and French Paintings, November 21–December 12 (catalogue)

Exhibition of Original Drawings by Ferdinand Hodler, December 19–31

1922

Annual Exhibition by the Professional Members, January 3–16

Exhibition of Drawings by Degas Loaned by Durand-Ruel, January 19–31

Exhibition of Paintings of Flowers and Gardens by Frank Galsworthy, January 19–31

Exhibition of Paintings and Stage Designs by Natalia Sergeyevna Goncharova and Mikhail Fyodorovich Larionov, February 3–18

Exhibition of Original Watercolors, Monotypes, and Oils by Mary Rogers (1881–1920), February 3–18

Exhibition of Valentines from the Collection of Mrs. Emma B. Hodge Loaned by The Art Institute of Chicago, February 22–March 7

Exhibition of Paintings by William E. Schumacher, February 22–March 7

Exhibition of Watercolors, Pastels, and Drawings by Carl Sprinchorn, March 10–25

Paintings by Claggett Wilson, April 4–20

Exhibition of Sculpture by Boris Lovett-Lorski, April 4–20

Exhibition of Ancient Greek and Roman Sculpture, April 25–May 16

Exhibition of Paintings by Frances Crammer Greeman, April 25–May 15

Paintings by Bertram Hartman, May 19–June 2 (catalogue)

Paintings and Conte Crayon Portraits by Demetrios A. Trifyllis, May 25–31 (catalogue)

Paintings and Sculpture by American Cor Ardens, November 16–29 (catalogue)

An Exhibition of Designs by Nicholas Roerich, November [?] (catalogue)

Chinese Sculpture, Bronzes, Potteries, and Porcelain from the Collection of C. T. Loo, December 8–30

Paintings by Jean-Louis Forain and Sculptures by Emile Bourdelle, December 15, 1922–January 5, 1923 at the Art Institute of Chicago (catalogue)

1923

Annual Exhibition by the Professional Members, January 2–16

Paintings of Ellis Island by Martha Walter, January 10–29 at the Art Institute of Chicago (catalogue)

Architectural Models, Drawings, and Murals by Eric Gugler and Barry Faulkner, January 19–February 7

Portraits of Whistler and Some Original Drawings by Whistler, January 19–February 7 (catalogue)

Original Sculpture and Drawings by Auguste Rodin, January 31–March 8 at the Art Institute of Chicago (catalogue)

Decorative Fabrics Loaned by the Frankl Galleries, March 1–8

Paintings by Leon Bakst, March 12–April 5

Exhibition of Modern Russian Paintings by Sergei Fatinsky, Adolph Feder, Boris Gregoriev, Di Lado Goudiachvili, Sergei Sudeykin, Josslyn Zadkine, March 12–April 7 (catalogue)

Exhibition of Paintings by Walt Kuhn, March 15–April 17 (catalogue)

Original Drawings by Pablo Picasso, March 20–April 22 at the Art Institute of Chicago (catalogue)

Table Decorations by Adeline de Voo Cummings, April 6–[?]

Paintings by Joseph Stella: "New York Interpreted," April 13–24

Sculpture by John Storrs, April 13–24

Paintings and Sculpture of the Romanesque, Medieval, and Renaissance Periods, Also Rare Bronzes and Enamels, May 1–31 at the Art Institute of Chicago (catalogue)

Paintings by Pablo Picasso, December 18, 1923–January 21, 1924 at the Art Institute of Chicago (catalogue)

1924

Paintings by Georges Braque, February 1–March 11 at the Art Institute of Chicago (catalogue)

Paintings by Marie Laurencin, February 1–March 11 at the Art Institute of Chicago (catalogue)

Paintings by Rockwell Kent, March 20–April 6 at the Art Institute of Chicago (catalogue)

Paintings, Drawings, and Lithographs by Pamela Bianco, April 8–22 at the Art Institute of Chicago (catalogue)

Sculpture: Egyptian, Greek, Roman, and Early Gothic Periods, May 1–31 at the Art Institute of Chicago (catalogue)

A Selected Group of American Paintings: American Exhibit Number One, November 14–28 (catalogue)

Annual Exhibition by the Professional Members, December 2–27

Paintings by Henri de Toulouse-Lautrec, December 23, 1924–January 25, 1925 at the Art Institute of Chicago (catalogue)

1925

Chinese Early Arts of Mr. C. T. Loo, January 7–22

Paintings and Drawings of Stage Settings by Nicolas Remisoff, January 27–February 5

Paintings by Berthe Morisot, January 30–March 10 at the Art Institute of Chicago (catalogue)

Exhibition of Paintings and Drawings by Boris Anisfeld, February 9–28

Exhibition of Paintings and Watercolors by Léopold Survage, February 9–28 (catalogue)

Exhibition of Paintings by Members of the Whitney Studio Club, February 9–28 (catalogue)

Exhibition of Sculpture, Paintings, and Drawings by Alexander Archipenko, February 9–28 (catalogue)

Exhibition of Spanish Paintings by Hermengildo Anglada y Camarasa, March 9–23

Paintings and Watercolors by William E. Schumacher, March 9–23

Paintings by Tito Cittadini, March 9–23

French Eighteenth-Century Paintings and Furniture, March 17–April 24 at the Art Institute of Chicago (catalogue)

Exhibitions of Russian Bolshevik and Anti-Bolshevik Posters and Paintings by L. N. Brailowsky, March 25–31 (catalogue)

Sculpture by Cecil Howard, April 3–17 (catalogue)

Sixteenth-, Seventeenth-, and Eighteenth-Century Tapestries, April 3–17 (catalogue)

Forty Modern Artists, April 13–May 14

Paintings and Sculpture Assembled by Mrs. Howard Linn for the Woman's World's Fair, April 13–May 14

Sculpture by Seraphin Soudbinine, April 30–May 14 (catalogue)

Sculpture by Elie Nadelman, May 1–June 4 at the Art Institute of Chicago (catalogue)

Exhibition of a Collection of Persian Fine Arts Belonging to Dr. Ali Kuli Khan, N.D., May 18–June 15 (catalogue)

American Indian Paintings and Applied Arts, October 23–November 12

French Watercolors and Drawings Assembled by Pierre Matisse, November 3–12

Antique Georgian Silver and Old Sheffield Plate from the Brainard Lemon Silver Collection, November 17–28

Miniatures and Watercolors by F. Enid Stoddard, November 17–28 (catalogue)

Early Chinese Arts Loaned by Mr. C. T. Loo, December 4–December 20

Paintings and Drawings by Helene Perdriat, December 4–31 (catalogue)

Antique Brocades and Tapestries from the Collection of Albert Trant, December 22–December 31

Original Sculpture by Gaston Lachaise, December 22, 1925–January 26, 1926 at the Art Institute of Chicago (catalogue)

1926

Original Sculpture by Edgar Degas, January 2–23 (catalogue)

Loan Exhibition of Early Oriental Carpets from Persia, Asia Minor, the Caucasus, Egypt, and Spain, January 3–February 10 (catalogue)

Paintings and Watercolors by Maurice de Vlaminck and Maurice Utrillo, February 4–March 14 at the Art Institute of Chicago (catalogue)

Exhibition of Paintings and Watercolors by James Chapin, February 12–28 (catalogue)

Six Original Paintings by Henri Matisse, February 12–28

Tibetan Paintings, February 12–28

Marc Chagall Exhibition, March 5–20 (catalogue)

Pastels and Etchings by Lucille Douglass, March 5–20

Fifty Prints of the Year, March 5–29 (catalogue)

A Group of Paintings by Various Modern Artists, March 19–April 25 at the Art Institute of Chicago (catalogue)

French and Flemish Tapestries, Italian and Spanish Brocades and Velvets, Antique Persian Rugs from the Collection of Prince Mohamed Kaby, March 5–April 1

Professional Members Exhibition, April 2–24

Recent Works by Roy MacNicol, April 5–25 at the Art Institute of Chicago (catalogue)

Drawings by Bertram Elliott, May 1–13 (catalogue)

Exhibition of Paintings by Paul Burlin, May 1–13 (catalogue)

An Exhibition of Portraits, Interiors, and Landscapes by Sir John Lavery, May 1–13 (catalogue)

Original Watercolors by a Group of International Artists, May 3–30 at the Art Institute of Chicago (catalogue)

Exhibition of Modern Italian Art, May 15–28 (catalogue)

Fifteenth-Century Sienese Painting by Taddeo di Bartolo and Sano di Pietro, May 15–June 3

Negro Sculpture from the Collection of John Quinn, June [?]

Exhibition of Plans and Drawings by Students of the Foundation for Architecture and Landscape Architecture, Lake Forest, Illinois, October [?]

An Exhibition of Early Chinese Paintings Collected by Mr. A. W. Bahr, November 7–18 (catalogue)

Polynesian Antiquities Collected by Mr. A. J. Morin in the South Seas During 1926, November 12–30 (catalogue)

Brainard Lemon Silver Collection and Antique Furniture, November 20–December 7

Loan Exhibition of Gothic Tapestries, December 12–27 (catalogue)

Loan Exhibition of Some Modern Paintings, December 21, 1926–January 24, 1927 at the Art Institute of Chicago (catalogue)

1927

An Exhibition of Sculpture by Brancusi, January 4–18 (catalogue)

Rare Persian Antiquities from the Collection of Mr. H. Khan Monif, January 4–18

John Duncan Fergusson, January 21–31 (catalogue)

Exhibitions of Paintings, Watercolors, and Silverpoint Drawings by George Biddle, February 1–15

Paintings by Boris Grigoriev, February 1–15 (catalogue)

Paintings by J. B. S. Chardin, February 3–March 8 at the Art Institute of Chicago (catalogue)

"The Last Supper" by André Derain, February 15–18

Exhibition of Black and White by Contemporary Italian Artists, February 17–27 (catalogue)

Paintings by Henri Matisse, February 17–27 (catalogue)

Paintings by Sidney Laufman, February 17–27 (catalogue)

Drawings and Watercolors by Constantin Guys from the Collection of Baron Napoleon Gourgaud, Paris, March 4–26 (catalogue)

Fifty Prints of the Year: Second Annual Exhibition, March 4–26 (catalogue)

Paintings by Walt Kuhn, March 15–April 17 at the Art Institute of Chicago (catalogue)

Paintings by Albert Bloch, March 18–31 (catalogue)

Annual Exhibition by the Professional Members, April 3–17 (catalogue)

Watercolors of Spain and North Africa by Martha Walter, April 28–May 30 at the Art Institute of Chicago (catalogue)

Paintings and Drawings by Kuniyoshi, April 29–May 20 (catalogue)

Paintings by Emil Ganso, April 29–May 20 (catalogue)

Exhibition of Plans and Drawings by Students of the Post-Graduate Institute of Architecture and Landscape Architecture, Lake Forest, Illinois, October 14–31

Screen and Paintings by Odilon Redon, November 4–18 (catalogue)

Screen by Natalia Goncharova (collection Mary H. Wiborg), November 4–18

An Exhibition of Modern Paintings Loaned by Mrs. Paul Reinhardt, November 4–12 (catalogue)

Paintings by Bernard Boutet de Monvel, November 17–December 7 (catalogue)

Exhibition of Rugs Designed by Some Modern Painters from Myrbor, Paris, November 20–December 7

Exhibition of Some Modern Paintings from Myrbor, Paris, November 20–December 7 (catalogue)

Sculpture by Boris Lovett-Lorski, November 20–December 7 (catalogue)

Paintings and Drawings by Jean Julien Lemordant, December 11–31 (catalogue)

Sculpture by John Storrs, December 11–31 (catalogue)

1928

Exhibition of Paintings by Savely Sorin, January 4–23 (catalogue)

Sculpture by Robert Laurent, January 4–23 (catalogue)

Early Chinese Arts Comprising Archaic Jades, Porcelains, Pottery, and Bronzes Loaned by Mr. C. T. Loo, January 23–February 2

Decorative Designs by Julius Moessel, January 24–February 7 (catalogue)

Exhibition of Sculpture by Jacob Epstein, January 24–February 7 (catalogue)

Exhibition of Sculpture by Allan Clark, February 10–24 (catalogue)

Modern American Paintings, February 10–24 (catalogue)

Watercolors and Drawings by Helen Walker Szukalska, February 10–24 (catalogue)

Original Drawings by Pablo Picasso, February 28–March 13 (catalogue)

Paintings and Watercolors by Marsden Hartley, February 28–March 13 (catalogue)

Paintings and Drawings by Maurice Sterne, March 15–24 (catalogue)

Paintings and Watercolors by J. Theodore Johnson, March 15–24 (catalogue)

Exhibition of Antique Georgian Silver, Old Sheffield Plate, and Fine Old Furniture from the Brainard Lemon Silver Collection, March 28–April 12

Annual Exhibition by the Professional Members,
April 15–May 5 (catalogue)

*Danish National Exhibition of Applied Art, Paintings,
and Sculpture,* May 9–31 (catalogue)

*Exhibition of Plans and Drawings of the Students at
the Foundation for Architecture and Landscape
Architecture, Lake Forest, Illinois,* October 19–
November 3

*Collection of Jade and Chinese Pottery and
Sculpture Loaned by Herbert J. Devine,* November
12–December 5

Modern Paintings by Eleven European Artists,
November 12–December 5 (catalogue)

*Modern Objects of Industrial Art from the Austrian
Werkbund of Vienna,* November 12–December 22
(catalogue)

Screen by Natalia Goncharova, November 29–
December 23

*Exhibition of Antique Georgian Silver, Old Sheffield
Plate, and Fine Old Furniture from the Brainard
Lemon Silver Collection,* December 10–22

Paintings, Watercolors, and Drawings by Mark Tobey,
December 24–31 (catalogue)

1929

*Loan Exhibition of Modern Paintings Privately
Owned by Chicagoans,* January 4–18 (catalogue)

Small Sculpture, January 4–18 (catalogue)

C. T. Loo Collection of Chinese Antiquities,
January 23–February 2

*Antique Jewels, Rare Gems, and Fine Pearls
Collected by Olga Tritt,* February 5–19

*Drawings by Amedeo Modigliani and Watercolors by
Auguste Rodin,* February 5–19 (catalogue)

Photographic Compositions by Man Ray, February
5–19 (catalogue)

Sculpture and Paintings by Alexander Archipenko,
February 22–March 8 (catalogue)

Some Modern Paintings, February 22–March 8
(catalogue)

Watercolor Drawings by Francis Picabia, February
22–March 8 (catalogue)

*Eighteenth- and Early Nineteenth-Century
Chintzes Loaned by Elinor Merrell, New York,*
March 12–26 (catalogue)

Paintings by William B. E. Ranken, March 12–26
(catalogue)

Paintings by William Merritt Chase, March 12–26
(catalogue)

Sculpture by John Duncan Fergusson, March 12–26
(catalogue)

Paintings by Angel Zarraga, March 28–April 12
(catalogue)

Paintings by Jerome Blum, March 28–April 12
(catalogue)

Sculpture by Raymond Duchamp-Villon, March 28–
April 12 (catalogue)

Annual Exhibition by the Professional Members,
April 14–May 4 (catalogue)

*Exhibition of Sixteenth-Century Rugs, Rare Velvets,
Tapestries, Egyptian, Khmer, and Gothic Sculptures,
Persian Potteries, and Miniatures Loaned by Dikran
G. Kelekian, Paris, Cairo, and New York,* May 6–20

The Forty-Second Annual Architectural Exhibition,
May 24–June 13 with the Chicago Architectural
Exhibition League (catalogue)

*Exhibition of Plans and Drawings by Students of
the Foundation for Architecture and Landscape
Architecture, Lake Forest, Illinois,* October 17–
November 1

*"The Feast in the House of Simon" by El Greco from
the Collection of Mr. Joseph Winterbotham, Jr.,*
November 15–30

Paintings by Amedeo Modigliani, November 15–30
(catalogue)

Thirty Years of French Painting: From 1900–1930,
November 15–30 (catalogue)

*Exhibition of Antique and Modern Jewels Collected by
Olga Tritt, New York,* November 29–December 23

Portraits of Maria Lani by Fifty-One Painters,
December 3–17 (catalogue)

*Exhibition of Antique Georgian Silver, Old Sheffield
Plate, and Fine Old Furniture from the Brainard
Lemon Silver Collection,* December 6–23

1930

*Loan Exhibition of Modern Drawings and Sculpture
Privately Owned by Chicagoans,* January 3–17 (cat-
alogue)

*Rubbings from Monumental English Tombs Loaned
by The University of Chicago,* January 3–17

Sculpture by Chana Orloff, January 3–17 (catalogue)

Watercolors by Arthur B. Davies, January 3–17
(catalogue)

Paintings by Raoul Dufy, January 21–February 4
(catalogue)

Sculpture by José de Creeft, January 21–February 4
(catalogue)

Watercolors by Leon Carroll, January 21–February 4
(catalogue)

Black Plastic by Ugo Mochi, February 7–21
(catalogue)

Paintings by Emile-Othon Friesz, February 7–21
(catalogue)

Paintings by Norman Jacobsen, February 7–21
(catalogue)

Drawings by Muriel Hannah, March 3–17
(catalogue)

Gouaches by Emil Ganso, March 3–17 (catalogue)

*Paintings, Watercolors, and Drawings by Ernest
Fiene,* March 3–17 (catalogue)

*Loan Exhibition from the Collection of Mary H.
Wiborg,* March 25–May [29?]

Contemporary Chinese Paintings, March 26–April 9
(catalogue)

Gouaches by Ossip Zadkine, March 26–April 9
(catalogue)

Paintings by Pablo Picasso, March 26–April 9 (cat-
alogue)

Sculpture by Isamu Noguchi, March 26–April 9
(catalogue)

Annual Exhibition by the Professional Members,
April 13–May 3 (catalogue)

*Exhibition of Models and Drawings of Dymaxion
Architecture by Buckminster Fuller,* May 8–13
(catalogue)

Paintings by Georges Rouault, May 8–13 (catalogue)

The Forty-Third Annual Architectural Exhibition,
May 15–June 7 with the Chicago Architectural
Exhibition League (catalogue)

*Exhibition of Plans and Drawings by Students of
the Foundation for Architecture and Landscape
Architecture, Lake Forest, Illinois,* October 17–
November 4

Paintings by Pierre Auguste Renoir, November 7–26
(catalogue)

Plaques by Carl Milles, November 7–26

Exhibition of Original Drawings by Pablo Picasso,
November 28–December 13

Paintings by Margarett Sargent, November 28–
December 13 (catalogue)

Paintings by Giorgio de Chirico, December 5–30
(catalogue)

Drawings and Paintings by William H. Littlefield,
December 16–30 (catalogue)

Paintings by Valentine Prax, December 16–30 (cat-
alogue)

1931

Paintings by Jacques Villon, January 9–24 (catalogue)

Sculpture by Ossip Zadkine, January 9–24
(catalogue)

Paintings and Drawings by Tsuguhara Foujita,
January 27–February 17 (catalogue)

Paintings by Joan Miró, January 27–February 17
(catalogue)

Paintings by Henri Rousseau, February 20–March 1
(catalogue)

Ancient Chinese Wallpaper, February 20–March 11

*Painted Linen by Raoul Dufy: Collection of Paul
Poiret, Paris,* February 20–March 11 (catalogue)

Paintings by Jean Victor Hugo, February 20–March
11 (catalogue)

Paintings by Edouard Goerg, March 2–11 (catalogue)

Bauhaus, Dessau, Germany, March 13–28 (catalogue)

Flower, Animal, and Still Life Paintings, March 13–28 (catalogue)

Paintings by Georges Rouault, March 13–28 (catalogue)

Sculpture by Henri Matisse, March 13–28 (catalogue)

Exhibition of Georgian Silver, Old Sheffield Plate, and English Period Furniture from the Brainard Lemon Silver Collection, April 1–13

Annual Exhibition by the Professional Members, April 19–May 9 (catalogue)

The Forty-Fourth Annual Architectural Exhibition, May 15–June 6 with the Chicago Architectural Exhibition League (catalogue)

Exhibition of Plans and Drawings by Students of the Foundation for Architecture and Landscape Architecture, Lake Forest, Illinois, October 16–31

Paintings by Three Women Painters, November 13–28 (catalogue)

Paintings and Drawings by Fernand Léger, November 20–28

Exhibition of Chinese, Indian, and Cambodian Art Formed by C. T. Loo, December 4–19 (catalogue)

1932

Paintings by Charles Dufresne, January 4–16 (catalogue)

Paintings by Pablo Picasso, January 4–16 (catalogue)

"The Wedding" by Henri Rousseau, January 13–[31?]

Paintings and Drawings by Charles Sheeler, January 19–February 2 (catalogue)

Paintings and Watercolors by Howard Ashman Patterson, January 19–February 2 (catalogue)

Paintings by André Bauchant, January 19–February 2 (catalogue)

Paintings and Drawings by Maurice Sterne, February 5–27 (catalogue)

Paintings by Georges d'Espagnat, February 5–27 (catalogue)

Brush Drawings and Sculpture by Isamu Noguchi, March 4–30 (catalogue)

Paintings by H. E. Schnakenberg, March 4–30 (catalogue)

The Blue Four: Feininger, Jawlensky, Kandinsky, Paul Klee, April 1–15 (catalogue)

Paintings by Edward Biberman, April 1–15 (catalogue)

Watercolors and Drawings by Roger de la Fresnaye, April 1–15 (catalogue)

The James Robinson Exhibition of Old English Silver and Genuine Old Sheffield Plate, April 11–16

Annual Exhibition by the Professional Members, April 17–May 7 (catalogue)

Loan Exhibition of Drawings by Sculptors Privately Owned by Chicagoans, May 10–30 (catalogue)

Loan Exhibition of Sculpture by Charles Despiau from the Collection of Mr. Frank Crowninshield, May 10–30 (catalogue)

Recent Drawings by Aristide Maillol, November 15–25 (catalogue)

Paintings and Sculpture by American Contemporaries, November 15–December 15 (catalogue)

Reconstructions of Seventeenth-Century Persian Fresco Paintings in Isfahan by Mr. Sarkis Katchadourian, November 15–December 27

1933

Exhibition of Paintings by Claude Monet in Retrospect, 1868–1913, January 6–31 (catalogue)

The Isabel Carleton Wilde Collection of Early American Folk Painting, January 6–31 (catalogue)

Memorial Exhibition of Paintings by Gardner Hale, February 3–14 (catalogue)

Paintings by Henry Billings, February 3–14 (catalogue)

Paintings by André Masson, February 17–March 14 (catalogue)

"Towards the New City and a New Life": An International Exhibition of Housing and City Planning Organized by the Gallery of Modern Life, February 17–March 14

Exhibition of Landscape Drawings by Walt Kuhn, March 17–29 (catalogue)

Modern Artists of the U.S.S.R. (Russia), March 17–29 (catalogue)

Exhibition of Early African Heads and Statues from the Gabun Pahouin Tribe, March 31–April 19 (catalogue)

Watercolors and Drawings by George Grosz, March 31–April 19 (catalogue)

Annual Exhibition by the Professional Members, April 23–May 13 (catalogue)

Exhibition of Modern Sculpture and Drawings by Sculptors, June 2–July 15 (catalogue)

Exhibition of the George Gershwin Collection of Modern Paintings, November 10–25 (catalogue)

Exhibition of Recent Paintings by Roger Fry, November 10–25 (catalogue)

Exhibition of Paintings and Etchings by Jacques Villon, November 28–December 23 (catalogue)

Exhibition of "Twenty-Five Years of Russian Ballet" from the Collection of Serge Lifar, November 28–December 23 (catalogue)

1934

Exhibition of Paintings by Edward Hopper, January 2–16 (catalogue)

Paintings by Georges Rouault, January 2–16 (catalogue)

Paintings by Georges Papazoff, January 19–February 8 (catalogue)

Watercolors and Drawings by Maurice Boutet de Monvel for the Jeanne d'Arc Album, January 19–February 8 (catalogue)

Ceramic Sculpture by Vally Wieselthier, February 16–March 6 (catalogue)

Paintings by Ernest Fiene, February 16–March 6 (catalogue)

Paintings by Pedro Pruna, February 16–March 6 (catalogue)

Paintings by Joan Miró, March 16–30 (catalogue)

Sculpture by John B. Flannagan, March 16–30 (catalogue)

Watercolors by Jane Berlandina, March 16–30 (catalogue)

Modern Paintings from the Collection of Mr. Earl Horter of Philadelphia, April 3–26 (catalogue)

Sculpture in Wood by John L. Clarke (Cutapuis), April 3–26 (catalogue)

Annual Exhibition by the Professional Members, April 29–May 19 (catalogue)

Exhibition of Paintings by José Clemente Orozco, May 23–June 15 (catalogue)

Exhibition of Watercolors by André Derain, May 23–June 15 (catalogue)

Original Etchings by Louis Marcoussis, November 9–30 (catalogue)

Paintings by Sir Francis Rose, November 9–30 (catalogue)

Drawings by Jean Cocteau, December 4–31 (catalogue)

Exhibition of the Leonide Massine Collection of Modern Paintings, December 4–31 (catalogue)

1935

Oceanic Sculpture, January 11–25 (catalogue)

Original Drawings by Romaine Brooks, January 11–31 (catalogue)

Paintings and Drawings by Pavel Tchelitchew, January 11–31 (catalogue)

"Mobiles" by Alexander Calder, February 1–26 (catalogue)

Paintings by Pedro Pruna, February 1–26 (catalogue)

Abstract Sculpture by Alberto Giacometti, March 8–31 (catalogue)

New Landscape Paintings by Oscar F. Bluemner: Compositions for Color Themes, March 8–31 (catalogue)

Paintings by Three Women Painters: Hermine David, Natalie Gontcharova, Alice Halicka, March 8–31 (catalogue)

Exhibition of the Sidney Janis Collection of Modern Paintings, April 5–24 (catalogue)

Set Designs by Jean Lurçat for the Ballet "Jardin Publique," April 5–24

New Works by Hilla Rebay, April 15–May 4

Annual Exhibition by the Professional Members, April 28–May 18 (catalogue)

Paintings by B. J. O. Nordfeldt, May 21–June 11 (catalogue)

Watercolors and Drawings from the Lillie P. Bliss Collection, May 21–June 11 (catalogue)

Exhibition of African Negro Art, November 15–December 7 (catalogue)

Exhibition: Juan Gris, December 13–30 (catalogue)

Exhibition of Sculpture by Guitou Knoop, December 13–30 (catalogue)

Paintings by Haim Soutine, December 13–30 (catalogue)

1936

Abstract Art: Gabo, Pevsner, Mondrian, Domela, January 3–25 (catalogue)

Paintings by Francis Picabia, January 3–25 (catalogue)

Retrospective Exhibition: Emmanuel Gondouin (1883–1934), January 3–25 (catalogue)

Gouaches by Ossip Zadkine, January 31–February 18 (catalogue)

Paintings from Mexico by Caroline Durieux, January 31–February 18 (catalogue)

Paintings by Elie Lascaux, February 25–March 14 (catalogue)

Paintings by Francisco Borès, February 25–March 14 (catalogue)

Exhibition of Paintings by Harry Carlsson, March 17–April 1 (catalogue)

Paintings by Serge Férat, March 17–April 1 (catalogue)

Annual Exhibition by the Professional Members, April 5–25 (catalogue)

Modern French Tapestries Designed by Modern Painters, May 1–9 (catalogue)

Paintings by Rudolf Bauer from the Collection of Solomon R. Guggenheim, May 12–June 6 (catalogue)

Exhibition of the Joseph Winterbotham Collection, December 9–31 (catalogue)

1937

Exhibition of the Walter P. Chrysler, Jr., Collection, January 8–31 (catalogue)

Exhibition of Paintings by Marcel Duchamp, February 5–27 (catalogue)

Exhibition of Paintings by van Dongen, February 5–27 (catalogue)

Paintings by André Derain, February 5–27 (catalogue)

Four Painters: Albers, Dreier, Drewes, Kelpe, March 5–24 (catalogue)

Memorial Exhibition of Iron Sculptures by Pablo Gargallo (1879–1934), March 5–25 (catalogue)

Pastels and Paintings by Dimitri Bouchène, March 5–25 (catalogue)

Exhibition of Modern Painters and Sculptors as Illustrators, March 30–April 19 (catalogue)

Paintings by Nicolas de Molas, March 30–April 19 (catalogue)

Annual Exhibition by the Professional Members, April 25–May 15 (catalogue)

Exhibition of Paintings by Carl Ruggles, May 18–June 5 (catalogue)

Exhibition of Stage Designs by Jo Mielziner and Rex Whistler, May 18–June 5 (catalogue)

Paintings by Albert Gleizes, May 18–June 5 (catalogue)

Exhibition of Contemporary Mexican Painting, November 9–27 (catalogue)

Paintings by Jack Gage Stark, November 9–27 (catalogue)

Exhibition of Chinese Furniture and Eighteenth-Century Paintings Including Early Bronzes, Sculptures, Pottery, and Porcelain Loaned by C. T. Loo and Company of Paris and New York, December 7–23 (catalogue)

Exhibition of Sculpture by Atanas Katchamakoff, December 7–23 (catalogue)

1938

Paintings by Walter Richard Sickert, January 4–24 (catalogue)

Exhibition of Caricatures by Max Beerbohm, January 4–27 (catalogue)

Exhibition of Watercolors by Issachar Ryback, February 4–18 (catalogue)

Paintings by Jean Hélion, February 4–18 (catalogue)

Portraits by Pavel Tchelitchew, February 4–18 (catalogue)

Exhibition of Paintings by Marie Laurencin, February 25–March 10 (catalogue)

Paintings by Kristians Tonny, February 25–March 10 (catalogue)

Ten Original Engravings on Wood by Paul Gauguin, February 25–March 10 (catalogue)

Abstractions on Plaster by John Ferren, March 15–28 (catalogue)

Exhibition of Paintings by Dietz Edzard, March 15–28 (catalogue)

George Gershwin, Painter (1898–1937): Memorial Exhibition, March 15–28 (catalogue)

Exhibition of Contemporary Italian Painting, April 4–19 (catalogue)

Exhibition of Watercolors by Raoul Dufy, April 4–19 (catalogue)

Paintings by Botkin, April 4–19 (catalogue)

Annual Exhibition by the Professional Members, April 24–May 14 (catalogue)

Gouaches by Max Jacob, May 20–June 5 (catalogue)

Sculpture by Renee Sintenis, May 20–June 5 (catalogue)

Textiles by Dorothy Liebes, May 20–June 5 (catalogue)

Loan Exhibition of Modern Paintings and Drawings from Private Collections in Chicago, November 4–25 (catalogue)

Retrospective Exhibition by André Dunoyer de Segonzac, November 30–December 19 (catalogue)

1939

Drawings by Pablo Picasso from the Collection of Walter P. Chrysler, Jr., January 3–27 (catalogue)

Exhibition of Paintings by Honore Palmer, Jr. (1908–1938), January 3–27

Retrospective Exhibition: Juan Gris (1887–1927), January 3–27 (catalogue)

Exhibition of Prints by Georges Rouault, February 1–25 (catalogue)

Paintings by André Derain, February 1–25 (catalogue)

Exhibition of Drawings by Herman Webster, March 3–24 (catalogue)

Exhibition of Paintings by John Kane (1860–1934), March 3–24 (catalogue)

Exhibition of Paintings by Maurice Grosser, March 3–24 (catalogue)

Exhibition of Paintings by B. G. Benno, March 30–April 18 (catalogue)

Exhibition of Paintings by Henri Matisse, March 30–April 18 (catalogue)

Jean-François Thomas: Memorial Exhibition (1898–1939), March 30–April 18 (catalogue)

Annual Exhibition by the Professional Members, April 23–May 13 (catalogue)

Sculpture by Wilhelm Lehmbruck, May 19–June 10 (catalogue)

William Glackens Memorial Exhibition, May 19–June 10 (catalogue)

The Masterpiece "Guernica" by Pablo Picasso Together with Drawings and Studies for the Benefit of the Spanish Refugee Relief Campaign, October 2–10 (catalogue)

Georges Braque Retrospective Exhibition, November 7–27 (catalogue)

Paintings and Drawings by Karl Hofer, December 6–21 (catalogue)

Watercolors and Pastels by Four Modern American Painters: Charles Demuth, Preston Dickinson, John Marin, Jules Pascin, December 6–21 (catalogue)

1940

Amédée Ozenfant: Retrospective Exhibition, January 2–27 (catalogue)

Sculpture by Painters, January 2–27 (catalogue)

Paintings by Abraham Rattner, February 2–27 (catalogue)

Paintings by Camille Bombois, February 2–27 (catalogue)

Yves Tanguy: Paintings, Gouaches, Drawings, February 2–27 (catalogue)

Mosaics by Jean Varda, March 5–23 (catalogue)

Paintings by William M. Harnett, March 5–23 (catalogue)

Recent Paintings and Constructions by Gallatin, Morris, Shaw, March 5–23 (catalogue)

Origins of Modern Art, April 2–30 (catalogue)

Annual Exhibition by the Professional Members, May 12–June 5 (catalogue)

Exhibition of Contemporary British Art from the British Pavilion, New York World's Fair, 1939, November 1–29 (catalogue)

Aristide Maillol, December 4–28 (catalogue)

Maximilian Mopp, December 4–28 (catalogue)

Portinari of Brazil, December 4–28 (catalogue)

1941

Courbet, January 3–27 (catalogue)

Exhibition of Paintings by Cristofanetti, January 3–27 (catalogue)

Kokoschka, January 3–27 (catalogue)

Exhibition of Paintings by Albert André, January 31–February 28 (catalogue)

Loren MacIver Exhibition, January 31–February 28 (catalogue)

Paul Klee Memorial Exhibition, January 31–February 28 (catalogue)

Alexandre Iacovleff Memorial Exhibition, March 7–29 (catalogue)

Charles Biederman: Exhibition of a Group of Ten Constructions Without Titles, March 7–29 (catalogue)

Mané-Katz, March 7–29 (catalogue)

Henri Laurens, April 4–22 (catalogue)

Martha Walter: Exhibition of Paintings and Watercolors, April 4–22 (catalogue)

Annual Exhibition by the Professional Members, April 27–May 17 (catalogue)

Exhibition of Paintings by Horace Pippin, May 23–June 14 (catalogue)

Fernand Léger, May 23–June 14 (catalogue)

Salvador Dalí, May 23–June 14 (catalogue)

Modern Tapestries Designed by Modern Painters, Executed under the Direction of Madame Paul Cuttoli, November 4–29 (catalogue)

Private Collection of Mr. and Mrs. Harold M. Florsheim, November 4–29 (catalogue)

Raoul Dufy Exhibition, December 4–27 (catalogue)

1942

Max Beckmann Exhibition, January 2–27 (catalogue)

Nine American Artists: Blume, Calder, Canadé, Corbino, French, Kuniyoshi, Poor, Priebe, Taubes, February 3–28 (catalogue)

Architecture of Eric Mendelsohn (1914–1940), March 6–25 (catalogue)

Ernst Barlach, March 6–25 (catalogue)

Ossip Zadkine Exhibition, March 6–25 (catalogue)

Eugene Berman Retrospective, March 31–April 20 (catalogue)

Mosaics by Jeanne Reynal, March 31–April 20 (catalogue)

Twenty-Sixth Annual Exhibition by the Professional Members, April 26–May 16 (catalogue)

André Masson, May 22–June 13 (catalogue)

Drawings and Paintings by Max Ernst, May 22–June 13 (catalogue bound in *View* 2 [April 1942])

Calder Drawings, November 6–27

Thirteen Mexican Artists, November 6–28 (catalogue)

Franklin C. Watkins Exhibition, December 4–26 (catalogue)

Jacques Lipchitz Exhibition, December 4–26

Kisling, December 4–26 (catalogue)

1943

Hélion, January 6–27 (catalogue)

Morris Graves, January 6–27 (catalogue)

American Prize Winners, February 3–25 (catalogue)

Jerome Myers Memorial Exhibition, March 4–20 (catalogue)

Joep Nicolas: Stained Glass Panels, March 4–20

Berthe Morisot, March 24–April 7 (catalogue)

Fine Prints of Musical Subjects, March 24–April 7

Joan Miró Exhibition, March 24–April 7

Twenty-Seventh Annual Exhibition by the Professional Members, April 11–May 1 (catalogue)

Twentieth-Century Portraits, May 5–31 (catalogue)

American Primitive Painting of Four Centuries, November 2–27 (catalogue)

Calder Jewelry, December 3–27

Roger de la Fresnaye, December 3–27 (catalogue)

1944

Matta Echaurren: Oil Pencils, Paintings, January 4–29 (catalogue)

Wifredo Lam: Gouaches, January 4–29 (catalogue)

Exhibition of Paintings, Drawings, and Architecture by Le Corbusier (Charles Edouard-Jeanneret), February 4–26

Grigory Gluckman, March 3–25 (catalogue)

Herbert Matter, March 3–25 (catalogue)

Twenty-Eighth Annual Exhibition by the Professional Members, April 2–25 (catalogue)

Avery, May 2–31 (catalogue)

New Paintings by Evsa Model, May 2–31 (catalogue)

Exhibition of Drawings by James Thurber, May 2–31

Hans Hofmann, November 3–25 (catalogue)

Enrico Donati, November 3–25 (catalogue)

Exhibition of Cuban Painting Today, December 1–29 (catalogue published as *Modern Cuban Painters* in *The Museum of Modern Art Bulletin* 11 [April 1944]).

1945

Hans Moller, January 2–31 (catalogue)

Marc Chagall, January 2–31 (catalogue)

Three Contemporary Americans: Karl Zerbe, Stuart Davis, Ralston Crawford, February 6–28 (catalogue)

Exhibition of Paintings and Watercolors by Jules Pascin, February 6–28 (catalogue)

I. Rice Pereira Exhibition, March 5–31 (catalogue)

Jackson Pollock, March 5–31 (catalogue)

Twenty-Ninth Annual Exhibition by the Professional Members, April 8–28 (catalogue)

Contemporary British Artists: Ivon Hitchens, Henry Moore, Paul Nash, John Piper, Ceri Richards, Graham Sutherland, John Tunnard, May 4–31 (catalogue)

Tamayo, May 4–31 (catalogue)

Wassily Kandinsky Memorial Exhibition, November 2–30 (catalogue)

Louis Vivin, December 7–31 (catalogue)

Marsden Hartley Memorial Exhibition, December 7–31 (catalogue)

1946

Exhibition of Sculpture by Mary Callery, January 8–30 (catalogue)

Paintings by Camille Pissarro, January 8–30 (catalogue)

Sculpture by Charles Howard, January 8–30

Mark Tobey, February 7–27 (catalogue)

Robert Motherwell: Paintings, Collages, Drawings, February 2–27 (catalogue)

Kurt Seligmann, March 5–30

Variety in Abstraction, March 5–30 (catalogue)

Thirtieth Annual Exhibition by the Professional Members, April 7–27 (catalogue)

Albert Pinkham Ryder/Arthur Bowen Davies: Exhibition, May 7–31 (catalogue)

Corrado Cagli from Cherbourg to Leipzig: Documents and Memories, May 7–31

Exhibition of Paintings and Drawings from the Josef von Sternberg Collection, November 1–27 (catalogue)

Jean Hugo: Paintings, Pastels, Drawings, and Theater, December 3–26

Landscapes: Real and Imaginary, December 3–26 (catalogue)

1947

Exhibition of Paintings by André Derain, January 3–25 (catalogue)

Exhibition of Paintings by Florine Stettheimer, January 3–25 (catalogue)

Exhibition of the Arthur Heun Collection of Modern Paintings and Drawings Bequeathed to the Arts Club, February 7–March 1 (catalogue)

Thirty-First Annual Exhibition by the Professional Members, March 9–April 5 (catalogue)

1951

Paris Masters, 1941–1951, June 15–July 13 (catalogue)

Exhibition: Ben Shahn, Willem de Kooning, Jackson Pollock, October 2–27 (catalogue)

Raoul Dufy: Impressions of America, October 30–November 17 (catalogue)

German Expressionists and Max Beckmann from the Collection of Mr. and Mrs. Morton D. May, November 20–December 15 (catalogue)

Jean Dubuffet, December 18, 1951–January 23, 1952 (catalogue)

Picasso: Lithographs, December 18, 1951–January 23, 1952 (catalogue)

1952

Two Exhibitions: Naum Gabo and Josef Albers, January 29–February 28 (catalogue)

Thirty-Second Annual Exhibition by the Professional Members, March 2–29 (catalogue)

Tamayo, April 4–28 (catalogue)

The School of Paris at Mid-Century: A Selection of Modern Paintings from the Collection of Mr. and Mrs. Charles Zadok, May 1–June 6 (catalogue)

Contemporary Swiss Paintings, October 1–21 (catalogue)

Exhibition of Paintings by Robert Delaunay, October 24–November 21 (catalogue)

Collage, Painting, Relief, and Sculpture by Schwitters, November 25–December 16 (catalogue)

Jacques Villon Exhibition, December 19, 1952–January 10, 1953 (catalogue)

1953

Exhibition: Adolph Gottlieb, Robert Motherwell, William Baziotes, Hans Hofmann, January 14–February 4 (catalogue)

Aubusson Tapestries Executed at Tabard Studios, February 6–28 (catalogue)

Richard Lippold: Sculpture, February 6–28 (catalogue)

An Exhibition of Italian Painters: Afro, Birolli, Cremonini, Morlotti, Vedova, March 4–25 (catalogue)

Thirty-Third Annual Exhibition by the Professional Members, March 29–April 25 (catalogue)

An Exhibition of Paintings by Cameron Booth, April 28–May 19 (catalogue)

Saul Steinberg: Drawings, April 28–May 19

An Exhibition of Paintings by Jean de Botton, May 21–June 20 (catalogue)

Chagall Etchings: "Fables de la Fontaine," October 1–31 (catalogue)

Exhibition of Paintings by Metzinger, October 1–31 (catalogue)

MacIver: Paintings, November 4–December 1 (catalogue)

Sculpture and Paintings by Alberto Giacometti, November 4–December 1 (catalogue)

Eight British Painters, December 4–31 (catalogue)

1954

New Work in Stained Glass, January 4–25 (catalogue)

John Heliker, February 3–25 (catalogue)

William Congdon, February 3–25 (catalogue)

Leonid, March 3–31 (catalogue)

Tchelitchew, March 3–31 (catalogue)

Thirty-Fourth Annual Exhibition of the Professional Members, April 4–May 1 (catalogue)

Paintings and Murals by José Guerrero, May 5–June 19 (catalogue)

Recent Graphic Work by Joan Miró, May 5–June 19 (catalogue)

Twentieth-Century Art Loaned by Members of The Arts Club of Chicago, October 1–30 (catalogue)

Georges Braque: Painter, Printmaker, November 2–26 (catalogue)

Mathieu/Soulages, December 3–29 (catalogue)

1955

Roy and Marie Neuberger Collection: Modern American Painting and Sculpture, January 4–30 (catalogue)

Janicki, Sterne, Glasco, February 2–26 (catalogue)

An Exhibition of Sculpture and Drawings by Young British Sculptors, March 2–29 (catalogue)

Thirty-Fifth Annual Exhibition by the Professional Members, April 3–May 6 (catalogue)

World at Work: An Exhibition of Paintings and Drawings Commissioned by Fortune, Presented on the Occasion of the Magazine's Twenty-Fifth Anniversary, May 12–15

An Exhibition of Cubism on the Occasion of the Fortieth Anniversary of The Arts Club of Chicago, October 3–November 4 (catalogue)

Noguchi: Sculpture and Scroll Drawings, November 11–December 7 (catalogue)

Accent Rugs Woven by Gloria Finn and Designed by American Painters, December 13, 1955–January 3, 1956 (catalogue)

Melanesian Sculpture, December 13, 1955–January 3, 1956 (catalogue)

1956

Les Fauves, January 10–February 15 (catalogue)

Fritz Wotruba, February 21–March 20 (catalogue)

Thirty-Sixth Annual Exhibition by the Professional Members, March 25–April 28 (catalogue)

Marsden Hartley, Edward Hopper, Walt Kuhn, John Sloan, May 8–June 15 (catalogue)

Chaim Soutine: Paintings, October 1–31 (catalogue)

Oskar Kokoschka: Paintings, Drawings, and Prints, October 1–31 (catalogue)

Paul Klee, November 8–December 6 (catalogue)

Le Corbusier, Riopelle, Poliakoff, Calliyannis, Dufour, December 11, 1956–January 8, 1957 (catalogue)

1957

Adventure in Glass, January 15–February 13 (catalogue)

Young American Painters: John Ferren, Julio Girona, John Grillo, Angelo Ippolito, Marca-Relli, Joan Mitchell, February 22–March 18 (catalogue)

Thirty-Seventh Annual Exhibition by the Professional Members, March 24–April 30 (catalogue)

Pre-Colombian Sculpture, May 7–June 20 (catalogue and supplement)

Graphic Work by Edvard Munch, October 1–19

Young British Painters, October 25–December 3 (catalogue)

Italian Sculptors: Marini, Manzù, Minguzzi, Mirko, Consagra, Fazzini, December 10, 1957–January 23, 1958 (catalogue)

1958

Paintings by Alberto Burri, January 30–March 7 (catalogue)

Prints by Matisse, March 14–April 4

Thirty-Eighth Annual Exhibition by the Professional Members, April 13–May 13 (catalogue)

Cicero, Knaths, Plate, Levee, Schneider: Paintings, May 20–June 20 (catalogue)

Surrealism Then and Now, October 1–30 (catalogue)

Six American Sculptors: Baskin, Farr, Glasco, Lipton, Schmidt, Schor, November 7–December 8 (catalogue)

Drawings and Small Sculpture: Barlach, Brown, Derain, Frasconi, Giacometti, Greco, Janicki, Kolbe, Lachaise, Manolo, Marshall, Nadelman, Perlin, Pozzati, December 16, 1958–January 26, 1959 (catalogue)

1959

Amedeo Modigliani, January 30–February 28 (catalogue)

Thirty-Ninth Annual Exhibition by the Professional Members, March 8–April 4 (catalogue)

Da Silva, de Staël, Wols, April 14–May 16 (catalogue)

Art and the Found Object, May 22–June 17

Sculpture by Constantino Nivola, October 1–29

Enrico Donati, November 3–25 (catalogue)

Contemporary Painters of Japanese Origin in America, November 6–December 5

Henry Moore: Sculpture and Drawings from Chicago Collections, December 11, 1959–January 14, 1960 (catalogue)

1960

Liturgical Art, January 22–March 1 (catalogue)

Fortieth Annual Exhibition by the Professional Members, March 13–April 9 (catalogue)

Sculpture and Drawings by Sculptors from the Solomon R. Guggenheim Museum, April 19–May 19 (catalogue)

Barnet, Sugai, Leyden, May 25–June 25 (catalogue)

Young French Painters, September 29–October 29 (catalogue)

Construction and Geometry in Painting: From Malevich to "Tomorrow," November 11–December 30 (catalogue)

1961

Smith College Loan Exhibition, January 10–February 15 (catalogue)

Joan Miró: Works from Chicago Collections/Hans Arp: Sculpture from Chicago Collections, February 22–March 25 (catalogue)

Forty-First Annual Exhibition by the Professional Members, April 9–May 6 (catalogue)

The Aldrich Collection, May 19–June 20 (catalogue)

First Midwestern Exhibition of Belgian Painters, September 28–October 28 (catalogue)

Modern Mosaics of Ravenna, November 3–30

Franz Kline, December 8, 1961–January 9, 1962 (catalogue)

1962

Paul Klee: Works from Chicago Collections, January 16–February 20 (catalogue)

Wit and Humor, February 28–March 31 (catalogue)

Forty-Second Annual Exhibition by the Professional Members, April 8–May 1 (catalogue)

Twentieth-Century Drawings from The Museum of Modern Art, New York, May 11–June 6

Stephen Pace/George McNeil, June 11–30

Abstract Paintings from the Whitney Museum of American Art, October 1–November 1 (catalogue)

Braque: An Exhibition to Honor the Artist on the Occasion of His Eightieth Anniversary, November 6–December 8 (catalogue)

Stravinsky and the Dance, December 13, 1962–January 10, 1963 (catalogue)

1963

Etienne Hajdu: Sculpture and Drawings, January 22–February 23 (catalogue)

Forty-Third Annual Exhibition by the Professional Members, March 3–31 (catalogue)

The Miniature in Persian Art, April 9–May 9 (catalogue)

Work by Ernst Barlach, May 16–June 15 (catalogue)

John Graham, September 26–October 31 (catalogue)

Drawings, Studies, and Paintings by Arshile Gorky, November 8–December 14

Julius Bissier Retrospective, December 20, 1963–January 18, 1964

1964

Primitive Paintings from the Pacific, the Americas, and Africa, January 24–February 25 (catalogue)

Robert Goodnough, March 3–31 (catalogue)

Forty-Fourth Annual Exhibition by the Professional Members, April 12–May 9 (catalogue)

Jacques Lipchitz: Bronze Sketches, 1912–1962, May 15–June 15 (catalogue)

Balthus, September 21–October 28 (catalogue)

Italian Votive Tablets from the Collection of Ermanno Mori, November 6–December 4 (catalogue)

Sidney Nolan, December 10, 1964–January 12, 1965

1965

Fritz Bultman, January 19–February 20 (catalogue)

Pierre Alechinsky: Paintings, Encres, and Watercolors, February 26–March 27 (catalogue)

Forty-Fifth Annual Exhibition by the Professional Members, April 11–May 8 (catalogue)

Lee Gatch: Recent Paintings, May 13–June 16 (catalogue)

Albert Gleizes: Oil Paintings, Watercolors, and Drawings, September 20–October 30 (catalogue)

Kinetic Art, November 8–December 11 (catalogue)

Marisol, December 14, 1965–January 15, 1966 (catalogue)

1966

Germaine Richier: Exhibition of Sculpture, Drawings, and Etchings, January 21–February 19 (catalogue)

Drawings, 1916/1966, February 28–April 11 (catalogue)

Forty-Sixth Annual Exhibition by the Professional Members, April 17–May 14 (catalogue)

Robert Rauschenberg: Illustrations for Dante's Inferno, May 20–June 24

The Raymond and Laura Wielgus Collection, September 26–November 2 (catalogue)

Roy Gussow, Jose De Rivera, Jan Yoors, November 11–December 10 (catalogue)

Works by Enrico Baj, December 16, 1966–January 21, 1967 (catalogue)

1967

Victor Vasarely, January 30–March 1

Pierre Courtin, March 7–April 8 (catalogue)

Forty-Seventh Annual Exhibition by the Professional Members, April 16–May 13 (catalogue)

Recent Works of Adolph Gottlieb, May 22–June 23 (catalogue)

Alan Davie, September 25–October 28 (catalogue)

Reuben Nakian, November 6–December 2 (catalogue)

Karl Gerstner: Optical Constructions/Josef Levi: Constructions in Light, December 11, 1967– January 17, 1968 (catalogue)

1968

Masayuki Nagare, January 24–February 24 (catalogue)

Marcelo Bonevardi: Paintings and Drawings, March 1–30 (catalogue)

Forty-Eighth Annual Exhibition by the Professional Members, April 7–May 11 (catalogue)

Jewelry by Contemporary Painters and Sculptors, May 24–June 28 (catalogue)

Louise Nevelson, September 23–October 26 (catalogue)

The Krannert Art Museum, University of Illinois, Champaign, Loan Exhibition, November 6– December 10 (catalogue)

Recent Paintings by Jimmy Ernst/Sculpture by Willi Gutman, December 17, 1968–January 25, 1969 (catalogue)

1969

Musical Sculptures by François and Bernard Baschet, February 6–March 15 (catalogue)

Hundertwasser, March 25–April 19

Forty-Ninth Annual Exhibition by the Professional Members, April 27–May 17 (catalogue)

Max Bill, May 27–June 27 (catalogue)

Julio Gonzalez, September 22–October 18 (catalogue)

The Crowd: An Exhibition of Sculpture, Painting, and Graphics, October 28–November 29 (catalogue)

Mario Prassinos, December 10, 1969–January 9, 1970 (catalogue)

1970

Assemblages by Varujan Boghosian, January 20–February 21 (catalogue)

The Calligraphic Statement: An Exhibition of Western and Eastern Calligraphy and Painting from the Eighth to the Twentieth Century, March 3– April 11 (catalogue)

Fiftieth Annual Exhibition by the Professional Members, April 19–May 15 (catalogue)

Artists Abroad, May 27–June 27

Chinese Art from the Collection of James W. and Marilynn Alsdorf, September 21–November 13 (catalogue)

Pol Bury: Kinetic Sculpture and Cinetizations, November 24, 1970–January 2, 1971

1971

Recent Paintings by Ray Parker, January 12– February 20 (catalogue)

Recent Sculpture by David Lee Brown, January 12– February 20 (catalogue)

Victor Pasmore, March 2–April 10 (catalogue)

Fifty-First Annual Exhibition by the Professional Members, April 18–May 15 (catalogue)

Carl-Henning Pedersen: Paintings, May 24–June 25 (catalogue)

Alfred Manessier: Paintings, Tapestries, Stained-Glass, Designs, Drawings, and Prints, September 20–November 4 (catalogue)

A Second Talent: An Exhibition of Drawings and Paintings by Writers, November 15–December 31 (catalogue)

1972

George Rickey, January 11–February 11

Fifty-Second Annual Exhibition by the Professional Members, February 20–March 22 (catalogue)

Folon and Topor, April 4–May 11 (catalogue)

Sculpture by Edgar Negret, May 22–June 27 (catalogue)

William Talbot, September 25–November 4 (catalogue)

Aubusson Tapestries by Alexander Calder with A Selection of Mobiles, November 15–December 30 (catalogue)

1973

Photographer as Poet, January 10–February 10 (catalogue)

Paintings from the Collection of the University of Iowa Museum of Art, February 21–March 28 (catalogue)

Fifty-Third Annual Exhibition by the Professional Members, April 8–May 4 (catalogue)

Jack Youngerman, May 15–June 21 (catalogue)

Charles O. Perry, September 24–November 3

Exhibition of Relief Prints by Juergen Strunck, September 24–November 3 (catalogue)

The American Landscape, November 14– December 29 (catalogue)

1974

Andrea Cascella, January 10–February 7 (catalogue)

John Civitello, January 10–February 7 (catalogue)

Fifty-Fourth Annual Exhibition by the Professional Members, February 17–March 15 (catalogue)

Bonnard: Drawings from 1893 to 1946, March 28– May 11 (catalogue)

Fifth Moon Group, May 22–June 21 (catalogue)

Joan Mitchell: Recent Paintings, September 23– November 9 (catalogue)

Loan Exhibition: Art Gallery, University of Notre Dame, November 20, 1974–January 4, 1975 (catalogue)

1975

The Horse as Motif, 1200 B.C.–1966 A.D., January 15–February 22 (catalogue)

Kyle Morris, James Prestini, Jack Tworkov, March 5–April 1 (catalogue)

Fifty-Fifth Annual Exhibition by the Professional Members, April 13–May 10 (catalogue)

Kurt Kranz: Bauhaus and Today, Multimedia, May 20–June 20

André Francois, September 22–November 1 (catalogue)

Sixty Years on The Arts Club Stage: A Souvenir Exhibition of Portraits, November 17, 1975– January 3, 1976 (catalogue)

1976

Cletus Johnson: Theaters, January 14–February 13 (catalogue)

John Willenbecher: Constructions, Paintings, and Works on Paper, January 14–February 13 (catalogue)

Theodore Roszak: Recent Works, February 23– March 27 (catalogue)

Fifty-Sixth Annual Exhibition by the Professional Members, April 11–May 11 (catalogue)

Mary Frank: Sculptures, Drawings, and Monoprints, May 24–June 22 (catalogue)

Ben Nicholson, September 20–October 29 (catalogue)

Horst Antes: Paintings, November 15–December 27 (catalogue)

1977

Archipenko: Polychrome Sculpture, January 10–February 9 (catalogue)

Ulfert Wilke: Recent Calligraphic Paintings, February 17–March 18 (catalogue)

Fifty-Seventh Annual Exhibition by the Professional Members, March 27–April 30 (catalogue)

Leon Berkowitz: Big Bend Series, 1976, May 11–June 24

John Pearson, September 21–October 30 (catalogue)

Howard Newman: Bronze Sculptures and Drawings, November 14–December 28 (catalogue)

1978

William Allan: Paintings and Watercolors, 1969–1977, January 9–February 11 (catalogue)

Prints from the Collection of Dimitri Hadzi: Old Masters to Modern, February 20–March 29 (catalogue)

Fifty-Eighth Annual Exhibition by the Professional Members, April 9–May 6 (catalogue)

Richard Pousette-Dart: Drawings, May 15–June 21 (catalogue)

Irving Petlin Rubbings …: The Large Paintings and the Small Pastels, September 20–October 31 (catalogue)

François Rouan: Paintings and Drawings, 1972–1976, November 13–December 30 (catalogue)

1979

Works on Paper: American Art, 1945–1975, The Washington Art Consortium Collection, January 10–February 14 (catalogue)

Ann McCoy: The Red Sea and the Night Sea, February 27–March 31 (catalogue)

Fifty-Ninth Annual Exhibition by the Professional Members, April 8–May 9 (catalogue)

Paul Sarkisian: Paintings, May 22–June 25 (catalogue)

Fletcher Benton: New Sculpture, September 17–November 3 (catalogue)

David Diao, November 12–December 30

1980

Vuillard: Drawings, 1885–1930, January 14–February 16 (catalogue)

Elmer Bischoff: New Paintings, February 25–March 22 (catalogue)

Sixtieth Annual Exhibition by the Professional Members: Paperworks and Sculpture, March 30–April 26 (catalogue)

Vija Celmins: A Survey Exhibition, May 12–June 20 (catalogue)

Books Illustrated by Painters and Sculptors, from 1900, September 22–October 31 (catalogue)

Works from the Twentieth-Century Collection of Indiana University Art Museum, November 12–December 31 (catalogue)

1981

Frank Faulkner: Paintings, January 12–February 14 (catalogue)

Jess: Paintings, February 25–April 4 (catalogue)

Painting and Sculpture: Sixty-First Annual Exhibition by the Professional Members, April 12–May 9 (catalogue)

Wolf Kahn: Ten Years of Landscape Painting, May 20–June 23 (catalogue)

Nathan Oliveira: Recent Paintings and Monotypes, September 21–November 6 (catalogue)

Arakawa, November 18–December 31 (catalogue)

1982

Biederman, Gummer, Kendrick, January 13–February 24 (catalogue)

Harry Bowers: Color Photographs, March 8–April 7

Sixty-Second Annual Exhibition by the Artist Members: Paperworks and Sculpture, April 18–May 15 (catalogue)

John Evans: Collage Diaries, May 26–June 25 (catalogue)

Robert Curtis: Sculpture, May 26–June 25 (catalogue)

Mies van der Rohe: Interior Spaces, September 20–November 4 (catalogue)

High Culture in the Americas before 1500, November 15–December 31 (catalogue)

1983

Raoul Hague, January 12–February 10 (catalogue)

Sixty-Third Annual Exhibition by the Artist Members, February 20–March 26 (catalogue)

Terence La Noue: Recent Paintings and Drawings, April 6–May 21 (catalogue)

David Smith: Spray Paintings, Drawings, Sculpture, June 1–30 (catalogue)

Elaine de Kooning and the Bacchus Motif, September 14–November 5 (catalogue)

Katherine Porter, November 16–December 31 (catalogue)

1984

David von Schlegell, January 9–February 29 (catalogue)

Nicol Allan: Collages, Watercolors, and Sumi Drawings, January 9–February 29 (catalogue)

Sixty-Fourth Annual Artist Member Exhibition: Paperworks and Sculpture, March 11–31 (catalogue)

Sixty-Fourth Annual Artist Member Exhibition: Paintings and Sculpture, April 8–28 (catalogue, same as above)

John Altoon: Works on Paper, May 9–June 27 (catalogue)

Venturi, Rauch, and Scott Brown: A Generation of Architecture, September 17–November 3 (catalogue)

Fairfield Porter: Paintings and Works on Paper, November 12–December 31 (catalogue)

1985

Charles Garabedian: Collages, 1974–1982, January 9–February 23 (catalogue)

Sixty-Fifth Annual Artist Member Exhibition: Works on Paper/Sculpture, March 3–23 (catalogue)

Sixty-Fifth Annual Artist Member Exhibition: Sculpture/Paintings, March 31–April 20 (catalogue)

Tom Holland, May 6–26 (catalogue)

Anni Albers: Prints/Ella Bergmann: Drawings/Ilse Bing: Photographs, September 11–October 22 (catalogue)

Selections from the Reader's Digest Collection, October 29–31

Michael Mazur: Monotypes with Pastels, Paintings, and Drawings, November 13–December 31 (catalogue)

1986

Sixty-Sixth Annual Artist Member Exhibition: Works on Paper and Sculpture, January 12–February 8 (catalogue)

Michelle Stuart: Essence of Place—Paintings, Objects, and Drawings from the Earth, February 17–March 22 (catalogue)

Modern Master Drawings: Forty Years of Collecting at the University of Michigan Museum of Art, March 31–April 26 (catalogue)

Idelle Weber: Paintings and Works on Paper, 1982–1985, May 5–June 25 (catalogue)

Portrait of an Era: Rue Winterbotham Carpenter and The Arts Club of Chicago, Seventieth Anniversary Exhibition, September 15–November 1 (catalogue)

Charles Arnoldi: A Survey, 1971–1986, November 14–December 31 (catalogue)

1987

Dorothea Rockburne: Recent Paintings and Drawings, January 12–February 25 (catalogue)

Sixty-Seventh Annual Artist Member Exhibition: Paintings and Sculpture, March 8–April 4 (catalogue)

Wayne Thiebaud: Works on Paper from the Collection of the Artist, April 15–June 24 (catalogue)

Chairs As Art/Art As Chairs, September 14–October 31 (catalogue)

Five Figures of Structure: Lawrence Weiner, November 11–December 31 (catalogue)

1988

The Altering Eye: Layered Photographic Images, January 13–March 5 (catalogue)

Sixty-Eighth Annual Artist Member Exhibition: Works on Paper and Sculpture, March 13–April 23 (catalogue)

The Objects of Sculpture, May 4–June 30 (catalogue)

Jan Håfström, September 13–October 31 (catalogue)

Vincent Gallo, September 13–October 31 (catalogue)

Joe Zucker, November 11–December 30 (catalogue)

1989

Tropism: Photographs by Ralph Gibson, January 11–March 1 (catalogue)

Sixty-Ninth Annual Artist Member Exhibition, March 12–April 22 (catalogue)

Drawings of the 80's from Chicago Collections, May 3–June 28 (catalogue)

The Unquiet Landscape: Recent Expressionist and Fantasy Landscape Paintings, September 13–October 30 (catalogue)

Gonzalo Fonseca: Sculpture and Drawings, November 8–December 29 (catalogue)

1990

American Abstract Drawings, 1930–1987: Selections from The Arkansas Arts Center Foundation Collection, January 8–February 12 (catalogue)

Jim Dine: Drawings, 1973–1987, February 21–March 31 (catalogue)

Seventieth Annual Artist Member Exhibition: Works on Paper and Sculpture, April 8–May 4 (catalogue)

Agnes Denes: Concept into Form—Works, 1970–1990, May 9–June 29 (catalogue)

Visions: Expressions beyond the Mainstream from Chicago Collections, September 17–November 3 (catalogue)

Gaylen Hansen: Paintings, November 12, 1990–January 12, 1991 (catalogue)

1991

Masterworks of Color and Design: Islamic Carpets from Oberlin College, January 23–March 13 (catalogue)

Seventy-First Annual Artist Member Exhibition, March 24–April 27 (catalogue)

Colin Lanceley: New Constructed Paintings, May 8–June 28 (catalogue)

Andy Goldsworthy: Sand Leaves—Michigan Dunes, August 1991/Illinois Woods, September 1991, September 16–November 4 (catalogue)

John Walker: Paintings and Drawings, November 13, 1991–January 11, 1992 (catalogue)

1992

Halftime: Celebrating Seventy-Five Years of Chicago Architecture, January 22–March 11 (catalogue)

Seventy-Second Annual Artist Members Exhibition, March 22–April 25 (catalogue)

Seventy-Fifth Anniversary Exhibition, 1916–1991, May 11–June 26 (catalogue)

Siah Armajani: Streets, Sculpture, and Notations, September 16–November 7 (catalogue)

Peter Shelton: Drawings and Sculpture, November 16, 1992–January 2, 1993 (catalogue)

1993

Matta: Works from Chicago Collections, January 11–March 6 (catalogue)

Seventy-Third Annual Artist Members Exhibition, March 14–April 25 (catalogue)

Ritual Raiment: Liturgical and Fraternal Order Vestments, 1850–1950, April 28–June 25 (catalogue)

René Daniëls, September 15–October 23 (catalogue)

Fluxus Vivus, November 2–December 4 (catalogue)

Seventy-Fourth Annual Artist Members Exhibition: Works on Paper and Sculpture, December 12, 1993–January 22, 1994 (catalogue)

1994

Marlene Dumas, February 1–March 5 (catalogue)

James Welling: Architectural Photographs; Buildings by H. H. Richardson (1838–86), 1988–94, March 16–April 23 (catalogue)

Nauman, Palermo, Schwarzkogler: Spaces, May 4–June 30 (catalogue)

Conflict and Creativity: Architects and Sculptors in Chicago, 1871–1937, Selections from the Seymour H. Persky Collection, September 20–October 22 (catalogue)

Rigidity/Flexibility on the Grid: Situated Works by Daniel Buren, November 2–December 10 (catalogue)

Seventy-Fifth Annual Exhibition of Artist Members, December 18, 1994–January 21, 1995 (catalogue)

1995

Richard Pettibone: Sculpture, January 31–March 11 (catalogue)

Ray Smith: Recent Paintings, May 10–July 14 (catalogue)

The Arts Club of Chicago, Designs for the New Building, Vinci/Hamp Architects, Inc., September 21–October 28

Marcel Broodthaers: The Complete Editions, November 8, 1995–January 5, 1996 (catalogue)

1996

Malcolm Morley: A Selection of Watercolors from 1976 to 1995, January 24–March 22 (catalogue)

D.I.: David Ireland, April 10–June 28 (catalogue)

Seventy-sixth Annual Artist Member Exhibition, September 18–November 1 (catalogue)

Bill Viola, "Reasons for Knocking at an Empty House," November 11–22 (catalogue)

Abbott, Berenice, 84
Addams, Jane, 11
Afro, 129
Albers, Anni, 132
Albers, Josef, 127, 129
Albert Roullier Art Galleries, Chicago, 113, 118 see also Roullier, Albert
Aldis, Arthur, 12
Aldrich, Abby. see Rockefeller, Abby Aldrich
Aldrich Collection, 130
Alechinsky, Pierre, 28, 32–33, 92, 110, 130
Allan, Nicol, 132
Allan, William, 132
Allerton, Robert H., 120
Alsdorf, James W., 30, 52, 111, 116, 131
Alsdorf, Marilynn, 30, 52, 111, 116, 131
Altoon, John, 132
André, Albert, 122, 128
Anisfeld, Boris, 123
Antes, Horst, 131
Apollinaire, Guillaume, 72, 88, 104
Appel, Karel, 28, 32, 110
Arakawa, 132
Archipenko, Alexander, 24, 34, 50, 110, 123, 125, 132
Arensberg, Louise, 11
Argotinsky, Prince W., 90, 119
Armajani, Siah, 133
Arnoldi, Charles, 132
Arp, Jean (Hans), 27, 35, 43, 58, 100, 110, 130
Ascher, Ltd., London, 117
Ashman, Howard, 126
Avery, Milton, 128
B
Bacon, Francis, 54
Badger, Frances, 104
Bahnc, Salcia, 110
Bahr, A. W., 124
Baj, Enrico, 28, 131
Bakst, Leon, 122, 123
Balla, Giacomo, 56
Balthus, 130
Barlach, Ernst, 128, 130
Barnet, Will, 130
Barr, Alfred, Jr., 16
Barrett, Neil (Mrs. Roger), 29
Barrias, Louis–Ernest, 49
Bartlett, Frederic Clay, 12, 22
Bartolo, Taddeo di, 124
Baschet, Bernard, 111, 131
Baschet, François, 111, 131
Baskin, Leonard, 130
Bataille, Georges, 52
Bauchant, André, 126
Bauer, Rudolf, 127
Baxter, James Phinney, IV, 29
Baziotes, William, 129
Beckmann, Max, 25, 128
Beerbohm, Max, 127
Bellows, George W., 21, 23, 66, 122
Benno, B. G., 127
Benton, Fletcher, 111, 132
Berggruen Gallery, New York, 112
Bergmann, Ella, 132
Berkowitz, Leon, 132
Berlandina, Jane, 126
Berman, Eugene, 128
Best-Maugard, Adolfo, 122
Bianco, Pamela, 123
Biberman, Edward, 126
Biddle, George, 124
Biederman, Charles, 128, 132
Bill, Max, 131
Billings, Henry, 126

Billon, Jacques, 126
Bing, Ilse, 132
Birolli, Renato, 129
Bischoff, Elmer, 132
Bissier, Julius, 130
Blackshear, Kathleen, 19
Blair, William McCormick, 111, 116
Bleumner, Oscar F., 126
Bliss, Lillie P. (Lizzie), 11, 127
Block, Albert, 124
Block, Leigh B., 111, 116
Block, Mortimer, 122
Bluemner, Oscar, 122
Blum, Jerome, 125
Blume, Peter, 128
Bock, Arthur, 102
Boghosian, Varujan, 131
Bolm, Adolph, 70
Bombois, Camille, 128
Bonevardi, Marcelo, 131
Bonnard, Pierre, 131
Booth, Cameron, 129
Borés, Francisco, 127
Botkin, Henri Albert, 127
Botton, Jean de, 129
Bouchène, Dimitri, 127
Bourdelle, Emile-Antoine, 28, 36–37, 49, 52, 111, 123
Boutet de Monvel, Bernard, 29, 111, 124
Boutet de Monvel, Maurice, 126
Bowers, Harry, 132
Brailowsky, L. N., 123
Branchard, Emile, 122
Brancusi, Constantin, 11, 15, 22, 23, 29, 58, 84, 108, 124
Braque, Georges, 15, 22, 24, 28–29, 38, 39, 50, 100, 103, 108, 111, 123, 128, 129, 130
Breton, André, 100
Brewster, Walter, 12
Broodthaers, Marcel, 133
Brooks, Romaine, 126
Brown, Carlyle, 130
Brown, David Lee, 131
Brown, Roger, 104
Brown, Denise Scott, 132
Brown, Theodora Winterbotham, 28, 110, 111, 116
Brummer Gallery, New York, 113
Brummer, Joseph, 15
Buffet-Picabia, Gabrielle, 118
Bulliet, Clarence J., 12, 13, 27, 107, 118
Bulliet, L. J., 118
Bultman, Fritz, 130
Buren, Daniel, 133
Burlin, Paul, 124
Burri, Alberto, 130
Bury, Pol, 131
W. Russell Button Gallery, Chicago, 119
C
Cage, John, 18–19, 25
Cage, Xenia, 25
Cagli, Corrado, 129
Calder, Alexander, 25, 26, 29, 40–43, 112, 126, 128, 131
Callery, Mary, 129
Calliyannis, 129
Camarasa, Hermengildo Anglada y, 123
Canadé, Vincent, 128
Canals, 122
Carlsson, Harry, 127
Carpeaux, Jean-Baptiste, 49
Carpenter, Genevieve. See Hill, Genevieve Carpenter
Carpenter, John Alden, 22, 29, 116

Carpenter, Rue Winterbotham, 11, 12, 15, 16, 21, 22, 23, 24, 28, 29, 56, 70, 116, 132
Carroll, Leon, 125
Cascella, Andrea, 131
Celmins, Vija, 132
Chagall, Marc, 124, 128, 129
Chanler, Robert W., 122
Chapin, James, 124
Chapman, Elizabeth Goodspeed, 111, 115
Chardin, J. B. S., 124
Charpentier, Alexandre, 49
Chase, William Merritt, 124
Chinese bodhisattvas, 46–47, 112; tomb sculpture, 44, 112; vases, 45, 112
Chirico, Georgio de, 125
Christo, 54
Chrysler, Walter P., 127
Cicero, Carmen, 130
Cittadini, Tito, 123
Civitello, John, 131
Clarke, John L., 126
Claudel, Camille, 49
Coburn, Annie Swan, 22
Cocteau, Jean, 15, 126
Colombian figure, 112
Cone, Claribel, 11
Cone, Etta, 11
Congdon, William, 129
Consagra, Pietro, 130
Coomaraswamy, Ananda, 122
Copland, Aaron, 15
Copley, John Singleton, 122
Cor Ardens, 123
Corbino, Jon, 128
Corbusier, Le, 28, 100, 128, 129
Cottingham, Robert, 112
Cottong, Kathy, 29
Courbet, Jean Désiré Gustave, 128
Courtin, Pierre, 112, 131
Cox-McCormack, Nancy, 21
Crammer, Frances
Crawford, Ralston, 128
Creeft, José de, 125
Cremonini, Leonardo, 129
Cristofanetti, Francesco, 128
Crowninshield, Frank, 126
Cummings, Adeline de Voo, 123
Curtis, Robert, 132
Cushman, Mrs. Allerton, 111, 116
Cushman, Mrs. Charles T. see Cox-McCormack, Nancy
Cuttoli, Marie Bordes (Madame Paul), 39, 111, 128
Czaky, Joseph, 108
D
Daley, Richard J., 28
Dalou, Jules-Aimé, 36, 49
Dalí, Salvador, 25, 128
Daniëls, René, 133
Da Silva, Maria Helena Vieira, 130
Davey, Randall, 122
David, Hermine, 127
Davidson, Mrs. Eugene, 111, 116
Davie, Alan, 131
Davies, Arthur Bowen, 66, 125, 129
Davis, Stuart, 128
De Rivera, Jose, 130
Dearth, Henry Golden, 21, 122
Degas, Edgar, 107, 123, 124
Delaunay, Robert, 35, 129
Delaunay, Sonia, 100
Demuth, Charles, 128
Denes, Agnes, 133
Derain, André, 15, 29, 48, 49, 112,

124, 126, 127, 129, 130
Derujinsky, Gleb, 122
Despiau, Charles, 49, 113, 126
Devine, Herbert J., 125
Diaghilev, Serge, 56, 90
Diao, David, 132
Dickinson, Preston, 128
Diederich, Wilhelm Hunt, 113, 122
Dine, Jim, 133
Dodge, Mabel, 11
Doesburg, Theo van, 43
Domela, Cesar, 127
Donati, Enrico, 128, 130
Dongen, Kees van, 127
Douglas, Mrs. Donald B., 111, 116
Douglass, Lucille, 124
Dreier, Katherine, 11, 127
Drewes, Werner, 127
Dubuffet, Jean, 19, 129
Duchamp, Marcel, 15–16, 22–23, 43, 86, 127
Duchamp-Villon, Raymond, 22, 125
Dudley, Katherine, 23
Dufour, Bernard, 129
Dufresne, Charles, 126
Dufy, Raoul, 125, 127, 128
Dumas, Marlene, 133
Durand-Ruel, 123
Durieux, Caroline, 127
E
Eakins, Thomas, 23
Echaurren, Roberto Matta, 128, 133
Eddy, Arthur Jerome, 22
Edzard, Dietz, 127
Eisendrath, William, 25, 28, 40
Elliott, Bertram, 124
Ehrich Galleries, 122
Eluard, Paul, 52
Epstein, Jacob, 124
Ernst, Jimmy, 131
Ernst, Max, 35, 128
d'Espagnat, Georges, 126
Evans, Anne, 11
Evans, John, 132
Exter, Alexandra, 86
F
Faggi, Alfeo, 113, 122
Falguière, Alexandre, 36
Farr, Fred, 130
Fatinsky, Sergei, 123
Faulkner, Barry, 123
Faulkner, Frank, 132
Fazzini, Pericle, 130
Feder, Adolph, 123
Feininger, Lyonel Charles Adrian, 126
Fergusson, John Duncan, 124, 125
Ferren, John, 127, 130
Field, Mrs. Henry, 15, 16
Fiene, Ernest, 125, 126
Finn, Gloria, 129
Fitzgerald, F. Scott, 90
Flannagan, John B., 126
Florsheim, Sue (Mrs. Harold), 30, 119
Florsheim, Mrs. and Mrs. Harold M., 128
Fluxus, 133
Folon, Jean-Michel, 113, 131
Folsom, Ethel, 122
Fonseca, Gonzalo, 133
Foote, Mary, 122
Forain, Jean-Louis, 123
Forbes, Vivian, 123
Ford, Charles Henri, 106
Ford, Ruth, 106
Foujita, Tsuguhara, 26, 50–51, 113, 122, 125
Francois, André, 131

Frank, Mary, 113, 131
Frankl Galleries, 123
Frasconi, Antonio, 130
Freehling, Mr. and Mrs. Stanley M., 30, 119
Freehling, Stanley M., 29
French, Jared, 128
Fresnaye, Roger de la, 126, 128
Friedman, 122
Friesz, Emile-Othon, 49, 125
Allan Frumkin Gallery, Chicago, 119
Fry, Roger, 126
Fuller, Buckminster, 84, 125
Férat, Serge, 113, 127
G
Gabo, Naum, 58, 127, 129
Galerie de France, Paris, 119
Galerie Denise René, Paris, 110
Galerie Jeanne Bucher, Paris, 115
Gallatin, A. E., 128
Gallo, Vincent, 133
Galsworthy, Frank, 123
Ganso, Emil, 124, 125
Garabedian, Charles, 132
Gargallo, Pablo, 127
Gatch, Lee, 130
Gauguin, Paul, 127
Genêt, Jean, 52
Georg, Edouard, 126
Gershwin, George, 84, 126, 127
Gerstner, Karl, 131
Giacometti, Alberto, 30, 52–53, 94, 113, 126, 129, 130
Giacometti, Diego, 52
Gibson, Ralph, 29, 113, 133
Gilmour, Leonie, 84
Gimpel Fils, London, 115
Gimpel, René, 48
Girona, Julio, 130
Glackens, William J., 66, 122, 127
Glasco, Joseph, 129, 130
Gleizes, Albert, 34, 127, 130
Gluckman, Gregory, 128
Gogh, Vincent van, 122
Goldman, Isaac, 112
Goldsmith, Myron, 29, 76
Goldsworthy, Andy, 30, 54–55, 114, 133
Goncharova, Natalia, 15, 24, 56–57, 70, 115, 123, 124, 125, 127
Gondouin, Emmanuel, 127
Gonzalez, Julio, 131
Goodnough, Robert, 130
Goodspeed, Elizabeth "Bobsy," 16, 17, 18, 24, 72 see also Chapman, Elizabeth Goodspeed
Gorky, Arshile, 131
Gottlieb, Adolph, 129, 131
Goudiachvili, De Lado, 123
Gould, Inc., 115
Gourgaud, Baron Napoleon, 124
Goya, Francisco, 18
Graff, Mrs. Robert D., 111, 116
Graham, Martha, 84
Graves, Morris, 128
Greco, El, 125, 130
Greenwood, Marion, 84
Gregoriev (Grigoriev), Boris, 123, 124
Grillo, John, 130
Gris, Juan, 17, 34, 127, 127
Grosser, Maurice, 127
Grosz, George, 126
Guerrero, José, 129
Gugler, Eric, 123
Gummer, 132
Gussow, Roy, 130
Gutman, Willi, 131

H

Hadzi, Dimitri, 132
Håfström, Jan, 133
Hague, Raoul, 132
Hajdu, Etienne, 29, 115, 130
Hale, Gardner, 126
Hale, Mrs. William B., 25
Halicka, Alice, 127
Halstead, Whitney, 19
Hannah, Muriel, 125
Hansen, Gaylen, 133
Harnett, William M., 128
Harriman, Marie, 11
Harris, Josephine R. (Mrs. Norman W.), 28, 113, 120
Harrison, Lou, 18
Harshe, Robert, 90
Hartley, Marsden, 124, 128, 129
Hartman, Bertram, 123
Hartung, Hans, 100
Heizer, Michael, 54
Heliker, John, 129
Hélion, Jean, 43, 127, 128
Hemingway, Ernest, 90
Henderson, William Penhollow, 122
Henri, Robert, 21, 122, 122
Hepworth, Barbara, 30, 58–59, 102, 115
Hermann, Grover, 29, 115
Heun, Arthur, 21, 23, 26–27, 113, 115, 116, 117, 120, 129
Hewman, Howard, 132
Hill, Genevieve Carpenter, 23, 120
Hitchens, Ivon, 128
Hodge, Emma B., 123
Hodler, Ferdinand, 123
Hofer, Karl, 128
Hoff, Margo, 115
Hofmann, Hans, 128, 129
Holland, B. C., 115
Holland, Tom, 132
Hopper, Edward, 126, 129
Horter, Earl, 126
Horwich, Ruth, 43
Howard, Cecil, 123
Howard, Charles, 129
Hugo, Jean Victor, 125, 129
Hull House, 123
Hundertwasser, Fritz, 131
Hutchins, Robert Maynard, 72
Hutchinson, Charles, 12, 13

I

Iacovleff, Alexandre, 128
Indian (Mughal) painting, 60, 115
Ingres, Jean-Auguste-Dominique, 89
Inness, George, 122
Introspective Artists, 123
Ippolito, Angelo, 130
Iranian (Safavid) illustration, 61, 115
Ireland, David, 133

J

Jacob, Max, 72, 108, 127
Jacobsen, Norman, 125
Janicki, Hazel, 129, 130
Janis, Sidney, 17, 127
Jawlensky, Alexey von, 126
Jess, 132
Jewett, Eleanor, 18
Johnson, Cletus, 131
Johnson, J. Theodore, 124
Johnston, Elizabeth "Mabel." see Wakem, Elizabeth "Mabel"
Jones, Robert Edmond, 29, 115
Jones, Robert, 122
Jorn, Asger, 32
Joyce, James, 106

K

Kaby, Mohamed, 124
Kahn, Ali Kuli, 123
Kahn, Wolf, 132
Kahnweiler, Daniel, 48
Kandinsky, Wassily, 35, 56, 100, 126, 128
Katchadourian, Sarkis, 126
Katchamakoff, Atanas, 127
Kelekian, Dikran G., 125
Kelpe, Paul, 127
Kendrick, 132
Kent, Rockwell, 23, 123
Key, Mabel, 122
Khokhlova, Olga, 89–90
Kirstein, Lincoln, 106
Kisling, Moise, 128
Klee, Paul, 26, 56, 62–65, 116, 126, 128, 129, 130
Klein, Yves, 54
Kline, Franz, 28, 32, 130
Knaths, Karl, 130
M. Knoedler and Co., New York, 115, 119
Knoop, Guitou, 127
Kokoschka, Oskar, 25, 128, 129
Kolbe, Georg, 130
Kooning, Elaine de, 132
Kooning, Willem de, 28, 32, 129
Kootz, Mrs. and Mrs. Samuel M., 119
Kramer, Hilton, 82
Kranz, Kurt, 131
Kuh, Katharine, 107
Kuhn, Walt, 30, 66–67, 116, 124, 126, 129
Kuniyoshi, Yasno, 124, 128
Kurumban headdress, 29, 68, 116
Kussevitsky, Sergei, 56

L

Laboureur, Jean-Emile, 116
Lachaise, Gaston, 122, 124, 130
Lam, Wifredo, 128
Lanceley, Colin, 133
Lani, Maria, 49, 125
La Noue, Terence, 132
Lanskoy, André, 100
Larionov, Mikhail Fyodorovich, 24, 29, 56, 70–71, 116, 123
Lascaux, Elie, 17, 127
Laufman, Sidney, 124
Laurencin, Marie, 26, 116, 123, 127
Laurens, Henri, 108, 128
Laurent, Robert, 102, 124
Lavery, John, 124
Lawson, Ernest, 122
Lefebre Gallery, New York, 110
Léger, Fernand, 15, 16, 86, 100, 103, 104, 126, 128
Lehmbruck, Wilhelm, 127
Leichenko and Esser, architectural firm, 28
Lemon, Brainard, 124, 125, 126
Lemordant, Jean Julien, 124
Leonid, 129
Levee, John, 130
Lever, Hayley, 122
Leyden, Seymour, 130
Liben, Yan, 44
Liebes, Dorothy, 127
Lifar, Serge, 126
Lindbergh, Mrs. Charles, 49
Linn, Mrs. Howard, 123
Lipchitz, Jacques, 50, 103, 108, 128, 130
Lippold, Richard, 129
Lipton, Seymour, 130
Littlefield, William H., 125

Logan, Josephine, 12 _(under L column)_

Logan, Josephine, 12
Long, Richard, 54
Loo, Cheng-Tsai, 23, 112, 123, 124, 125, 126, 127
Lovett-Lorski, Boris, 123, 124
Lurçat, Jean, 39, 127
Lynes, George Platt, 106

M

McCormick, Chauncey, 13
McCormick, Elizabeth D., 122
McCormick, Harold F., 24
McCormick, Mr. and Mrs. Harold F., 111
McCormick, Mrs. Rockefeller, 23
McCoy, Ann, 132
McEvoy, Ambrose, 123
McGann, Mrs. Robert (Grace), 21, 22
MacIver, Loren, 128, 129
McNear, Ann, 28, 117, 119
McNear, Everett C., 25, 28, 117, 119
McNeil, George, 130
Macdougal Alley Sculptors, 122
MacNicol, Roy, 124
Magritte, René, 104
Maillol, Aristide, 89, 126, 128
Main Street Gallery, Chicago, 111
Manessier, Alfred, 131
Manny, Carter H., Jr., 29, 76
Manolo (Manolo Hugué), 130
Manzù, Giacomo, 130
Mané-Katz, 128
Marc, Franz, 56
Marca-Relli, Conrad, 130
Marcoussis, Louis, 24, 72–73, 116, 126
Marin, John, 128
Marini, Marino, 130
Marisol (Marisol Escobar), 130
Marshall, Helen, 130
Massine, Leonide, 15, 126
Masson, André, 126, 128
Mathieu, Georges, 129
Matisse, Henri, 15, 22, 37, 52, 74–75, 117, 124, 126, 127, 130
Matisse, Pierre, 52, 124
Pierre Matisse Gallery, New York, 117
Matter, Herbert, 128
Matulka, Jan, 122
Mazur, Michael, 132
May, Mr. and Mrs. Morton D., 129
Meeker, Arthur, Jr., 26
Mendelsohn, Eric, 128
Merrell, Elinor, 125
Merritt, Raymond W., 29, 113
Metzinger, Jean, 34, 129
Meunier, Constantin, 49
Michael Klein Gallery, New York, 117
Mielziner, Jo, 127
Mies van der Rohe, Ludwig, 19, 27–28, 29, 43, 76–77, 117, 132
Mihalovîci, Marcel, 70
Miller, Mrs. Phillip C., 111, 116
Milles, Carl, 125
Mills, Helen Harvey, 25, 30, 113, 115
Minguzzi, Luciano, 130
Mirko, Basaldella, 130
Miró, Joan, 28, 43, 78–79, 117, 125, 126, 128, 129, 130
Mitchell, Joan, 130, 131
Mitchell, Mrs. William H., 111, 116
Mochi, Ugo, 125
Model, Evsa, 128
Modigliani, Amedeo, 35, 50, 108, 125, 130
Moessel, Julius, 124
Moffett, Ross, 122
Moholy-Nagy, László, 25
Molas, Nicolas de, 127

Moller, Hans, 128
Mondrian, Piet, 43, 58, 127
Mondzain, William Simon, 122
Monet, Claude, 126
Monif, Hassan Khan, 115, 124
Monroe, Harriet, 11
Moore, Henry, 58, 80, 102, 117, 128, 130
Mopp, Maximilian, 128
Mori, Ermanno, 130
Morin, A. J., 124
Morisot, Berthe, 123, 128
Morley, Malcolm, 30, 81, 117, 133
Morlotti, Ennio,129
Morris, George L. K., 128
Morris, Kyle, 131
Motherwell, Robert, 129
Muckley, Mrs. Robert, 29, 111
Munch, Edvard, 130
Munson, Mrs. Curtis B., 111, 116
Murphy, Gerald, 90
Murphy, Sara, 90
Myers, Jerome, 128

N

Nadelman, Elie, 123, 130
Nagare, Masayuki, 131
Nakian, Reuben, 131
Nash, Paul, 128
Nauman, Bruce, 133
Negret, Edgar, 131
Neuberger, Roy and Marie, 129
Nevelson, Louise, 82–83, 118, 131
Nezami (Persian poet), 61
Nicholson, Ben, 58, 131
Nicolas, Joep, 128
Nivola, Constantino, 130
Noguchi, Isamu, 24, 84–85, 118, 125, 126, 129
Noguchi, Yone, 84
Nolan, Sidney, 130
Nordfeldt, B. J. O. (Bror), 122, 127

O

d'Oettingen, Baroness Hélène, 104
Oldenburg, Claes, 30, 118
Oliveira, Nathan, 132
Oppenheimer, Seymour, 119
Orloff, Chama, 125
Orozco, José Clemente, 126
Ozenfant, Amédée, 128

P

Pace Gallery, New York, 118
Pace, Stephen, 130
Paderewski, Ignace, 112
Paepcke, Mrs. Walter, 111, 116
Page, Mrs. Ruth, 111, 116
Palermo, Blinky, 133
Palmer, Bertha, 22, 122
Palmer, Honore, Jr., 127
Palmer, John, 29, 115
Palmer, Potter, 22
Palmer, Potter, Jr., 13
Pann, Abel, 122
Papazoff, Georges, 126
Parker, Lawton, 21
Parker, Ray, 131
Parton, Anthony, 56, 70
Pascin, Jules, 128
Pasmore, Victor, 131
Pearson, John, 132
Pedersen, Carl-Henning, 131
Perdriat, Helene, 124
Pereira, I. Rice, 128
Perlin, Bernard, 130
Perman, Mr. and Mrs. Norman, 30
Perry, Charles O., 131
Persky, Seymour H., 133
Petlin, Irving, 132

Pettibone, Richard, 133
Pevsner, Antoine, 127
Phillips, New York, 111, 115
Picabia, Francis, 22, 27, 86–87, 118, 125, 127
Picasso, Pablo, 15, 17–18, 22, 23, 28, 50, 80, 88–91, 103, 104, 108, 118, 123, 124, 125, 126, 127, 129
Picasso, Paulo, 89, 90
Picher, W. S., 113
Piper, John, 128
Pippin, Horace, 128
Pisarro, Camille, 129
Plate, Walter, 130
Poliakoff, Serge, 100, 129
Pollock, Jackson, 28, 128, 129
Poor, Henry Varnum, 128
Porter, Fairfield, 132
Porter, Katherine, 132
Porter, Mrs. George F., 23
Pousette-Dart, Richard, 132
Pozatti, Rudy, 130
Prassinos, Gisèle, 92
Prassinos, Mario, 28, 92–93, 119, 131
Prax, Valentine, 125
Prendergast, Maurice, 122
Prestini, James, 131
Priebe, Karl, 128
Pruna, Pedro, 119, 126
Purcell, Charlotte Picher, 113
Puvis de Chavannes, Pierre, 89

Q

Qi Baishi, 85
Quinn, John, 15, 124
Quinn, Mary. see Sullivan, Mary Quinn

R

Ranken, William B. E., 125
Rattner, Abraham, 128
Rauch, 132
Rauschenberg, Robert, 28, 130
Ray, Man, 125
Rebay, Hilla, 127
Redon, Odilon, 107, 124
Reinhardt, Mrs. Paul, 124
Remisoff, Nicolas, 123
Renoir, Pierre-Auguste, 89, 90, 122, 125
Repin, Ilya, 122
Reynal, Jeanne, 128
Reynolds, Anne M. see Winterbotham, Anne M. Reynolds
Richard Gray Gallery, Chicago, 110
Richards, Ceri, 128
Richier, Germaine, 30, 94–95, 119, 130
Rickey, George, 131
Rienhardt Galleries, New York, 113
Riopelle, Jean Paul, 129
Robinson, James, 126
Rockburne, Dorothea, 133
Rockefeller, Abby Aldrich, 11
Rodchenko, Alexander, 86
Rodin, Auguste, 36, 49, 102, 108, 122, 123, 125
Roerich, Nicholas, 123
Rogers, Mary, 122, 123
Rose Fried Gallery, New York, 118
Rose, Sir Francis Cyril, 17, 119, 126
Rosenberg, Paul, 89, 90, 119
Rosse, Hermann, 122
Roszak, Theodore, 131
Rouan, François, 132
Rouault, Georges, 22, 125, 126, 126, 127
Roullier, Albert, 107 see also Albert Roullier Art Galleries, Chicago
Roullier, Alice, 11, 12, 15, 16, 22, 24, 40, 56, 103, 104, 106, 111, 113,

116, 117, 119, 120, 121
Rousseau, Henri, 125, 126
Rowlandson, Thomas, 96–97, 119
Rubin, William, 89
Rubinstein, Helena, 106
Ruggles, Carl, 127
Russell, William, 18
Ryback, Issachar, 127
Ryder, Albert Pinkham, 129
Ryerson, Mr. and Mrs. Martin A., 22
S
Salmon, André, 72
Sandzen, Birger, 123
Sargent, John Singer, 122
Sargent, Margarett, 125
Sarkisian, Paul, 132
Sartre, Jean-Paul, 43, 52, 92
Sazonova, Julie, 70
Schempp, Theodore, 112
Schlegell, David von, 132
Schmidt, Julius, 130
Schnakenberg, H. E., 126
Schneider, Gerald, 130
Schofield, Flora, 104
Schor, Ilja, 130
Schrimpf, Georg, 123
Schulze, Paul, 122
Schumacher, William E., 123
Schwarzkogler, Rudolf, 133
Schwitters, Kurt, 82, 129
Segonzac, André Dunoyer de, 49, 127
Seligmann, Kurt, 129
Sergeyevna, Natalia, 123
Shahn, Ben, 28, 129
Shapiro, Joseph Randall, 25, 28
Shaw, Alfred P., 27
Shaw, Charles, 128
Shaw, Patrick, 30
Shaw, Rue Winterbotham, 12, 40, 18, 25, 25, 26, 27, 128
Sheeler, Charles, 126
Shelton, Peter, 133
Sherman, Devorah (Mrs. Saul), 121
Sickert, Walter Richard, 127
Sidney Janis Gallery, New York, 110
Sintenis, Renee, 127
Sitwell, Edith, 82
Sitwell, Osbert, 96
Sloan, John, 21, 122, 129
Smith, David, 132
Smith, Mrs. Edward B., 111, 116
Smith, Ray, 133
Smithson, Robert, 54
Sorin, Savely, 124
Soudbinine, Seraphin, 123
Soulages, Pierre, 28, 98–99, 119, 129
Soutine, Chaim (or Haim), 50, 127, 129
Sprinchorn, Carl, 123
St. Hubert, Robert La Montague, 122
Staël, Nicolas de, 30, 98, 100–101, 119, 130
Stark, Jack Gage, 127
Stein, Gertrude, 16–17, 24, 72, 106, 121
Steinberg, Saul, 129
Stella, Joseph, 122, 123
Sternberg, Josef von, 129
Sterne, Maurice, 122, 124, 126, 129
Stettheimer, Ettie, 16
Stettheimer, Florine, 72, 129
Stoddard, F. Enid, 124
Storrs, John, 24, 102–103, 119, 122, 123, 124
Straus, Dr. Gerhard, 115
Stravinsky, Igor, 130
Strunck, Juergen, 131
Stuart, Michelle, 122, 132

Sturzwage, Leopold. see Survage, Léopold
Sudeykin, Sergei, 123
Sugai, Kumi, 130
Sullivan, Mary Quinn, 11
Survage, Léopold (Leopold Sturzwage), 20, 24, 34, 104–105, 120, 123
Sutherland, Graham, 128
Sweeney, James Johnson, 43, 98, 112, 119
Szukaski, Stanislaw, 122
T
Talbot, William, 131
Tamayo, Rufino, 128, 129
Tanguy, Yves, 128
Tatlin, Vladimir, 86
Täuber-Arp, Sophie, 35, 58
Taubes, Frederic, 128
Tchelitchew, Pavel, 106, 120, 126, 127, 129
Thecla, Julia, 107, 120
Thévenaz, Paul, 23, 120–21, 123
Thiebaud, Wayne, 133
Thomas, Jean-François, 127
Thomson, Virgil, 16, 72
Thurber, James, 128
Ting, Walasse, 32
Tobey, Mark, 125, 129
Tofel, Jennings, 122
Toklas, Alice B., 24
Topor, Roland, 131
Toulouse-Lautrec, Henri de, 22, 123
Trant, Albert, 124
Trifyllis, Demetrios A., 123
Tritt, Olga, 125
Tsirch, Awa, 122
Tunnard, John, 128
Turbyfill, Mark, 121
Tworkov, Jack, 131
U,V
Utrillo, Maurice, 124
Varda, Jean, 128
Vasarely, Victor, 131
Vechten, Carl van, 17, 121
Vedova, Emilio, 129
Venturi, Robert, 132
Villon, Jacques, 125, 129
Vinci/Hamp Architects, 29
Vinci, John, 7, 29, 76, 133
Viola, Bill, 133
Vivin, Louis, 128
Vlaminck, Maurice de, 124
Vollard, Ambroise, 38, 88
Von Hoffman, Ludwig, 35
Vuillard, Edouard, 132
W
Wakem, Elizabeth "Mabel" Johnston, 25, 40
Walker, Helen, 124
Walker, John, 133
Waller, Ellen W., 29, 115
Wanamaker, John, 122
Walter, Martha, 123, 124, 128
Watkins, Franklin C., 128
Watteau, Antoine, 90
Weber, Idelle, 132
Webster, Herman, 127
Weiner, Lawrence, 133
Weisenborn, Rudolph, 104
Welling, James, 133
Welling, Mrs. John, 111, 116
Whistler, James Abbott McNeill, 123
Whistler, Rex, 127
Wiborg, Mary H., 125
Wielbus, Raymond and Laura, 130
Wieselthier, Vally, 126

Wilde, Isabel Carlteton, 126
Wilder, Thornton, 16, 17
Wilke, Ulfert, 121, 132
Willenbecher, John, 121, 131
Wilson, Claggett, 123
Winterbotham, Anne M. Reynolds (Mrs. John H.), 29, 112
Winterbotham, Joseph Humphrey, 23
Winterbotham, Joseph, Jr., 24, 127
Winterbotham, Rue. see Carpenter, Rue Winterbotham
Winterbotham, Theodora. see Brown, Theodora Winterbotham
Wols, 130
Wood, James N., 29, 76
Wood-Prince, Eleanore (Mrs. William), 29, 111, 116
Worcester, Charles, 12
Wotruba, Fritz, 129
Wright, Frank Lloyd, 102, 122
Y, Z
Yoors, Jan, 130
Youngerman, Jack, 131
Zabriskie Gallery, New York, 113
Zadkine, Josslyn, 123
Zadkine, Ossip, 24, 108–109, 121, 125, 127, 128
Zadok, Mr. and Mrs. Charles, 129
Zarraga, Angel, 125
Zerbe, Karl, 128
Zettler, Emil, 122
Zorach, William, 102
Zucker, Joe, 133
Zuloaga, Ignace, 122